READINGS OF THE *VESSANTARA JĀTAKA*

COLUMBIA READINGS OF BUDDHIST LITERATURE

COLUMBIA READINGS OF
BUDDHIST LITERATURE

SERIES EDITOR: STEPHEN F. TEISER

This series is published with the sponsorship
of the Dharma Drum Foundation for Humanities
and Social Science Research.

Readings of the Lotus Sūtra, Stephen F. Teiser
and Jacqueline I. Stone, editors

Readings of the Platform Sūtra, Morten Schlütter
and Stephen F. Teiser, editors

READINGS OF THE *VESSANTARA JĀTAKA*

Edited by Steven Collins

COLUMBIA UNIVERSITY PRESS NEW YORK

Columbia University Press
Publishers Since 1893
New York Chichester, West Sussex

Copyright © 2016 Columbia University Press
All rights reserved

Library of Congress Cataloging-in-Publication Data
Names: Collins, Steven, 1951– editor.
Title: Readings of the Vessantara Jataka / edited by Steven Collins.
Description: New York : Columbia University Press, 2016. | Series: Columbia
readings of Buddhist literature | Includes bibliographical references and index.
Identifiers: LCCN 2015012734 | ISBN 9780231160384 (cloth) |
ISBN 9780231160391 (pbk.) | ISBN 9780231541008 (electronic)
Subjects: LCSH: Tipiòtaka. Suttapiòtaka. Khuddakanikāya. Jataka.
Vessantarajåataka—Criticism, interpretation, etc.
Classification: LCC BQ1470.V487 R43 2016 | DDC 294.3/82325—dc23

Cover design: Noah Arlow
Cover image: *Vessantara Jataka*, Chapter 4, Vessantara, Maddi, Jali
and Kanha Enter the Forest. Thai, late 19th century, pigments on wood.
17 1/2 × 21 5/8 in.
Doris Duke Charitable Foundation's Southeast Asian Art Collection
(date and mode of acquisition unknown); Walters Art Museum, 2002,
by gift. Accession number 35.234.

CONTENTS

Preface vii

Introduction, *Dramatis Personae*, and Chapters
in the *Vessantara Jātaka* 1
Steven Collins

1. Readers in the Maze: Modern Debates
About the Vessantara Story in Thailand 37
Louis Gabaude

2. Emotions and Narrative: Excessive Giving and Ethical
Ambivalence in the Lao *Vessantara Jātaka* 53
Patrice Ladwig

3. Blissfully Buddhist and Betrothed: Marriage in
the *Vessantara Jātaka* and Other South and
Southeast Asian Buddhist Narratives 81
Justin Thomas McDaniel

4. Jūjaka as Trickster: The Comedic Monks
of Northern Thailand 100
Katherine A. Bowie

5. Narration in the Vessantara Painted Scrolls
of Northeast Thailand and Laos 122
Leedom Lefferts and Sandra Cate

6. A Man for All Seasons: Three *Vessantaras*
in Premodern Myanmar 153
Lilian Handlin

7. Vessantara Opts Out: Newar Versions
of the Tale of the Generous Prince 183
Christoph Emmrich

Index 211

PREFACE

WHEN STEPHEN F. TEISER asked me, some years ago, to consider editing a volume on a Pali text for the Columbia Readings of Buddhist Literature series, I immediately thought of the wonderful *Vessantara Jātaka*, a text widely known in name at least, but in my view sadly underappreciated. From the wide range of textual versions available from all over Asia, and from the frequent mention of it in ethnographic reports, we know it to be a central text in all of Asian Buddhism, indeed *the* central text in the Theravāda Buddhism of South and Southeast Asia. It has been, in some (notably urban) contexts, eclipsed only in modern times, and indeed mostly among Buddhist Modernists, by the Life of the Buddha. It is a striking text, full of strong emotions and drama, and it is morally both very striking and challenging.

Readers should obviously have read the story before undertaking this volume. While it was being prepared, the contributors knew only the translation by Margaret Cone, published in 1977 as Margaret Cone and Richard Gombrich, *The Perfect Generosity of Prince Vessantara: A Buddhist Epic translated from the Pali and illustrated by unpublished paintings from temple murals*. After a time this book went out of print, but in 2011 the Pali Text Society republished the translation, without the illustrations, as *The Perfect Generosity of Prince Vessantara*. (Although this book is hardback, it is sold at paperback price.) As this volume was in its final stages of preparation we learned of another translation, by Sarah Shaw, which appears in in the third volume of Naomi Appleton and Sarah Shaw, *The Ten Great Birth Stories of the Buddha* (Chiang Mai: Silkworm, 2015).

Shaw's introduction to her Vessantara translation is very helpful and thought-provoking, and both it and her translation could well be read in conjunction with this book.

Neither this collective volume nor the Appleton/Shaw book is the last word on the great Vessantara story (who could have the last word on *Hamlet*?), but they do, we hope, constitute the beginning of a realistic appreciation of the complexities and beauties of the text (indeed of the variety of texts called "Vessantara," not merely the Pali), and of the extraordinary variety of contexts for ritual performance and artistic representation of it.

<div style="text-align: right;">Steven Collins
University of Chicago</div>

READINGS OF THE *VESSANTARA JĀTAKA*

INTRODUCTION, *DRAMATIS PERSONAE*, AND CHAPTERS IN THE *VESSANTARA JĀTAKA*

Steven Collins

IF ONE approaches Buddhism from a perspective that sees it as a "world religion" comparable to others such as "Christianity" and "Islam," then its most important narrative will be the life of the Buddha, comparable to the lives of Jesus and Muhammad. The story of the Buddha's life is standardly used to begin both introductory books and university courses on Buddhism.[1] If, however, one approaches Buddhist textual traditions as civilizational-literary achievements to be compared to, say, the works of Homer, the Greek tragedians, or Shakespeare, then the story of central historical and ethnographic importance will be that of Vessantara, the prince who takes the Buddhist virtue (indeed the Perfection) of Generosity to such an extreme that he not only gives up his life as a royal and goes to live in a forest but also then gives away his two children and his wife. If one assumes that "religious" texts are necessarily and simply didactic, then the extravagance—indeed, to use a word that will be discussed below, the tragedy—of Vessantara's actions must be ignored or somehow smoothed over as ultimately not in conflict with Buddhism's core values and teachings. This was done by other premodern Pali texts, although not without difficulty. But if, on the other hand, one takes the Pali textual archive— what I have called elsewhere the Pali *imaginaire*[2]—to be not only recommending and extolling certain virtues and values but also thinking critically about them, then stories such as Vessantara's are exploring value conflicts rather than ignoring or solving them. As a "religion," Buddhism must in the end offer a resolution of the tragedies and suffering of human existence; but Pali texts (some of them, anyway) as literature, as works of

art, can accept and even celebrate the fact that conflicts between transcendental and everyday values can become themselves tragic (as well as comic, as does the Vessantara story). The Birth Story of Vessantara (*Vessantara Jātaka*; on the genre of *jātaka*, see below) is everywhere in South and Southeast Asia at least as important as the life of the Buddha, indeed usually more so,[3] which suggests that the unthinking classification of Buddhism as a "religion" immediately closes down the possibility of reading Buddhist literature, or some of it, as art, as itself both giving voice to and reflecting critically on a heterogeneous set of human, civilizational aspirations and achievements.

The form of Buddhism with a scriptural corpus in Pali, a form of Middle Indo-Aryan, that has become predominant in Sri Lanka and Southeast Asia (with a significant twentieth-century revival in Nepal) has in modern times been known as Theravāda, "the Way of the Elders," those who recited and—allegedly—fixed forever "the Pali Canon" at three Councils (literally "recitings," *saṅgāyana*) in India after the death of the Buddha.[4] The Theravāda claim is that its monastic ordination lineage and its view of Buddhist doctrine have been preserved faithfully since those ancient times. In Theravāda Buddhism there are three ways of being "enlightened," which are relevant to one's reading of the *Vessantara Jātaka*. All three refer to individuals who realize salvific truth, and subsequently at the end of their lives bring an end to rebirth by attaining timeless, indescribable nirvana. The first way is as a *sammāsambuddha* (Sanskrit *samyaksambuddha*), a fully enlightened buddha: this is someone who, like our Buddha Gotama, discovers the truth of life (and of death, and of what is beyond both) for himself, then preaches it by creating a *sāsana*, a conceptual and institutional Teaching through which the truth is disseminated. We are currently living at the time of Gotama's *sāsana*; in the future this will disappear, everything being impermanent, and a new buddha will appear to rediscover and preach the truth once again, founding his own Teaching. The next buddha will be known as Metteyya (Sanskrit: Maitreya). In certain texts, such as the *Vessantara Jātaka*, this aspiration is also called the aspiration to omniscience. The second kind of buddha is a *pacceka-buddha* (Sanskrit: *pratyeka-buddha*), a concept and word on which more work needs to be done.[5] It may be translated, *pro tempore*, as solitary buddha: this is someone who, like a *sammāsambuddha*, discovers the truth for himself but does not found a Teaching. This category is not relevant to the *Vessantara Jātaka*. Both fully enlightened and solitary buddhas must be male, but the third kind of enlightened status is achievable by both men and women. This is as an *arhat*, literally a "Worthy One."

This refers to anyone, man or woman, who hears and then realizes the salvific truth either from a buddha himself or at any time during the existence of a teaching, and thus attains nirvana. Such people are also known, for obvious reasons, as "Hearers" (*sāvaka*-s; Sanskrit: *śrāvaka*-s), and hence Theravāda is sometimes reckoned as one of a number of traditions making up the *Śrāvaka-yāna*, "the Hearers' Vehicle," as opposed to the Mahāyāna, which is the self-designation of those Buddhists who regard themselves as following "the Great Vehicle."[6] In Thailand especially, a popular text known as the *Phra Malai* (Pali: *Māleyya[deva] Sutta*) describes Malai's visits to various hells and heavens; in the Tusita heaven he meets the future Metteyya, who tells him that anyone who listens to a complete recital in one day of the *Vessantara Jātaka* will be reborn when he is Buddha, and so have the opportunity for enlightenment.[7]

The sequence of events, and of lives, leading to the attainment of fully enlightened buddha status has a determinate form, which is important to one's reading of the *Vessantara Jātaka*. Each candidate for this status must first, eons before his own enlightenment, meet a buddha and at that time make an aspiration to achieve fully enlightened buddhahood. The buddha at that time then makes a prediction of his future buddhahood. In the sequence of lives that culminated in Gotama Buddha, the aspiration was made by an ascetic called Sumedha to the then-Buddha Dīpaṅkara, who predicted his future enlightenment as Gotama.[8] Once such a prediction has been made, the future buddha is a *bodhisatta* (Sanskrit: *bodhisattva*); the etymology of this term is uncertain, but it can be glossed as "future buddha."[9] Vessantara is the last human life in the bodhisatta sequence that culminated in Gotama Buddha.[10] This sequence is also described as the systematic attainment of Ten Perfections: in the life of Vessantara this was the Perfection of Generosity.[11] Later in this introduction, and throughout the book, readers will be asked to reflect on whether this aspiration is for all Buddhists or just those rare and unusual beings, bodhisattas.

The Vessantara (pronounced Vessàntara) story, in many different forms, is known throughout the Buddhist worlds of Asia, where the protagonist's name in Sanskrit is Viśvantara (pronounced Vishvàntara); in Tibetan, Dri med kun ldan (pronounced Drimay kùnden); in many, especially East Asian versions, it is Sudāna (pronounced Sudàna).[12] This book is concerned with versions (better, tellings, on which term see below) and performances of the text in South and Southeast Asia. Although there are many vernacular tellings, contributors will refer to the Pali *jātaka* text. One excellent translation of this has recently been republished:

Margaret Cone and Richard Gombrich, *The Perfect Generosity of Prince Vessantara*, which is referred to throughout this book by the initials CG, in parentheses with a page number.[13] In the final stages of preparing this book for publication I learned of another version, translated by Sarah Shaw, due out in 2015.[14] The chapters that follow are concerned, overall, with two things: first, the interpretation of the Vessantara story itself, its characters, narrative dynamics, and ethics; second, with the contexts, ritual-performative and representational, in which the story is told: recited, painted on or woven into textiles, or—in various ways—acted out as a form of theater. As do other books in this series, this volume presupposes no previous specialized preparation.

WAS THERE AN "ORIGINAL" VERSION? MULTIPLE TELLINGS, AUTHORITATIVENESS, AND QUESTIONING

I want to begin this section by mentioning, and then dismissing, an attempt by the German scholar Alsdorf to find an "original" version of the story. In an article published in 1957, which remains very valuable from a philological point of view,[15] Alsdorf argued, in the words of the English summary given at the end of the article, that by editing and rearranging the verses

> it can be conclusively proved that the *Vessantara Jātaka* . . . is just as completely un-Buddhist or rather pre-Buddhist as the vast majority of the other Jātakas. This of course applies only to the verses, in sharp contradistinction to the prose which, with its excess of Buddhist piety, its boundless exaggerations, and its exuberance of sometimes rather insipid miracles breathes the totally different spirit of much later centuries.

From the perspective of the twenty-first century it is easy to see this as a kind of cartoon sketch of an outmoded Orientalism: the natives, in their blindness, have all-unknowingly preserved as their favorite Buddhist text something that in fact, as revealed by the dogged philological labors of the rationalist Herr Professor in his European library, has in itself nothing to do with them. There are so many ways to argue against this kind of approach. First, note the ambiguity in "un-Buddhist or rather pre-Buddhist." Take, for example, the Buddhist virtue of *mettā* (Sanskrit: *maitrī*), often translated "loving-kindness" but etymologically more literally as "friendliness." Within Buddhist teaching, this is one of

the four Divine Abidings (*brahma-vihāra*), along with compassion, sympathetic joy, and equanimity; it can be described and discussed within a firmly Buddhist doctrinal context.[16] But obviously the values of friendliness, kindness, beneficence, etc., can be found in any and every cultural context, both before and outside of Buddhist texts. So when a Buddhist acts in a kind, friendly manner toward a fellow human being, is he or she then being "completely un-Buddhist or rather pre-Buddhist"? Buddhists are human beings and so share many values and aspirations with many, most, or all other human beings: it is often unnecessary, and often quite inappropriate, to ask whether their conduct and their textual and other aspirations are "Buddhist" or not.

But much more important than the issue of an unnecessary identity language is the fact that the search for an original ur-text, founded in Western classical scholarship on the written texts of Greek and Latin, misunderstands the narrative traditions of South and Southeast Asia, where a complex mixture and overlap of orality and literacy makes the search for origins quixotic at best. The similarities between the Vessantara story and that of Rāma and Sītā in the Hindu *Rāmāyaṇa* have often been noted (Vessantara's wife, Maddī, herself makes the connection, CG 60). I have elsewhere argued that the two stories emerge from the same story matrix, and that there is a discernable "division of labor" between the two, with no Pali *Rāmāyaṇa* (because of the existence of the *Vessantara Jātaka*) but many vernacular versions of it.[17] (There is at least one "Hindu" telling of the Vessantara story; see below.) So it is not merely to argue by analogy for me to take up some language and some perspectives drawn from two edited volumes on the *Rāmāyaṇa*.[18] In the first, A. K. Ramanujan outlines an approach quite unlike that of Alsdorf, which has rightly become very influential. He prefers the word "tellings" to the usual "versions" or "variants," because the latter terms can and typically do imply that there is an invariant, original, or ur-text from which "later versions" diverge. Rather,

> the cultural area in which *Rāmāyaṇa*s are endemic has a pool of signifiers (like a gene pool) that include plots, characters, names, geography, incidents, and relationships. Oral, written, and performance traditions, phrases, proverbs, and even sneers carry allusions to the Rāma story. When someone is carrying on, you say, "What's this *Rāmāyaṇa* now? Enough." And to these must be added marriage songs, narrative poems, place legends, temple myths, paintings, sculpture, and the many performing arts.

Every text, he suggests, dips into this pool of signifiers and

> brings out a unique crystallization, a new text with a unique texture and a fresh context.... In this sense, no text is original ... no telling is a mere retelling—and the story has no closure, although it may be enclosed in a text. In India and Southeast Asia, no one ever reads the *Rāmāyaṇa* or the *Mahābhārata* [or the *Vessantara*, SC] for the first time. The stories are there—"always already."[19]

I have given below what I hope is a comprehensive list of translations into English or French of different tellings, different crystallizations, of the Vessantara story from all over Asia. Contributors to this volume describe regionally variant tellings of the story in texts and ritual performances in Southeast Asia and Nepal. Readers who compare one or more such tellings with the *Vessantara Jātaka* will be able to see how each has "a unique texture and a fresh context." For example, the characters of Maddī and Jāli, the wife and son Vessantara gives away, can be quite different: more or less passive, more or less vocal. One may say that the *Vessantara Jātaka* is, like Vālmīki's *Rāmāyaṇa*, the earliest and most prestigious telling we now have. But this does not make it an ur-text of which other tellings are versions or variants. Better than the chronological language of original and later versions is a distinction made by Richman in the second of the two *Rāmāyaṇa* volumes, between "authoritative" and "oppositional" tellings: authoritative tellings are linked with normative ideologies or content, preserved and spread by elites as models of dharmic action. They tend to affirm the values of the existing social order. Oppositional tellings, by contrast, "tend to be more involved in telling Rāma's story in ways that leave room to question selected aspects of normative behavior and conventional interpretation."[20]

I will leave it to readers of the *Vessantara Jātaka* to decide whether they agree that the text itself contains the potential to be read either as authoritative or as involving opposition to, or better questioning of, Buddhist ideology (or as both).[21] Given that in most tellings of the story Vessantara ends by returning to reign as king in the country from which he was exiled, apparently a king who also embodies the transcendental virtues of Buddhist renunciation, it is easy to see how kings could use the story to bring an ascetic-transcendentalist luster to their military-political power. Kings in Thailand, for example, have commissioned "royal" tellings of the story, called *Maha Chat Kham Luang*, none of which has been translated.[22] A clear example of an oppositional telling

is the northern Thai tradition discussed by Bowie in this volume, where the focus on the buffoonish antics of the Brahmin Jūjaka clearly irked the Bangkok nationalizing royal elite.

IS VESSANTARA'S STORY OFFENSIVE? IS HIS GENEROSITY "GREAT" OR "EXCESSIVE" (*ATI-DĀNA*)?

In this section I will attempt an analysis of the *Vessantara Jātaka* using a particular concept of ideological offensiveness, which I take from Ernest Gellner's reading of Kierkegaard. But before and after that I will look at evidence from Buddhist texts and ethnography that his giving (*dāna*) has been regarded as *excessive* rather than *great* (these are two meanings of the prefix *ati-*). Gombrich reports (CG xvi) that some monks in Sri Lanka "opine[d] that what Vessantara did was wrong." In *Nirvana and Other Buddhist Felicities* (*NOBF*) I reported a nineteenth-century description from Burma of how "men [could be] moved to tears by a good representation of this play"; in Sri Lanka, apparently, in one modern dramatic performance, when Vessantara was about to give the children away, young women in the audience cried out "Don't do it!"[23] The high-poetic Sanskrit verse telling of Viśvantara's story by Ārya Śūra (see below, p. 20 and notes 24 and 49) starts, as do all his stories, with a motto, a general reflection: in Khoroche's translation[24] this reads, "Those who are mean of heart scarcely even approve of the way a Bodhisattva acts, let alone follow his example." The Sanskrit text is: *na bodhisattva-caritaṃ sukham anumoditum apy-alpasattvaiḥ prāgevācaritum*. The compound *alpa-sattva*, here translated "those who are mean of heart," means literally "small being(s)": it is in implicit contrast with *mahāsattva*, "great being(s)," which is a standard synonym in Buddhist texts for *bodhisattva*, a future buddha. The verb translated "approve" is *anumoditum*, from *anu-mud*, which means literally "to rejoice after": dictionaries give the senses "to join in rejoicing, to sympathize with, to allow with pleasure, express approval, applaud, second, permit."[25] Khoroche does not translate the word *sukham* directly: in such contexts it means "happily" or "easily." Thus a more literal rendering would be: "it is not easy for small beings to express approval of what a bodhisattva [great being] does, still less act (in the same way)." This is a clear statement that the conduct of future buddhas cannot be taken as normative for everyone. It is not, or is not in any simple way, an example to be followed: on the contrary, what future buddhas do is not straightforwardly laudable from the point of view of

those small beings who are not on that special path that leads, eventually, to buddhahood, as Vessantara's actions are on the path that leads him to become Gotama Buddha. The introduction to the Pali *jātaka* collection describes the gloriousness of the deeds of a Great Man as "unthinkable" (*acintiya*, also "unimaginable").

In *NOBF* (38–40) I used an idea from Gellner, who took the term "offensive" from Kierkegaard in a discussion of ideology. I have been arguing that we should read the *Vessantara Jātaka* as literature, but Buddhism as a "religion" is clearly also a transcendentalist ideology: that is, it offers ideas and narratives that form a discursive articulation of the universe as a whole, in which (re)birth and (re)death are set within an overall worldview that provides the possibility of transcending death. (Marxism as a lived tradition, for example, is, or rather was, undoubtedly an ideology—but it was not transcendentalist in that it offered no escape from death.) In explaining what he meant by the "offense" of Christianity, Kierkegaard used the example of an emperor offering to a day laborer the chance to become his son-in-law: the laborer would at one and the same time be enticed by the possibility and repelled, since he would be unable simply to accept the offer, out of fear that the emperor was trying to make a fool of him. Kierkegaard uses this imaginary scene as a "perfectly simple psychological investigation of what offense is," in claiming that

> There is so much said now about people being offended at Christianity because it is so dark and gloomy, offended at it because it is so severe, etc. It is now high time to explain that the real reason why man is offended at Christianity is because it is too high, because its goal is not man's goal, because it would make of a man something so extraordinary that he is unable to get it into his head.[26]

Gellner argues that all ideologies inspire both hope and fear, in a Kierkegaardian manner:

> Ideologies contain hypotheses, but they are not simply hypotheses. They are hypotheses full of both menace and sex-appeal. They threaten and they promise; they demand assent with menaces; they re-classify the moral identity of the believer and the sceptic; and they generate a somewhat new world. . . . It seems to me that this offence-generating characteristic of ideologies is *inherent* in them, that it is implied in their very intellectual content. . . . Ideologies contain contentions which are fear- and hope-inspiring, and are meant to be such to anyone, anywhere.[27]

That is to say, what is on offer from Buddhist ideology is both enticing and repelling (offensive): an escape from all suffering in the timeless bliss of nirvana as an arhat is certainly enticing, but the renunciation and detachment required by the path to future buddhahood are too high for ordinary beings. Ārya Śūra would agree with Kierkegaard: the nonheroic small beings who do not have an extraordinary goal beyond becoming ordinary arhats (as if the realization of ultimate truth and a complete escape from birth-and-death could be "ordinary"!) cannot easily approve of what Vessantara does, but must necessarily find it offensive, too lofty a goal: the idea of enlightened buddhahood inspires both hope and fear.

In Pali texts, as mentioned above, Vessantara's story is said to exemplify the Perfection of Generosity, one of the Ten Perfections that must be completed in order to attain buddhahood (see also below on the *Cariyā-piṭaka*). In itself, such a categorization does not pretend to offer a complete textual analysis of the *Vessantara Jātaka*, but often in modern scholarship the story is presented blandly in the same way, as simply being about generosity. But the fact that the story is not so easily and wholly characterizable is shown by a discussion of it in a Pali text called "The Questions of King Milinda" (*Milinda-pañha*), which probably originated in North India and purports to be a record of conversations between the second century B.C. Greek king Menander and a Buddhist monk named Nāgasena.[28] Throughout the text the king asks questions, often in the form of an apparent contradiction between different statements attributed to the Buddha. Vessantara is discussed twice. On the first occasion the king cites a canonical text that states that there are eight causes of earthquakes, without mentioning the Vessantara story, but then states, correctly, that in the *Vessantara Jātaka* the earth is said to quake seven times. Nāgasena's reply, which insists on Vessantara's possession of many Buddhist virtues, is that his case is *akālika* and *kadācuppattika*, which Horner translates "that was exceptional . . . it happened only once."[29] It is clear from the context, however, that this means only once in the interval between the immediately previous Buddha Kassapa and Gotama Buddha; the concluding remarks by the king refer to buddhas and future buddhas in the plural, so it would seem that there is a (unique) Vessantara-style life for every buddha. This is explicitly stated in the second episode mentioning Vessantara.

The second episode is an extended conversation, lasting ten pages in the original.[30] The arguments are often intricate and the logic not always easy to follow. I must leave it to readers to go through it all if they wish. Here I will concentrate on some main points. The king asks whether all future

buddhas give up their children and wife, or was it only Vessantara, and is told that all future buddhas do. He asks if Vessantara's children and wife were given with their consent and is told that Maddī consented, but the children were too young to understand the situation: had they understood it, they would have approved (the word is again *anumoditaṃ*). The king then gives a series of criticisms of Vessantara, finding fault, for example, in his lack of compassion when his son, Jāli, remonstrates that he must have a heart of stone (cf. CG 54); Milinda ends by suggesting that someone desirous of making merit should not cause suffering to others but give himself or herself instead. Nāgasena replies that the fame of Vessantara has reached all corners of the universe and has come down to the present time, such that "we sit slandering and insulting (his) gift (by even asking the question) 'Was it rightly or wrongly given?'" He then lists ten qualities special to future buddhas, of which the last three are that their path is hard to understand, hard to acquire, and unique. After discussing various gifts that cause suffering to others, the king declares that Vessantara's gift was an *ati-dāna*. As mentioned above, the prefix *ati* has an inherent ambiguity: *ati-X* can mean "(very) great X" or "excessive X." Clearly the king means the latter, since he says such a gift is "criticized and censured by wise people in the world." Nāgasena replies that the gift was indeed *ati-dāna*, but in the former sense, that such "(very) great giving" is "praised, lauded, and extolled by wise people in the world." There follows a discussion of various kinds of gifts, during which Nāgasena argues first that it is an accepted practice in the world that a man in debt or in need of making a living should give his children as a pledge or sell them; and also that it would have been improper for Vessantara, being asked for his children and his wife, to have given himself instead.

His defense of Vessantara seems to culminate in a verse cited by the text from the *Cariyā-piṭaka*: "My two children were not hateful to me; Lady Maddī was not hateful. Omniscience is dear to me, so I gave (away) what was dear." The general point of Nagasena's defense is thus that a future buddha's path to omniscient buddhahood is, ethically, *sui generis*. But in fact the conversation ends with two other points. First, Nāgasena goes on to emphasize how painful giving the children away was to Vessantara: he felt anguish because of his "great (or: excessive) affection" (*ati-pema*) for them; his heart became hot, he had difficulty breathing, he cried tears of blood (cf. CG 55–56). Second, he insists repeatedly that Vessantara knew that the children could not be kept in slavery but would be ransomed by his father, Sañjaya. So the giving of the children was not, in fact, a complete and final abandonment, just a temporary state before their inevitable

return to the family. This is rather like the giving of Maddī: the audience/ readers of the *Vessantara Jātaka* know that she is being given to the king of the gods in disguise and will shortly be returned. So Nāgasena's main point is that all future buddhas, but only future buddhas, are capable of such an *ati-dāna*, which is in Vessantara's case, at least, not a permanent alienation of possessions; and he stresses how hard it was for the man Vessantara to behave in the ways required of future buddhas. For Vessantara the future buddha, his generosity was (very) great; for Vessantara the man it was excessive.

THE QUESTION OF GENRE: *JĀTAKA*, EPIC, TRAGEDY, COMEDY, MELODRAMA, UTOPIA

The *Vessantara Jātaka* is one of 547 "birth stories" included in the Pali Canon under the general title of *Jātaka*. The collection contains many different kinds of story: many are rightly classed as folklore, and they include animal stories of the same kind as Æsop's Fables, as well as stories more directly related to Buddhist doctrinal concerns.[31] The *Vessantara Jātaka* is clearly "Buddhist," with its repeated use of the concept of omniscience and the ubiquitous, if unstated, fact that Vessantara will be Gotama Buddha in the future. But at the same time, if one wishes to use these terms, the virtue of generosity is both "non-Buddhist" and "pre-Buddhist," as is also the frequent connection between extreme generosity and (self-) sacrifice.[32] The stories in the *jātaka* collection are arranged by the number of verses they contain: the first section has one verse, the second two, etc. The *Vessantara Jātaka* is the last story in the collection, with the most verses (786).[33] Each story consists of three parts: the Story of the Present, which situates the Buddha's telling of the tale in his lifetime; the Story of the Past, which is the main part of each *jātaka*; and the Connection, a short section at the end where the characters in the Story of the Past are identified with people living at the time of the Buddha. Naturally the hero of the story, usually but not always, is identified with the Buddha himself. Apart from the verses there are two kinds of prose, both traditionally called the Commentary (*aṭṭhakathā*): one is a direct exegetical commentary on the text of the verses, but the other also carries parts of the narrative, sometimes repeating what is in the verses but sometimes giving parts of the story they do not give. CG translate this second kind of prose as well as the verses, but not the verse commentaries. It seems to me that, as is the case with other texts in the *Khuddaka Nikāya* section of

the canon, *jātaka* stories were originally in prose and verse combined (in Sanskrit called the *campū* style), which the later tradition has bifurcated into canonical verses and prose commentary. Stories of past lives, of the Buddha and his disciples, are found in many other Pali texts, canonical and postcanonical.

What can one say of the question of genre, using Western categories? No Western category can, *a priori*, wholly and successfully describe a text in Pali. But a brief consideration of some can, I think, be useful, not as a guide to choosing some English term for the text but to illuminate all the different things the text is doing. CG subtitle their translation "A Buddhist Epic." The word "epic" in a general sense is accurate: the *Oxford English Dictionary* (*OED*) has "pertaining to that species of poetical composition . . . which celebrates in the form of a continuous narrative the achievements of one or more heroic personages of history or tradition." The word "epic" also compares the *Vessantara Jātaka*, appropriately, to what are often called the two epics of Brahmanical Hinduism, the *Mahābhārata* (textual links with which in the *Vessantara Jātaka* are mentioned by CG xxi–xxii) and the *Rāmāyaṇa* (to which, as mentioned already, the *Vessantara Jātaka* compares itself explicitly). But beyond a general appropriateness, the word does not tell us much about the content of the *Vessantara Jātaka*.[34]

What of "tragedy"? *OED* defines this as "A play or other literary work of a serious or sorrowful character, with a fatal or disastrous conclusion. . . . That branch of dramatic art which treats of sorrowful or terrible events, in a serious and dignified style"; in both cases it is opposed to "comedy." The *Vessantara Jātaka* is certainly of a serious and sorrowful character, and it certainly deals with sorrowful and terrible events in a serious and dignified style. But what of the conclusion? Even in those tellings (discussed in the text below and in Emmrich's chapter) where Vessantara does not go home to kingship but remains in the forest, one cannot say that the conclusion is fatal or disastrous, since the final ending of the story (beyond the text itself) is Gotama Buddha's enlightenment. Indeed, it might be thought a defining characteristic of all transcendentalist ideologies that they exist to prevent tragedy in the universe in this sense. (Even when such an ideology condemns some people, for example, to everlasting hell, within the terms of the ideology this is a *just* ending for them, if not a happy one.) There are many ways the *Vessantara Jātaka* could be interpreted as a tragedy; I will deal with just three.[35]

First, a topic I will mention here but not elaborate, is an aspect described by Shulman in relation to the *Rāmāyaṇa* as follows: "[it] illustrates the

tragedy always consequent on perfection or the search for perfection, just as the work as a whole could be characterized by . . . the 'poetics of perfection.' It creates a sustained, lyrical universe peopled by idealized heroes whose very perfection involves them—and the audience—in recurrent suffering." The sufferings undergone by all the characters in the *Vessantara Jātaka* are heavily emphasized in the text, and numerous ethnographic reports on performances of the Vessantara story emphasize its capacity to evoke tears in its audience, especially the chapters on the children and Maddī.

Second, the plot involves numerous instances of what an author dealing with Western tragedy calls "a feeling of the inevitability of the avoidable."[36] There are any number of occasions on which one feels "if only X had not done Y." This is the case with Vessantara himself; with his father, Sañjaya; the Sivi people; and others (but not, or at least not directly, by Phusatī or Maddī, Vessantara's mother and wife, the two most important female characters in the story). I will illustrate it here with a minor episode: the beginning of the story of Jūjaka and his wife, Amittatāpanā. Overall, Jūjaka combines two stock characters of comedy or melodrama: the persecuting villain and the buffoon. As CG say, "at first, in his marital troubles and his hardships on the journey he supplies an element of farce. But ultimately he is a bogeyman pure and simple—as the children point out" (xviii). For most of the story he is not benevolent at all, but in the very earliest scenes in which he is introduced there are elements that make him something of a sympathetic, or at least innocent character, if simultaneously and increasingly a farcical one. He lives in a Brahmin village called Dunniviṭṭha, which CG render nicely as Foulstead, in the kingdom of the Kaliṅgans. He is married to a wife much younger than he, whom he received from a family in lieu of some money they owed him. She cares for him very well, so well that other Brahmin men complain to their wives that they are not like her. The women resolve to get rid of her, and insult her when they meet at the river. An example of their abuse is given, in sing-song verses whose repeated chorus tells her that her family "gave you to a worn-out old man although you are so young" and that are full of sexual innuendo: "there is no fun with an old husband, no pleasure [*rati*, which implies sexual pleasure]. . . . When a young man and a young woman talk together in private, whatever sorrows lodge in the heart of a woman melt away. You are young and comely, desirable to men. Go and stay with your family. What pleasure will a worn-out old man give you?" (CG 36ff.). Amittatāpanā is upset and refuses to fetch water anymore; Jūjaka consoles her and offers to get water himself. I assume that this is

intended to portray him as both kindhearted, and, in a patriarchal society, weak. She is too proud to accept the offer—"I was not born into the sort of family to let you fetch the water"—and tells him to go and procure a slave; she has heard that Vessantara and his family are living in the mountain forest and suggests he go there. He protests that he is too old for such a journey and offers again to become her servant, at which now she insults him roundly, saying that if he does not go she will leave him and enjoy herself with other men. At this, "frightened and subject to the Brahmin girl, distressed by his passion" (i.e., in a state of sexual jealousy), he leaves, "warning her not to go out after dark, but to take especial care until he returned." He is "greedy for his pleasures," and "unrestrained in his lusting for enjoyment." In place of their earlier marital harmony, now Jūjaka's relationship with his young wife is one of lust and fear of being cuckolded. Who is at fault here? Jūjaka? Amittatāpanā? The other village Brahmin men and/or their wives?

Third, to return to the central character, Vessantara, one could argue that he has what Greek tragedy referred to as a tragic fault; indeed a number of them. As Aristotle said, in a tragedy neither should good men be shown passing from good fortune to bad, since "this is not fearsome or pitiable, but repellent," nor should a bad man be shown to find misfortune, since this too, although appropriate morally, is neither fearsome nor pitiable.[37] The tragic hero has one or more faults that render him liable to the tragedy he suffers without making him directly responsible for it. So Vessantara's (and his family's) suffering must in some way(s) be consequent on Vessantara's character. Although in Buddhist ideological terms it would be absurd to describe a future buddha as "flawed," for Vessantara the man there is a tragic mismatch between the demands of his soteriological destiny and his immediate feelings. But even in Buddhist doctrinal terms, he comes close, in fact or imagination, to breaking all of the Five Precepts that are the basis of all Buddhist ethics: to refrain from killing, stealing, sexual misconduct, lying, and taking intoxicants:

1. When Jūjaka takes the children for the last, final time, Vessantara considers going after him to kill him (CG 56);
2. At the same time he considers taking the children back by force, but restrains himself with the acknowledgment that it is wrong to take back a gift (ibid.);
3. He does not offend against the third precept directly, although he does revert to being an affectionate (though not sexually passionate) husband when Maddī faints (CG 56),[38] and he reasons with her that they can have

more children later (ibid.), which is not appropriate to his then status as an ascetic;
4. He deceives Maddī in the matter of her dream (CG 48: "deceivingly" translates *mohetvā*, from *muh*, a strong word in Buddhist terms);
5. In his longing to give the children away he is "like a drunkard eager for a drink" (ibid.).

The standard opposite to tragedy is comedy, according to *OED*, in both classical and modern times a "stage-play of a light and amusing character, with a happy conclusion to its plot. . . . In the Middle Ages the term was applied to other than dramatic compositions, the 'happy ending' being the essential part of the notion." As already mentioned, as a transcendentalist ideology Buddhism must, overall, have a "happy ending," and in most tellings of the Vessantara story, he and his family return in triumph to the city and the life of royalty. The comedy, as Bowie shows in her chapter here, is in the figure of Jūjaka: "amusing," if not always "light."

"Melodrama," according to *OED*, was originally "a stage play, usually romantic and sensational in plot, and interspersed with songs, in which the action is accompanied by orchestral music appropriate to the various situations. Later (as the musical element ceased to be regarded as essential): a play, film, or other dramatic piece characterized by exaggerated characters and a sensational plot intended to appeal to the emotions." Throughout the *Vessantara Jātaka*, in various ways, one can see "exaggerated characters and a sensational plot intended to appeal to the emotions." And there is a musical element, as CG say: "long set pieces in which couplets are repeated with the variation of just one word; these we assume were songs" (xxi).

Finally, utopianism. Once again, one could use this word in relation to any and every transcendentalist ideology per se. Those tellings—the majority—of the Vessantara story that have the happy ending of Vessantara the pious king ruling over a society of abundant wealth (with showers of rain and of jewels) offer a vision of a society if not perfect, then at least characterized by a king who is on his way to fulfilling the Perfections. There are numerous utopian elements within the narrative. I will exemplify just one, what I have called in *NOBF* the theme of Arcadia. This is a utopia in which nature is bountiful and the problems of social order and well-being are solved by the moderation of desires; people live in a state of peaceable and calm harmony with nature and each other, usually in a rural setting. One can trace in the *Vessantara Jātaka* differing visions of life in the forest: the bad forest, one might say, is characterized as a frightening

place, full of dangerous animals and "creepy-crawlies"; the good forest, described in many long eulogistic passages such as both the Short and Long Descriptions of the Forest (CG 42–44, Appendix 89–96), is where nature provides for the moderate needs of Vessantara and his family, and animals for miles all around their hermitage live peaceably thanks to Vessantara's "friendliness" ("loving-kindness," *mettā*; CG 35 have "friendly sympathy"). Such descriptions of the good forest and of Vessantara and his family's simple, happy life in it can be described as what Lovejoy and Boas called, in a study of Western antiquity, "soft" as opposed to "hard primitivism."[39] The former is a "Golden Age" of simplicity and comfort in a beneficent natural setting, free of the unnecessary and inhibiting excesses of civilization: "the alluring dream ... of a life with little or no toil or strain of body and mind." The latter is a life of austerity and self-discipline, where people are "inured to hardship, [being] hardy fellows to whom 'Nature' [is] no gentle or indulgent mother. Their food [does] not drop into their laps, they [are] obliged to defend themselves against predatory animals, [etc.]."

A NOTE ON GENDER, INSIDE AND OUTSIDE THE TEXT

This section is intended merely to raise some issues for discussion; it will not answer the questions or resolve the conflicts and problems. The subject of gender is, throughout the essays that follow, either explicit or at least implicit. I think it helps to divide the issues into two: How is gender represented within the text? And what is the place of gender in the reception history of the text, specifically in the many performative contexts of public recitation and dramatic portrayal in which the *Vessantara Jātaka* has been represented?

The only two main characters in the story who never do anything wrong or even morally ambiguous are Vessantara's mother, Phusatī, and his wife, Maddī. The text opens with a transmigratory biography of Phusatī, whose ten wishes (an interesting set by themselves) include the hope to have a generous son like Vessantara, to whom she provides material for giving as soon as he is born and asks for it (CG 7). Whereas her husband, King Sañjaya, decides to exile Vessantara, in an act sometimes described as wrongdoing,[40] Phusatī is adamant as to Vessantara's innocence (CG 18–20); she asks him not to take Maddī to the forest (CG 24); she waits patiently to take the children to rejoin their parents until after they have "assuaged their grief" (CG 80–81); and she provides Maddī with clothing and jewelry when she resumes her life as princess (CG 84). In a text

that carefully tries to place blame to some extent on all the men involved, as well as on Jūjaka's wife, Amittatāpanā, and the Brahmin women of her village, Phusatī is unambiguously proper, both in interpersonal relations and in her support of Vessantara's extravagant generosity.

Maddī, like the Sītā to whom she compares herself, is the perfect wife (perhaps, for modern readers, altogether too much so). She bravely insists that she will accompany Vessantara to the forest ("I would not wish for any joy that was without Vessantara," CG 24), describing their future life there in utopian terms; and she provides food for the family when they are living there. Despite her distress when she returns to the hermitage and does not find the children, she does not blame Vessantara but, after she has recovered from her faint, celebrates his generosity. Not only is she entirely innocent, she has to endure injustice, as when Vessantara interprets her terrible nightmare "deceivingly" (CG 47–48), and, worst of all, when he insinuates that her late arrival in the hermitage is because she has been misbehaving with the "ascetics and magicians" who also live in the forest (CG 63). She is a tragic heroine with no tragic flaw; when she meets the children again at the end she is the image of maternal fecundity, with milk flowing spontaneously from her breasts to give them sustenance (CG 81). When she has been washed and dressed as a royal again she is "as beautiful as a nymph in the heaven of the thirty-three gods" (CG 84). I can find but one very marginally negative thing about her, itself a matter of rather senstitive narrative irony at a moment of overenthusiasm: when she is happily reunited with her children she makes the wish, "Whatever works of merit your father and I have performed, by that truth, by that righteousness, may you be ageless and free of death" (ibid.). Alas, that is not a gift in even a buddha's power to grant; the children, like all else except nirvana, are impermanent and doomed to die. Her maternal feelings have got the better of her.

Turning now to the outside of the text: as anyone who has visited a Buddhist country will know, and as is clear from the entire ethnographic record, the majority of participants at the majority of Buddhist public occasions are women. I leave aside here such private intramonastic matters as some parts of the ordination of novices and monks, which take place in a hall, Thai *ubosot*, Pali *uposathāgāra*, from which women are permanently excluded. But even the temporary ordination of teenage boys as novices is regarded as a means of making merit for the mother.[41] In general, it seems safe to say, the majority of people listening to recitations of the *Vessantara Jātaka* or attending public dramatic presentations of it will always have been women. Does it make a difference to read (hear, see)

the story as a man or a woman? No doubt essentialist answers one way or the other would be inappropriate: we need more empirical ethnographic investigation of this, more interviews with people about the story that will pay attention to gender difference (or lack of it). Discussions of the story might well take up this theme.

Rather than speculate further without evidence, I would like to refer to two pieces of anthropology that might suggest the extent of the change in perspective that noting the predominance of woman in Buddhism can bring about. In my view this change is very striking and very suggestive for the way future work in this area might go. H. Leedom Lefferts, a contributor to this volume with Sandra Cate, earlier wrote a book chapter entitled "Women's Power and Theravāda Buddhism: A Paradox from Xieng Khouang."[42] The "paradox" (not, I think, the best word to use) is that although in a particular Buddhist ceremony in Laos (and this is universally true) monks are accorded positions of precedence, either walking in front of the ritual procession or being carried on chairs above peoples' heads, it is only through the existence of laypeople (mostly women) at the ceremony, and through their mothers' having given them birth, that the monks can come to have such a status at all:

> Thus, while the lay people celebrate and raise these monks, they [also] contain them.... Carrying a monk above the crowd shows his elevated statues vis-à-vis the laity, at the same time his containment by them shows that this celebration occurs because they [the laity] deem it appropriate. ...
> On the one hand, there is the power that comes through the teachings of the Buddha, which are perpetuated through the line of members of the sangha. On the other hand, there is the power of origin and lineal descent, codified through the presence of the monk's mother, without whom he could not be where he is.

Let us use the metaphor of Buddhism as a form of social theater, and let us assume that celibate ascetics (usually monks, though there have been nuns and are nowadays an increasing number of "nuns"[43]) are the actors on stage, with laity as the audience. If one thinks sociohistorically, institutionally, of drama, opera, and other performance modes, one does not focus solely on what happens on stage. The audience also is a necessary constituent of the whole: they are what makes an area of space a *stage*. If Buddhism is something people do, then the majority of those people are women.

The second piece of anthropology I want to discuss here is Nancy Eberhardt's magnificent *Imagining the Course of Life: Self-Transformation in*

a Shan Buddhist Community.⁴⁴ Among many other things, she treats at length the colorful Shan novice ordination ceremony, in which young boys are dressed in bright, extravagant clothing, wear make-up, etc., before becoming novices, usually for the length of a Rainy Season. She notes that such ordinations have always been seen as a rite of passage for the boys involved, but suggests that this is, or at least has now become, only "nominally" the case: more important, it is a rite of passage for the sponsors of the ordination, notably the boys' mothers. Throughout the preparations for and holding of the ceremony, and thereafter, various forms of social status, including honorific terms for "sponsor (of an ordination)," are acquired and displayed: "ordination rituals are [public occasions] in which women are allowed to be seen on center stage where they have a prominent, even commanding public presence." So whereas Shan novice ordination has standardly been taken to be "about" the boys, it is in fact (or at least, also) about their mothers.

If, then, the majority of people on Buddhist public occasions are women, what difference does that make to the fact of the Vessantara story's being the most popular Buddhist text in South and Southeast Asia?⁴⁵

TELLINGS OF THE VESSANTARA STORY AVAILABLE IN TRANSLATION

This section will not refer to editions of texts and to other such specialist works, nor to all of the art-historical studies of the very many Buddhist sites, in India and Southeast Asia, where representations of the Vessantara/Viśvantara story are found: preliminary information about them can be obtained from the introduction to CG, from several of the works to be mentioned here, and from a number of the chapters in this volume.⁴⁶ But a catalog from the whole of Asia would be a gigantic task beyond the resources of any single scholar, and many of the works would be entirely inaccessible to the majority of readers of this book. I restrict myself here, for pragmatic and pedagogical reasons, to translations available in modern Western languages (only, it seems, in English and French), and to studies such as those (to be discussed below) by Lienhard on Nepal and by Durt on China, where summaries of the stories are given in sufficient detail to provide a sense of the whole. These can be read and compared to the CG translation of the *Vessantara Jātaka*. In most cases these translations can be copied and distributed, either because the works are so old that they are no longer in copyright or because they form a small part of the books and journals in which they are found, and so can be copied without violating

copyright laws. Most tellings are much shorter than the *Vessantara Jātaka*. I would recommend that readers, especially students in courses studying the *Vessantara Jātaka* in CG's translation and by means of this book, read at least one other telling as well. I note occasional differences of plot.

From Pali

A French translation of the *Vessantara Jātaka* has recently been published, with a useful introduction ("Présentation"), by Osier.[47] A short verse telling of the tale, without any great literary sophistication, that occurs in the canonical *Cariyā-piṭaka*, "Basket of Conduct," has been translated in its entirety by Horner and in part by Strong.[48] This work as a whole consists of brief collections of verses illustrating seven of the Ten Perfections a future buddha must accomplish. The Vessantara story, which is the longest poem in the collection, is one of ten to illustrate the Perfection of Generosity.

From Sanskrit

Ārya Śūra's succinct and elegant telling of the Viśvaṃtara story (transliterated thus) in his *Jātaka-mālā*, "Garland of Birth Stories," has been ably translated by Khoroche.[49] A telling found in a text called the *Saṃghabhedavastu* has been translated twice, first—in a book that has a German title but consists entirely of transliterated texts in Sanskrit and Tibetan, with an introduction and translations in English—by Das Gupta, and also more recently by T. Lenz.[50] Das Gupta includes a translation of a short verse telling by Kṣemendra in the *Avadāna-kalpalatā*, "A Wish-Fulfilling Creeper of Birth Stories."[51] A telling of the story in a non-Buddhist (so-called "Hindu") text is found in the *Kathāsaritsāgara*, "The Ocean of Streams of Stories," where the protagonist is named Tārāvaloka, his wife is Madrī, and his children are Rāma and Lakṣmaṇa (the names of Rāma's sons in the *Rāmāyaṇa*). Tārāvaloka returns to kingship, but at the very end of the story, once again feeling dispassion (*vairāgya*), he returns again to the forest as an ascetic.[52]

From Tibet

There are two Tibetan tellings available in translation. The first, a prose text, was translated into German and thence into English by Ralston, in which the protagonist is called Viśvantara.[53] The second, the script

of a dramatic performance, was translated into French and thence into English.[54] In the latter the protagonist is called Dri med kun ldan. What appears to be the same telling, if not exactly the same text, has also been translated by Duncan.[55]

From Nepal

Various tellings from Nepal are discussed in the chapter in this volume by Emmrich. There is no direct and full translation of any telling from Nepal, but Lienhard has published a number of articles and a book that give a good view of what some are like.[56] Of crucial importance is the fact that in one of them, as in at least one Chinese telling, Vessantara does not go back to his city to take up kingship, but stays as a lone ascetic in the forest while Maddī returns to the city, where his son, Jāli, becomes king. The potential rapprochement, albeit mythical rather than real, of ordinary social and transcendental ascetic virtues found in most tellings is thus sidestepped.

From China

One of the earliest tellings of the Vessantara story to appear in a Western language was a text included by Chavannes in 1911 in his *Cinq cent contes et apologues* under the title *Sutra du prince héritier Sudāna*.[57] (*Sudāna* means "Good Gift.") Other than this, there are two detailed articles by Durt, who refers to the text translated by Chavannes as the "Monographic Sūtra." Durt offers summaries of two other texts, both earlier than the Monographic Sūtra, one of which he refers to as "the Archaic version," the other attributed to an Indian writer, Saṃghasena.[58] Both the Archaic version and the Monographic Sūtra end in the usual way with Sudāna and Mādrī returning to the city. But the ending of Saṃghasena's telling is quite different: after Sudāna gives Mādrī to the king of the gods, Śakra (Pali: Sakka), disguised as a Brahmin (an episode found in all tellings of the tale), asks for Sudāna's eyes.[59] As Sudāna is about to offer them Śakra reveals himself, prevents the gift, and gives back Mādrī. The end of the story has Śakra return to his heaven, after predicting Sudāna's future attainment of buddhahood. Durt remarks: "Confirming the radical aspect of our text, we observe that there is no mention here of reconciliation between the prince and his father, nor of the visit to his mountainous abode by his parents and his two children . . . nor of the triumphal return of the prince-bodhisattva to his kingdom in order to exercise kingship."

From Other Languages of Central and East Asia

At the start of the twentieth century a number of manuscripts were discovered in Central Asia written in Sogdian, the language of Sogdiana, in what is now Uzbekistan and Tajikistan. One of these was a telling of the Vessantara story, later edited and translated into French by Benveniste.[60] A telling in Mongolian was edited and translated by Poppe.[61] In his introduction Poppe cites a Mongolian saying, "If you want to cry read [the Vessantara story], if you want to laugh read [a different story]." Other tellings are described in the scholarly literature, such as those in Khotanese and Tokharian, but there is no translation or extensive summary such that they can be compared as narratives with the others mentioned here.

From Vernacular Languages in South and Southeast Asia

There have been many Sinhala tellings of the Vessantara story; two from the thirteenth century have been translated. In the telling from the *Butsarana*, after Vessantara has given away the state elephant, the Sivi people go to his father the king and complain, describing the prince as having fallen into "a madness of faith."[62] The *Pūjāvaliya* gives a summary telling of the narrative, in a list of "Nine Offerings": seven earthquakes, the "Lotus" shower (CG 2, 81–82), and the Rain of Jewels (CG 86–87). Remarkably, in a telling that takes only eight and a half pages in translation, almost three whole pages are devoted to the "Long Description of the Forest" given by the sage Accuta, which in fact is little more than a list of names of plants and trees.[63] In modern Thai temple paintings, postcards, etc., the scene where Accuta talks to Jūjaka and gives the Long Description of the Forest is almost always represented.[64] CG took the editorial decision to excise this description from the text and give it as an appendix (CG 46–47, 89–96), on the grounds that "this tedious botanical catalogue, inserted before the story's climax, may well have built up suspense in an audience already familiar with the plot, but can only dishearten the solitary reader." This may be true, but readers might ask themselves what this Long Description is doing in a narrative text. I think there is an element of extravagant richness, which fits with the utopianism of what I have called "the good forest."

From Burmese there is a telling "sketched from the Burmese version of the Pali text"[65] and one from a version set for school examinations.[66] A telling from Thailand is available online.[67] It gives synopses of the chapters of the story along with various kinds of exegetical matter: the text is part narrative, part encyclopedia. There is a very remarkable modern

short story in Thai, by Sridaoruang, called *Matsii* (i.e., Maddī, Vessantara's wife), in which a young woman abandons her children at a bus stop. Her interrogation by a police officer ends abruptly when she exclaims "Well, Phra Wetsandon did it!"[68] From Cambodia there is a rather long telling translated into French.[69]

TELLINGS OF THE BIOGRAPHY OF THE BUDDHA

If readers of this book and one or more tellings of the Vessantara story wish to contrast them with the life of the Buddha, there are very many translations and modern retellings of the latter. Two important Pali and Sanskrit tellings are *The Story of Gotama Buddha*, translated from the introduction to the Pali *jātaka* collection (*Jātaka-Nidāna*) by Jayawickrama, and Aśvaghoṣa's elegant and sophisticated Sanskrit work *Life of the Buddha by Ashvaghosha*, by Olivelle.[70] A very fine compilation from many different sources can be found in Strong's *The Buddha: A Beginner's Guide*.[71]

CHAPTERS IN THIS VOLUME

The contributors to this volume approach the *Vessantara Jātaka* from a variety of different perspectives, though they can, necessarily, only begin to suggest something of the story's complexity and multidimensionality. For most, but not all, the focus is on the modern world. All of them are conscious of historical change, and all explore how each retelling is a new interpretation of one or more inherited versions. Thai specialist Louis Gabaude's essay shows that the moral dilemmas and difficulties of the story have continued to exercise thinkers in modern Thailand: not only Western readers of the text are challenged by it. The story continues to provide material for Thai intellectuals to reflect on their society. He discusses defenders and detractors of the story, political and feminist. Anthropologist Patrice Ladwig focuses on the story in a popular Laotian milieu, arguing that "folk narratives, often performed by monks in a dramatic, hyperbolic, and witty way, constitute a body of knowledge that is used by laypeople and monks to discuss ethics, models of the good and virtuous life, matters of law, and sometimes also problematizations of these latter that reach beyond simple didacticism." This is, I think, an approach readers of this book would do well to imitate. Historian of religions Justin McDaniel shows that, although "students of Buddhism are regularly told, quite correctly, that nonattachment is a virtue for both

the laity and the monastic community ... positive views of marriage and the married life are a significant part of Buddhist narrative literature in Southeast Asia." The *Vessantara Jātaka* is quite extraordinary in its presentation of the strength of marital and family emotion. Anthropologist Katherine Bowie shows that although for many readers of and listeners to the text, the figures of Vessantara and his family are uppermost, in northern Thailand in the modern world the comical figure of Jūjaka has received the most attention. The story there becomes not a royalist display of how a virtuous king can somehow encapsulate within himself the values of renunciation and asceticism but a bawdy celebration of village life and antiroyalist sentiment. Anthropologists Leedom Lefferts and Sandra Cate discuss ritual enactments of the story in northern Thailand and Laos, which involve large painted scrolls of the story being ritually processed back to villages from the forest. In this way, "performing collectively, the Thai-Lao retell the story with themselves as the actors, celebrating the promises of success of the prince and his subjects as their own, both in the present moment of the celebration and in the future." Many people in South and Southeast Asia know the story through this kind of ritual enactment rather than as a text to be read or listened to. Like Lefferts and Cate, art historian Lilian Handlin takes up the iconographic and artistic dimensions, discussing three "tellings" of the tale in Burma: two are visual, painted on plaques and as wall murals, from the period between the tenth and thirteenth centuries, and a third is the first Burmese prose version, from the eighteenth century. Arguing that "visual and verbal transmission technologies are not as distinct as it seems," she describes vividly how depictions of the same story can be "read" quite differently in different milieux, and serve quite different purposes. Finally, historian of religions Christoph Emmrich takes us to Nepal and the Newars of the Kathmandu Valley, where there have been "unique narrative developments and an unexpected convergence between story and ritual." The rituals can be large-scale public affairs, such as what he calls "the performance of the Eighth-Day Vow," which involves the narration of several birth stories, including that of Vessantara, or private viewings of the kind of text he deals with, a painted scroll with captions and pictures telling the story. The version he discusses has the striking peculiarity (also found in some Chinese tellings) that Vessantara does not return to the city and kingship: he stays in the forest as a renouncer and his son, Jāli, returns to become king. Readers of this book might well reflect on and discuss just how extensive a difference this ending makes to the meaning of the story as a whole.

INTRODUCTION, *DRAMATIS PERSONAE*, AND CHAPTERS [25]

Chapter/Section Headings (Titles as in CG, with Pages)

The tale opens (1–2) with a story of the present, in which the Buddha performs a miracle to make his family, the Sakyans, less proud. After that, a lotus-leaf shower rains down, in which only those who are willing get wet. The Buddha says, "This is not the first time, monks, that a great cloud has rained a lotus-leaf shower on my assembled relatives. At the monks' request he [tells] them of the past" (Section 12 below; CG 81–82).

1. Verses About the Ten Wishes (2–5)

After a brief account of her past lives, the future mother of Vessantara, Queen Phusatī, who is about to be reborn from a heaven to a life on earth, is granted ten wishes by Sakka, the king of the gods. They include various wishes for her personal appearance, the chance to be Queen of the Sivis, and "May the king obtain a son who will be open-handed in granting requests and without avarice."

2. Description of the Himālayas (5–18)

Vessantara is born to Queen Phusatī and King Sañjaya. As he is leaving the womb, he says, "Mummy, I want to give a gift; have you anything?" On the same day a female flying elephant brings for him a completely white elephant. This is a magical elephant that ensures adequate rainfall in the kingdom. As he grows up, Vessantara gives many gifts, and at sixteen he is married to Maddī, who in time gives birth to a son, Jāli, and a daughter, Kaṇhājinā. During a drought and famine in the neighboring kingdom of the Kaliṅgans, some Brahmins come from there to ask for the elephant. Vessantara gives it to them. The Sivis are angry at the loss and complain to King Sañjaya, demanding that Vessantara be exiled. In a discussion with Vessantara, Maddī describes the beauty of the Himālayas.

3. Chapter About the Gift-Giving (18–29)

Phusatī laments Vessantara's exile. He makes the Gift of the Seven Hundreds (elephants, horses, etc.). Sañjaya tells Maddī of the rigors of forest life, trying to persuade her to stay, but she insists that she will accompany Vessantara and also take the children. They leave in a carriage drawn by

DRAMATIS PERSONAE

Pali (examples)	Sanskrit	Thai/Lao	Newari	Character	Name at the time of Gotama Buddha
Sañjaya	Saṃjaya Sonjay	Sibi	Vessantara's father	Suddhodana (the Buddha's father)	
Phusatī	[not named]	Phusadi	[not named]	Vessantara's mother	Mahāmayā (the Buddha's mother)
Vessantara [Sudāna]	Viśvantara Wetsandon, Phra Wet	Bisvaṃtara	the Prince-Renouncer	Gotama Buddha	
Maddī	Mādrī	Matsi	Madri	Vessantara's wife	Gotama's wife, usually called "Rāhula's mother" (also Yasodharā)
Jāli	Jāli	Chalii	Jalini	Vessantara's son	Rāhula (the Buddha's son)
Kaṇhājinā	Kṛṣṇājinā	Kanhaa	Kṛṣṇājini	Vessantara's daughter	Uppalavaṇṇā (a nun, one of the two chief female disciples)
Jūjaka	Jūjuka, Jambuka [sometimes not named]	Chuchok	[not named]	Brahmin	Devadatta (a monk, the Buddha's cousin and enemy)
Amittatāpanā the Cetan (CG 39, 46–50)	[not named]	Amittada	[not named]	Jūjaka's wife	Ciñcamānavikā (a wicked nun)
	[not named]	Jetabutr	[not named]	posted as a guard, meets Jūjaka	the monk Channa
Accuta the seer (CG 50–53)	[not named]	Ajuta	[not named]	ascetic, gives the Long Description of the Forest	the monk Sāriputta
Sakka (Inda)	Śakra (Indra)	Inthaa		king of the gods	the monk Anuruddha
Vissakamma	Viśvakarma	Vishnukam	Bisvakarma	[builds the hermitage]	

four horses; Brahmins ask for the horses and then for the carriage, which Vessantara gives away. The family proceed on foot.

4. Chapter About Entering the Forest (29–36)

"Out of pity for the children," divine spirits shorten the road, so they reach the city of the Cetans in one day. The Cetans offer Vessantara kingship over them, but he refuses. The Cetans describe the route, and they set off. Sakka has his assistant deity Vissakamma build two leaf huts in the mountain forest suitable for hermits. Vessantara lives in one, Maddī and the children in the other. During the day Maddī goes off in search of roots and fruits. They live like this for seven months.

5. Chapter About Jūjaka (36–42)

The scene now changes to the village Foulstead. An old Brahmin, Jūjaka, has been given a young wife, Amittatāpanā, by another Brahmin family in payment of a debt. She at first serves him well, but other Brahmin women, whose husbands complain they do not serve them as well themselves, insult Amittatāpanā, making innuendos about being married to an old man. She demands that Jūjaka go to ask Vessantara for his children as slaves. Jūjaka sets off and meets a Cetan hunter, to whom he lies about his mission.

6. Short Description of the Forest (42–44)

The Cetan tells Jūjaka the route, and describes the beauty of the place where the hermitage is located.

7. Long Description of the Forest (44–47, 89–96)

The ascetic Accuta, to whom Jūjaka also lies about his intentions, feeds him and sends him on his way with a long and elaborate description of the forest (put in appendix 1 by CG).

8. Section About the Children (47–59)

Jūjaka arrives late at the hermitage and decides to wait until the next day, when Maddī will be gone. During the night she has a frightening dream, but when she tells Vessantara about it he "deceivingly" consoles her, although he knows what the dream portends. The next day, with Maddī gone, Jūjaka

asks for the children. Vessantara gives them, but they run and hide in a pond. Vessantara goes after them and asks them to "fulfill [his] Perfection." Amid many tears and much strong emotion, Jūjaka takes them away, to the great sorrow of Vessantara, who nonetheless lets them go.

9. Section About Maddī (59–67)

In order to prevent Maddī from getting home early and running after the children, three divine beings disguise themselves as a lion, a tiger, and a leopard, and block her path. They let her go and she returns to the hermitage; not seeing the children, she looks in distress in the places they used to play. At first Vessantara refuses to speak to her; then he accuses her of impropriety with someone in the forest. She faints, and Vessantara takes her on his lap and strokes her. She recovers and he tells her the truth, which she accepts without complaint.

10. Section About Sakka (67–71)

Sakka disguises himself as a Brahmin and asks Vessantara for Maddī. He gives her to him and Sakka reveals his identity and gives Maddī back. He grants Vessantara eight wishes, one of which is to have a son.

11. Section About the Great King (71–78)

Jūjaka, possessed by a deity, goes to Jetuttara instead of going home. King Sañjaya ransoms the children, giving Jūjaka a large palace to live in. The children talk about their parents' lives, and Sañjaya prepares a large army to bring Vessantara home.

12. Chapter About the Six Nobles (78–82)

Sañjaya's expedition reaches the hermitage; such is the emotion that all six (Vessantara, Maddī, Sañjaya, Phusatī, Jāli, and Kaṇhājinā) collapse in a faint. Sakka send a lotus-leaf shower to wake them up.

13. End of the Story of Vessantara (82–87)

Vessantara expresses willingness to govern the kingdom. He removes his ascetic dress, Maddī is bathed, and "mountain- and forest-sports" are held for a month. They all return to the city. "The great king Vessantara

[has] every creature set free, including the cats." The ending is one of harmony—familial, social, and political. Vessantara reigns as a righteous and munificent king and goes to heaven when he dies. At the end of the tale, as at the end of all *jātaka*-s, the Buddha identifies the characters with contemporary people: his father, Suddhodhana, was King Sañjaya, etc., and "I myself was King Vessantara."

NOTES

This introduction draws on my previous discussion of the Vessantara story in S. Collins, *Nirvana and Other Buddhist Felicities: Utopias of the Pali Imaginaire* (Cambridge: Cambridge University Press, 1998). I will refer to this book hereafter as *NOBF*. Readers should also look at Richard Gombrich's preface to the Cone and Gombrich translation (see text and note 13). I would disagree with some of the things said there, but I leave it to readers to decide for themselves. There is also now Sarah Shaw's excellent introduction to her new translation: see note 14 below.

1. Some references to translations of the Buddha's biography are given on page 23 and in notes 70 and 71 below.
2. Collins, *NOBF*, 58–59, 73–78 and *passim*.
3. For some quotations as evidence of this, see Collins, *NOBF*, 497–98.
4. On the history of the term *theravāda*, see P. Skilling, J. A. Carbine, C. Cicuzza, and S. Pakdekhan, eds., *How Theravada Is Theravada? Exploring Buddhist Identities* (Chiang Mai: Silkworm Books, 2012), especially the essays by Rupert Gethin and Todd Perreira.
5. The usual derivation of *pacceka* is *paṭi-eka*, "by oneself," "single," but K. R. Norman has argued that the original form was *pratyaya-buddha*, which he translates as "'one awakened by an (external) cause' as opposed to Gotama or Mahāvīra [the founder of Jainism] who were 'self-awakened' without any external cause." "The Pratyeka-Buddha in Buddhism and Jainism," in *Collected Papers*, vol. II (1981; reprint, Oxford: Pali Text Society, 1991), 233–48, citation from 244. In Pali stories *pacceka-buddha*-s often live in groups and even on occasion preach the Truth (give *dhamma-desanā*-s).
6. Good introductions to all these terms and traditions are R. Gethin, *The Foundations of Buddhism* (Oxford: Oxford University Press, 1998), which concentrates for the most part on Theravāda, and P. Williams, *Mahāyāna Buddhism: The Doctrinal Foundations*, 2nd ed. (London: Routledge, 2008).
7. See B. Brereton, *Thai Tellings of Phra Malai: Texts and Rituals Concerning a Popular Buddhist Saint* (Tempe: Arizona State University, Program for Southeast Asian Studies, 1995); E. Denis, "Brah Māleyyadevattheravatthuṃ," *Journal of the Pali Text Society* XVII: 19–64, and S. Collins, "Introduction," ibid., 1–18, and "The Story of the Elder Māleyya" [translation], 65–96.
8. See below, page 23 and notes 70, 71.
9. The word *bodhisattva* in Sanskrit has traditionally been analyzed as *bodhi* + *sattva*, "enlightenment being," by both Buddhist scholars and Western philology. But that makes no grammatical sense. What seems to have happened historically is that the Pali (or related Middle Indo-Aryan) word *satta* was re-Sanskritized as *sattva*.

This is a possible correspondence, but *satta* in Pali can be equivalent to two other words in Sanskrit, both of which make better sense than *sattva*. From the verb *sañj*, to adhere to, be intent on, the past passive participle is *sakta*, *satta* in Pali; *bodhi-satta* would then mean someone who is "intent on enlightenment." From the verb *śak*, to be able to, be capable of, the past passive participle is *śakta*, also *satta* in Pali; *bodhi-satta* would then mean someone "capable of enlightenment." Both possibilities are more à propos than "enlightenment being," so it is likely one of these two senses of *bodhisatta* was the original.

10. It is often said that the *Vessantara Jātaka* is the penultimate life of Gotama Buddha, which is inexact: it is the penultimate human life. At the end of the story Vessantara is said to be "reborn in heaven" (CG 96). Other texts specify that this was the Tāvatiṃsa heaven, the Heaven of the Thirty-three, where Vessantara/Gotama's name is Setaketu. At the end of that life he will die and be reborn as the human Siddhattha, who will in that lifetime become Gotama Buddha.

11. See Naomi Appleton, *Jātaka Stories in Buddhism: Narrating the Bodhisatta Path* (Farnham, England: Ashgate, 2010).

12. See the list of *dramatis personae* on page 26.

13. London: Pali Text Society, 2011. The original title and publication details are: R. F. Gombrich and M. Cone, *The Perfect Generosity of Prince Vessantara: A Buddhist Epic translated from the Pali and illustrated by unpublished paintings from Sinhalese temples* (Oxford: Clarendon Press, 1977).

14. It will be in the third volume of: Naomi Appleton and Sarah Shaw, trans, *The Ten Great Birth Stories of the Buddha (The Mahānipāta of the Jātakatthavaṇṇanā)* (Chiang Mai, Thailand: Silkworm, 2015).

15. L. Alsdorf, "Bemerkungen zum Vessantara-Jātaka," *Wiener Zeitschrift für die Kunde Süd- und Ost-Asiens* I (1957): 1–70, reprinted in *Kleine Schriften* (Wiesbaden: Franz Steiner Verlag, 1974), 270–339 (quotation from the latter, 339). Also valuable philologically is K.R. Norman, "Notes on the Vessantara-jātaka," in *Collected Papers*, vol. II: 172–86. A similar conclusion to Alsdorf's, though without his contemptuous dismissal of Buddhist tradition, is found in R. Fick, "Zur Entstehungsgeschichte des Vessantara-Jātaka" (in *Beiträge zur Literaturwissenschaft und Geistesgeschichte Indiens. Festgabe Hermann Jacobi zum 75* . . . herausgegeben von Willibald Kirfel [Bonn: F. Klopp, 1926]). O. von Hinüber, *Entstehung und Aufbau der Jātaka-Sammlung: Studien zur Literatur des Theravāda Buddhismus I*, Abhandlungen der Geistes- und Sozialwissenschaftlichen Klasse, Nr. 7 (Mainz: Akademie der Wissenschaften und der Literatur; Stuttgart: F. Steiner, 1998) deals with the *Vessantara Jātaka* only occasionally.

16. As is done by the great fifth-century scholar Buddhaghosa; see Ñāṇamoli, trans., *The Path of Purification* (1955; reprint, Onalaska: BPS Pariyatti Publications, 1999), 288–306 (chapter IX, 1–76).

17. S. Collins, "What Is Literature in Pali?," in S. Pollock, ed., *Literary Cultures in History: Reconstructions from South Asia* (Berkeley: University of California Press, 2003), 649–88, esp. 658–69. Cf. also, inter alia, R. F. Gombrich, "The Vessantara Jātaka, the Rāmāyaṇa, and the Dasaratha Jātaka," *Journal of the American Oriental Society* 105, no. 3 (1985): 427–38.

18. P. Richman, ed., *Many Rāmāyaṇas: The Diversity of a Narrative Tradition in South Asia* (Berkeley: University of California Press, 1991); P. Richman, ed., *Questioning Rāmāyaṇas: A South Asian Tradition* (Berkeley: University of California Press, 2001).

INTRODUCTION, *DRAMATIS PERSONAE*, AND CHAPTERS [31]

19. A. K. Ramanujan, "Three Hundred Rāmāyaṇas: Five Examples and Three Thoughts on Translation," in Richman, ed., *Many Rāmāyaṇas*, 22–49; quotations from 46.
20. Richman, ed., *Questioning Rāmāyaṇas*, citation from 11. Sanskrit *dharma*, Pali *dhamma*, has multiple meanings: early translations used "truth," "righteousness," etc. In *NOBF* I rendered the word by the phrase "what is right," and distinguished between two levels: *dhamma* 1 is an ethics of reciprocity, in which the assessment of violence, including the actual and threatened violence necessary to the maintenance of any social order, is context-dependent and negotiable. Buddhist advice to kings in *dhamma* 1 tells them to not to pass judgment in haste or anger, but appropriately, so that the punishment fits the crime. To follow such advice is to be a good king, to fulfill what the philosopher F. H. Bradley would have called the duties of the royal station. *Dhamma* 2 is an ethic of absolute values, in which the assessment of violence is context-independent and non-negotiable, and legal punishment, as a species of violence, is itself a crime. The only advice possible for kings in *dhamma* 2 might seem to be "Don't be one!," "Renounce the world!," "Leave everything to the law of karma!" Many stories recommend just this. Others, however, envisage the utopia of a nonviolent king. Both Vessantara and Rāma, in any and every telling, oscillate between *dhamma* 1 and 2.
21. In *NOBF*, especially chapter 6, "A Perfect Moral Commonwealth? Kingship and Its Discontents," and chapter 7 on the *Vessantara Jātaka*, I have tried to construct a vision of the Pali *imaginaire* as a whole in which it has the potential to be used both in support of military-political power and in opposition ("one-upmanship") to it.
22. On Kham Luang versions and others, see Nidhi Eoseewong, *Pen and Sail: Literature and History in Early Bangkok* (Chiang Mai, Thailand: Silkworm, 2005), 54–55, 201–26; and Sombat Chantornvong, "Religious Literature in Thai Political Perspective: The Case of the Maha Chat Kamluang," in Tham Seong Chee, ed., *Essays on Literature and Society in Southeast Asia: Political and Sociological Perspectives* (Singapore: Singapore University Press, 1981).
23. Collins, *NOBF,* 45. The Sri Lankan anecdote is from John Holt (personal communication), referring to a performance of Ediweera Saratchandra's Sinhala adaptation of the Vessantara story in Colombo in 1985.
24. P. Khoroche, *Once the Buddha Was a Monkey: Ārya Śūra's Jātakamālā* (University of Chicago Press, 1989), 58.
25. M. Monier-Williams, *Sanskrit-English Dictionary* (Oxford: Clarendon Press, 1899); V. S. Apte, *The Practical Sanskrit-English Dictionary*, 4th and rev. ed. (Delhi: Motilal Banarsidass, 1965).
26. S. Kierkegaard, *Sickness Unto Death*, trans. W. Lowrie (1941; reprint, Princeton: Princeton University Press, 1974), 214.
27. E. Gellner, *Spectacles and Predicaments: Essays in Social Theory* (Cambridge University Press, 1979), 118, italics in original.
28. For discussion of this text see K. R. Norman, *Pāli Literature* (A History of Indian Literature VII, 2) (Wiesbaden: Harrassowitz, 1983), 110–12; and O. von Hinüber, *A Handbook of Pali Literature* (Indian Philology and South Asian Studies vol. 2) (Berlin and New York: Walter de Gruyter, 1996), 82–86. Translations include: I. B. Horner, *Milinda's Questions* (London: Luzac, vol. I, 1963, vol. II, 1964); *Milindapañha = Die Fragen des Königs Milinda: Zwiegespräche zwischen einem Griechenkönig und einem buddhistischem Mönch aus dem Pāli übersetzt von Nyanatiloka; herausgegeben und teilweise neu übersetzt von Nyanaponika* (Interlaken, Schweiz: Ansata, 1985); E. Nolot, *Entretiens de Milinda et Nāgasena* (Paris: Gallimard, 1995).

T. W. Rhys Davids' early version, *The Questions of King Milinda* (vol. I, 1890, vol. II, 1894) is long out of print, but available at http://www.sacred-texts.com/bud/milinda.htm.

29. Horner, *Milinda's Questions* vol. I, 159; Rhys Davids, *Questions*, 114, has "that was out of season, it was an isolated occurrence"; Nolot, *Entretiens*, 109, has "ce fut une phenomène exceptionnel, particulier." M. Cone, *A Dictionary of Pali, Part One a-kh* (Oxford: Pali Text Society, 2001), s.v. *kadācuppattika* has "rarely occurring." Nyantiloka/Nyanaponika do not translate this passage.

30. Horner, *Milinda's Questions* vol. II, 95–109, with an added section title "Do all Bodhisattas give away their Wife and Children?"; Nolot, *Entretiens*, 218–26, with the added section title "Le Don exorbitant de Vessantara"; Nyantiloka/Nyanaponika, *Die Fragen*, 256–63, with the added section title "Vessantaras Wegschenken von Weib und Kind."

31. For fuller treatments see Norman, *Pāli Literature*, 77–84; von Hinüber, *A Handbook of Pali Literature*, 54–58; N. Appleton, *Jātaka Stories in Theravāda Buddhism: Narrating the Bodhisatta's Path* (London: Ashgate, 2010).

32. Cf. the remarks on the words *tyāga* (Sanskrit) and *cāga* (Pali) in *NOBF*, 525–26, citing in this regard J. Parry, "The Gift, the Indian Gift, and the 'Indian Gift,'" *Man* (n.s.) 21 (1986): 453–73 (on Hinduism). Cf. also on Jainism J. Laidlaw, "A Free Gift Makes No Friends," *Journal of the Royal Anthropological Institute* 6, no. 4 (2000): 617–34; for generosity/sacrifice as a Buddhist virtue, see R. Ohnuma, *Head, Eyes, Flesh, and Blood: Giving Away the Body in Indian Buddhist Literature* (New York: Columbia University Press, 2007), passim.

33. See C. Cicuzza and P. Skilling, "The Number of Stanzas in the Vessantara Jātaka: Preliminary Observations," in *Buddhist Asia 2: Papers from the Second Conference of Buddhist Studies* held in Naples in June 2004, ed. G. Orofino and S. Vita (Kyoto: Italian School of East Asian Studies, 2010), 35–45.

34. J. Brockington selects, on philological grounds, verses from what is now known as Vālmīki's *Rāmayaṇa* to produce what he takes to be "the earliest version" of the story, in which Rāma is entirely a human hero, and not the incarnation of the god Rāma he is "later" taken to be (*Rāma the Steadfast*, Penguin Classics, 2006). Brockington claims, in a less critical style than Alsdorf, but with some of the same Orientalist prejudices, that "the term 'epic' can justifiably be applied only to its later, developed form; the story lying at its heart would in Western literary terms best be classified as a heroic romance, for it is the personal story of the Prince . . . : no wider or national interests are involved" (x). It was "the desire to aggrandize Rāma . . . that led to the change in genre undergone by the text at this point. It is no longer a romance concerning the private antagonism between one man and his lustful enemy . . . it is a struggle of cosmic significance . . . and the gods themselves must take a hand to remedy the situation. In Western terms, the romance has been transformed into an epic" (367). In Brockington's use of the terms, is the Vessantara story a private romance concerning the extreme generosity of a prince and the effect this has on his family (parents, wife, and children), or "a struggle of cosmic significance" in which the future Buddha Gotama fulfills one of the Perfections necessary on his path to buddhahood? Or both?

35. The following remarks draw on these sections of *NOBF*: tragedy, 499–500 (citation from D. Shulman, "Towards a Historical Poetics of the Sanskrit Epics," *International Folklore Review* [London], vol. 8); V. Newall, ed., *Folklore Studies from Overseas*, 499 and 522–41; comedy, 534–37; melodrama, 541–44; utopianism, 548–54.

36. R. Heilman, *Tragedy and Melodrama: Versions of Experience* (Seattle: University of Washington Press, 1986), 30, cited in *NOBF,* 531.
37. *Poetics* XIII.2, cited in *NOBF,* 525; cf. 531.
38. Cf. the linguistic argument about the order of events in this passage in *NOBF,* 513–14.
39. A. Lovejoy and G. Boas, *Primitivism and Related Ideas in Antiquity* (Baltimore: Johns Hopkins University Press, 1935), quotations from 9–11.
40. See *NOBF,* 524–25.
41. See C. Keyes, "Mother or Mistress but Never a Monk: Buddhist Notions of Female Gender in Rural Thailand," *American Ethnologist* 11, no. 2 (1984); "Ambiguous Gender: Male Initiation in a Northern Thai Buddhist Society," in *Gender and Religion: On the Complexity of Symbols,* ed. C. W. Byum, S. Harrell, and P. Richman (Boston: Beacon, 1986).
42. Published in Grant Evans, ed., *Laos: Culture and Society* (Chiang Mai: Silkworm, 1999).
43. The need for inverted commas is explained in my *Civilisation et femmes célibataires dans le bouddhisme en Asia du Sud et du Sud-Est: une étude de "genre"* (Paris: Les Éditions du CERF, 2011).
44. University of Hawaii Press, 2006; see chapter 6, "Marking Maturity: The Negotiation of Social Inequalities at Midlife," quotation from 143.
45. In this connection, very thought-provoking is B. Watson Andaya, "Localising the Universal: Women, Motherhood and the Appeal of Early Theravāda Buddhism," *Journal of Southeast Asian Studies* 33, no. 1 (2002). By "early" she means when it first became culturally widespread, from about the thirteenth century on.
46. For recent bibliography see, for example, L. Grey, *A Concordance of Buddhist Birth Stories,* 3rd ed. (Oxford: Pali Text Society, 2000); B. K. Behl, *The Ajanta Caves: Artistic Wonder of Ancient Buddhist India* (London: Thames and Hudson, 1998), Visvantara [sic] on 158ff. A. P. Bell, *Didactic Narration: Jataka Iconography in Dunhuang with a Catalogue of Jataka Representations in China* (Münster, Germany: LIT, 2000) also deals extensively with Indian sites.
47. J-P. Osier, *Le "Vessantara jātaka" ou l'avant-dernière incarnation du Bouddha Gotama* (Paris: Les Éditions du CERF [Patrimoines bouddhisme], 2010).
48. I. B. Horner, *The Minor Anthologies of the Pali Canon Part III (Buddhavaṃsa and Cariyā-piṭaka)* (London: Pali Text Society, 1975). J. S. Strong, *The Experience of Buddhism: Sources and Interpretations,* 3rd ed. (Belmont: Thompson-Wadworth, 2008), 33–36. Strong omits the last five verses, 54–58, in which it is clearly stated that Vessantara and his family return to the city of Jetuttara in the company of his parents. It was perhaps this omission that led Strong to make the erroneous statement that in this text Vessantara "ends up possessionless, wifeless, without children, and alone in a hermitage" (33). Given the importance of the ending of the story in assessing Vessantara's actions, and the fact that versions in Nepal and China do end without Vessantara returning to kingship, it is important to note that the "Basket of Conduct" version does contain the usual ending, albeit given in extreme brevity.
49. Khoroche, *Once the Buddha Was a Monkey,* 58–73.
50. K. Das Gupta, "Viśvantarāvadāna, Eine Buddhistische Legende. Edition eines textes auf Sanskrit und auf Tibetisch eingeleitet und übersetzt," Inauguraldissertation ... der Freien Universität, Berlin, 1978, translation on 65–83. (This work is available through interlibrary loan from several universities in the U.S.A. and Europe.)

T. Lenz, *A New Version of the Gāndhārī Dharmapada and a Collection of Previous-Birth Stories*, Gandhāran Buddhist Texts 3 (Seattle: University of Washington Press, 2003), 226–37, and cf. 96–97.

51. Das Gupta, "Viśvantarāvadāna," 139–44.
52. C. H. Tawney, *The Kathāsarit sāgara; or, Ocean of the Streams of Story* (1924–28; reprint, Delhi: Motilal Banarsidass, 1968), vol. 8, 125–31. In French there is N. Balbir et al., *Océan des rivières des contes* (Paris: Gallimard, 1997), 1184–90, notes on 1499–501.
53. W.R.S. Ralston, *Tibetan Tales* (translated from the German of A. von Schiefner) (London: Kegan Paul, Trench, Trübner, 1893), Viśvantara on 257–72.
54. J. Bacot, "Drimedkundan, une version Tibétaine dialoguée du Vessantara Jātaka," *Journal asiatique* XIe série, 1914, 221–305, republished in his *Trois mystères Tibétains* (Paris: Éditions Bossard, 1921). An English version, from the French, is H. I. Woolf, *Three Tibetan Mysteries: Tchrimekundan, Nasal, Djroazanmo, as Performed in the Tibetan Monasteries* (London: Routledge, 1924). This latter reads oddly to modern ears, as it uses a now passé biblical style: "thou goest," "he hath," etc.
55. M. H. Duncan, *More Harvest Festival Dramas of Tibet* (London: Mitre Press, 1967).
56. S. Lienhard, "La légende du Prince Visvantara dans la tradition népalaise," *Arts asiatiques* XXXIV (1978): 139–56; *Die Legende vom Prinzen Viśvantara* (Berlin: Museum für Indische Kunst, 1980); "Toiles et textes: deux rouleaux bouddhiques du Népal," *Studia Asiatica* IV–V (2003–04): 539–50.
57. E. Chavannes, *Cinq cent contes et apologues* (Paris: Ernest Leroux, 1911). For details about the text Chavannes chose to translate, see H. Durt, "The Offering of the Children of Prince Viśvantara/Sudāna in the Chinese Tradition," *Journal of the International College for Postgraduate Buddhist Studies* II (1999): 147–82, esp. notes 2 and 37.
58. Durt, "The Offering of the Children," and "The Casting-off of Mādrī in the Northern Buddhist Literary Tradition," *Journal of the International College for Postgraduate Buddhist Studies* III (2000): 133–58. See also S. R. Bokenkamp, "The Viśvantara Jātaka in Buddhist and Taoist Translations," in *Daoism in History: Essays in Honour of Liu Ts'un-yan*, ed. B. Penny (London: Routledge, 2006), who does not make reference to Durt's work.
59. The giving away of bodily parts, or the whole body, is a frequent motif in Buddhist stories. See H. Durt, "Two Interpretations of Human-Flesh Offering: Misdeed or Supreme Sacrifice," *Journal of the International College for Postgraduate Buddhist Studies* I (1998): 57–83; Ohnuma, *Head, Eyes, Flesh, and Blood*.
60. E. Benveniste, *Vessantara Jātaka, texte sogdien édité, traduit et commenté* (Paris: Librairie orientaliste Paul Guethner, 1946).
61. N. Poppe, *The Mongolian Versions of the Vessantarajātaka* (Helsinki: Societas Orientalis Fennica, *Studia Orientalia*, v. 30, 1964), introduction, 2–14 (citation from 6); translation, 74–92.
62. C.H.B. Reynolds, ed., *An Anthology of Sinhala Literature up to 1815* (London: George Allen and Unwin, 1970), 130–67. The phase "madness of faith" is "*saedaevasmara; saedae* is *saddhā* [trust, confidence]; *vasmara roga* is epilepsy, so *saedae vasmara* would be something like a fit of *saddhā*. *Vasmara* also means changing, perverted" (Charles Hallisey, personal communication).
63. Head of the Mayūrapada Pirivena, Wākirigala, *Pūjāvaliya (A Sinhala Classic of the 13th Century)*, trans. H.D.J. Gunawardana (Department of Cultural Affairs, 2000), 146–55. The Sinhala *Thūpavaṃsa* contains a summary of the story: see S. Berkwitz,

The History of the Buddha's Relic Shrine: A Translation of the Sinhala Thūpavaṃsa (Oxford: Oxford University Press, 2007), 219–22.

64. http://www.seasite.niu.edu:85/thai/literature/sridaoruang/matsii/matsii2.htm #13kans has an example of the set.
65. L. A. Goss, *The Story of Wethan-daya: A Buddhist Legend* (Rangoon: American Baptist Mission Press, 1895).
66. O. White, *A Literal Translation of The Textbook Committee's Revised Edition of Wethandaya, the prescribed text for the sixth, seventh and eighth standard and entrance examinations* (Rangoon: American Baptist Mission Press, 1906). This book is very difficult to find: I have a .pdf file version that I will be happy to send anyone who would like a copy—contact me at s-collins@uchicago.edu. See further Lilian Handlin's essay in this volume.
67. http://dspace.anu.edu.au/html/1885/41898/wetsandon.html. The only information as to the provenance of the Thai text is the following: "This English version of the story of Prince Wetsandon was translated by John Crocker, an Asian Studies student, from a Thai summary book of the *Thet Maha Chat* given to Thai worshippers." Still of interest is G. E. Gerini, *A Retrospective View and Account of the Origins of the Thet Mahâ Ch'at Ceremony (Mahā Jāti Desanā) or Exposition of the Tale of the Great Birth as Performed in Siam*, 2nd ed. (1892; reprint, Bangkok: Bangkok Sathirakoses-Nagapradipa Foundation 1976).
68. Translated by S. Kepner in *The Lioness in Bloom: Modern Thai Fiction About Women* (Berkeley: University of California Press, 1996), 95–100. Kepner's translation along with the Thai text is available at http://www.seasite.niu.edu:85/thai/literature/Sridaoruang/matsii/default.htm.
69. A. Leclère, *Le livre de Vesandâr, le roi charitable* (Paris: Ernest Leroux, 1902). The transliteration of Cambodian versions of the characters' names makes this sometimes difficult reading.
70. N. A. Jayawickrama, *The Story of Gotama Buddha: The Nidāna-kathā of the Jātakaṭṭhakathā* (Oxford: Pali Text Society, 1990). P. Olivelle, *Life of Buddha by Ashvaghosha* (New York: New York University Press/JJC Foundation [Clay Sanskrit Series], 2008).
71. J. S. Strong, *The Buddha: A Beginner's Guide* (2001; reprint, Oxford: One World, 2009).

{ 1 }

READERS IN THE MAZE

MODERN DEBATES ABOUT THE
VESSANTARA STORY IN THAILAND

Louis Gabaude

THE MAZE is a universal symbol of initiation and spiritual quest. In the Middle Ages, Christians could trace their way into salvation through a labyrinth engraved on the pavement of European cathedrals. Now, the Shan of northern Thailand walk into their future through a wooden or bamboo maze they have built in their temple, trying their best to get to the central point, an image or a miniature replica of an ashram. Some monks explain the game as an exercise reflecting the hits and misses of life one has to experience before the final liberation from desires. A more down-to-earth belief promises success in this life to whoever manages to reach the center.

The maze set up by the Shan people is no ordinary maze. It has a precise location and reference in the Buddhist literature and worldview, right at the core of the last previous life of the Buddha, simply because it is called *Mangkapa* in Shan[1] and *Wongkot* in Thai—the very name of the Vaṅkatapabbata Mountain[2] where Prince Vessantara took refuge and where the old Jūjaka wandered before finding the two children as servants for his young wife. The central point is supposed to be Vessantara's ashram, and sometimes there is a second one for Maddī and the children. Other ashrams may be found too, in sets of five named according to the five buddhas of the present cosmic eon.

Today, like Jūjaka, modern Thai listeners and readers of the *Vessantara Jātaka* (hereafter *VJ*) still do wander, and sometimes feverishly, but in a forest of symbols and a maze of meanings, searching for a Vessantara they

will naturally pretend in the end to be the real one. The questions asked in the introduction by Steven Collins about the possibly excessive moral code of Vessantara are not simply Western theoretical inquiries concocted in a distant ivory tower. The fact is that the story has confused and disoriented the East too, from at least the time of King Milinda and Nāgasena. In Thailand, it has generated hot debates among elite as well as common voices. All have found and painted our hero together with his foils under various lights, shades, and colors, depending on their quest for formal, social, or spiritual interests.

In addition to innumerable expressions in iconography, the tale is known through hundreds of literary versions in the Buddhist Asian world, both scholarly and popular. It is also known, as a number of contributors to this volume attest, in rituals, whose climax is the recital of the story, often acted out as a form of theater. This ritual celebration was justified and popularized, perhaps even created, by the story of the monk Māleyya, who came back from his journey in hell and heaven to report that whoever listened to a reading of the entire *VJ* during less than twenty-four hours would be reborn in the world at the time of the next Metteyya Buddha.[3] Such an aspiration was made more urgent by the prediction that, during the gradual disappearance of Buddha Gotama's teaching, this tale would be the first within the book of the *jātaka*s to vanish. Often at the very beginning of the celebration, people try to propitiate natural forces by inviting Upagupta, the exemplary disciple of the Buddha whom Māra was not able to vanquish, to participate.[4]

This chapter will examine two kinds of modern reaction to *VJ*. The first attacks it in the name of modern values, the second vindicates it in the name of "eternal" values.

CRITICISM OF THE *VESSANTARA JĀTAKA*

Certainly, the extreme generosity of Vessantara's behavior did not start to shock readers only in the twentieth century. But the controversy was before that time the main reason people were interested in the tale, since it increased the dramatic intensity of the realization of the Perfection of Generosity. However, during the past 150 years criticisms have developed that have questioned either the historical accuracy of the previous lives or their exemplary moral value, their political neutrality, or the very religious system they convey.

Critique of Authenticity

While opening to the "scientific" ideas of the Western world, Thailand received, among other things, its critical theories of religious texts, which were used, sparingly but significantly, by Prince and then King Mongkut.[5] At the end of the nineteenth century, Gerini saw that members of the royalist and reformist sect of the Thammayut generally did not organize recitations of *VJ* since they considered it not to be the "Buddha's word."[6] The king at the time, Chulalongkorn, actually thought that the *jātaka*-s were popular fables that the Buddha had simply reused for giving moral lessons, and that it was only later that he had been turned into this "Great Being," the hero of each tale, to strengthen their authority. Even later, he thought, correspondences between the characters of the *jātaka*-s and those surrounding the Buddha were added to vindicate even more the theory of the ripening of action, *kamma*, by claiming that the fable was history.[7]

Put into play by royal and religious authorities, this first critique of the historical value of the previous lives of the Buddha was soon controlled, channeled, and balanced by the later hermeneutical theory of Bhikkhu Buddhadasa, which was actually traditional; it permitted the literal content of the tales written in "personal" language (*puggalādhiṭṭhāna*) while interpreting them according to their "doctrinal" meaning (*dhammādhiṭṭhāna*). This kind of criticism of authenticity intended no more than to salvage the essential, the original, the genuine.

Moral and Economic Critique

A second wave of challenges appeared, especially in the 1960s and 1970s, that radicalized the internal criticisms of Vessantara's behavior already found within the tale. However, it was further based on the requirements a "developing country" was supposed to follow. This kind of criticism is illustrated by the reply Kukrit Pramoj wrote to a letter from a reader. (Kukrit, at that time already the director of a newspaper and a successful literary author, had not yet grown into a full political figure: he was to be appointed Prime Minister in 1974.) Like his Thammayut masters, Kukrit asserts first that the story of Vessantara is not to be found in the canon and that he himself believes "in the Buddha, but not in Vessantara"! The most problematic issue, for him, is not authenticity, but rather the corrupted lesson that the tale claims to give. Vessantara cultivates the

virtue of generosity, disregarding ordinary morality. Imitating him without understanding would end up ruining the basic principles of contemporary society.

Vessantara first cultivates generosity at the expense of general welfare: he gives disproportionate alms from the state revenue, and during his exile society still needs to pay a hunter to protect him against people who might ask him for money. Vessantara is "a king who fails to keep the morality of kings"; in other words, he fails to obey the national interest: he knows that his rain-bringing white elephant is an important element in the natural, seasonal balance and that it guarantees the prosperity and happiness of his people. He nevertheless gives it away, knowing that the people will have to suffer the consequences: "it is absolutely normal that the people got rid of him." Vessantara is "a husband who fails to keep the morality of husbands": far from protecting his wife, Maddī, making her happy, and being lavish with her according to their social status, he lets her slip into poverty and even gives her away to another man "as if she were not a human being." Vessantara is a "father who fails to keep the morality of fathers": he does not protect his children or make them happy. He accepts seeing them beaten in front of him by Jūjaka.

The writer finally attacks what he sees as two "flaws" of contemporary Thai society: corruption and the inability to develop economically. One must first cultivate generosity in a moral fashion, and not steal or cheat in one place and then be generous in another by funding new hospitals. The budget of a university should not be used to show off with a major gift when the king comes to visit. It is necessary, during this phase of economic development, to "teach Buddhism with intelligence by examining the ins and outs of it so that it does not impede development: if the government supports rural development with millions of dollars but farmers then use all their revenue to build pagodas so that they can acquire merit, they will continue to live in huts for a long time and the development will have been worth nothing."

Appearing in his newspaper as a guru who gives advice about everything, particularly about Buddhism, Kukrit does not challenge the religion from the outside; nor is he a royal figure whose opinions cannot be challenged. He already belonged to the Thai political world and was neither external nor supposedly neutral to political institutions. To put it simply, he was a conservative who, cherishing both Buddhist and monarchical traditional institutions, allowed himself to give his opinion regarding how Buddhism should be taught so that civil society and economic society would not be threatened. The criticisms he voiced against *VJ* on the one

hand, and against the teaching of Buddhadasa about the empty mind on the other hand,[8] follow the same logic.

It is probably difficult for a non-Thai to imagine the scandal that such a statement could cause for the dominant religious ideology, which considered the existence of Vessantara to be the culmination of all the previous lives of the bodhisatta, and hence to offer an individual and social model that all beings and society are supposed to emulate. We will measure a little the extent of this scandal by investigating below the responses that Kukrit's criticism provoked. But we first need to pay attention to a new kind of challenge faced by the Vessantara.

Political Critique

The challenges examined so far all came from people who presented themselves as Buddhist and claimed to provide the most genuinely Buddhist interpretation of *VJ*. Nevertheless, each criticism necessarily presupposed a dividing line between itself and the traditionally received interpretation, in terms of historical or moral authenticity. But this dividing line never set the critics at a distance from the Buddhist institution as a whole. This is, however, the case with a position held by university professors or scholars that challenged the exclusively religious nature of *VJ*, i.e., its political neutrality. Even if he doubted the political common sense of the hero of the fable, Kukrit could hardly imagine that the kings of Thailand, whom he generally held in high regard, would have wanted to use the popularity of *VJ* for Machiavellian purposes. This is what was claimed by some university professors in the 1970s, whose main opinions I will now present in a general way, drawing on a book by two such scholars, Sombat Chantornvong and Chai'anan Samutwānit.[9]

They highlighted first of all the constant collusion between political and religious authorities in Buddhist countries and illustrated this fact with the political intentions behind the composition of a version of *VJ* called "Mahachat Kham Luang" ordered by King Trailokanat of Ayuthaya in 1482. Trailokanat was a clever political leader who succeeded in unifying the two kingdoms of Sukhothai and Ayuthaya. To this end, he highlighted as much as possible his religious identity, in two ways: he built and restored pagodas in both kingdoms and had himself ordained as a monk, following the example of the kings of Sukhothai.

Sombat and Chai'anan point out that for some people this version was perhaps the first to include, besides the Pali text, a poetical translation in vernacular language. While they recognize that the text could not have

had much influence over the reign of Trailokanat, since it was written at the end of it, they consider that it was a key instrument in spreading the ideology of merit during the next centuries. For them, it is an obvious example of a literature that is not "religious" but "politico-religious," through which power attempts to impose an image of the world and, in this case, of the state itself.

For these writers, it was difficult to imagine that the composition of the Mahachat Kham Luang was without political ulterior motives. Besides the fact that the composition of a religious work set Trailokanat alongside the King of Sukhothai, who wrote the cosmological treatise on the three worlds (the "Trai Phum"),[10] it made possible the spread of a whole political and merit-based ideology, known as the *sakdi na* system.[11] Based originally on land ownership, this came to incorporate all people in the country, from the king at the top (or rather, above the top) down to commoners, beggars, and slaves. People at each level would be assigned a rank expressed as a numerical value; rank in any one life was justified by the ideology of karma and merit. This ideology, paradigmatically exemplified in the previous lives of the Buddha, had the significant advantage for a king that it explained present social status as the ripening of actions that individuals performed in previous lives. How did that apply more precisely to King Trailokanat himself? In "his" version—all the more easily perhaps in that its vernacular language, insofar as we can recover it, was more likely to sound appealing than the Pali version—distinctions between the names of the bodhisatta, the Buddha, Vessantara, and the king are removed, helping to create the equation: King Trailokanat = Vessantara = Buddha. To support the suggestion that the king desired to be assimilated to the Buddha, Gilles Delouche refers to the fact that at the temple when he was ordained, five of his dignitaries, previously ordained, were in attendance, representing the five first disciples of the Buddha.[12]

For Sombat and Chaiyanant, the Mahachat Kham Luang sends two more ideological messages. The first is that the Sivi people are foolish, and even evil, to banish Vessantara. If the people of Sivi cannot understand lofty intentions, the people of Ayuthaya should see in them a counter-model for themselves. Kings and princes, on the contrary, "understand." They are privileged by their peers and by nature. The other ideological message relies on the figure of Amittatāpanā, Jūjuka's wife. He plays the villain, but he would not have acted without the inflexibility of his wife, who embodies the antithesis of the perfect spouse—faithful, obedient to her husband, going to bed after him and getting up before him, —portrayed in the tale by Maddī.

Feminist Critique

Just as *VJ* has been held responsible for the political and economic flaws of Thai society, this tale, like the other *jātaka*s and much of traditional Buddhist literature, is held accountable, in some feminist readings, for the plight of women. In 1980 the Burmese writer Khin Thitsa published a highly controversial book, *Providence and Prostitution: Image and Reality for Women in Buddhist Thailand*,[13] in which she argued that "men and women live their everyday lives as Buddhists under very different circumstances: men are the 'first-class' citizens, and women are 'second-class.'" The story of Vessantara and Maddī is taken as a paradigmatic example of the *jātaka* stories, where "the setting is always the same: [a] wise, pure male . . . [is] assisted in following his spiritual goal by the services of a devoted female, usually mother or wife. The other portrayal of woman is again as seductive and avaricious, an evil force which is duly chastised. Thus the young boy and girl learn their different roles in life." Although the book ends with a reference to the coming of the future Buddha Metteyya, which is "perhaps the land of true Buddhism, where Absolute Truth would be attainable because there would be absolute equality between women and men and amongst all the peoples of Thailand," in "Thailand, reactions to [the book] predictably ranged from outrage to curt dismissal . . . on the grounds that she did not know what she was talking about."[14]

In 1989 Kornvipa Boonsue also took the Vessantara tale as the archetype of *jātaka* literature, listing five ways it distorted feminine identity:

1. Woman is matter, the womb, while man is the soul, the form who comes to look for his final liberation
2. Woman is a being with material craving longing for physical beauty
3. Woman is an object under male's possession: Vessantara gave 700 women before giving Maddī
4. Woman and the image of feminine morality: a wife always obeys her husband to be
5. Man is the decision maker; woman the follower.[15]

These social issues raised about the *VJ* all take for granted that Buddhist literature has been a calculated and efficient tool in the making of Thailand's political and familial structures. This alone could be a topic for discussion: are practices producing literature or is literature producing practices? Should feminists rejoice now because Thai women do not follow subservient Maddī's path and are found by a survey to be the second most unfaithful group of women in the world?[16]

Less condemnatory readings of the *VJ* are made by a Catholic professor of philosophy at Chulalongkorn University, Suwanna Satha-Anand. Approaching dialogue between religions from a point of view she describes as "challenge with respect," in one article she explores the "moral conflicts inherent in the text," looking "from the perspectives of those around Vessantara, rather than from Vessantara himself," and hoping "that the two extremes of negation of anything traditional on the one hand, and a non-thinking acceptance of anything inherited on the other, would be better balanced in this process of re-orientation and re-appropriation of the story."[17] In another,[18] attempting "to re-read [the story] from a feminist perspective," she asks, "Why is Madsi [= Maddī] not also considered a bodhisattva?" and concludes that "An alternative mode of reasoning could be a logic which includes the possibility of bodhisattvahood for Madsi." She stresses the fact that Vessantara, Maddī, and the children are all (in the end) in favor of Vessantara's heroic generosity. This mode of reasoning would hold that:

1. A wife is a "life partner" of her husband. Their relationship could be described by the term "equality" or "reciprocal superiority."
2. A wife, the husband and the children all belong to each other. No one party should assume the ultimate "ownership."
3. The "self" of the wife is both part of and independent from the "self" of the husband, and vice versa. The ground for negotiation is open to both parties in the relationship.
4. A woman's and a man's actions do carry independent weight and credit. If we choose the logic of interdependence rather than that of one-sided dependence, it is time we opened up the possibility of giving the credit to Madsi, and to women in general. It [is] about time we introduced new elements into our classical heritage, so that it belongs to the people and becomes more relevant.

This brief overview of the reproaches addressed to the Vessantara story displays a certain radicalization of the criticisms and a variety in their presuppositions. The critique of authenticity was set within Buddhism and aimed to support it, whereas the political critique does not investigate at all the transcendental value of the message conveyed by the tale, attempting merely to decode its sociopolitical motives and goals. Situated between the two, Kukrit's moral criticism attempts to protect the ethical foundation of Buddhism as well as the economic interests of society. The radical feminist critiques, and the development and

partial recuperation of the story attempted by Satha-Anand, all assume that the story in its unreconstructed version is unacceptably patriarchal. Because of their diverging presuppositions, these critiques do not assign to the events and the characters the same significance or the same values: the ideological challenge sees for instance in the people who ban Vessantara foolishness and evil, whereas moral challenge sees their reason and rightfulness.

DEFENSES OF THE VESSANTARA JĀTAKA

Although we have distinguished four kinds of criticisms of *VJ*, depending on the point of view authors prioritized—authenticity, morality, ideology, feminism—I will refer here only to two general kinds of defense of the *jātaka*, one that can be called "classical" and the other "modernist."

Classical Defenses

I will focus here mainly on two lay apologists, Sathien Bodhinantha and Pin Muthukant, who both replied to attacks of the kind made by Kukrit Pramoj. I have not been able to ascertain the date of the conference Sathien dedicated to the defense of *VJ*, nor the specific people to whom he was responding, beyond the fact that he was targeting professors from Chulalongkorn University. Besides objections similar to those of Kukrit Pramoj, Sathien reports some criticisms with a political implication: if everybody were to behave like Vessantara, Thailand would end up being handed over to the enemy. In his defense, Sathien is consequently concerned with showing that the ideal of the bodhisatta is not contradictory to the ideals of genuine nationalists. He passed away in 1966 and was not able to read the letter Kukrit Pramoj sent to the editor as a response, which provoked the direct and at times treacherous counterattack of Pin Muthukan, the then Director of the Department of Religions. (Since these two apologists start with general considerations and then follow the sequence of events of the tale, I will present their arguments in this order and will simply point out the author of the argument each time.)

Pin Muthukant first disagrees, against Kukrit, with the idea that *VJ* is not in the Pali Canon. He points at the volume and the pages where it can be found and recalls that generally one should start the preaching of *VJ* with a reading of the "1,000 stanzas" of the Pali Canon, a way to vouch for the authenticity of the narrative.[19]

On the subject of the gift of the white elephant, Sathien disagrees with the accusation that it is a misuse of public property: the elephant appeared at the same time as Vessantara and therefore truly belonged to him. Pin reminds his readers that at the time kings had the right of life or death over all their subjects and possessed rightfully everything in the country. Hence Kukrit's criticism does not carry weight. According to Pin and Sathien, by giving the white elephant, Vessantara made a personal sacrifice for the greater benefit of all. Given the position and power of the kingdom that was asking for it, war would have broken out if he had not yielded to the request. In the past, Thailand often imitated Vessantara by depriving itself of useful things in order to help others, such as when Thai soldiers were sent to Korea or Vietnam.

A "group of monks" considered that the decision to ban Vessantara was a model of monarchical democracy since King Sañjaya follows popular opinion. Didn't the King of Thailand do the same thing in October 1973 when he exiled leaders that the people did not want anymore? The same group considers that by practicing chastity in their hermitage after the birth of their two children, Vessantara and Maddī represent the perfect couple embodying birth control.[20]

Was Vessantara lacking in his morality as a father? We should avoid comparing ourselves to Vessantara, who had only one existence left before becoming the Buddha. Sometimes parents who live in the countryside entrust their children to someone living in the city as domestic servants. Sometimes even a monk asks for a child. Indeed, some very successful people have come to town in such circumstances. Hence Vessantara's behavior is not so uncommon. After putting the future Buddha's behavior into perspective, Pin ironically praises Kukrit Pramoj's paternal love, saying that, seeing how desperate the death of his favorite dog made him, he understands that Kukrit has not yet reached Vessantara's spiritual state. As for Sathien, he explains that by giving his children away Vessantara was able to become Buddha for the sake of all beings. He sacrificed his paternal affection for the realization of a larger universal well-being. Do not soldiers make similar sacrifices without shocking us? And isn't it even more justifiable to fight against passions rather than for a nation? For Sathien, Vessantara knew well that putting a very high price on his children would mean that only King Sañjaya could ransom them.

Saying that Vessantara was a liar because he did not tell Maddī immediately that he gave away the children is forgetting, according to Pin, that it is sometimes necessary to choose the right time to tell the truth. It happens to us all at some point.

If, for Sathien, it is foolish to fear that everybody might resemble such a hero, it is still a fact that the history of Thailand offers role models, namely people who behaved like bodhisattas. For example, every time he gave to beggars, the future Rama III would always repeat, "May I reach the enlightenment of a buddha in the future!" One day, a monk came to see him and asked for two of his children who were of the same age as Jāli and Kaṇhājinā. He gave them away to him, and the monk gave them back, saying that he wanted to test his Perfection of Generosity.

If we gather together the main kinds of argument, the shocking behavior of Vessantara is put into perspective and justified by:

- a change of data: the elephant is not public property, but private property;
- the other side's anachronistic argument: a king does not distinguish between public and private property;
- an anachronistic argument: Sañjaya is a democratic king;
- a concern for the greater good: peace instead of the white elephant; enlightenment, or the welfare of a maximum of beings, instead of individual well-being;
- a comparison with daily life: children from the countryside are entrusted to people living in towns; soldiers sacrifice their wives and children; truth should not always be told at any time;
- the political and even "nationalist" ideal of Vessantara: King Rama III wanted to become Buddha; he gave away two of his children like Vessantara;
- Vessantara's shrewdness: the amount needed to ransom his children.

All these justifications answer especially the "moral" challenges targeting Vessantara's attitude in its individual and social dimensions. However, the political justification is there: far from being a ground for accusation, a king's imitating Vessantara is evidence that accomplishing the highest perfection is not politically dangerous. As for the risk of seeing the country sold by a crowd of Vessantarians, that is just madness.

Modernist Defenses

Whereas the classical defense by definition upholds a worldview in which individuals pass from one life to the other with a balance sheet of good and bad past actions that they now must try to improve in order to prepare for a happy next life, the modernist defense expressed

by Phosaenyanuphap—real name Mongkut Kaendiao—refuses such a framework from the outset. For this writer indeed,

> the belief that the bodhisattva is born from the mother's womb, accumulates Perfections until his death, and is reborn for hundreds, thousands, hundreds of thousands of lives until the moment when he reaches Enlightenment as a Buddha or as one of his disciples, comes from the belief that a being really exists, that there is a real individual, that their ego and that of others really exist. They read Scriptures as if they were history, they interpret them anthropomorphically, dominated by ignorance as they are.[21]

As he himself recognizes, Phosaenyanuphap would never have "invented" his interpretation of *VJ* without the teachings of Buddhadasa Bhikkhu. The latter indeed made popular the reinterpretation of the traditional image of the world through the differentiation between "human language," expressed in individuals' stories, which either occludes or lets through the meaning of "dhammic language," depending on whether one has the keys to interpret the text; among the most important meanings is the emptiness of self and mine.[22]

Encouraged as well by the example of Chapphong, alias Kowit Anekachai, also a disciple of Buddhadasa, who interpreted the Chinese novel *Journey to the West* allegorically as a quest for Buddhist wisdom, Phosaenyanuphap had started to interpret legends or parts of legends allegorically. These interpretations were favorably welcomed by his colleagues, who urged him to continue. Phosaenyanuphap produced a rather significant bibliography of sixteen titles, among which many are collections of allegorical interpretations of tales and legends. The first edition of "Dissecting Vessantara" appeared in 1977, the second in 1985, and it has been reprinted regularly since.[23]

The author wanted to suggest a "new way of accomplishing the Perfections at the level of the senses, so as to reach the state of an 'awakened one' (*buddha*) characterized by a kind of calm, liberation, and fulfillment, that enables one to solve problems of daily life." He considers that traditional religion with its irrational ritualistic practices ends up making people unbelievers when they realize they have been deceived. It is thus important to propose to people of our time interpretations that allow them access to a deeper doctrine. Rituals can be preserved in their materiality, but they acquire—and maybe get back to—a spiritually enriching meaning. Thus ablutions with water, for example, are neither necessary nor to

be banned; the crucial point is to know that one should purify one's mind through loving-kindness, compassion, joy, and equanimity.

Following the advice and in the manner of Buddhadasa, Phosaenyanuphap does not claim that his interpretation of *VJ* is "true," in the sense of being faithful to the intention of the ancient author. He would simply like to interest people in his manner of solving the "enigmas" of the tale according to the supreme criterion: getting rid of suffering. This is the reason he dared to "open the heart of Vessantara" (who was himself ready to give it away), to present it to the people of our century so that they could appreciate it. His method consists in starting from the etymology of the names of the characters in the tale, discovering in them the doctrinal ideas they conceal so that the relationships between the ideas somehow reproduce the relationships between the characters. I can only give here a summary of the keys to the main characters' names, which will be enough to understand the approach:

Sañjaya embodies pure perception (*saññā*) that has not yet passed judgment on the contacts (*phassa*) it feels.

Vessantara is the one who is born in between (*antara*) the merchants (*vessa*), namely between gain and loss, good and evil, happiness and misfortune, satisfaction and dissatisfaction. In other words, by embodying emptiness, he is the one who is detached from contradictory notions. *Vessantara* and *Maddī*—pleasant sensation (*sukha-vedanā*)—give birth to *Jāli* and *Kaṇhājinā*, conventional notions (*sammuti* and *paññatti*), namely misleading labels that we impose on everything we perceive when we say, "This is my wife," "This is my husband," "This is my child."

The white elephant *Paccaya*, who was born at the same time as Vessantara, represents the innocence of a newborn child whose mind is still pure and ignores conventional, contradictory notions of gain and loss, defeat and victory, wealth and poverty, good and evil, meritorious and nonmeritorious, etc., that people project on everything they apprehend.

The kingdom of *Kaliṅga* represents time (*kāla*), duration, which calls for the innocence of Vessantara. Whereas the latter knows good and evil, satisfaction and dissatisfaction, the kingdom of Kaliṅga experiences on the contrary the bliss brought by the white elephant.

The inhabitants of *Sivi*, who ban Vessantara, are the conventional notions of merit and nonmerit that push emptiness out of the mind.

Jūjaka represents impermanence (*anicca*) in the first edition. He has become attachment (*upādana*) in the second. He keeps making requests to satisfy self and mine. He will finally be overcome when *Sañjaya/saññā* sees the vanity of conflicts as he observes that the suffering of children

is based on the ceaseless play between satisfaction and dissatisfaction caused by conventional notions, which are contradictory and mistaken.

If King Sañjaya welcomes Vessantara, Maddī, Jāli, and Kaṇhājinā back to the kingdom, it is because the mind, having completely realized emptiness, can apprehend the world without being attached to it. The sign of this success is that the innocence of the mind, the white elephant, returns as well.

According to this kind of interpretation or development of VJ, the whole story happens in the mind. Each character is situated in the "I" of everyone, who, like Vessantara, has to learn to get back to his or her own original innocence through daily life. In this perspective, obtaining buddhahood is not postponed for millions of future lives. The mind of *buddha*, enlightenment to the true nature of things, is within us and merely needs to be developed, provided that we practice the appropriate mental training. In the end Phosaenyanuphap turns the VJ into a metaphor for the quest for enlightenment, whereas traditionally the tale would only concern the accumulation of merit.[24]

Supporters of such a reading think that Kukrit and bold freethinkers point out these issues because they cannot conceive of another possible reading different from that of literal, infantile language. As for the political accusations directed toward VJ, Mongkut Kaendiao told me that he was not aware of them. In his opinion, he is convinced that there was no Machiavellian strategy on the part of kings to help this story spread through literature and ritual.

CONCLUSION

The apologists we have characterized as "classical" generally think that the so-called shocking episodes of the Vessantara story are no longer so when they are put in the perspective of the accomplishment of the Perfection of Generosity, which is the climax of a strategy of meritorious actions carried on for countless rebirths.

The "moral," "economic," "political," and "feminist" critiques see in this "religious" tale either a bad example of government management (Kukrit) or, on the contrary, an instrument of ideological propaganda serving government and patriarchal interests.

The "modernist" interpretation declines to read VJ literally and aims to deflate the contradictions of "classical" and political" interpretations by reading them as the effort to regain the pure and original mind that each of us needs to make in daily life. This interpretation, even if it parallels

traditional practices in its principle and inspiration,[25] questions the three pillars of Thai Buddhism: the ideology of rebirth, the ideology of merited power, and their being transmitted through rituals. If a book from Phosaenyanuphap is sometimes used for preaching during the celebration of *VJ* instead of the traditional tale, its author agrees with a smile that it must confuse many believers. Indeed, his Vessantara may satisfy an intellectual, but it is both pale and demanding compared to the old one that promised Metteyya's heaven.

In the end, it seems that the arguments conveyed in these debates express the identity crisis that modern culture imposes on Thailand and reflect the sometimes contradictory sensibilities, concerns, and questions of the middle class that voiced them. Is one supposed to believe literally everything that is said in the canon? Can a head of state sacrifice national interests? Can a hero who sacrifices his children still be held as a model? What is the real usefulness of rituals? We have seen that the answers are inspired by the basic, traditional resources of Buddhism, but also reflect its diversity.

NOTES

For the transcription of Thai words, I use the Royal Institute of Thailand system, except, for proper nouns, when another transcription has become more or less official ("Silpakorn University" for "Sinlapakon University"). In the transcription of Thai book records, I have added punctuation marks. When the translation of a title is not between square brackets, it comes from the original publication and may be more prone to language or typo errors for which I do not claim responsibility.

1. These mazes may be dismantled after the maze festival (*Poi mangkapa*) or remain all year long to be renovated and decorated anew for the next festival, generally held in November.
2. Other Pali names: *Vaṅkapabbata*; *Vaṅkagiri*. Cf. G. P. Malalasekera, *Dictionary of Pali Proper Names*, Vol. II (London: The Pali Text Society/Luzac & Co., 1960), 801.
3. See Steven Collins's introduction above, p. 3 and note 7.
4. See John S. Strong, *The Legend of King Asoka: A Study and Translation of the Aśokāvadāna* (Princeton: Princeton University Press, 1983), 185–89, and *passim*); John S. Strong, *The Legend and Cult of Upagupta: Sanskrit Buddhism in North India and Southeast Asia* (Princeton: Princeton University Press, 1992).
5. See Louis Gabaude, *Une herméneutique bouddhique contemporaine de Thaïlande: Buddhadasa Bhikkhu* (Paris: Ecole française d'Extrême-orient, 1988), 346ff.
6. G. E. Gerini, *A Retrospective View and Account of the Thet Mahā Chat (Mahā Jāti Desanā) or Exposition of the Great Birth as Performed in Siam* (1892; reprint, Bangkok: Sathirakoses-Nagapradipa Foundation, 1976), 26 n. 16.
7. See Patrick Jory, "The Vessantara-jataka, Barami, and the Bodhisatta-kings: The Origin and Spread of a Thai Concept of Power," *Crossroads: An Interdisciplinary*

Journal of Southeast Asian Studies 16, no. 2 (2002): 36–78; Patrick Jory, "Thai and Western Scholarship in the Age of Colonialism: King Chulalongkorn Redefines the Jatakas," *Journal of Asian Studies* 16, no. 3 (2002).

8. Gabaude, *Une herméneutique bouddhique contemporaine*, 92 n. 102.
9. *Khwamkhit thang kanmueang thai* (Bangkok: Bannakit, 2523/1980). See also Sombat Chantornvong, "Religious Literature in Thai Political Perspective: The Case of the Maha Chat Kamluang," in *Essays on Literature and Society in Southeast Asia: Political and Sociological Perspectives*, ed. Tham Seong Chee, 187–205 (Singapore University Press, 1981).
10. See Frank E. and Mani B. Reynolds, *Three Worlds According to King Ruang: A Thai Buddhist Cosmology* (Berkeley: Asian Humanities Press, 1983).
11. See Charles F. Keyes, *Thailand: Buddhist Kingdom as Modern Nation-State* (Boulder: Westview, 1989), 29–31; Bas J. Terwiel, *A Window on Thai History* (Bangkok: Editions Duang Kamol, 1991), 35–37.
12. Gilles Delouche, "L'incorporation du royaume de Sukhotay au royaume d'Ayutthaya par le roi Phra Boromotrailokanat (1448–1488): le Bouddhisme, instrument politique," *Cahiers de l'Asie du Sud-Est* 19 (1986): 61–82, citation from 75.
13. Khin Thitsa, *Providence and Prostitution: Image and Reality for Women in Buddhist Thailand* (London: International Reports, 1980), citations from 20, 23.
14. Susan F. Kepner, *The Lioness in Bloom: Modern Thai Fiction About Women* (Berkeley: University of California Press, 1996), 36 n. 55.
15. Kornvipa Boonsue, *Buddhism and Gender Bias: An Analysis of a Jataka Tale* (Toronto: York University Press, 1989), 33–39.
16. "Thais top the infidelity charts," *Bangkok Post*, July 28, 2012.
17. Suwanna Satha-Anand, "Renegotiating a National Tradition: Moral Dilemma in the Vessantara Jataka Tale," *International Journal of the Humanities* 4, no. 10 (2007): 99–102, citations from 99, 100.
18. "Madsi: A Female Bodhisattva Denied?," in *Women, Gender Relations and Development in Thai Society, Vol. One*, ed. Virada Somswasdi and Sally Theobald, 243–56 (Women's Studies Center, Faculty of Social Sciences, Chiang Mai University, 1997); citations from 244, 250–51.
19. In fact, the canonical version now extant contains only 786 verses.
20. Khanasong Wat Sihakraison, *Mahachat 21: Anuson nai ngan thet Mahachat na Wat Sihakraison, 1-2-3 kanyayon 2521* (Bangkok: Rongphim Rungrueantham, 2521/1978), 139–40, 143.
21. Phosaenyanuphap, *Chamlae Phravetsandon—Baep Putchawisatchana* (Bangkok: DETAILS, 2530/1987).
22. Gabaude, *Une herméneutique bouddhique contemporaine*.
23. Phosaenyanuphap, *Chamlae Phrawetsandon* (Bangkok: DETAILS, 2520/1977).
24. See Donald K. Swearer, "A New Look at Prince Vessantara," *Journal of the National Research Council of Thailand* 10, no. 1 (1978),: 1–9.
25. See Francois Bizot, *L'Amour symbolique de Rama et de Sita* (Paris: Ecole française d'Extrême-Orient, 1990).

{ 2 }

EMOTIONS AND NARRATIVE

EXCESSIVE GIVING AND ETHICAL AMBIVALENCE IN THE LAO *VESSANTARA JĀTAKA*

Patrice Ladwig

The road to excess leads to the palace of wisdom.
—WILLIAM BLAKE, *THE MARRIAGE OF HEAVEN AND HELL*

STORIES OF exemplary donors who give away huge amounts of wealth, body parts, or even their own life are not uncommon in Buddhism. The most famous of these, about the perfect generosity of Prince Vessantara—in which the protagonist loses his right to inherit the throne because of his excessive giving, is expelled from the kingdom, and finally gives away his children and wife—is in Laos perhaps better known than the biography of the Buddha himself. While I was in the field, surrounded by monks with an often profound knowledge of and love for traditional literature, and participating in hour-long recitations of this and other stories, Martha Nussbaum's[1] idea that narrative poses and attempts to answer questions about how best to live in the world evolved into a starting point for my inquiry into Lao notions of ethics. The more explicit treatments of ethics and morality in doctrinal Buddhist texts commonly used by scholars to analyze ethics may somehow inform the tales, but are ultimately of limited use for anthropological analysis: the refinements and subtleties of the Buddhist canon are of little interest to the average Lao monk, and more often than not remain completely obscure for the lay Buddhist. In contrast, folk narratives, often performed by monks in a dramatic, hyperbolic, and witty way, constitute a body of knowledge that is used by laypeople and monks to discuss ethics, models of the good and virtuous life, matters of law, and sometimes also problematizations of these that reach beyond simple didacticism.

Although there has been a tendency to move away from a mainly philological approach to Buddhist ethics, the conceptualization of ethics as being encoded in text and simultaneously affecting people's praxis and their way of actually reflecting on ethics has only been marginally investigated. Hallisey and Hansen[2] have applied some theories of narrative ethics to Buddhist texts, and I think reading texts not only as pure ethical instructions but also as potential areas of reflection with a multiplicity of voices (heteroglossia) is an approach worth expanding upon. This chapter will therefore explore to what extent some works in literary studies that emphasize the moral and emotional aspects of narratives and the encounter between reader/listener and narrative can be used to rethink aspects of the study of ethics and its didactics. One of the aims is thus to root ethics in narrative practice and to move to a "performative" approach[3] that allows for analysis of the conditions of perpetuation and transformation of ethical understandings, including the expression of moral ambiguities and paradoxes in emotions. When taking ritual recitations as a starting point to think about ethics, it is vital to remember that in Laos these are didactic (the monk instructs a layperson), but they also leave space for and even stimulate the hearer's own reflections on the topic. The reception by the audience is not simply passive and not a reproduction of an ethical homeostasis; through hyperbolic and emotionally loaded aesthetics, ritual and narrative also create a field of discourse that articulates and dramatizes conflicts and ethical dilemmas and is therefore a place of dialogical exchange between an idealized moral system and the requirements of the quotidian. The latter point is of particular importance for religions like Buddhism or Jainism, in the translation of the somewhat extreme ascetic system of values and practices into an ethics applicable to the lives of laypeople. I here follow James Laidlaw's discussion of Jain ethics and will explore "how values and ideals, which are in themselves unrealizable, can nevertheless inform a life which answers also to other, conflicting values."[4] I suggest that this produces an ethical ambivalence that is at the basis of the *Vessantara Jātaka* (hereafter *VJ*).

After some references to the story of Vessantara and the context of its ritual performance, I shall first discuss the didactic relationship between monk and lay Buddhist and the position of ethics in it. I shall then discuss the question of how narrative works on people's understanding of ethics. Following Maria Heim's idea about the significance of emotions in South Asian Buddhism,[5] I will focus primarily on the role of emotions and their importance in Lao Buddhist conceptions of sermon making and performances of narratives. The recurring themes of pity, fear, strangeness, and

failure in these stories play a central role. The final part will relate to concepts of responsibility and sovereignty as topics in the story and pick up on Steven Collins's reading of the *VJ*.[6] The different voices in the text, the ethical dilemmas of the protagonist, and the diverging understandings of some of my informants serve as examples for a short discussion of Jacques Derrida's ideas on responsibility with respect to a Lao Marxist critique of Buddhist kingship. The partial moral defeat of the protagonist due to his excessive giving and subsequent interpretations of this in Buddhist discourse illustrate the potential functions of conflicts in ethical reasoning, linked to the ethical value of failure and ambivalence.[7]

STORY AND PERFORMANCE: PREACHING AS ETHICAL DIDACTICS

The *VJ* is the most important and final "birth story" (Pali: *jātaka*)[8] in a series of 547 tales that describe the various rebirths of the entity that later became the Buddha.[9] In a kind of eon-stretching ethical bricolage including rebirths as matter, animals, women, and men, he finally succeeds in achieving the perfections (Pali: *pāramitā*).[10] Each story represents the perfection of one virtue, with generosity (Pali: *dāna*) being paramount.[11] The story of Vessantara and his concluding act of renunciation through giving away his possessions, children, and wife are the telos of this process of ethical self-perfection and will lead to Vessantara's rebirth as a Buddha, his enlightenment, and the proclamation of Buddhist teachings (Pali: *dhamma*).

Researchers like Bernard Formoso, Stanley Tambiah, and Milford Spiro agree that the *VJ* is one of the most well-known stories in Buddhist Southeast Asia.[12] In Laos, as in Thailand, Burma, and Cambodia, there is a yearly Vessantara festival; during the ritual, monks recite the full story in vernacular language without intermission in a performance lasting between twelve and eighteen hours, with monks and laypeople from other temples being invited and hosted. The festival—in Laos called *boun pha wet*—takes place between February and April every year, so that laypeople and monks from neighboring villages can visit each other and participate. The temple is decorated in imitation of the forest to which Vessantara retreats with his family after being exiled, and some scenes are acted out in theatrical performances by laypeople one day before the festival, a practice now often relinquished. There is also an invitation of Upagupta (*Upakhut*), who, as I have recorded in Luang Prabang, is invited to come from the Mekong River and enter a statue, which is then carried to the

temple holding the festival. In areas where there is no river he can even be invited through normal water pipes, as I have observed several times in Vientiane. Upagupta is supposed to protect the ritual surroundings of the temple during the performance.[13] Before the recitation of the *VJ*, other entities such as the future Buddha Metteyya (*Pha Malay*) are also invoked through a short recitation of a text called *Malay muen malay saen* (ten thousand *malay*, hundred thousand *malay*), to be found in most palm leaf and printed book Lao versions of the *VJ*.[14]

The text itself is subject to advance preparation: each monk is assigned in advance to a specific part. The *VJ* has 13 chapters (*khan*) and is further divided into 1,000 *khataa*. These parts of the text are objectified in decorated sandal flower sticks before the start of the recitation. The *VJ* is said to have one thousand *khataa*, and on the evening before the recitation they are placed in an offering bowl in front of the main Buddha statue of the temple.[15] Thereby, the "wholeness" of the text is celebrated and the text in its objectified form is sanctified. The text is then split into different parts, and monks are in advance assigned a specific *khataa* to perform. The recitation is an explicit chanting competition with a judging audience of laypeople who have heard the story dozens of times and are capable of detailed aesthetic evaluations concerning voice modulation, the expression of emotional, dramatic moments, and clarity of recitation. The use of amplifiers and huge speaker systems today facilitates the acoustic irradiation of the whole village area. The audience rewards a good performance with special gifts, the striking of gongs, and enthusiastic applause. Because the ritual takes place on different days in each temple, some people may hear the story several times a year. Pictorial expressions of it feature prominently in temples—most graphic depictions in Lao temples are related to the *VJ*, usually giving the full story and key scenes arranged in the order of the thirteen chapters. Moreover, a procession of painted scrolls can take place during the ritual, thereby enabling participants to visualize the story in a performative way. In Thailand the *VJ* is screened on television, and there are comic books and other forms of modern artistic adaptations that sometimes make their way to Laos.

Although the story is part of the Buddhist canon, it occupies an interesting middle position between canonical text and folk narrative.[16] It is usually adapted to the local context, and there are multifarious vernacular forms in Laos, connected to different chanting styles. The basic story outline is kept in each of them, but the extensive depictions of nature in it vary, and there are also references to local customs (like specific Lao rituals) in the text that distinguish it from the original Pali version.

For example, in a version from Luang Phrabang in the north of Laos[17] there are references to local customs such as the "binding of the soul ritual" (*su khwan*) that is practiced by the ethnic Lao for all kinds of rites of passages and involves the binding of cotton threads around one's wrist in order to fix various kinds of soul substances to the body and promote well-being. Other concepts of Lao local cosmology are to be found in Lao versions of the text. The magic white elephant, for example, is described as being the *ming khwan* (soul substance; fate) of the kingdom.[18] This adaptation is also observable in Lao versions of other classical Hindu-Buddhist texts. In the Lao Ramayana (*Phralak phralam*), Rama travels down the Mekong, and the text contains lengthy descriptions of the local fauna and flora, the customs of diverse populations (including animist minorities), and the geography of the region.[19] Both the VJ and the *Phralak phralam* sometimes insert additional minor characters into the plot, usually borrowed from other Lao folktales and having Lao names.

LAYPERSON AND MONK: SERMON MAKING AS ETHICAL DIDACTICS

Although there are many areas of Lao society in which ethics are perpetuated, transmitted, and negotiated (family, school, etc.), the relationship between monk and householder is also constitutive for a specific ethical field. The clergy can be seen as an interface mediating between the ethical demands of the quotidian and rather abstract soteriological Buddhist teachings. Monks visit local schools and talk about virtuous behavior, family values, and current topics like drug addiction.[20] Apart from these more visible and "official" missions, monks are considered advisors, and individuals and families consult them for advice and blessings. The interaction between monk and layperson very often takes on characteristics of sermon making and preaching. Indeed, the words spoken by a monk even in everyday conversation often have (in their style of speech and reception by laypeople) features of sermons, which may, depending on context, be properly ritualized or, in a one-on-one situation, rather less regulated.[21] Whether in a more official ritual sermon or in a sort of counseling situation, every sermon and preaching of the Buddha's teachings is considered a "gift of the dhamma" (Pali: *dhamma-dāna*); the preaching and exegesis of the dhamma, "giving" moral precepts and explaining virtuous models of behavior, is considered one of the main tasks of a Buddhist monk.

An important part of sermon making is its performance and aesthetics. Preaching in specialized and vernacular language and, more specifically,

chanting is one of the major arts a monk has to master, and the ability to build a reputation as a monk is very much dependent on being a good speaker, advising people in appropriate language, and also being capable of entertaining them and expressing the beauty of language through chanting. The bodily postures a layperson assumes when listening to a ritualized preaching like the *VJ* indicate the respect due to monks as well as the special position they occupy in society. The layperson should ideally kneel in a lower position than the monk, with hands folded continuously. Some people keep this posture for hours while listening to the recitation and are only able to approach a monk in the temple hall by crawling on their knees. For special occasions like the *VJ* festival, a sort of pulpit is used on which the monk sits, holding a palm-leaf manuscript from which the text is read out or on which his improvisation is built. The place of the palm-leaf document in a monk's hands is comparable to the position occupied by the Greek *skeptron*, which signifies a position of authority and clearly imbues the speaker's ritual discourse with symbolic capital.[22] The words of monks and their effect on the listener are also clearly distinguished from the everyday efficacy of words, even when not always understood semantically.[23] Listening to a sermon is in itself an ethical and meritorious activity that works positively on one's karma and contributes to the cultivation of wisdom.

The physical form of the text preached is also significant: palm-leaf manuscripts are written in a special script (*dtoo tham*) that has a larger number of letters than normal Lao script. Although the words used in chanting and writing are mostly normal Lao with a higher frequency of technical Pali terms, most people are convinced that only monks and very learned people can master the script. Palm-leaf manuscripts in themselves are containers of merit and auspiciousness and always have to be placed higher than other objects. The chanting of monks based on these manuscripts is believed to have a direct, "physical" effect on the listener, increase his positive karma, and protect him. This belief might derive from the fact that in a form of esoteric Buddhism the human body itself is made up of different constitutive letters that all together make up the Buddhist dhamma. The correct pronunciation of the syllables of a text can in some schools of Theravāda Buddhism be a means of salvation and purification,[24] or in less ambitious understandings be a source of blessing and protection. The knowledge kept in palm-leaf manuscripts can almost be appropriated by being able to pronounce the letters, even without understanding them semantically. In recent years more and more books have been used for chanting the *VJ*, and monks in the provinces have

been quite upset to discover that in the capital palm-leaf manuscripts are now rarely used. Hence there are now differing and competing notions of textuality.

Official readings of narratives in the temple were in the past a form of moral education through the medium of literature. As older informants told me, almost every temple in central Vientiane had readings of a variety of stories during the three-month rain retreat. Each evening, twenty to forty people gathered in the main hall of the temple and monks read out different stories (often *jātaka*s) to the audience. Difficult passages were explained by the monks, and the educational flavor of this textual exegesis was obvious; appropriate ethics, values, and morality were prominent discussion subjects. Monks could even indulge in spicy commentary usually not appropriate for them, but nonetheless appreciated by the audience. Since the economic liberalization the mid-1990s, however, other leisure-time options (like watching Thai TV) have taken over much of Lao people's evening entertainment, and most temples in the city center have abolished evening sermons. On Thai television and on the rarely watched Lao television there are also some programs that feature Buddhist sermons and preaching, as does the radio. In the countryside, there are some temples where this kind of literary education has survived.

Because the story is taught in schools, theater groups play scenes from it, and people know it from many other sources, the *VJ* occupies an important position in the public imaginary throughout Buddhist Southeast Asia. The range of topics it touches on and its loaded aesthetics involving hyperbolism, tragedy, and even comical elements make it one of the crucial narratives that serve as a means of reflecting on a variety of moral, political, and even feminist issues. On a popular and also more intellectual level, the *VJ* has been a yearlong subject of discussions by Thai feminists reflecting on role models, and of competing interpretations by more conservative and reform Buddhists in neighboring Thailand.[25] Peasant leaders have often chosen Vessantara as a sort of role model for community mobilization.[26] The more or less detailed knowledge of the story on the part of most Lao is also reflected in sayings, expressions, and its significance for other, extraritual areas of discourse. If you generously give something away, someone might allude to Vessantara as a role model. A good wife who follows her husband without hesitation is said "to behave like Vessantara's wife." Children who listen to their parents and follow their orders are equated with Vessantara's two children who are given away. These are the more traditional interpretations that are also elaborated in some Lao commentaries and by Lao intellectuals like Mahasila Viravong, who

strongly emphasizes the moral aspect of the story and literal understanding through listening.[27] The story serves as a model confirming traditional roles, family dynamics, and discourses such as that of respect for the head of the family, and it is in that sense very didactic. Monks like to employ it in order to point out the meritorious character of giving, refer to the great rewards Vessantara received through his generosity, and motivate the laypeople to follow his example on a more moderate level and make regular donations to the temple. However, there are also critical potentials in the text that move beyond a call for emulation. For example, certain Lao government-inspired interpretations have used the story to reflect on the inadequateness of Buddhist kingship and argue for a more Marxist and "democratic" point of view, to which we shall return.

Listening to sermons like the *VJ* is, alongside gift giving (Pali: *dāna*), meditation (Pali: *bhāvanā*), and keeping precepts/moral training (Pali: *sīla*), another method by which the individual can gain merit and cultivate wisdom and virtuous behavior. Listening to and reflecting on stories is often slotted into the category of "moral practice." It's one of the various strategies society offers the individual to actively shape his ethical subjectivity. These technologies, or practices of the self, are linked to didactics and pedagogies taken care of by the temple qua institution, with monks as specialists who define a specific "regime of truth" and practice an exegesis of ethical standards.[28] The interpretations put forward by monks in, for example, the case of the *VJ* partly serve to reproduce role models and values (practices of generosity, obedience of wife and children, etc.) and often aim at an ethical homeostasis. However, the story itself and the discourse surrounding it are much more controversial and mixed than they seem at first sight. Suggested meanings can be appropriated, interpreted, and transformed by the individual as a form of autopoietic practice,[29] and as shall be discussed in the next part, the performance of the *VJ* also entails sequences that actually open up the text and expose the listener to ruptures and fissures that create room for ambiguities and contrarian interpretations. I will largely focus on these critical understandings, which facilitate a diversity of readings and defy a purely didactic interpretation of the story.

EXCESS AND EMOTIONS

Some Lao and Western interpretations of the *VJ* postulate that the heroic act of excessive giving is just an exaggeration that in a hyperbolic way reflects the virtue of generosity and should inspire laypeople

to imitate—on a less drastic level—the exemplary figure's actions. Spiro, for the case of Burma, argues that the story's "sacrificial idiom provides the charter for and reinforces the Burmese belief in the religious efficacy of giving" and furthermore sees his excessive giving as a sort of narcissist drive typical in stories of Buddhist monastics.[30] Many monks I have asked in Laos about the "meaning" of the *VJ* have given similar answers and referred to the exemplary character of Vessantara, but insisted that he was a special case, which should nevertheless make laypeople think about the high value of generosity for self-cultivation. In contrast to these opinions, James Egge poses a legitimate question: "One may ask, however, why stories of what may seem like immoral and insane acts committed against self and family appeal to Theravādin audiences."[31] In a similar manner, Gombrich tells of two Sri Lankan monks who say that Vessantara acted in an egoistic way and who think the act morally wrong.[32] So the intuitive response can in many cases be more than simple praise. Despite Vessantara being an "exemplary donor" worthy of admiration due to his selflessness, his acts in themselves and their consequences carry an ethical ambivalence that is reflected in Buddhist commentary and the statements of Lao laypeople and monks. Why then does the *VJ* work with such drastic, excessive means, and what role does this have for listeners' potential ethical readings of the story?

Stories about excessive giving actually constitute a subgenre in Buddhist scriptures. Heroic and transgressive acts of giving, and especially "gifts of the body," are often-used themes.[33] In a *jātaka* story where the Buddha is born as King Sibi,[34] he pulls out his eyes and donates them to a blind Brahmin, and in another narrative he roasts his own body, which he then donates as food.[35] The *VJ* deals with donation in a less graphic and drastic way, but the depiction of the dramatic moment of giving is a similar stylistic device: the giving away of children (in the Lao story also classified as an inner-body-object donation, *thaannayga*—they are the "fruit of his loins") is the climax of the story. In the *VJ* and many other stories, the protagonists' acts are often quite transgressive and, like Vessantara's gift, clearly beyond the call for equanimity and modesty so often associated with Buddhism. These acts are not invariably applauded by the witnesses; some report of a more ambivalent, even disgusted audience response.[36]

The gift of the magic white elephant, the gift of the children into slavery to an evil Brahmin, and the gift of his wife are the acts most frequently evoked in discussion with laypeople and monks. Vessantara is praised for this renunciation, but his behavior is also highly questionable. How can the act of giving away one's family, an obvious transgression of moral

values, be seen as meritorious? In the famous Buddhist commentary, "The Questions of King Milinda,"[37] Vessantara's gift is described as just that—excessive and transgressing the moral order:

> Done by the Bodhisattva, revered Sir, was what was difficult to do in that he gave the dear children of his own breast to a Brahman's slaves. And this second thing he did was even more difficult to do in that he bound the dear children of his own breast, young and tender though they were, with jungle-creeper, and when he saw them being flogged by that Brahman with the jungle-creeper he did not interfere. And this third thing he did was even more difficult to do in that when his son had freed himself by his own efforts from the bonds and had come back overcome by fearfulness, once again he bound him with jungle-creepers and gave him back (to the Brahman). And this fourth thing he did was even more difficult to do in that when the children were lamenting and said to him: "Father, this ogre is leading us off to eat us," he did not comfort them by saying: "Don't be afraid." And this fifth thing he did was even more difficult to do in that when Prince Jāli flung himself at his feet in tears and implored him saying: "Be satisfied, father, get back Kaṇhājinā and I will go alone with the ogre; let the ogre eat me," he did not agree even to that. And this sixth thing he did was even more difficult to do in that he showed no pity when Prince Jāli was lamenting: "Have you a heart of stone, father, that you can look upon our suffering as we are being led away by the ogre into the vast virgin forest and not keep us back?" But this seventh thing he did was more difficult to do in that, though he was in great distress and terror as the children were being led away and had gone out of sight, his heart did not split into a hundred or a thousand pieces. What has a man desiring merit to do with bringing anguish to others? ... Revered Nagasena, whoever gives a gift that causes anguish in another, is it conducive to (the giver's rebirth in) heaven?[38]

And in Rhys David's older translation of this text we read: "And excessive giving is by the wise in the world held worthy of censure and of blame.... And as king Vessantara's gift was excessive no good result could be expected from it."[39]

Although the *Milindapañhā* does not belong to the standard repertoire of the Lao Buddhist, some laypeople and monks address similar questions when discussing the story. In a way, Milinda's question is from a moral perspective "only natural"—how can irresponsible and transgressive behavior like this be the final and supreme act of renunciation? A friend of

mine, a high-ranking monk with an administrative position in the upper echelons of the Lao Buddhist Fellowship Organization, wrote a "critique" of the story pointing out the failures to adhere to values linked to Vessantara's responsibilities at the level of the kingdom ("state") (the gift of the elephant) and particular family values (gift of the children and wife). Although the story has a clear happy ending, the sequence of dramatic gifts also leads laypeople to the opinion that, at least in these instances, Vessantara acts in a selfish way. A well-educated elderly man I interviewed during a festival in a Vientiane temple told me:

> When he gives away his personal wealth [the gifts of the 700], this is a skillful act of generosity and renunciation. But the more he gives away, the more problematic and egoistic his generosity becomes. His drive for giving becomes a burden for other people and it produces considerable suffering. His excessive generosity is almost comparable to a kind of illness. Only in the end are people able to understand it.

When one carefully observes the reactions of the audience during the performance, it becomes clear that the intensification and production of certain emotional states is indeed a main feature of *VJ* recitations, as both the chanting-education by monks and the reactions of the audience confirm. The invocation and intensification of emotions such as horror, pain, and grief as intended reactions to these ethically ambivalent acts is an essential part of the story. In the 1972 Lao edition of the *VJ* the author of the preface invites the audience to "share the sensations of the difficulty of Vessantara's sacrifice and take pity on him, his children, and his wife."[40] Bountan Boundteun, a teacher at the Buddhist College in Vientiane, has been offering a course specifically designed for chanting training for the *VJ*. He gives explicit instructions as to how the chanters should use voice-modulation techniques to "make the audience cultivate [feelings of] the heart and sensations which are depicted in the story"[41] and then lists "domains of emotions" that include admiration, awe, love, fear, calm, grief, suffering, pity, and, most interesting for the analysis here, an emotion that is said "to make the heart feel *phalaad*."[42] *Phalaad* translates as strange, bizarre, abnormal, extraordinary.[43] When I personally asked Boundteun about the latter emotion, he stated that the recitation should inspire awe and admiration for Vessantara's acts, but also perplexity and confusion. This strangeness and bizarreness evoked by inner-body-object donation stories is an important component of the *VJ* and other Buddhist narratives. Maria Heim, also referring to Nussbaum's

work on ethics, has skillfully suggested that in South Asian Buddhist literature these rhetorical devices of "horripilation" are based on concepts of emotions and aesthetics that move emotions into the center of processes of accessing and interpreting the story. For her, this particular view confirms "that such terrible events invoke emotional experience but also that such events are morally ambiguous in themselves; the texts lead us—through emotion—to a place of moral bewilderment."[44] In current Lao Buddhism there seems to be a similar idea: the audience of the *VJ* is both with the protagonist and against him—it admires his generosity and is filled with awe of his heroic renunciation of family life (trying to approach "selflessness"), but also shocked by the excess that is a result of his selfish striving for perfection.[45]

The reactions of the audience during the recitation are at times quite emotional: the chanting of the monks is accompanied by a steady appreciation of the scenes depicted. When a particularly dramatic or intense passage of the story occurs, an enthusiastic audience moans, groans, sighs, applauds, strikes gongs, and throws rice about. At the climax of the story, which illustrates the essential acts of the giving away of children and wife, women sometimes start weeping and run out of the temple hall.[46] The scene of the excessive gift in the Lao version reflects the difficulty of the decision and the ambivalence of the situation:

> Vessantara's eyes were filled with tears, as Jujaka pulled his children away and lashed their tiny bodies repeatedly with the rough and tough vine. While they left whimpering tearfully, he was heartbroken, as the moon was moved into the mouth of Rahu. He went to his cottage and muttered, "My children will confront a violent fate. No one will take care of them. . . . Their tiny legs, feet, and soles, which are used to stepping along a short way and on smooth ground, will walk a distant way and on rough ground; they will swell, blister, and be bruised painfully. This old man is cruel; I have given him my children; I have not hindered him from taking them away, and they have agreed to go with him without resistance. . . . Why do I not untie the knot that I have knotted myself? I should pick up my sword, bow, and arrows and force him to give back my children. No, I won't do that. I will continue to do what I have done in order to gain meritorious perfection, to reach nirvana—for my children, my family, and myself."[47]

When I asked a woman in a temple in Luang Phrabang why she started crying during the recitation, she explained:

It is like I can't stand the suffering of the father, mother, and children. When Chuchok [the evil Brahmin] starts hitting the children and they are tied together with a jungle rope, it breaks my heart and I have to cry. Otherwise it would drive me crazy. Giving away your own children and seeing them mistreated—this must be one of the most horrible things that can happen.

Usually only women cry during the recitation, and especially during this passage. This also points to the gendered aspects of the act of listening and of the narrative itself. Men and women might not share the same set of reactions to specific parts of the narrative. On a more general level, the reactions of the audience and the feelings of the protagonist are embedded in ambivalence. The heroic act of giving away the children is by no means a firm decision without thought for their suffering and the harshness of the decision. In the end, the quest for moral perfection in order to reach nirvana is stronger, but is taken only after considering the use of weapons to get the children back. Vessantara here seems to be momentarily estranged from his usual rational calculation,[48] a point to which I will return in the next part.

Martha Nussbaum has dealt with situations similar to that of Vessantara in Greek tragedy, which she calls "tragic conflicts." In them "we see wrong action without any direct compulsion and in full knowledge of its nature, by a person whose ethical character or commitments would otherwise dispose him to reject it. The constraint comes from the presence of circumstances that prevent the adequate fulfilment of two valid ethical claims."[49] These dilemmas can be stylistic means to evoke certain feelings in the audience. Although a comparison between Buddhist and ancient Greek notions of narrative might seem a bit far-fetched, the feelings of pity and fear play an important part in both Aristotle's *Poetics*, with its fundamentally ethical approach to narrative, and the *VJ*. In Aristotle's philosophy of virtue-ethics emotions are closely connected to judgment and belief, and their cultivation is an important part of moral education. Nussbaum, referring to this, supports the view that "emotions become intelligent parts of the moral personality, which can be cultivated through a process of moral education. Such a process will aim at producing adults who not only control their anger and fear, but experience anger and fear appropriately, towards the appropriate objects at the appropriate time in the appropriate degree."[50] The invocation and experiencing of emotion is thus a didactic practice that can contribute to the cultivation of virtuous behavior, or, as Clifford Geertz has put it for the Balinese cockfight, "a kind of sentimental education."[51]

In addition to the emotional and ethical didactics that can be ascribed to literature and narratives like the *VJ*, I think Lao or Buddhist understanding reaches beyond Nussbaum's thesis. The *VJ* here exposes a conflict quite common in cultures divided between a professional ascetic ethics designed for monks and renouncers and the values of the householder with obligations toward wife and children. The conflict is not only about appropriate moments and spaces in which emotions can be articulated and thereby be an element of ethical didactics, but also about differences in value systems in which feelings are not just easily "worked off" in mimetic experience. The question of whether the conflict is finally resolved in the story is a vital one. Is there a cathartic effect involved in which the audience, led at first through feelings of pity, fear, and strangeness, is finally relieved? Aristotle's claim that the audience is purified in catharsis "through pity and fear effecting the proper purgation of these emotions"[52] is, in my opinion, only partly true for the *VJ*. The story has a happy ending, and ultimately all Vessantara's sacrifices materialize in his ethical perfection, but the act of giving nonetheless remains essentially both cruel and egoistic and heroic and selfless. Only a stringently consequentialist interpretation ("the positive outcome legitimizing the means") could classify his behavior as ethically appropriate.

The question is whether narrative, in order to be ethically efficacious, has to offer solutions to conflicts in order to give guidance to the reader/listener. Hegel, dealing with Greek tragedy and dilemmas similar to that of Vessantara, claims that the "true course of dramatic development consists in the annulment of contradictions viewed as such, in the reconciliation of the forces of human action"—a sort of dialectics of conflict resolution.[53] I think approaches like that would fail to consider the effect the recitation of *VJ* is meant to have on the audience. In the end, the tale does not offer an exemplary world in which ambiguity is eliminated. The recitation is not a constant process of affirming how the world should ideally be, but a confrontation of an excessiveness that exposes and points to ethical rifts primarily through the evocation of certain emotional states of bizarreness and bewilderment. The exposition of a dilemma in which none of the options can be correct is an essential feature of how narrative can address problems and conflicts of spheres of value. In some readings of the *VJ*, there is no "point of closure" in the narrative, no catharsis that purges the dilemma. Instead, there is an intentionally and emotionally augmented rupture that exposes the listener to an ethical dilemma. In conceptualizing the ethical efficacy of narrative, Gibson proposes that "the point is not to purge a paradox, either by reining back one's sceptical critique, or

by leaping into some magic sublation beyond antagonism of suspicion and affirmation, but rather to find productive ways of living and thinking within and through paradox."[54] In that perspective, the ethical efficacy of narratives like the *VJ* is partly based in the fact that the listener is emotionally conducted into an ambiguous emotional state where ethical judgments are destabilized or temporarily suspended.[55] This "nonresponse," as Paul Ricoeur calls it, adds new elements to the process of a potential ethical autopoiesis.[56]

SOVEREIGNTY, RESPONSIBILITY, AND FAILURE

The feelings of pity and fear provoked by the performance of the *VJ* have their roots in the failure of the protagonist to find a medium path between the quest for salvation and its absolute demands and the burdens of the social world, which include a family, children, and even a political position.[57] In the *VJ*, the evaluation of generosity, a paramount value in Buddhism, goes through a gradual transformation with changes in intensity. Vessantara's acts of generosity become increasingly alienating for the other characters in the story (and the listener). From simple acts of lauded generosity when he still is a king, they move on to the realm of Buddhist kingship and politics (the magic white elephant and Vessantara's exclusion from society) and finally to the sphere of family and body-object donation. By following this linear ascension of excessive generosity, Vessantara himself gets closer to a realm that, one could say, is ethically pure because it is beyond the ethics of the quotidian.

Interestingly, Vessantara's excess has some strong Nietzschean connotations. He appears as a sort of Buddhist Übermensch who increasingly moves away from the "justice of commoners," which according to Nietzsche[58] is based on the principle of reciprocity. For Vessantara there is no reciprocity in the immediate social realm; he gives everything without hesitation and increasingly becomes a parasite of the social domain. By using others as gifts to achieve his own ends and not only giving his personal belongings, he creates a sort of parasitic relationship of unequal exchange. The excess has to be paid with gifts extracted from domains that are beyond the property of the giver. Michel Serres has argued that the parasite is a catalyst for complexity, because it interrupts the normal flow of things and introduces a break into the system, which then can lead to transformations.[59] In that sense, the achievement of buddhahood entails a parasitic component. What he gets from his acts of gift giving are the "transcendent" rewards that will enable him to become the future

Buddha. He is, though, still caught between the two realms, and as can be seen in his reaction to giving away the children, still feels doubt and guilt. His free gifts based on parasitism make enemies, and he is expelled from his own kingdom for giving away something of which he was not sole proprietor. He is a lawbreaker in that sense, someone "who has broken his contract and his word to the whole," as Nietzsche puts it in his analysis of morality.[60] Vessantara is consequently exiled. In a sort of economy of excess, he increasingly alienates himself from Nietzsche's slave economy that is grounded on the law of equal returns and enters what Alan Schrift calls a "higher, noble economy."[61] Nietzsche's depiction of the basic attitude of this excess fits the *VJ* quite well: "the feeling of fullness, of power that seeks to overflow, the happiness of high tension, the consciousness of wealth that would give and bestow: the noble human being, too, helps the unfortunate, not, or almost not, from pity, but prompted more by an urge begotten by an excess of power."[62] In the *VJ*, Nietzsche's ideas of master and slave morality clash. Vessantara creates and represents new values, transgresses traditional values, and arouses fear and insecurity among his subjects—and receives his punishment for that.

This excess and "reckless" striving for sovereignty beyond the social world also have some political implications regarding responsibility and ethics. In Vientiane I met a few very well-trained monks and laypeople who used the *VJ* as a field of reflection on the vanished institution of Buddhist kingship.[63] These were mostly members of the communist party's mass organization and trained in Marxism-Leninism, but also fervent Buddhists who used stories such as the *VJ* for reflecting on contemporary society. A friend of mine, who had been a monk for seventeen years, then disrobed and was given the opportunity to study literature in Vietnam, gave me a good summary of this view of responsibility in Buddhist kingship and the way the *VJ* problematizes this:

> I think there is nothing wrong with generosity and it's important in our culture. But it depends what one gives and in which context. As a king, Vessantara has responsibility for the kingdom and all the people living in it. They pay taxes, are his subjects and the kingdom flourishes until he gives away the magic white elephant. Although the elephant was born on the same day as Vessantara, it's strictly speaking not his personal property. It is the ming-khwan of the kingdom and it is necessary to protect it and make the rice fields fertile. The elephant is the property of the people. Vessantara knows that, but still gives it away without any conditions when the Brahmins from the other kingdom beg for it. The people are right to demand

his dethronement, because he has acted in a highly irresponsible manner. A king cannot simply do what he wants to do, he has to care for the people and listen to them. That is sometimes the problem with kingship.

What at first sight might seem a crude Marxist interpretation[64] of a story with an argument drawing on property relations and the "voice of the people" is actually a well-informed opinion, equally present in Buddhist literature, but here presented in novel guise. As Collins has shown, the relationship between worldly responsibility/power and an ascetic Buddhist philosophy is not unproblematic, although they draw power from each other and are symbiotic. The responsibilities of a king always involve a partial violation of moral precepts: one has to punish delinquents, make war, extract taxes, and do all sorts of other morally reprehensible things when confronted with the social world. The monk and the ascetic, outside of society, are often not exposed to these problems. It is easy to locate Theravāda Buddhist texts from all periods and regions that take a very critical stance on kingship and compare kings to thieves and other phenomena that can bring danger and ruin, contrasting this to the pure lifestyle of the monk and renouncer.[65]

Thus, to complete his perfection, Vessantara has to move out of the sphere of normal morality and into a realm where he, with the help of excessive giving, becomes a perfected sovereign, not bound to society by the responsibilities of kingship or family ties and now capable of being reborn as the Buddha who will declare the dhamma. For that, however, he has to leave the rules of the social world behind him and transgress, or betray, the ethics of kingship and the household. The possibility of becoming the most ethically perfected being is bound up with the ethics of betrayal, a sort of "possible-impossible aporia." Similar to Derrida's reading of Kierkegaard's treatment of the story of the son sacrifice demanded of Abraham,[66] the absolute call for ethical perfection (or in Abraham's case, the absolute duty toward god and a simulation of an ultimate sacrificial test) makes Vessantara move beyond rational calculation and planning into a moment of "madness" inherent in the decision and beyond the possibility of acting fully responsibly:

> In both general and abstract terms, the absoluteness of duty, of responsibility, and of obligation certainly demands that one transgress ethical duty, although in betraying it one belongs to it and at the same time recognizes it. . . . Duty demands that one behave in an irresponsible manner (by means of treachery and betrayal) while still recognising,

conforming, and reaffirming the very thing one sacrifices, namely the order of human ethics and responsibility. . . . I am responsible to any one (that is to say to any other) only by failing in my responsibility to all others, to the ethical or political generality.[67]

This moment of madness, or less drastically, the opaqueness of the subject's decision to himself, is triumph and failure at the same time. The failure is a result of a collision with a value regime in a social world that demands responsibility for one's family and kingdom; nevertheless, in the sense of fulfilling an ascetic ideal, Vessantara becomes an actor of truth, renouncing everything he has. How do Lao Buddhists who are not inspired by Marx or Derrida view this problem? People often distinguish between the positive long-term effects of Vessantara's excessiveness and the immediate moment of the giving. The story has a happy ending, and all of Vessantara's sacrifices ultimately lead to his ethical purity and his achievement of the perfections. His children are liberated, the evil Brahmin dies, the people love him again, and he rules the kingdom with the righteousness of the dhamma. Still, the moment of decision is seen as an unavoidable failure by many Lao. During one of the recitations a man told me:

> If you think about the difficulty of his decision, what options did he have? He loves his wife and children, but he also wants to attain enlightenment. He acts incorrectly in some sense in order to advance on the path of enlightenment. I pity him for that, but through this big sacrifice he becomes the Buddha and will be able to show humanity the way out of suffering. And in the end, when he was Vessantara, he was a being with much merit, but still a human, and as humans we sometimes fail.

In some sense the pity and compassion the audience shows for the protagonist during the performance is also an approval of his failure. The feeling of "strangeness" discussed in the previous section is also accompanied by pity and compassion, and people in the audience repeatedly referred to the immense difficulty of Vessantara's decision. Instead of having a perfect and flawless exemplary figure in the story, the audience is confronted with a doubting protagonist who through his excessive acts exposes himself, puts himself at risk. Is there a moral lesson to be learned from this exposure and the partial failure of the protagonist in the story? At first, a protagonist who has an absolutely clear and calculable subjectivity with the capacity to judge everything in an appropriate way would perhaps be too tedious. Furthermore, though, witnessing the failure of others in narrative

(or real life) and understanding the difficulty of some decisions, or the sheer impossibility of making a just decision in certain situations, also allows the option of recognizing one's own opacity and thereby cultivating patience and compassion. An exemplary figure that is human, in the sense that it fails to accomplish perfection without producing suffering and carrying out acts that are at least ambivalent, is probably more accessible for the listener than a completely perfected being. Sharing the suffering resulting from failure in the narrative and pitying the protagonist are therefore ethically relevant for the listener.

CONCLUSION

By participating in ritual recitations like the *VJ*, the listener is, through the rhetoric and aesthetics of chanting, exposed to a range of emotional states. The situations the listener is led through touch on basic values such as generosity, responsibility, and failure, and confront the audience. In the *VJ* and other Buddhist narratives, the role of emotions such as pity, fear, and bizarreness is didactic in the sense that they are invoked and augmented. The story and the performers not only teach the listener, through the generation of particular emotional states, what is an appropriate experience and ethical evaluation of an action but also expose the listener to radical situations without necessarily pointing to an ethical model. This differentiates the role of emotions in narrative from a pure emotivist[68] approach to ethics. Narrative here opens up a gap of strangeness and bizarreness in which conflicting regimes of values can be thought through and reflected upon; narrative understanding enables us to deal with complexity in that sense.[69] Emotions that are invoked in the *VJ* are not only a posteriori expressions of ethical reasoning and do not merely sustain them, but also intentionally employed to destabilize the listener and decenter his basis of ethical judgment. In contrast, Bernhard Williams argues that the position of emotions in the ethics of Western moral philosophy (especially deontological traditions)[70] has been partly considered "potentially destructive of moral rationality and consistency."[71] Indeed, this aspect of emotions, in the case of the *VJ* recitation, is used as an instrument for enhancing ethical reflections on conflicting regimes of value.

Buddhist stories and their recitations that involve excessive dramatic giving or gifts of the body and make use of "horripilation" bear some resemblance to Antonin Artaud's concept of the "theater of cruelty."[72] Artaud intended to remove the spectator from the everyday and use symbolic objects to work with the audience's emotions, attack their senses

through an array of technical methods and acting so that they would be brought out of their desensitization and forced to confront themselves. The use of the grotesque, the ugly, and pain in this form of 1930s French avant-garde theater might have been driven by other motives, but it shares the strategy of destabilization and undermining of the audience's sense of security through the invocation of strangeness and bizarreness. This opens up space for what Ricoeur calls the reconfiguration of the listener/reader through narrative and the option of designing one's own views about specific topics.[73] Hence, the ethical contents of narrative recitations like the *VJ* also have the potential to become a vehicle for reflecting on the nature of responsibility concerning the political sphere and family values in contemporary society.

In the didactic effect the recitation of the *VJ* is intended to have on the audience, there is also the element of ambiguity that facilitates a decentered reading, as mentioned above—a visible striving for ethical homeostasis. More conservative readings insist that the obedience of wife and children is exemplary behavior despite the protagonist's failures. Here Vessantara's transgression is framed in terms of excessive but still skillful selflessness in the quest for an ascetic life. The emphasis is more on Vessantara as an exemplary figure whose acts are extraordinary, who inspires awe but can also perhaps be taken as an ethical model for Buddhist behavior in social life, though in less intense form and transformed into generosity toward Buddhist institutions. As Michael Lambek puts it, for religion and ritual in general, "religion at its best attempts to provide a space and direction for moral practice, to enlarge opportunity and access; at its most limited, it aims to make a virtue out of constraints."[74] In some cases the narrative can also inspire practices that are quite mimetic in relation to the exemplary figure. The donation of body objects, which in the *VJ* is only indirectly dealt with (the children as a part of Vessantara's body), has in the other *jātaka* story mentioned (King Sibi's eye donation) more direct effects in real life, as for example documented for Sri Lanka, where monks recite the story on festival days in order to motivate laypeople to donate their eyes or bodies for organ transplantations or medical research.[75]

Charles Hallisey has suggested that the search for a unitary theory of ethics in Buddhism is a task that many have focused on, but it cannot be accomplished "simply because Buddhists availed themselves of and argued over a variety of models." He instead pleads for an "ethical particularism."[76] If one moves away from strictly canonical text material and includes a broader range of narratives in the analysis, stories like the *VJ* can reveal a complex moral universe with all its situations, paradoxes,

contingencies, and ambivalences. However, the use of the text in performance and the didactics and pedagogies involved must be taken into account: which institutions, places, and occasions are chosen and to what extent these prescribe a moral understanding (rules, duties, etc.) and at the same time leave space for ethical autopoiesis. As discussed, Buddhist monks, qua respected authorities and performers, "instruct" laypeople through the recitation of narratives, and such performances and subsequent commentary can aim at a reproduction of values and actions by, for example, pointing to exemplary figures like Vessantara. However, the openness of both text and the listening/reading subject, and a space of emotional indeterminacy, create the basis for a dialogical relationship. In a performative manner, the relationship between an idealized moral system of the text and ethical reasoning is negotiated and concatenated. Vessantara's narrative about the achievement of perfection on the road of excess therefore simultaneously contains elements of an ethical homeostasis and potential for an ethical reconfiguration.

NOTES

This is a reworked and expanded version of text originally published as "Narrative Ethics: The Excess of Giving and Moral Ambiguity in the Lao Vessantara-Jātaka," in *The Anthropology of Moralities*, ed. Monika Heintz (Oxford/New York: Berghahn, 2009), 136–58. The text was originally written for an anthropology conference dealing with theories of ethics. Therefore basic Buddhist concepts are explained in more detail, and the chapter uses theory that might be somewhat unfamiliar to a non-social science audience. Fieldwork was carried out in Vientiane, the capital of Laos, from September 2003 to June 2005. Financial assistance from the University of Cambridge and the German Academic Exchange Service (DAAD) is gratefully acknowledged. I am indebted to all the Lao monks and laypeople who welcomed me in their temples and houses and shared their thoughts and lives with me. I also thank the Religious Section of the Lao National Front for Reconstruction for giving me permission to ordain. An earlier draft was presented in the Ph.D. writing seminar at the Department of Social Anthropology, University of Cambridge. I have greatly benefited from comments on earlier drafts by Matthew Carey, Jacob Copeman, and my supervisor, James Laidlaw. Conversations with colleagues at the University of Bristol (especially Rita Langer and Rupert Gethin) and at the Max Planck Institute for Social Anthropology have enabled me to rethink some of the themes of the original article. Steven Collins and Stephen Teiser also gave me valuable feedback. Attending the panel on the *VJ* at the International Association of Buddhist Studies in Taipeh in 2011, and the presentations of Leedom Lefferts and Sandra Cate, gave me further food for thought.

1. Martha Nussbaum, *Upheavals of Thought* (Cambridge: Cambridge University Press, 2001).
2. Charles Hallisey and Anne Hansen, "Narrative, Sub-Ethics, and the Moral Life," *Journal of Religious Ethics* 24, no. 2 (1996): 323.

3. Stanley S. Tambiah, "A Performative Approach to Ritual," in *Culture, Thought, and Social Action: An Anthropological Perspective*, ed. Stanley Tambiah (Cambridge, MA: Harvard University Press, 1985), 123–66.
4. James Laidlaw, *Riches and Renunciation: Religion, Economy and Society Among the Jains* (Oxford: Clarendon Press, 1995), 388.
5. Maria Heim, "The Aesthetics of Excess," *Journal of the American Academy of Religion* 71, no. 3 (2003): 531–54.
6. Steven Collins, *Nirvana and Other Buddhist Felicities: Utopias of the Pali Imaginaire* (Cambridge: Cambridge University Press, 1998).
7. Instead of attempting to give a "complete" interpretation of the story, I have largely followed my Lao informants in identifying central themes (generosity, responsibility, failure, emotions) and discussing key scenes, focusing on the acts of giving that constitute the various climaxes of the story. Obviously, a number of different readings are possible, and my intention is not to give a thorough philological account but rather to see what potential ethical claims and problematizations the story of Vessantara might contain. I here also emphasize alternative interpretations that go beyond the pure mimetic understanding of the story.
8. Terms in Pali are marked as such. Terms in Lao are simply in brackets without reference to Lao. There is no established transcription system for Lao. For common terms I use the most widely used transcriptions.
9. For a translation of the oldest remaining Pali version from Sri Lanka, see CG. For an excellent philological discussion of the origins and form of *jātaka*s as a part of Buddhist literature, see Oskar von Hinueber, *Entstehung und Aufbau der Jātaka-Sammlung* (Stuttgart: Steiner, 1998). The significance of *jātaka*s in "modernized" countries seems to have undergone some crucial changes, as for example attested for Thailand. Jory speaks of "the jatakas' marginalization in Thai Buddhism." He traces the significant shifts of their position and interpretation under the reign of King Chulalongkorn and Thailand's encounter with modernity and orientalist scholarship in the nineteenth century. Patrick Jory, "Thai and Western Buddhist Scholarship in the Age of Colonialism: King Chulalongkorn Redefines the Jatakas," *Journal of Asian Studies* 61, no. 3 (2002): 892.
10. In Pali the word *pāramitā* (perfection) literally signifies "having reached the other shore." See Leslie Kawamura, "Paramita (Perfection)," in *Macmillan Encyclopedia of Buddhism*, ed. Robert Buswell (New York: Macmillan, 2004), 631–32. In Lao the term is also used in the sense of "charisma."
11. In the list of the Ten Perfections and other enumerations of virtues, *dāna* (giving, generosity) is usually stressed as the most important. This is no surprise, as the order of monks is largely dependent on donations from laypeople and the very existence of Buddhism has been dependent upon the gift, ranging from daily almsgiving to large-scale donations of plots of land and incredible amounts of wealth. On a general level, the giving of gifts (*dāna*) and the practice of generosity constitute, along with *sīla* (moral undertaking, keeping precepts) and *bhāvanā* (exercise of contemplation/meditation), one of the elementary three meritorious acts in Theravāda Buddhism that lead to a gradual approximation of the soteriological goal of nirvana and better rebirths. Giving in its different forms is a way of renouncing the material world. Hibbets therefore concludes that the gift is often "described as primarily an ethical category." Maria Hibbets, "The Ethics of Esteem," *Journal of Buddhist Ethics* 7, no. 1 (2000): 30. However, one probably has to distinguish different kinds of gifts and rewards. In doctrinal Buddhism the gift of, for example, alms

to monks is not directly reciprocated, only in the form of "transcendent" karmic rewards. In practice, however, laypeople often expect a direct return and an effect in this life. See Reiko Ohnuma, "Gift," in *Critical Terms for the Study of Buddhism*, ed. Donald S. Lopez, Jr. (Chicago: University of Chicago Press, 2005), 103–23. For an excellent overview of the literature on gift giving in the contemporary South Asian context, see Jacob Copeman, "The Gift and Its Forms of Life in Contemporary India," *Modern Asian Studies* 45, no. 3 (2011): 1051–94. Others suggest that giving in Buddhism is not only the practice of generosity but also an act of worship directed toward the recipient. See James Egge, *Religious Giving and the Invention of Karma in Theravāda Buddhism* (London: Routledge, 2002), 3. Vessantara's gifts and the cases of "gifts of the body" (donating limbs, eyes, and other body parts) are again of another kind, and extreme acts of heroic giving described in many *jātakas*. See Reiko Ohnuma, *Head, Eyes, Flesh, and Blood: Giving Away the Body in Indian Buddhist Literature* (New York: Columbia University Press, 2007). Interesting is here that givers like Vessantara—living in a time before the monastic order was established—often don't take into account the status of the receiver, as later became common in Buddhism. The practice of giving remains a prominent focus of discussions about what defines "proper" Buddhism. For *dāna* practice in contemporary Thailand and a criticism of it as being based on materialism, see Louis Gabaude, "Le don ou dāna comme fenêtre sur les mentalités bouddhistes thaïes," paper presented at the conference "Buddhist Legacies in Southeast Asia," Ecole française d'Extrême-Orient, Bangkok, 2003.

12. For the ethnic Lao in Thailand, see Bernard Formoso, "Le bun pha w:et des Laos du nord-est de la Thaïlande," *Bulletin de l'Ecole Francaise d'Extreme-Orient* 78, no. 2 (1992): 233–60, and Stanley J. Tambiah, *Buddhism and Spirit Cults in North-East Thailand* (Cambridge: Cambridge University Press, 1971). For Burma, see Milford E. Spiro, *Buddhism and Society: A Great Tradition and Its Burmese Vicissitudes* (Berkeley: University of California Press, 1971).

13. For Upagupta and his protective qualities, see John S. Strong, *The Legend and Cult of Upagupta: Sanskrit Buddhism in North India and Southeast Asia* (Princeton: Princeton University Press, 1992).

14. This short recitation is composed of a conversation between *Pha Malay* and the god Indra taking place in Tusita heaven. See Louis Finot, "Recherches sur la littérature laotienne," *Bulletin de l'Ecole Francaise d'Extreme-Orient* 17, no. 5 (1917): 65–66.

15. See Leedom Lefferts, "The Bun Phra Wet Painted Scrolls of Northeastern Thailand in the Walters Art Museum," *The Journal of the Walters Art Museum* 64–65 (2006–2007): 149–70, for more details on the chapters and the *khataa*. On the visual aspects of the *VJ*, see Daravanh Somsavaddy's master's thesis, "Les réprésentations du Vessantara Jātaka dans l'iconographie Lao," Sorbonne, 2003.

16. Reiko Ohnuma, "Jātaka," in *Macmillan Encyclopedia of Buddhism*, ed. Robert Buswell (New York: Macmillan, 2004), 400–401.

17. Anonymous, *Lueang phavetsandoon phasa lao—phasa angkit* [The Story of Vessantara Lao-English], unpublished manuscript, Luang Phrabang, 2002.

18. *Khwan* is a pre-Buddhist Tai Kadai concept denoting "soul," whereas *ming* is a Chinese expression for "life" or "fate." For the latter term, see Marcel Granet, *La pensée chinoise* (Paris: Editions Albin Michel, 1968), 376.

19. Sachchidanand Sahai, *Phralak phralam lue phralamsadok* [Phralak Phralam or the Rama Jataka: The Lao Version of the Story of Rama] (Vientiane: Embassy of India, 1973).

20. Patrice Ladwig, "Between Cultural Preservation and This-Worldly Commitment: Modernization, Social Activism, and the Lao Buddhist Sangha," in *Nouvelles recherches sur le Laos*, ed. Yves Goudineau and Michel Lorillard (Paris: Ecole Française d'Extrême-Orient, 2006), 477–78.
21. Giving advice to a layperson may not be classified as preaching (Pali: *desanā*; in Lao *thet*), but still shares some characteristics with it. For proper sermon making in Lao and Thai Buddhism, see the excellent study by Justin McDaniel, *Gathering Leaves and Lifting Words: Histories of Buddhist Monastic Education in Laos and Thailand* (Seattle: University of Washington Press, 2008).
22. Pierre Bourdieu, *Language and Symbolic Power* (Cambridge, MA: Harvard University Press, 1991), 109.
23. Stanley J. Tambiah, "The Magical Power of Words," in *Culture, Thought, and Social Action: An Anthropological Perspective* (Cambridge: Cambridge University Press), 17–59. The extent to which the texts and the recitation of the *VJ* are really understood in this context is debatable. The holiness of the words that give access to a source of merit beyond semantics has led some observers to doubt the attention with which people listen. See Peter Koret, "Past and Present Lao Perceptions of Traditional Literature," in *New Laos, New Challenges*, ed. Jacqueline Butler-Diaz (Temple: Arizona State University, 1996), 113, 121–22. This may also depend on how fervently or seriously one takes his belief. The *VJ* is highly poetic in style, with a lot of special Pali vocabulary that makes it hard for the average educated Lao to grasp everything. According to my experience, people attending the ritual understand between 50 and 80 percent of the chanting. However, most people know the story and the visual depictions in the temple, the more prosaic forms of it taught at school, and its screenings on Thai TV ensure that many people know the plot quite well.
24. François Bizot and François Lagirarde, *La pureté par les mots. Saddavimala* (Paris, Vientiane, Bangkok: EFEO, 1996).
25. Louis Gabaude, "Controverses modernes autour du Vessantara-Jātaka," *Cahiers de l'Asie du Sud-Est* 29/30, no. 1 (1991): 51/73. Vessantara's wife, Matsi, appears as a very traditional role model in the narrative. See Collins's section on gender in the introduction to this book for further discussions.
26. Paul T. Cohen, "A Bodhisattva on Horseback: Buddhist Ethics and Pragmatism in Northern Thailand," *Mankind* 14, no. 2 (1983): 101–11.
27. See Mahasila Viravong's preface in Anonymous, *Vetsantarasadok (phen khamgoon)* [The *Vessantara Jātaka* in Poetry Form] (Vientiane: u.p., 1972). See also Gregory Kourilsky, "Recherches sur l'institute bouddique au Laos (1930–1949). Les circonstances de sa création, son action, son échec," master's thesis, EPHE, 2006.
28. Michel Foucault, *Ethics: Subjectivity and Truth*, ed. Paul Rabinow (London: The New Press, 1997), 225, 263.
29. I largely follow here James Faubion's discussion of Foucault's technologies of the self as an interplay between institutions (or in general, in the environment) that represent certain values and truths and the appropriation and transformations of these meanings through a sort of autopoetic practice. James D. Faubion, "Towards an Anthropology of Ethics: Foucault and the Pedagogies of Autopoiesis," *Representations* 74, no. 1 (2001): 100. The term "autopoetic" refers to Niklas Luhmann's system theory and is understood as giving rise to changes in the system through the appropriation and inclusion of new elements beyond pure reproduction; i.e., the subject not only blindly follows the practices that society offers but also uses

them to attain certain states of freedom and wisdom and form its own ethical subjectivity. Niklas Luhmann, *Essays on Self-Reference* (New York: Columbia University Press, 1990), 9–10. On the latter point and its use for anthropology see also James Laidlaw, "For an Anthropology of Ethics and Freedom," *Journal of the Royal Anthropological Institute* 8, no. 2 (2002): 311–32.

30. Spiro, *Buddhism and Society*, 108, 337.
31. Egge, *Religious Giving and the Invention of Karma*, 103.
32. Richard Gombrich, *Buddhist Precept and Practice: Traditional Buddhism in the Rural Highlands of Ceylon* (London: Routledge, 1996), 321.
33. See Ohnuma, *Head, Eyes, Flesh, and Blood*.
34. Peter Khoroche, *Once the Buddha Was a Monkey: Ārya Śūra's Jātakamālā* (Chicago: University of Chicago Press, 1989).
35. Nancy Auer Falk, "Exemplary Donors of the Pali Tradition," in *Ethics, Wealth, and Salvation: A Study in Buddhist Social Ethics*, ed. Richard Sizemore and Donald Swearer (Columbia: University of South Carolina Press, 1990), 124–43.
36. See for an example Heim, *The Aesthetics of Excess*, 538.
37. Many of the questions posed by Milinda in the *Milindapañhā* can be seen as representative of the interrogation of difficulties with some Buddhist teachings. Nagasena, as a monk, defends the dhamma, but is somewhat at pains to answer the question and replies that Vessantara certainly loved his wife and children, but he loved enlightenment more. Furthermore, Nagasena replies that there is nothing negative about excessiveness in general and refers to the excessive hardness of diamonds, which is a sign of high quality.
38. Isaline B. Horner, *Milinda's Questions, Vol. II* (Oxford: The Pali Text Society, 1999), 96–97.
39. Thomas W. Rhys Davids, *Questions of King Milinda* (1890–1894), http://www.sacred-texts.com/bud/sbe36/sbe3606.htm (accessed September 2, 2011).
40. Anonymous, *Vessantarasadok*, 2.
41. Bountan Boundteun, *Khu mue gantheetsanaa lueang phaventsandoon* [Handbook for the Chanting of the Vessantara Story] (Vientiane: u.p., 2003), 4.
42. Bountan Boundteun, *Vetsandon gap sivit khun lao* [Vessantara and His Relation to the Life of the Lao], unpublished manuscript in Lao, Vientiane, 2004.
43. Marc Reinhorn, *Dictionnaire Laotien–Français* (Paris: You Feng, 2001), 1336, 1394.
44. Heim, *The Aesthetics of Excess*, 538, 545.
45. There is an interesting interplay between selflessness and selfishness at work here. In order to practice selflessness, i.e., giving away and renouncing, Vessantara has to be selfish. The action itself is therefore caught up in contradiction.
46. This is an audience at its best, however. Depending on the location, the skills of the monk, and the appreciation of the spectators, one might also witness rather unspectacular performances with a present, but inattentive audience more involved in chatting and other detracting activities.
47. Anonymous, *Lueang phavetsandoon phasa lao—phasa angkit*, 46.
48. In other scenes Vessantara is rather instrumental and just waits for an occasion to give away his children. When his wife has a dream the night before the children are given away, he knows that the Brahmin will come to ask for the children and directly sees that as a chance to perform a body-object donation. He doesn't tell his wife, though, and just says that she should forget the dream.
49. Martha Nussbaum, *The Fragility of Goodness: Luck and Ethics in Greek Tragedy and Philosophy* (Cambridge: Cambridge University Press, 2001), 25.

50. Martha Nussbaum, "Morality and Emotions," in *Routledge Encyclopedia of Philosophy* online, 1998, ed. Edward Craig, http://www.geocities.com/Athens/Rhodes/3724/Cytrix/cdrom5/Routledge_morality_emotion.htm (accessed 19.9.2005).
51. Clifford Geertz, "Deep Play: Notes on the Balinese Cockfight," *Daedalus* 134, no. 4 (2005): 83. Geertz also draws a nice parallel between theatrical performance and emotions: "If, to quote Northrop Frye again, we go to see *Macbeth* to learn what a man feels like after he has gained a kingdom and lost his soul, Balinese go to cockfights to find out what a man, usually composed, aloof, almost obsessively self-absorbed, a kind of moral autocosm, feels like when, attacked, tormented, challenged, insulted, and driven in result to the extremes of fury, he has totally triumphed or been brought totally low" (86).
52. Aristotle, *Poetics*, part IV, trans. Steven Butcher, http://classics.mit.edu/Aristotle/poetics.html (accessed October 10, 2005).
53. G. W. Hegel cited in: Andrew C. Bradley, "Hegel's Theory of Tragedy," in *Oxford Lectures on Poetry*, ed. Andrew Bradley (London: Macmillan, 1950), 71.
54. Andrew Gibson, *Postmodernity, Ethics and the Novel: From Leavis to Levinas* (London, New York: Routledge Chapman & Hall, 1999), 8.
55. Buddhist laypeople asked whether Vessantara's behavior is correct from a moral point of view mostly answered "Yes, but . . . ". Most informants admitted that an ethical evaluation of his actions is very hard to accomplish, and some monks answered that his actions cannot be evaluated at all.
56. Arguing in the context of a larger historical approach, Ricoeur states: "The nonanswering to the moral problems of an epoch is perhaps the most powerful weapon which literature has in order to influence morality and change practice." Paul Ricoeur, *Zeit und Erzählung (Band III)* (München: Kohlhammer, 1991), 283.
57. Indeed, "abandoning" one's family was one of the first things that the abbot of the monastery where I ordained explained to me. "Monks don't have families in the sense others have it. I still have a father and a mother, and we see each other now and then. But they can never really comfort you or embrace you. In the ordination ceremony you have left your family behind; the circle we closed around you when the ceremony was at its end represents that. You have entered the monk's homelessness, and you are not a householder anymore." Vessantara doesn't become a monk in the story, but a hermit who lives according to similar standards. Although he takes his wife with him, they live in chastity and take on the precepts—an arrangement prone to give rise to conflicts. The failure of Vessantara is therefore also rooted in the fact that he sets out to live in both worlds; a liminal state.
58. Friedrich Nietzsche, *On the Genealogy of Morality*, trans. Carol Diethe (Cambridge: Cambridge University Press, 1994).
59. Michel Serres, *The Parasite* (Baltimore: Johns Hopkins University Press, 1982), 35 ff.
60. Nietzsche, *On the Genealogy of Morality*, 50.
61. Alan Schrift, "Logics of the Gift in Cixious and Nietzsche," *Angelaki: Journal of Theoretical Humanities* 6, no. 2 (2001): 116.
62. Nietzsche, *On the Geneaology of Morality*, 166.
63. Laos was a kingdom for more than 600 years, and Buddhism and kingship were from the beginning intricately intertwined, with the king usually supporting the clergy and vice versa. Buddhism is indeed imbued with ideas of kingship, and the Buddha was a prince himself, who abandoned the luxuries of his palace and his family after seeing the suffering in the world. In the case of Laos, it is no surprise

that the disappearance of kingship after the socialist revolution of 1975 (the king was arrested and sent to a "reeducation camp," and died there) created some problems of political legitimization and stimulates discourses like the one inspired by the *VJ*. See Grant Evans, *The Politics of Ritual and Remembrance: Laos Since 1975* (Honolulu: University of Hawai'i Press, 1998).

64. There has indeed been an alliance of Buddhism and the communist movement in Laos that sometimes still today gives rise to such interpretations among party-loyal Buddhists. See Patrice Ladwig, "Prediger der Revolution: Der buddhistische Klerus und seine Verbindungen zur Kommunistischen Bewegung in Laos (1957–1975)," *Jahrbuch für Historische Kommunismusforschung* XV (2009): 181–97.

65. Collins, *Nirvana and Other Buddhist Felicities*, 414, 423. Other birth stories of the Buddha take a much more explicit stance than the *VJ*, and in the "birth story of the dumb cripple," still very popular in Sri Lanka, the Buddha is born as a king again, but tries to escape kingship. He reflects: "I was a king here for twenty years, and as a result cooked for eighty thousand years in hell; now I have been born again in this criminal house." Then a deity comes to give him advice and says, "Dear Temiya, don't be afraid. If you want to escape from here, act as if you can't walk properly, even though you can; act as if you are deaf and dumb, even though you are not" (Collins, *Nirvana and Other Buddhist Felicities*, 425). In order to escape his responsibility, he fakes being handicapped and unable to rule. Not all stories contrast the strict ethics of the ascetic with those of the worldlier householder or king like this, but there is often a certain ironic critique involved.

66. Jacques Derrida, *Deconstruction and the Possibility of Justice* (New York/London: Routledge, 1992), 26. Jacques Derrida, *The Gift of Death* (Chicago: University of Chicago Press, 1996), 65. The case of Abraham, on which Derrida builds his argument, is in some respects fundamentally different from that of Vessantara. Abraham follows his duty toward a monotheistic God ("the wholly Other") and the sacrificial lamb could be put to death. Vessantara does not follow God, but a personal striving for self-perfection, and his gifts are in that sense not put to death, just given away or enslaved. One could therefore speculate that Vessantara has a different kind of freedom of choice from Abraham.

67. Derrida, *The Gift of Death*, 66, 70.

68. Emotivism denies that moral judgments can be true or false, maintaining that they merely express an attitude or an emotional response. I think Nussbaum's idea is different, as there is a basis for ethical judgment (Aristotle's virtues, or *eudaemonia*) and emotions are constitutive of that.

69. See Michael Carrithers, *Why Humans Have Cultures: Explaining Anthropology and Social Diversity* (New York: Oxford University Press, 1992), 91.

70. Although Kant gives emotion a certain place in his idea of virtue, he rejects, for example, pity as a morally significant emotion. His "sympathy with joy and sadness" (*sympathia moralis*) is an inborn capacity that cannot enhance correct decision making. For him, with an apprehension of duty that is based in rationality and rational decision making, emotions are secondary products of ethical reasoning. Immanuel Kant, *Doctrine of Virtue: Part II of the Metaphysic of Morals* (Philadelphia: University of Pennsylvania Press, 1971), 456.

71. Bernhard Williams, *Problems of the Self* (Cambridge: Cambridge University Press, 1973), 207.

72. Antonin Artaud, "The Theatre of Cruelty," in *Selected Writings of Antonin Artaud*, ed. Susan Sontag (Berkeley: University of California Press, 1988).

73. Paul Ricoeur, *Zeit und Erzählung (Band I)* (München: Kohlhammer, 1988), 120, 127.
74. Michael Lambek, "The Anthropology of Religion and the Quarrel Between Poetry and Philosophy," *Current Anthropology* 41, no. 3 (2000): 317.
75. See Bob Simpson, "Impossible Gifts: Bodies, Buddhism and Bioethics in Contemporary Sri Lanka," *Journal of the Royal Anthropological Institute* 10, no. 2 (2004): 847.
76. Charles Hallisey, "Ethical Particularism in Theravāda Buddhism," *Journal of Buddhist Ethics* 4, no. 1 (1996): 37.

[3]

BLISSFULLY BUDDHIST AND BETROTHED

MARRIAGE IN THE *VESSANTARA JĀTAKA* AND OTHER
SOUTH AND SOUTHEAST ASIAN BUDDHIST NARRATIVES

Justin Thomas McDaniel

For my twenty-second birthday, I visited my friend (now wife) Christine, who was a Peace Corps volunteer in Nepal. She had to conduct a children's health survey near the Tibetan border, close to the town of Simikot, and asked if I would like to tag along. I had saved up a little money as a teacher in Thailand, where I had been living since graduating from college, and decided to follow her, as she could speak the language and I was interested in the region. After the short flight and a two-day walk into the mountains along the border, we decided to knock at the door of a remote monastery and ask if we could spend the night. We were greeted by a Tibetan nun and, to my surprise, her seven children. They were all dressed in monastic robes. Christine spoke to her in Nepali, and she welcomed us and said that we could stay in her husband's room since he was away performing a funeral in another village. I was shocked, not by her hospitality but by her robes, her children, and the casual mention of her husband—a monk! My shock was rooted in three basic misconceptions I held about religion, monastic life, and Buddhism. First, in Thailand, where I had been learning as much as I could about Pali, Theravāda Buddhism, and monastic life, monks are forbidden to marry. There are no exceptions. Second, because I had grown up in an Irish family and studied in exclusively Catholic schools, my ingrained belief was that priests, monks, and nuns do not and should not marry. Third, the Buddhist introductory textbooks, suttas, and monastic codes I had been reading made no mention of Buddhist marriage or the ability of monks and nuns to marry.

Fast-forward to fifteen years later: I teach Buddhist studies at an American university, and my students still read a textbook that makes no mention of monastic nuptials. Scholars have largely avoided the study of Buddhism and marriage. However, even though there have not been many publications to date, over the past few years there has been a growing interest in Buddhist monastic marriage and family life among scholars, especially those who research Indian and Japanese Buddhism. Monastic marriage has a complicated and controversial history in Japan, as noted by Covell, Jaffe, Reader, Tanabe, and others. However, strikingly, it has not been a controversial issue in Thailand or Southeast Asia in general. Although some in the vocal elite have been pushing to restart the *bhikkhunī* (nun) lineage in Theravāda Buddhism, there has not been any serious suggestion that monks or nuns should be permitted to marry. This is strange, since marriage and married life are such a significant part of Buddhist narrative literature in Southeast Asia, especially in Thailand.

Of course, in Buddhist teachings, marriage and the love felt by married or monogamous couples are often seen as leading to the dangers of attachment and desire. Nuns, monks, buddhas, and bodhisattas are seen as abandoning love and marriage, in most cases, to gain enlightenment. In fact, the Pali word most commonly used for love, *sineha*, is found only in three canonical *jātaka*-s. *Sineha* (literally an oily substance or a discharge like semen) can also mean affection or even lust. In the *Guṇa Jātaka*, it is used in the sense of a lion showing affection to a she-jackal who had saved his life (*sineham karoti*: he shows/makes affection).[1] In the *Abhiṇha*, it is used to express the platonic friendship between an elephant and a dog.[2] In the *Kaṇha*, love or affection is associated with aversion and greed.[3] Abandoning romantic love and family attachment is praised. For example, in the *Suruci Jātaka*, a queen asks her husband to be monogamous, but when she cannot bear a son for him, he marries 16,000 other women.[4] In the *Āsaṅkha Jātaka* it is said that women are a stain on the religious life.[5] However, in other stories it is a woman who abandons the path of marriage and parenthood and is praised for choosing the ascetic life, as in the story of the nun named Sukkā.[6] Both women and men ideally should refrain from love and marriage. Romantic, dedicated, or passionate types of love, it seems, are not soteriologically or ethically productive drives or emotions in Buddhism.

However, nothing is ever so straightforward in Buddhist literature. A broad look at Pali and vernacular literature shows that *sineha* is not necessarily a dominant emotion in marriage, and loyalty, dedication, and

attachment to one's spouse are not universally condemned. Husbands and wives are described as loyal and devoted, but not necessarily full of uncontrollable *sineha* that leads to delusion and attachment. Many stories seem to suggest either that married life without that suffering is possible, or that the suffering that marriage (and having children) often causes can be soteriologically productive and ethically pedagogical. Other stories in Buddhist literature circulated or composed in Thailand explicitly promote the virtues of falling in love, marriage, and monogamous dedication. Some speak of the virtue of marriage and married love even within narratives that are ultimately focused on teaching the dangers of attachment. In other words, the divisions between asceticism and the attachments often found in married life are not so clear cut.

Students of Buddhism are regularly told, quite correctly, that nonattachment is a virtue for both the laity and the monastic community. Not surprisingly, therefore, research on married or monogamous love has largely not been part of the field of Buddhist studies. Love and marriage necessitate attachment and dedication, it seems.[7] However, positive views of marriage and married life are a significant part of Buddhist narrative literature in Southeast Asia, especially Thailand. Why is this the case? If nonattachment is lauded, the ideal Buddhist life is that of a nun and monk, and nuns and monks cannot marry, then one would assume that Buddhist teachings in Southeast Asia would either ignore the subject or condemn it as a hindrance to leading an ideal ethical life.

In this chapter, I will approach the subject of marriage through the lens of the most popular story in the Thai Buddhist cultural tradition, the *Vessantara Jātaka*. Since the *Vessantara*, like many other Buddhist narratives circulated in Thailand, has a married couple as the main protagonists, I will describe, as much as space allows, the ways their relationship is treated in a selection of Buddhist texts, sermons, and murals. I will show that even though the very idea of permitting marriage among Buddhist monastics in Thailand is unheard of, the stories Thai Buddhists enjoy and the ones nuns and monks ritually perform and teach show the virtues of marriage and loyalty between wife and husband. Despite the ideal of nonattachment, committed supportive and romantic relationships are greatly valued. My seemingly random choices of examples are based on my effort to show how pervasive these stories are; they are found throughout canonical, extracanonical, Pali, and vernacular texts in many regions and literary traditions of what we now call Thailand.

[84] JUSTIN THOMAS MCDANIEL

MARRIAGE IN NARRATIVE ART
AND LITERATURE IN THAILAND

The murals at the ordination hall of Wat Kongkaram (Ratchaburi Province, central Thailand) are a good example of the complicated teachings on marriage. Built in the eighteenth century, the monastery was originally used by the Mon ethnic community in the area. The murals on the interior walls depict sections of several different stories. There are scenes from the story of Prince Siddhattha's "Great Departure" into the ascetic life, from the Thai *Three Worlds of King Ruang* (*Traibhūmikathā*) cosmology, and from various *jātaka*-s, some included in the last ten, like the *Temiya*, the *Suvaṇṇasāma*, and the *Nimi*. Among these more common *jātaka*-s is a rendering of erotic and violent parts of the *Cullapaduma* (the 193rd story in the canonical collection), in which a king becomes nervous that his seven sons will try to kill him and take over the throne. Therefore, he exiles all of them with their wives. In the forest, desperate for food, the brothers devise a sinister plot to kill each of their wives over seven days. They plan to cut them up and roast and eat pieces of their flesh, muscles, and organs so as to stave off hunger. The youngest brother, being compassionate and in love with his wife, goes along with the plot. However, every night, instead of eating his portion of his roasted sisters-in-law, he hides it. On the seventh night, instead of killing his own wife, he gives the brothers the portions of their spouses he has saved and escapes with his wife deeper into the woods. As they wander without food for many days, she begins to starve to death. Even though he is starving too, he puts her needs first (beautifully depicted in the mural)— he cuts his knee open and she feeds on the blood dripping from it. Nourished by his blood, they wander deeper into the forest. Finally, along a stream, reminiscent of the forest hermitage in the *Vessantara Jātaka*, they make a humble home and go about collecting fruit and water. One day, this prince, Cullapaduma, sees a man floating in a small boat in the stream. The man has no arms, no legs, and no nose. He has been tortured by the king (the prince's father) and thrown into a boat to float away and die a slow and agonizing death in the wilderness. Cullapaduma and his wife take pity on the man and bring him into their hut. Every day the wife takes care of the man's wounds while Cullapaduma searches for food and water. This is similar to the *Vessantara Jātaka* as well, but gender roles are reversed there: Maddī goes looking for food and water while Vessantara stays at home and meets the physically hideous Jūjaka (see below). Over time, Cullapaduma's wife falls in love with the armless, legless, and

noseless man and has a sexual affair with him while Cullapaduma is out looking for food. She wants to kill her husband so she can marry the tortured man. She plots to lead Cullapaduma to the edge of a cliff and push him over. Her plan works, but instead of falling to his death, Cullapaduma gets caught in some tree branches growing out from the cliff face and is fed by a lizard who rescues him.

Now, this story, while certainly showing the dangers of marriage and depicting Cullapaduma's wife as unappreciative and maliciously cunning, spends a great deal of time describing the love between the couple. Cullapaduma is honored for his dedication to his wife and in the end, when he has returned to be king, he does not have his former wife punished. He simply allows her to live the life of poverty she has chosen with her new husband. The story does not discount Cullapaduma's love for his wife but emphasizes that it is one of his virtues as a Buddhist hero. Perhaps this is why the muralist chose to depict the tender scenes of love between the couple on the monastery walls more than other scenes.[8] Murals depicting love scenes are found not only in small rural temples but also in central urban royal temples in Bangkok. For example, in Wat Suthat (a first-rank royal monastery), there are paintings from the Thai version of the Panji theme from Java, the *Inao*. The scene is of Princess Bussaba asking a Buddha statue to hear her plea and return her true love to her. Even though this incident is not in any known Javanese or Malay version of the story, here a creative muralist inserted a "Buddhist" scene into a foreign love story.[9]

The *Dhammapada-Atthakathā* (*Dhammapada Commentary*) is a collection well known in Thailand that forms the content of multiple monastic examinations and from which many sermons are drawn. There are several stories featuring married couples. Unlike the wife in *Cullapaduma*, wives here are depicted as loyal, loving, and often clever in teaching their husbands or avoiding the violent aggression of men. For example, in the *Bālavagga*, the fifth story in the collection, there is the long tale of Dinnā. She is a young queen who is tricked into being sacrificed to a tree spirit by the jealous king of Benares. Sakka (the god Indra) uses this event to teach the jealous king, the tree spirit, and the other assembled kings and queens the meaning of true merit making. Dinnā is said to be superior to all others in her understanding of merit and intention. She speaks highly of the value of marriage and states that a wife should honor her husband above all other kings, gods, and spirits. Although this might seem androcentric (as many Buddhist stories do), the importance of marriage as a loyal relationship is promoted. In other parts of this story, four kings are

destined to spend 240,000 years boiling in a cauldron in the Avīci hell for stealing wives away from other men. In another section, Queen Mallikā, with the help of the Buddha, teaches her husband the value of marriage and the dangers of pursuing other men's wives.

Although there are other stories from the *Dhammapada-Atthakathā*, most notably the heartbreaking tales of the two wives and mothers in *Paṭācārā* and *Kisa Gotamī*, that offer sober lessons about the sorrow that comes with attachment to husbands and children, other stories recount the affection between wives and husbands. Indeed, even *Paṭācārā* and *Kisa Gotamī* seem to speak highly of such love, even though they ultimately teach the lesson of the suffering that comes when love is lost.[10] However, the story of *Kukkuṭamitta*, a hunter who marries a wealthy woman who falls in love with him despite his lowly profession, actually features a section where the Buddha chides other monks for thinking that all marriage is unsuitable. The Buddha states, "If in his hand there be no wound, a man may carry poison in his hand. Poison cannot harm him who is free from wounds. No evil befalls him who does no evil." This means that if a wife and a husband have already gained enough merit to enter onto the path to enlightenment, they can perform actions that are outwardly signs of attachment and desire (like being married and having children or being a hunter and killing animals) but remain unscathed. They are married, but not attached (*Dhammapada-Atthakathā* 9.8).

This message is taught in a much more bizarre way in the famous story of Sorreya.[11] A man is rewarded for his attraction to the arahant Mahākaccāyana (known for his handsomeness). The story goes that Sorreya, who is married and has two children, sees Mahākaccāyana on the road. He wishes that either the arahant could become his wife or his wife's skin could somehow look like the golden skin of the arahant. This wish leads him to be magically transformed from a man to a woman. He is shocked by this spontaneous sex change and runs away to hide in the forest. Later, living as a woman with beautiful skin leads to her/his marriage (as a woman) to a treasurer's son, bearing two children with him, and living a comfortable life. When s/he meets Mahākaccāyana again years later, s/he transforms back into a man. He decides to become a monk, apparently to be closer to the true object of his attraction, a male arahant. The desire for a spouse with golden skin and the love s/he experienced in the previous two marriages is not criticized. Indeed, Mahākaccāyana seems to reward him, and he gains arahantship because his previous merits allowed him to have two marriages and two sets of children (as a man and as a woman) in one lifetime and be detached from both situations.

In Southeast Asia, several extracanonical Pali *jātaka*-s from the so-called *Paññāsa (Fifty) Jātaka* collection(s) and *jātaka*-like vernacular stories circulated among the Shan, Khoen, Lue, Lao, Burmese, Khmer, Mon, and Thai language communities speak highly of marriage. A few examples will suffice to make this point. In the *Akkharalikhita Jātaka* (Birth Story of the One Who Writes Letters) is a long list of the benefits of writing and producing Buddhist texts, including the benefits of being a good wife and a good husband. Verses 24, 28, and 29 read:

> Those [husbands] who take care of their wives and children . . . will be reborn in heaven . . . a woman who diligently attends her husband, her parents-in-law, her friends, and other relations, attains to the highest happiness and the foremost position. A woman who is endowed with virtues and is respectful to her husband and others becomes beautiful and is always reborn in heaven.[12]

Later the story states that the Buddha, when he was a bodhisatta in a previous existence, "surpassed all other men of the entire Jambudīpa in beauty and form, and who resembled the Mahābrahmā of the Rūpa world, enjoyed marital happiness with both human females as well as celestial maidens . . . having lived to the full extent of his life, after his death he was reborn in heaven."[13] In the *Brahmakumāra Jātaka*, the Buddha, in a previous life, was born as a prince in Benares. At sixteen years old he was betrothed to a beautiful princess who "was endowed with every auspicious mark, and she was given to good conduct and good religious practice. She was extremely pleasing to the Bodhisatta."[14] Later, the story makes a point about the auspicious marriage and being born into a good family to emphasize to the reader the importance of associating with the right people—a "man becomes worthy by learning the good law from good people."[15] As in many other *jātaka* stories, at the end, it is stated that the bodhisatta's wife went on to be reborn as Yasodharā and the bodhisatta as Gotama. They were linked in the past and remained bound to each other through time.

There are many other examples of praise for marriage in Pali stories in Southeast Asia, and even more in stories in vernacular languages that often have the same format as *jātaka*s, but have no known Pali equivalent. The Khoen (an ethnic group who largely follow Theravāda Buddhism and live along the Chinese, Burmese, Thai, and Lao borders) have a great affection for romantic tales. One of the most famous love stories in Khoen is the *Along Chao Sam Lo,* about two rich and beautiful young people who fall

in love and conceive a child, but are not permitted to marry by the young man's mother. The young lady, U Piem, and her unborn baby die from wounds inflicted by the mother. The young man, Sam Lo, commits suicide when he learns of her death.[16] In the *Chao Bun Hlong*, another noncanonical Khoen *jātaka*, numerous scenes describe great feelings of passion and lust felt by young women toward one of the heroes, Bun Hlong. Besides this overflowing expression of passion, there are also passages describing undying love between Bun Hlong and a young woman, Bimba.[17] In manuscripts Anatole Peltier copied at monasteries in and around Chieng Tung are seven stories that could be called romances, which praise the intense love of the main characters. For example, in the *Ratana Saeng Beu*, a noncanonical *jātaka*, the hero gives up the ascetic life because he longs for a wife. When he cannot find one, he sends a parrot flying all around the world to deliver love letters. When he finds her, her father refuses to give her away in marriage, so the hero attacks the father's kingdom with an army and wins the girl.[18]

One of the best known stories among the Khoen and other Tai ethnic groups in the region is the *Sujavaṇṇa Wua Luang*, a vernacular *jātaka* composed in Khoen.[19] One day the Buddha overhears two monks recounting a story they heard of a woman who became pregnant after drinking the urine of a bull and gave birth to a child who would become a Buddhist monk. The Buddha then uses this occasion to relate the story of himself in a former life when he was the Bodhisatta Sujavaṇṇa. One of Indra's wives, Ummādantī, agreed to be reborn in the human realm as long as Indra assured her that she would be able to marry a future buddha. Ummādantī was born, and one day she went to a great celebration at the palace. She was so beautiful that many princes wanted to marry her, but the other women were jealous and ridiculed her. Ummādantī was ashamed and went to live alone in the forest. There she ended up living with the king of the bulls. He rewarded her loyalty and service to him by building her a miraculous one-pillar palace. Then Indra magically inspired the bodhisatta Prince Sujavaṇṇa to go into the forest to hunt deer. Carrying the sword of victory, the prince entered the forest and chased a golden deer, who led him to the one-pillared palace. Sujavaṇṇa had no way of climbing the pillar and had to chant a mantra to give him the power to reach Ummādantī. She allowed Sujavaṇṇa to stay in the palace because he possessed a protective mantra that asked the gods for the power to fly, because he had achieved many of the perfections and acquired merit for the sake of reaching nirvana and escaping the cycle of rebirths. After he had flown up to Ummādantī, she tested him further with riddles involving

doctrine, which he answered with skill. The king and queen were worried when their son did not return from his hunting excursion and consulted a *purohita* (a Brahmin spiritual advisor and soothsayer), who was knowledgeable about the three Vedas and trained in the use of mystical diagrams (*yantra*) and mantras. He told the king through his interpretation of these *yantra* that the prince would return on the eighth day of the crescent moon of the seventh month (which turned out to be correct). Ummādantī and Sujavaṇṇa remained alone in the one-pillared palace for seven days (without marrying) and then flew on a magical horse first to her mother in the city of Rājagaha and then to the parents of Sujavaṇṇa in Jetuttara. They felt obligated to show respect to their parents. The couple were married and had a boy and girl, who in turn married each other. One day Sujavaṇṇa realized that everything was impermanent and decided to become a renunciant.[20] He decided to give up his flesh and his own life to anyone who requested it. He prayed to Indra, Brahma, and even hell beings. Then Indra changed into the form of an old Brahmin and asked for Sujavaṇṇa's limbs, which he gave freely. Indra returned the limbs to Sujavaṇṇa and Sujavaṇṇa ascended a jeweled throne to preach the word of the Buddha. He gave a sermon about the first Noble Truth of suffering and instructed people to maintain the Buddhist precepts, listen to sermons, and take refuge in the Buddha, the Dhamma, and the sangha. Ummādantī also became a renunciant. They practiced the ascetic exercises together to achieve the perfection of asceticism (*nekkhammapāramī*) and *jhāna* meditation. They were reborn in the thirty-third heaven and lived in a jeweled palace.

The *Sujavaṇṇa Wua Luang* does not mark romantic love as a hindrance to spiritual advancement. Sujavaṇṇa and Ummādantī are depicted as a couple very much in love.[21] Their children, who have a sibling marriage, also live happily together. In the fifth *phūk* (section), Ummādantī is worried that because she is a daughter of a bull, Sujavaṇṇa will be attracted to firm-breasted, fully human women and reject her when they return to the city together. She begs his faithfulness. Sujavaṇṇa assures her that he will only love her. He declares: "*Thī rak khot sāi jai nāng yā dai song sai lāi yūang jai fon fūang glā bai . . . phī bao liao chāk nong sak an thāe lāe* (my love, untie the knots of your heart, give up this intense doubt and that heart of yours that flitters and flutters to and fro . . . your man [literally elder brother] will truly not stray away from you even for one instant)."[22] These heartfelt expressions continue for several lines, and Sujavaṇṇa states that Ummādantī is more beautiful than all other women and that he loves her ("I see you as greater than all other women . . . I love you deeply").[23]

Sujavaṇṇa gladly dedicates himself to his princess and promises his faithfulness, which he maintains throughout the story. Even after Sujavaṇṇa has sacrificed his eyes and legs and has retreated to the ascetic life in the forest, he still feels attachment to his wife. He worries about her being left alone in the world and takes her with him into the forest to live as a renunciant.[24] They live there until both are freed from mental defilements (*kilesa*) and pass away together, to be reborn as husband and wife in heaven. This is truly an undying love!

Jaini has pointed out the prevalence of these themes in the *Paññāsa Jātaka* collections. For example, he acknowledges Madame Terral, who published an edition of the Khmer/Thai version of the *Samuddaghosa Jātaka* from the *Paññāsa Jātaka*, because her "translation and grammatical notes introduced to scholarship a beautiful love-story not found in the Theravāda canon or its commentaries." The *Paññāsa Jātaka* stories themselves often tell of the longing and separation of young lovers. For example, the *Saṅkhapattarāja Jātaka* describes how the Buddha courted his wife, Yasodharā, in past lives. In one scene Yasodharā, born in the past as Ratanavatī, attempts suicide after the loss of her lover.[25] The *Sudhanukumāra Jātaka*, Jaini notes, is very similar to the well-known love story of Sudhana and Manoharā, which is performed in plays in Thailand and Burma.[26] The *Lokaneyyapakaraṇam*, a noncanonical *jātaka*, also offers what Jaini calls "a startling defense of the superiority of monogamy over polygamy. [This] is the only place in Pali literature where a Bodhisatta refuses to accept the king's offer of a royal princess for a second wife."[27] He was not familiar with the Sujavaṇṇa story or vernacular Buddhist literature in Southeast Asia, so we cannot fault him for not noticing the support of monogamy in Southeast Asian vernacular Buddhist literature. What is important is that marriage and monogamy are values promoted by some Southeast Buddhist narratives, and some of these noncanonical *jātaka*-s can be read as stories of dedicated love.[28]

MADDĪ AND VESSANTARA

I have had the great pleasure of watching many performances (which include Pali chanting, vernacular Thai chanting, and a dramatic performance) of the *Vessantara Jātaka* in Thailand, or as it is called there, *Mahachat kham luang* or *Mahawessandon Chadok*. It is also known by the name of the larger annual performance and chanting of the story, *Thet mahachat*, which is part of the national celebration often called the *Bun Phra Wet*. Other authors in this volume discuss the performances

extensively, so I will not provide an ethnographic account here. However, if a person had never read the older Pali telling of this story (which most Thai people have not), they might assume from the dramatic performance that it is more about the love between Maddī and Vessantara than about the value of generosity (*dāna*). Indeed, the most popular sections are about Maddī and Vessantara living in the forest with their children and the suffering both experience when Vessantara gives their children away to Jūjaka. It is an ethical Buddhist narrative, but it is also an emotionally wrenching tale about the love between a woman and a man and their dedication to their children.

Maddī and Vessantara's relationship is complex and often infuriating. In both Pali and Thai tellings, Vessantara is portrayed as being infatuated with Maddī's beauty. For example, her physical beauty is described in at least forty verses, and she is often introduced in various parts of the story as the princess Maddī, "on whose every limb sat beauty" (Pali: *sabbaṅgasobhanā*).[29] Moreover, her family and even Vessantara's own mother consider her almost too good for him. There is a very long passage begging Maddī not to go with Vessantara and their children into exile in the forest (CG 27). Vessantara agrees that the forest is no place for his family and that they would miss the comforts of court life and be attacked by insects, wild beasts, and disease. However, Maddī will hear nothing of it. She emphatically tells his parents: "I would not wish for any joy that was without my Vessantara." Then she offers a speech about the duties of a wife:

> A woman obtains a husband by many kinds of behavior; by holding her figure with corsets and stays of cowbone [Pali: *bahuhi vata cariyāhi kumārī vindate patiṃ udarassuparodhena gohanubbeṭhanena ca*], by tending the sacred fires, by sweeping out water . . . a river without water is bare . . . and bare and defenceless is a woman who is a widow . . . that woman is honoured who shares the poverty of her husband as well as his riches. . . . I will follow my husband always, wearing the yellow robes, for without Vessantara I would not want even the whole earth. . . . What sort of heart have they got, those callous women who can wish for their own comfort while their husbands are suffering? (CG 25–26)

While it could be argued that Maddī is more afraid of being a widow than inseparable from her husband, she could have stayed in comfort in the palace without fault, according to the king and queen. Moreover, as the story progresses, her love for Vessantara is obviously not simply

because of social pressure. Maddī shows her continued dedication by collecting their food and water and taking care of the children. She never complains, even when her husband is callous and unfeeling. For example, one night Maddī has a dream in which her limbs are severed, her eyes dug out, and her breasts split open by a Brahmin (a man wearing saffron robes and a red flower garland). She wakes up in a panic and goes to see Vessantara. They do not sleep together because Vessantara has determined the "proper" times for them to be alone and warned her against "improper desire." He says to her, "Why have you broken our agreement?" (CG 48). To which she responds, "My lord, it is not improper desires that bring me here, but I have had a nightmare." She tells him, and although he knows what the dream means, because he earlier that day agreed to give his children away to Jūjaka as servants (for Jūjaka's young wife, Amittatāpanā), he acts as if he does not know. He dismisses her dream and makes her feel silly. The next morning he tricks her into staying away from the hut and the children while he happily gives the children away. The children beg for him to wait for their mother to come home, but he ignores their tears. Later he does show an emotional attachment to his children, and, "trembling like a rutting elephant seized by a maned lion, or like the moon caught in the jaws of Eclipse, his feelings unable to bear it, he went into the leaf-hut with eyes full of tears" (CG 55–56). Later, "tears that were drops of blood poured from his eyes. Realizing that such pain overcame him because of a flaw in him, his affection, and for no other reason, and certain that affection must be banished and equanimity developed, he plucked out that dart of grief" (CG 58). However, the feelings he shows over the loss of his children are not shown to his wife. While Maddī is returning to the hut, a trip that was magically delayed by the interference of Indra (discussed below), she declares to wild beasts who have blocked her way, "I am the wife of that glorious prince who was exiled, and I shall never desert him, just as the devoted Sītā never deserted Rāma" (CG 60). Vessantara is no Rāma, it seems, subject to proclamations of love. Even though she implores him to tell her what happened to the children, he remains silent and allows her to believe that they have been killed by animals. She cries out, "This is worse pain. I feel a wound like the tearing of a dart, because today I do not see my children . . . this is a second dart which shatters my heart: today I do not see my children, and you will not speak to me." Then she threatens suicide: "O Prince, if tonight you do not explain to me, in the morning you will surely see me dead, all life gone" (CG 62). When he finally speaks, he

does not tell her what happened to the children. Instead he suggests that it is her fault that they are missing:

> Indeed, Maddī, famous princess of lovely hips, you went out this morning to gather food. Why have you returned so late this evening? . . . You are beautiful and attractive, and in the Himālayan forests live a lot of people like ascetics and magicians. Who knows what you have been doing. . . . Married women do not behave like this, going off into the forest leaving young children. You did not so much as ask yourself what was happening to your children or what your husband would think. (CG 63)

After this callous and unfounded accusation, Maddī finally stands up for herself. She explains the reason for the delay and the wild beasts that surrounded her.[30] Then she asserts, "I look after my husband and children," and tells Vessantara about the gifts of flowers and fruit she gathered in the forest for them. However, she returns to self-blame and states that she must have "offended wandering ascetics somewhere in the world, Brahmins, virtuous and learned men, aiming for a life of restraint, for today I cannot see my children" (CG 64). Vessantara continues to allow her to blame herself and stays silent as she wanders around looking for her children. However, his love for Maddī finally overwhelms his stoic resolve when he sees her collapse on the ground in grief.

> Trembling at the thought that she was dead, the Great Being was filled with deep grief at the idea that Maddī had died . . . when he placed his hand on her heart he felt warmth, and so he brought water in a jar, and although he had not touched her body for seven months, the strength of his anxiety forced all consideration for his ascetic state from him, and with eyes filled with tears he raised her head and held it on his lap, and sprinkled her with the water. So he sat, stroking her face and her heart. After a little while Maddī regained consciousness and rose. (CG 66)

Then Vessantara admits to her what he has done. She forgives him when she hears about the miraculous act of generosity. She understands his need to perfect generosity and nonattachment, so much so that when Indra comes the next day, disguised as another Brahmin, and asks Vessantara for his wife, he gives her and she freely agrees. The final act of generosity leads to Indra giving Maddī back to Vessantara immediately, stating, "My lord, I give you back your wife Maddī, in whose every limb

sits beauty. You belong with Maddī, and Maddī belongs with her husband. Just as milk and a conch-shell are alike in colour, so you and Maddī are alike in heart and thoughts" (CG 70). He grants the loving couple eight wishes and along with a long life and to be a just and charitable king, Vessantara wishes, "may I be faithful to my own [wife]."[31]

Obviously this is not a simple story about a king who turns ascetic and gives away his wealth, his power, his children, and his wife. Vessantara doesn't act without some regret, and his wife does not easily accept his actions. They both struggle emotionally with their own decisions. They are apprehensive and unsure how to act, caught between uncontrollable love for each other and their children and the determination to be detached ascetics. They are bound to each other even though they both realize how much pain attachment can cause. Without this emotional struggle, which is emphasized in dramatic performances in Southeast Asia, the gifts of Vessantara and the understanding and loyalty of Maddī would not seem as difficult. Any parent or spouse understands the pain that love causes. This story is as much about marriage and children as it is about the importance of equanimity and generosity. In the end, of course, Vessantara and Maddī live happily as a married couple, and their children are returned to them. The value of the family is celebrated. Indeed, it is celebrated in Southeast Asia in art, drama, and literature as much as (if not arguably more than) the life of the Buddha, who, of course, does not return to his wife and son. Marriage is neither condemned nor seen as unproblematic, but the struggles that come with it are acutely acknowledged and displayed.

The difficulties that occur in marriage are not simply shown between Maddī and Vessantara. Vessantara's parents, Queen Phusatī and King Sañjaya, are seen as struggling with their decision as a couple to exile their son and daughter-in-law to protect the health of the kingdom and their own royal household. Jūjaka and Amittatāpanā also have marriage problems. Without them, Vessantara would not have been given the chance to make the ultimate gift of his children and his wife. Jūjaka seems reluctant to look for servants for his wife, but she presses him because she is mocked by the other wives in the village for marrying a poor and ugly husband. To save face, she needs to have servants. The importance of this aspect of the story is emphasized in the Thai tradition. In the most common Thai vernacular telling of the *Vessantara Jātaka*, the scene of the women mocking Jūjaka's wife is expanded extensively. In the Pali telling, this scene is quite short, twelve verses in which a group of women poke fun at Jūjaka's wife for being so obedient to an old man. There is only a subtle mention of the lack of romance and sex in their relationship. Thai tellings depict the

women as much more vicious in their verbal attacks.³² The expanded scene is featured in murals and paintings, with one notable addition in a cloth painting that shows several women ridiculing Amittatāpanā. The painting is quite bawdy. The women are depicted groping each other, dancing, and holding long wooden phalluses (dildos). Many are half-naked and pretending to penetrate each other vaginally in various positions. This kind of explicit sexual display is not mentioned in the Pali text, but must have caused some shock and delight in late nineteenth-century viewers, as well as showing the difficult social situation in which both Amittatāpanā and Jūjaka find themselves.³³ Today there is a popular protective amulet of Jūjaka (Thai: Chuchok), usually in the form of a decrepit old man with a long beard, hunched over and walking with a cane. This small wooden or metal amulet is supposed to bring much merit to its owner since, on the one hand, Jūjaka was able to get everything he asked for, including a young and pretty wife, and on the other hand, without his requests, Vessantara would never have been able to perform his final acts of giving.³⁴

If we look at the *Vessantara Jātaka* not simply as a story about making merit and perfecting the art of giving but rather as part of a larger genre of stories about marriage, we can learn a lot about how an ascetic religion that promotes celibacy and monastic life communicates with a larger population that chooses to support the institutions and ideals of marriage and children. Murals, dramas, poems, and reliefs in Southeast Asia often celebrate love and loyalty between married couples. They depict the struggles couples go through to stay together and raise children. While women are often shown in a submissive role, there are many stories in which husbands are devoted to their families. As we saw, religious quests for merit do not necessarily necessitate the abandonment of marriage and family. When the choice is made to no longer participate in family life and romantic love, it is not depicted as an easy decision in any way. One may not be able to realize enlightenment while married and attached to spouse and children, but this does not mean that one can't cultivate merit and Buddhist virtues. In Southeast Asia's most popular narrative, the *Vessantara Jātaka*, family is described as the ultimate sacrifice, and without it, Vessantara would not have been able to perfect his practice of generosity.

Marriage in its Buddhist context in Southeast Asia has not, to date, been a subject of much study or debate. When it is mentioned, marriage

is described by scholars as something to be abandoned, and wedding ceremonies are described as an irritating duty for monks to perform for the lay masses who haven't woken up to the dangers of attachment. However, in narratives, both Pali and vernacular, marriage is not a problem to be ignored or an institution to be condemned, but a very worthy subject on which to write and ruminate. Indeed, as a popular Thai saying suggests, Buddhist monasticism is seen as not incompatible with marriage but a precondition for it. *Buat gon biat* loosely translates as "a man should be a monk in order to be fit for marriage," or more literally, "the experience of ordination (and monastic life) is an appropriate precondition before pressing your body against another." Men in Thailand are often described as *dip* (raw) until they have ordained. Women should not trust a man to be a good husband if he has not ordained for a short period (usually three months or one rainy season is an ideal) before getting married. Monkhood "cooks" a man and prepares him for the restraint and the dedication needed to be a good husband. Perhaps this is how we should think about reading Buddhist stories in which these two institutions, monkhood/asceticism and marriage/family, are featured, not as foes but as complementary, even necessary paths toward self- and other-awareness.

NOTES

1. See Ja II 27. I have geared the transcription system to a general audience without advanced skills in Thai, Pali, or Sanskrit. For Thai, I follow with a few exceptions the Royal Institute's *Romanization Guide for the Thai Script* (Bangkok, April, 1968), which also elides most diacritical marks for easy reading. This closely follows international library standards. Pali transcription is now relatively consistent internationally. For references to Pali texts, I follow the standard *CPD* (Helmer Smith, *Critical Pali Dictionary, Epilogomena to Vol. I*, Copenhagen, 1948) used by the Pali Text Society. I have not translated the titles of most Pali texts I referred to into English because nearly every title is a personal name. For example, the *Nimi Jātaka* would translate as the "Birth Story of Nimi." This is also largely the case for the Tai Khoen and Thai texts titles I provide. Translating the titles would be redundant.
2. Ja I 190.
3. Ja IV 11. See also Ja I 61. The term *rāga*, commonly translated as "passion," is universally an unskillful (*akusala*) quality in a person and is supposed to hamper spiritual advancement. It is often found in a triad with *dosa* (aversion) and *moha* (delusion).
4. Ja IV 314–25.
5. Ja III 250.
6. See for example Thī-a 57.
7. Even though there have not been many publications to date and the subject is not covered in any major textbook on Buddhism, over the past few years there has been a growing interest in Buddhist monastic marriage and family life among scholars, especially in Japanese Buddhist studies. Monastic marriage has a complicated and

controversial history. Those interested in the subject of the acceptance of marriage as an institution permitted for monks, nuns, and priests should see Alan Cole, "Buddhism," in *Sex, Family, and Marriage in World Religion*, ed. Don Browning, Christian Green, and John Witte, 299–366 (New York: Columbia University Press, 2006); Stephen Covell, *Japanese Temple Buddhism* (Honolulu: University of Hawaii Press, 2005); Richard Jaffe, *Neither Monk nor Layman: Clerical Marriage in Modern Japanese Buddhism* (Princeton: Princeton University Press, 2000). Shayne Clarke also discusses the issue of marriage, children, and family life in early Indian Buddhism extensively in his forthcoming book, *Family Matters in Indian Buddhist Monasticisms* (Honolulu: University of Hawaii Press). I thank him for sending me an advance copy. Anne Hansen is presently working on a project about love and passion in Cambodian Buddhism and Southeast Asian Buddhist texts more broadly.

8. See Chutima Chunhacha, ed., *Chut chitakam faphanang nai prathet Thai Wat Khongkharam* (Bangkok: Muang Boran, 2537 [1994]), and Sanitsuda Ekachai, "Thailand's Gay Past," *Bangkok Post*, February 23, 2008, 1. See also No Na Paknam's historical introduction to the temple and the special issue on Wat Khongkaram in *ASA: Journal of the Association of Siamese Architects* 3, no. 1 (2517 [1974]): esp. 19–52, with contributions from Nit Ratanasanya, among others. I thank Donald Swearer for giving me a copy of this last source. A very similar story is found in the *Dhammapada-Atthakathā* (Dhp-a 8.3). However, here the husband plots to kill his wife by throwing her off a cliff. She uses this treacherous plan against him and is able to throw him off instead. She is lauded for her actions and becomes a *bhikkhunī*.

9. Santi Phakdikham has shown that the walls of one monastic building can have paintings of a canonical *jātaka*, while the doors of the room can have paintings from noncanonical *jātaka*s and other local romance stories that have little to do with Buddhist teachings or religion in general, like the romance story of *Sangthong*. Santi Phakdikham, "Chitakam wanakhadi Thai nai phra ubosot Wat Ratchaburana," *Muang boran* 33, no. 3 (2550 [2007]): 78–92. See also Stuart Robson, and Prateep Changchit, "The Cave Scene or Bussaba Consults the Candle," *Bijdragen tot de Taal-, Land- en Volkenkunde* 155, no. 4 (1999): 585.

10. Dhp-a 8.12; 8.13. See also different versions of their stories along with 38 other female sages (*Therī*) in the *Paramatthadīpanī VI*. A partial English translation is available: Willaim Pruitt, trans., *The Commentary on the Verses of the Therīs* (Oxford: Pali Text Society, 1998).

11. Dhp-a 3.9. For an English translation see Burlingame, *Buddhist Legends*, vol. 2, 23–27.

12. Padmanabh Jaini, *Apocryphal Birth-Stories*, vol. II (London: Pali Text Society, 1986), 204.

13. Ibid., 205.

14. Ibid., 185.

15. Ibid.

16. See Anatole-Roger Peltier, ed., *Along Chao Sam Lo* (Chiang Mai, Paris: L'École française d'Extrême-Orient, 1988).

17. See Anatole-Roger Peltier, ed., *Chao Bun Hlong* (Chiang Mai, Paris: L'École française d'Extrême-Orient, 1992).

18. See Anatole-Roger Peltier, *La Litterature Tai Khoeun* (Chiang Mai: L'École française d'Extrême-Orient, 1989), 227–28.

19. I discuss this story extensively in "Creative Engagement: The *Sujavaṇṇa Wua Luang* and Its Contribution to Buddhist Literature," *Journal of the Siam Society* 88 (2000): 156–77.
20. Anatole-Roger Peltier, ed., *Sujavaṇṇa Wua Luang* (Chieng Tung: Wat Tha Kradas, 1993), 174.
21. See Anatole-Roger Peltier, *Kalasa Grua Dok* (Chiang Mai: L'École française d'Extrême-Orient, 1990), introduction. He notes that romance is one of the most dominant subjects in Khoen literature.
22. Peltier, *Sujavaṇṇa Wua Luang*, 126.
23. Ibid.,128.
24. Peltier, *Sujavaṇṇa Wua Luang*, chapter 7.
25. Jaini, *Apocryphal Birth-Stories*, vol. I, 100–28.
26. PJ, vol. II., xviii and vol. I, 129–59. See also Andrew Rotman's new translation, *Divyāvadāna (Divine Stories: Translations from the Divyāvadāna, Part 1)* (Boston: Wisdom, 2008), which recounts many love stories popular in South Asian Buddhist literature.
27. Jaini also points out another story in the *Lokaneyyapakaraṇam* in which the author states that one of the main characters should not be faulted for being sexually promiscuous. See *Apocryphal Birth-Stories*, vol. I, 32–33.
28. We cannot say that monogamy was a value of the Khoen people in general. Numerous narratives in Khoen mention men having two or more wives, and they are not crtiticized for this practice. See manuscripts 16, 135, 188, and 202 of Peltier, *La Litterature Tai Khoeun*. Furthermore, there is no extensive ethnographic material available about Khoen marriage patterns.
29. Gombrich and Cone's translation of *sabbaṅgasobhanā* is literally correct. *Aṅga* does mean "limb"; however, it might translate into contemporary English better as "whose beauty was flawless" or colloquially as "who was beautiful from head to toe."
30. This section of the story is greatly expanded in several Thai versions, in which Maddī is confronted by ascetics and magicians in the forest and they try to rape her. However, she is saved by Indra, who sends "fruit-maidens" to protect her. Fruit maidens, *makkaliphon* or *nariphon*, are a well-known part of Thai folklore. The source of the story undoubtedly comes from a scene in the *Wessandon chadok*, in which, while in exile in the Himavanta Forest, Maddī finds sixteen *makkali* trees on which, instead of fruit, hang small beautiful women (Pali: *makkaliphala*). Scenes from the Himavanta Forest are popular in Thai mural paintings, and many people I have spoken with seem to know this episode both within the context of the Vessantara story and from other stories. It is believed that these trees were miraculously planted by Indra (Sakka) to distract men so that Maddī would be safe in the forest gathering water and food for her family. If a man, usually depicted as a Brahmin ascetic or Chinese medicine man in murals, picked and had sex with a fruit maiden, he would lose all of his magical and virile powers. Maddī is protected by the tree, as she does not desire the female fruit.

In Singburi Province, Luang Pho Charan is the abbot of the large *vipassanā* meditation center at Wat Ampawan. He is well known as a person with the power to grant wishes in central Thailand. He has put on display two corpses of "fruit maidens" at the nearby Wat Prangmuni. These are about eight inches long and have grayish leathery skin, and he claims that they were given to him by an ascetic in Sri Lanka in 1972. Luang Pho Charan claims that these fruit maidens are real and that when they fall to the earth and shrivel up, they can be collected by human beings.

He claims that he was given two while on pilgrimage in Sri Lanka. Only ascetics with certain powers are able to enter the Himavanta Forest, where the *makkali* trees grow. Today at Wat Prangmuni visitors can hold the dried-up corpses, which do look like young girls with stems coming out of their heads; however, they certainly look like carved rather than organic pieces. They are kept on a small pillow and surrounded by gifts of flowers. Holding these corpses of mythical beings is believed to grant a person good luck, especially in love. In August 2011 I was able to acquire two fruit maidens from an amulet dealer in Bangkok. Interestingly, male fruit "maidens" are also available now.

31. Steven Collins has worked on the subject of adultery in Pali literature. In regard to monogamy, see particularly note 3 from his article in the *Journal of the Pali Text Society* ("On the Third Precept: Adultery and Prostitution in Pali Texts," vol. XXVIII, Festschrift for K. R. Norman, 2007), where he writes: "Many texts praise monogamy for man and wife, in deed and thought, as a virtue; see, e.g., the *Suruci Jātaka* (Ja IV 314ff.), which contains the very widespread motif that jealousy of one's co-wives (*sapattiyo*) is one of the sufferings particular to women. A man is urged not to visit other men's wives; women are encouraged not even to think of other men (e.g., D III 190 with Sv 955). See also DPPN s.v. for the story of Nakulapitā and his wife."

32. See, for example, the *Mahawessandon chadok chabap 13 kan*, published by the Department of Education in Thailand. It has gone through fifteen printings to date and is easily found in Thai libraries. In this edition, the section on the mockery of Amittatāpanā by the other Brahmin wives takes up more than fourteen pages of text in the form of an extended *vohāra*-style gloss of the Pali verses.

33. I appreciate Forrest McGill taking time to show me this painting at the Asian Art Museum. See CG 36–37. Naked women are not limited to cloth paintings and are found in prominent royal temple murals like those at Wat Pathumwanaram, Wat Rakhang, among others.

34. Arthid Sheravanichakul gave a talk on the popularity of the Jūjaka amulets in Thailand at the European Association of Southeast Asian Studies Conference in Gothenburg, Sweden (August 28, 2010). I thank him for conversations about these amulets.

{ 4 }

JŪJAKA AS TRICKSTER

THE COMEDIC MONKS OF NORTHERN THAILAND

Katherine A. Bowie

CONTEMPORARY SCHOLARLY analyses of the *Vessantara Jātaka* in Thailand, as elsewhere, have focused on the renunciatory acts of Prince Vessantara, leading to both sober royalist and somber monastic interpretations of the *jātaka*. Pursuing the political potential inherent in such interpretations, Patrick Jory and others have argued that this *jātaka* was "one of the most important texts in the premodern Thai State for the expression and dissemination of a political theory"; it is interpreted as having served to legitimize kingship by drawing upon "the concept of *barami* [sacred charisma] and the exemplary figures of the bodhisatta-king."[1] However, in addition to formal recitations in court settings, which may indeed have been intended to glorify divine kings, bawdy comedic performances of the *jātaka* were once widespread among the Thai peasantry. In Rabelaisian Europe, peasant humor mocked "the official and serious tone of medieval ecclesiastical and feudal culture."[2] The popularity of bawdy recitations of the *Vessantara Jātaka* in Thailand raises the possibility that its village performances had alternative meanings and even may have served not to glorify but to mock royal and ecclesiastical pretentiousness.

In Thailand such comedic performances fell into elite disfavor over the course of the nineteenth century. In an edict issued in 1865, King Mongkut denounced "buffoonish recitations" and declared that "the money collected for such a purpose could be better employed in buying fuel to burn dead dogs' carcasses."[3] King Mongkut had been a monk for over two decades before coming to the throne in 1851 and had founded a reformist

order of monks known as the Thammayut; under his guidance, this order emphasized the study of the historical life of the Buddha rather than folkloric prebirth myths. In the king's view, comedic recitations of the *Vessantara Jātaka* made a "burlesque of the life of him whose career they were intended to honour."[4] However, perhaps bawdy recitations made a burlesque not of the Buddha, but of those who laid pretentious claims to being Buddhist. Village performances of the *Vessantara Jātaka* may have been an embarrassment to a Westernizing aristocracy; they may also have been its veiled critique.

Influenced differentially by the rise of the central Thai court-supported Thammayut sect, the performance and interpretation of the *Vessantara Jātaka* developed divergent trajectories in each of the four main regions of Thailand.[5] The northern region was not integrated into the central Thai state until the early twentieth century, enabling it to maintain its own performative tradition in which comedy played a major role; its humor is centered on the figure of Jūjaka (Thai: Chuchok), the old Brahmin-beggar who receives Vessantara's children. In other regions, Jūjaka is often portrayed as a frightening incarnation of evil. In central Thai versions in particular, he is considered "a cruel, selfish, wicked, and heartless man," a figure "whose cruel treatment of the children often makes the listeners or the readers cry."[6] In northern Thailand, Jūjaka has long been by far the favorite character in the *jātaka*, a loveable—albeit absurdist—figure who makes his audiences laugh. Paul Radin, who made pioneering contributions to the anthropological study of tricksters, notes that although "laughter, humour and irony permeate everything Trickster does," the figure is fundamentally ambiguous, such that "it is difficult to say whether the audience is laughing at him, at the tricks he plays on others, or at the implications his behaviour and activities have for them."[7]

In this chapter I shall argue that in the northern Thai interpretation, Jūjaka is best understood as a trickster whose all-too-human desires teach important moral lessons. Analyzing humor is always challenging, since it is particularly sensitive to historical performative context. Furthermore, comedic performances of the *Vessantara Jātaka* have been declining in northern Thailand. My analysis is based upon interviews with monks and laity, firsthand observations, audiocassette recordings, videos and photographs of performances, as well as secondary comparative works. In the first of four sections, I highlight the unique importance of Jūjaka in traditional northern Thai performances, noting the existence of specialized *tujok* monks. In the second section, I show how the Jūjaka figure becomes elaborated as a trickster. In the third section, I describe vignettes of bawdy

humor. In the final section, I suggest that villagers enjoyed the *Vessantara Jātaka* primarily because of its engagement with the problems of everyday life, not because of its potential as royalist propaganda or its reinforcement of monasticism. Appreciating the importance of Jūjaka as a trickster expands our contemporary understanding of the range of historical meanings the *Vessantara Jātaka* held for its audiences, allowing the possibility for nonroyalist and even antiroyalist interpretations.

JŪJAKA AND THE NORTHERN THAI *TUJOK*

The Jūjaka character first appears in the fifth chapter (the Jūjaka chapter) of the *Vessantara Jātaka* and dies in the eleventh chapter (the Maharaat or Great King chapter). In the Pali and the Thai regional variations, the overall plotline is similar. In the fifth chapter, Jūjaka obtains Amittatāpanā (Thai: Amittata) as his wife; she is badly treated by jealous village women and sends Jūjaka off on the journey to obtain Vessantara's two children as her servants. In subsequent chapters, Jūjaka travels through the forest, meets Vessantara, and receives the children. He treats them heartlessly, but ultimately ends up in the court of Vessantara's parents, where he overeats and dies. In the concluding paragraph of the Pali version, Jūjaka is explicitly identified with the future evil monk, Devadatta, and Amittatāpanā is identified as the future Ciñcamānavikā, the woman who falsely accuses the Buddha of making her pregnant.

The Pali version contains no obvious humor. As the following description by Vessantara's son reveals, Jūjaka is portrayed as cruel, heartless, and physically grotesque:

> He is splay-footed; his nails are filthy; his calves are rolls of fat. He has a long upper lip; he slavers and his teeth stick out. He has a broken nose. He is potbellied, hunch-backed, and cross-eyed. His beard is red and his hair is yellow, and he is covered with wrinkles and freckles. With his red eyes, with massive hands, bent and deformed, wearing an antelope skin, he is horrible, he is not human. . . . Your heart must be made of stone or strongly bound with iron, if you do not care that we have been tied up by a brahmin greedy for money, excessive and ferocious, who drives us along like cattle. (CG 54)

Although many central and northeastern Thai vernacular versions find opportunities for humor in the Jūjaka chapter, Jūjaka himself is often portrayed not as humorous but as frightening. Instead the humor focuses

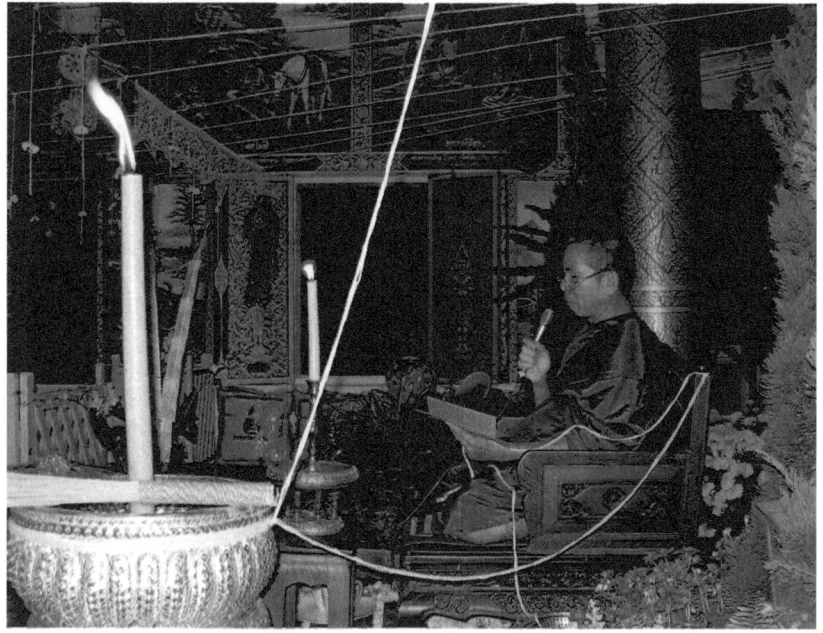

FIGURE 4.1 Monk reciting the Vessantara Jataka, Wat Umeng, November 3, 2006 PHOTO COURTESY OF YUWA TAMBON COUNCIL, SANPATONG DISTRICT, CHIANG MAI PROVINCE

primarily on the jealous anger of the village women. Their negative associations with the Jūjaka character are reflected both in the reluctance of monks to recite this chapter and in the reluctance of villagers in these regions to sponsor its recitation. Several monks indicated that monks prefer to be known for their mellifluous voices rather than for their ability in mimicking the voice of an old man. Furthermore, they noted that monks who recite the Jūjaka chapter often receive less generous donations from lay sponsors. A northeastern and a central Thai monk who both currently specialize in performing the Jūjaka chapter told me they developed their specialization because other monks were unwilling to perform the chapter. When I asked which chapters the laity were least eager to host, many central Thai monks and villagers replied that it was the Jūjaka chapter, explaining that laypeople feared that they would become afflicted with Jūjaka's poverty, ugliness, and inauspiciousness (*baab*). Monks described having to cajole members of the laity to agree to serve as sponsors of the reading of this chapter. One monk explained to chapter hosts that Jūjaka

was a *khuu baramii* or partner to Vessantara, since if Jūjaka did not take the children, Vessantara could not reach enlightenment. One person suggested that lay sponsors drew lots to determine chapter sponsorship to avoid this very problem.

The northern Thai interpretation of Jūjaka is very different. Traditionally, northern Thai monks developed specializations in each of the thirteen chapters. Monks with soft, high voices specialized in the chapters about Maddī (chapter 9) and the children (chapter 8: Kuman). Monks with deep, booming voices specialized in the chapters entitled "Maharaat" (chapter 11: Great King) and "Nakornkan" (chapter 13: Return to the City). Monks with creative energy and a sense of comedic timing specialized in the Jūjaka chapter; their special status is reflected in their unique categorization as *tujok*; *tu* is the northern Thai word for monk and *jok* is an abbreviation of "Chuchok," the Thai pronunciation of "Jūjaka." Like in northeastern Thailand, the actual recitation of the *Vessantara Jātaka* should be completed within a twenty-four-hour period and is preceded by the reading of the Malai Sutra.[8] However, unlike in northeastern Thailand, where the recitation takes place only during *bun prawes* (generally March–April), northern recitations of the full *jātaka* can take place during *dyan yii paeng* (circa November), during *Boi Luang* festivities celebrating new temple construction, and on special occasions called *Tang Tham Luang* (hosting the great sermon). In addition, in northern Thailand individual chapters can be recited at funerals; the most commonly selected chapters are Maddī, Kuman, and until recently, Jūjaka.[9]

The unique emphasis on the Jūjaka chapter in northern Thailand is reflected in the visual ritual accoutrements surrounding the actual recitation of the text. The decorative elements of the *Vessantara Jātaka* recitations in the northern and northeastern regions share much in common. However, in northeastern Thailand villagers carry a long painted scroll through the village, representing the return of Vessantara and Maddī to the palace and highlighting the northeastern emphasis placed on the final chapter.[10] By contrast, the importance of Jūjaka in northern Thai recitations is highlighted visually by the construction of large, elaborate mazes. Called *wongkot*, the mazes represent the journey taken by Jūjaka in his search to find Vessantara and his family at Khao Wongkot (Crooked Mountain). At the entrances to the mazes, Jetabutr, the Cetan hunter who had been assigned to guard Vessantara and his family, is represented, sometimes in drawings on simple cardboard and sometimes in elaborate papier-mâché forms. The mazes are constructed from bamboo strips or wood; in the past, some were even built with roofs. They involve considerable advance

JŪJAKA AS TRICKSTER [105]

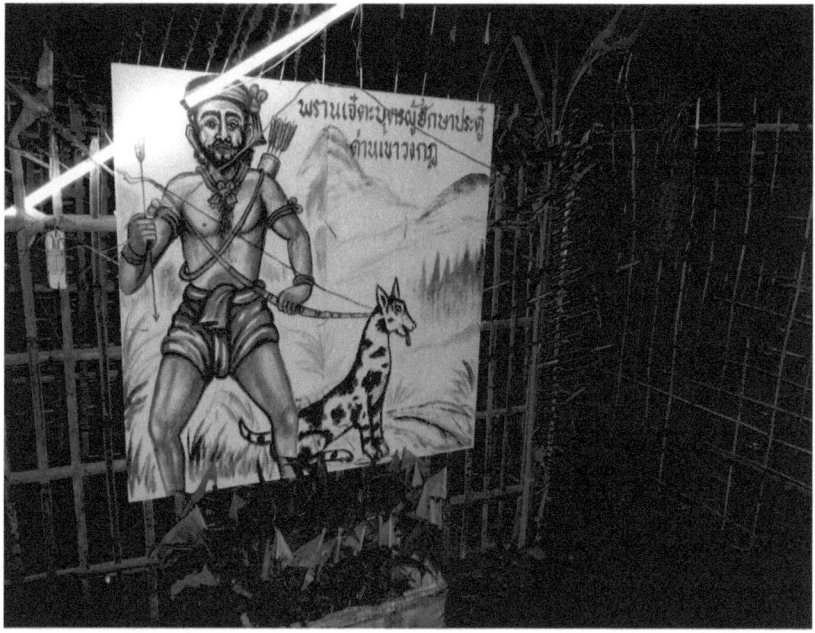

FIGURE 4.2 Jetabutr guarding maze entrance to Crooked Mountain, Tambon Hankaew, Hang Dong District, Chiang Mai Province, August 5, 2009 PHOTO BY AUTHOR

planning and cooperation; in the old days, villagers had to travel into the forest to gather all the necessary raw materials and then haul them to the temple. At the center of the maze is often a Buddha image or other representation of Vessantara.[11] In the maze in which I found myself lost, children, teenagers, and adults alike were clearly enjoying the challenge, with squeals of laughter as they met another dead end. Intended to draw a large audience to the temple, wandering the maze remains a source of entertainment.

The entrance of *tujok* monks into the temple grounds was also very different from that of any other monk. Although today monks dressing in costume would be denounced as heretical, the *tujok* formerly often wore costumes over their yellow robes. They typically carried a cane and over their shoulder wore a bag or a bamboo container, used to carry salt on long journeys. Some donned a wig with white hair. One *tujok* had betel juice dripping out of his mouth. Northerners repeatedly told me how villagers awaited the arrival of the *tujok* with eager anticipation. Because the

FIGURE 4.3 Villagers making bamboo maze, Wat Umeng, January 26, 2009 PHOTO COURTESY OF TAMBON COUNCIL, TAMBON YUWA, AMPHUR SANPATONG, CHIANG MAI PROVINCE.

chapter was generally performed in the late morning, after everyone has finished breakfast, there was often a large gathering of children waiting outside the temple. When the *tujok* arrived, a cry would go up, "*Tujok maa laew!*," "The *tujok* has come." Often the *tujok* would chase after the giggling children, waving his crooked walking cane at them and threatening to hit them. One *tujok* made his arrival with a group of children who had dressed up to look like Jetabutr's dogs in the story; they then chased a few of the onlookers up a nearby tree. Another *tujok* monk entered the temple holding the leashes of several dogs. Other *tujok* brought children dressed up as Kanhājinā (Thai: Kanhaa) and Jāli (Thai: Chalii) who were bound with ropes. Monks and laity explained these dramatic entrances as a strategy intended to draw interest. Far from being reviled, the *tujok* monk was likely to receive the largest donations.[12]

Unlike in other regions of Thailand, where the primary associations with Jūjaka are often negative, in northern Thailand the primary audience reaction remains overwhelmingly positive. The very same descriptions

that appear in the Pali and other Thai vernacular versions generate laughter—the uglier, the funnier. The northern versions often add that he smells like a vulture, has wrinkled skin, and manifests other assorted forms of ugliness. Thus when Jetabutr sees Jūjaka hiding in a tree to escape his dogs, Jetabutr cannot determine what is in the tree. In one northern version, Jetabutr speculates:

> Maybe it is a *phii tamoi* (a spirit that produces flashes of light), but it isn't flashing. It may be a monkey, but it has no tail. It could be a deer, but they don't climb trees. It could be a wild chicken, but it doesn't have feathers. It could be a person, but it doesn't look like one, so it must be a *phii phraaj* (a form of ghost).[13]

As analysis elsewhere has shown, while humor always depends on the comic figure having some resemblance to the human, it also involves distancing in the form of physical caricaturing. Thus Henri Bergson has noted that the comic is dependent on "an absence of feeling" because it is difficult to laugh at someone who inspires pity. As he explains, "To produce the whole of its effect, then, the comic demands something like a momentary anesthesia of the heart. Its appeal is to intelligence, pure and simple."[14] Thus the northern portrayal of Jūjaka's remarkable physical form serves to distance him, allowing the audience to laugh at Jūjaka's exploits, even while recognizing a common humanity in their shared desires for wealth and happiness.

JŪJAKA'S EXPANDED JOURNEY

Although consistent with the overall plotline of the Pali version, the northern Thai versions significantly expand the number of incidents occurring in Jūjaka's life of travel. As Lewis Hyde has noted, "all tricksters are 'on the road.'" He continues: "Tricksters are the lords of in-between. A trickster does not live near the hearth; he does not live in the halls of justice, the soldier's tent, the shaman's hut, the monastery. He passes through each of these when there is a moment of silence, and he enlivens each with mischief."[15]

Thus considerable humor emerges from Jūjaka's improbable success in overcoming obstacles on his journey through the forest to find Vessantara. Unlike central Thai versions that make use of court imagery and vocabulary, the northern Thai versions are grounded in the events and language of village life.[16] In part, the humor is based on incongruities

created by unexpected references to familiar aspects of northern culture (e.g., courtiers serving Jūjaka village foods rather than court delicacies) or other inversions (e.g., thin as a rhinoceros). Listeners also enjoy the verbal wit of the *tujok*. Each *tujok* is free to develop his own comic vignettes, drawing upon versions developed by fellow *tujok* to varying degrees. Humor also emerges from a *tujok*'s ability to create rhyming patterns in which the last word of a line rhyme with a key word in the following line. All *tujok* significantly expand upon the minimalist account provided in the Pali version.

For example, the Pali version begins as follows:

At that time there was living in the brahmin village of Foulstead in the kingdom of the Kalingas a brahmin called Jūjaka. He left a hundred kahapanas he had gained by begging in the care of a certain brahmin family while he went off again in search of more money. As he was away a long time the family spent the money, and when pressed for it on his return, since they were unable to give back the kahapanas, they gave him their daughter, whose name was Amittatāpanā. (CG 36)

In the northern Thai renditions, the problems for Jūjaka could begin even before his earthly birth. One of northern Thailand's most famous *tujok* was Luang Poh Bunthong.[17] As recorded on one of his audiocassettes in 1990,[18] Luang Poh Bunthong began his version of the Jūjaka chapter by creating a prebirth scenario in which Jūjaka is living in one of the hells, looking for ghosts who will agree to become his parents so he can be reborn in the world of the humans. Playing with a rhyming pattern in which the last syllable of the line rhymes with an individual's name, he created the following passage:

Baj haa Lung Ai, Lung Ai bo ow	He went to Lung Ai; Lung Ai refused.
Baj haa Lung Mao, Lung Mao ko bo hyy	He went to Lung Mao; Lung Mao said no.
Baj haa Lung Tyy ko pan	He went to Lung Tyy, who sent him on
Baj haa Ui Chan	to see Ui Chan.
Baj haa Ui Chan, Ui Chan ko klua	He went to Ui Chan, but Ui Chan was afraid.
Baj haa Ui Bua, Ui Bua ko bo daj	He went to Ui Bua; Ui Bua wouldn't agree.
Baj haa Lung Ai . . .	He went to see Lung Ai . . .

The passage is funny because the audience appreciates the verbal skills of the rhyming pattern and because it accentuates just how disgusting Jūjaka must be if no one will agree to become his parents. Nonetheless, Jūjaka persists and finally finds parents willing to give him birth on earth.

Once the main character is born in human form, the *tujok* could then continue to invent early life stories, centered on the theme of how Jūjaka was a particularly difficult child. These stories conclude with Jūjaka becoming a beggar, entrusting his gold to Amittatāpanā's parents, and ultimately winning Amittatāpanā as his bride. In the Pali version, there is no speculation about how Amittatāpanā or her parents feel about having their daughter marry the old beggar.[19] It simply continues, "Returning with her to the brahmin village of Foulstead in the kingdom of the

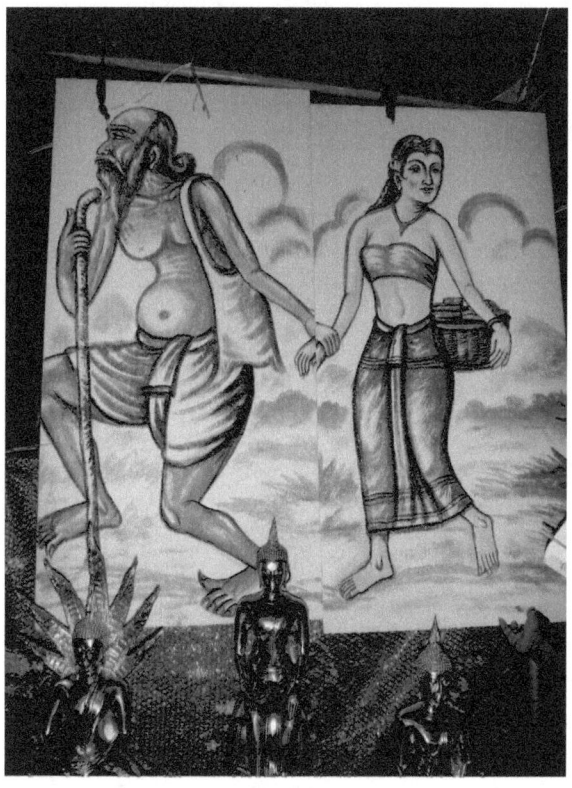

FIGURE 4.4 Jujaka and Amittatâpanâ, *Vessantara Jātaka* recitation, Tambon Hankaew, Hang Dong District, Chiang Mai Province, August 5, 2009 PHOTO BY AUTHOR

Kalingas, he made his home there, and Amittatāpanā cared for him very well" (CG 36). However, the various regional Thai versions create different motivations as explanations, in some cases highlighting the agony of the parents or the filial piety of the daughter. Northern versions tend to portray Amittatāpanā as having made the decision herself, because she is tricked into thinking she is going to help him take care of his home, because she is conniving in her own right, or because she is filial and wants to help her parents.[20]

Many *tujok* monks have developed an elaborate wedding ceremony for Jūjaka and his bride, drawing upon villagers' often bawdy cultural associations with a form of witty courtship repartee (*ben khao ben khrya*) and a genre of bawdy songs known as *joi* and *soh*. Although monks in the past were never likely to go as far as the raunchier *soh* verses, they nonetheless skirted around the edges. Some *tujok* apparently developed a section where Jūjaka threatens his bride's parents, wanting more money to spend, using the old language of poetic couplets. Descriptions of the wedding guests provide further opportunities for levity, with some guests as thin as rhinoceri and others as tall as dachshunds. Some *tujok* described strange wedding gifts, ranging from baby cribs to funerary hangings (*thung saam hang*). *Tujok* typically elaborate on postprandial merriment, setting the scene of a master of ceremonies coordinating a range of different styles of singing (e.g., *soh chiang mai, soh phra lor, soh saelemao*). The wedding scenario provides *tujok* monks an opportunity to discuss with humor the various problems of married couples.

After the wedding, Jūjaka and his bride move to Jūjaka's village (this does not conform with the dominant uxorilocal postmarital residence patterns among Thai villagers). In central, south, and northeastern Thai versions, his home is described as being dilapidated because he has no money or time to make repairs, since he is off begging. The northern Thai versions provide a much more detailed description, highlighting the fact that it is built on four pillars.[21] Thai village homes have long been built on pillars, and everyone knows that a house needs a minimum of six to ensure stability; only spirit houses would have four pillars. Furthermore, house pillars are generally made of teak for maximum strength and termite resistance, but often the *tujok* describe the posts as made of young *mai pao* wood, which any villager knows is not strong enough for house building.[22] *Tujok* typically describe the house as so wobbly that it would sway if a dog wagged its tail or if a cat coughed. Jūjaka was so frugal, according to some *tujok*, that he made his bed pillows from chicken excrement.

JŪJAKA AS TRICKSTER [111]

Like other Thai regional variations, the northern versions find humor in describing how upset the village women are that their husbands praise Amittatāpanā as a model wife. *Tujok* embellish this village scene, often by having Jūjaka ask which women were involved.²³ When Amittatāpanā says she never wants to interact with them again, many *tujok* enjoyed elaborating on how unbelievably solicitous Jūjaka is of Amittatāpanā's feelings, reversing normal gender roles with his willingness to draw well water, wash clothes, and perform other domestic chores usually done by women.

Amittatāpanā finally convinces Jūjaka to travel to ask for Vessantara's children. *Tujok* had considerable fun describing the travel preparations and farewell scene. Unlike the Pali text, which then describes Jūjaka's arrival in Vessantara's kingdom, the *tujok* had Jūjaka wandering all over, traveling to such places as India, Japan, Vietnam, the United States, and whichever other countries the *tujok* might have some familiarity with and hence be able to incorporate a few words from the local language. Passing reference may be made to his wife wondering what is taking him so long. Only at the end of this international digression does Jūjaka finally end up in Vessantara's former court town to learn where Vessantara can be found.

Upon receiving directions to Khao Wongkot (Crooked Mountain), Jūjaka then sets off through the forest to find the royal family. This phase of his trip provides additional opportunities for entertaining challenges. The most important are getting past the royal guard, Jetabutr, and the hermit, Accuta, both of whom are suspicious of Jūjaka and initially reluctant to help him find Vessantara. The improbable scenarios end up with Vessantara's guardians assisting Jūjaka, who amazingly tricks them into believing he is a messenger of the king. While in some regional variations Jūjaka acts high-handedly, in the northern versions he is often portrayed as terrified of Jetabutr. Rather than using imperious language and treating Jetabutr as his inferior, Jūjaka accords him royal status. With tears running down his cheeks, saliva drooling from his mouth, he bows down before Jetabutr and begs not to be killed.²⁴

All texts appear to include Jūjaka's encounter with Jetabutr's dogs during his trip to the forest. The Pali version briefly mentions that Jūjaka sits in a tree, besieged by dogs, until he is rescued by Jetabutr (CG 39–40). However, this scene is another opportunity that *tujok* enjoyed expanding. One common expansion is giving the dogs names and characteristics (northern accounts typically note the presence of thirty-two dogs, and sometimes even more). Another expansion may be about Jetabutr's discovery of Jūjaka cowering in the tree and trying to figure out what strange sort of animal might be up there. Another variation is to pursue

a scenario in which Jūjaka hurts his leg during his journey; he then has various encounters with alleged doctors who suggest various improbable remedies.[25] Luang Poh Bunthong developed a scenario in which Jūjaka falls from branch to branch until he finally lands on the ground, where he is then chased by thirty-two dogs; he eventually captures all of them and ties each one to a different tree. The process is described to the audience in a rhyming pattern. The following is an abbreviated example, the *"tua"* being elongated for humorous effect:

Tua thii nyng baj mat ton basalang	The first dog was tied to a salang tree.
Tua thii song ow baj mat ton makkham	The second dog was tied to a tamarind tree.
Tua thii saam ow baj mat ton mai khii	The third dog was tied to a khii wood tree.
Tua thii sii . . .	The fourth dog . . .

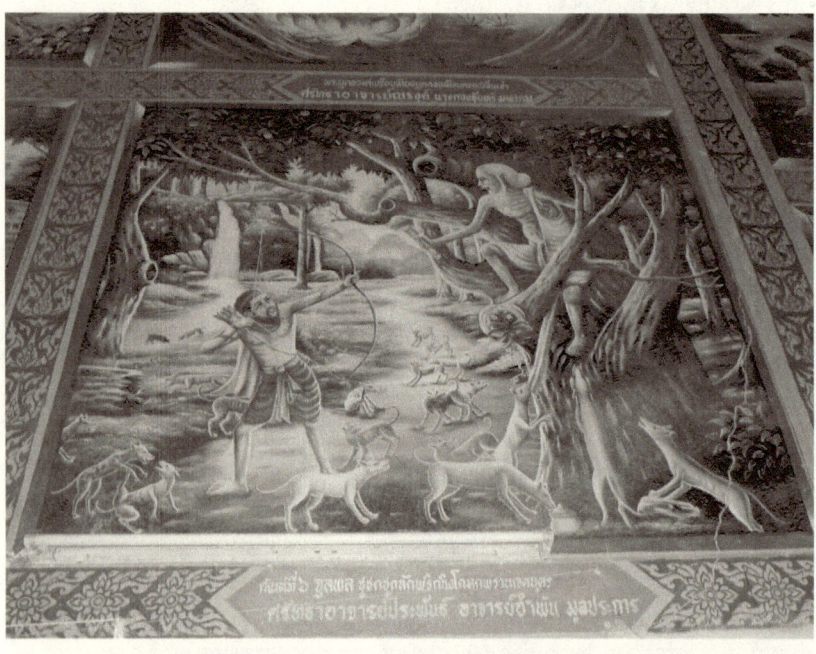

FIGURE 4.5 Temple painting of Jujaka in the tree, surrounded by Jetabutr and his dogs, Wat Huarin, Tambon Thungsatok, Sanpatong District, Chiang Mai Province PHOTO BY AUTHOR

This successful encounter with Jetabutr and his dogs brings the Jūjaka chapter to an end. Jūjaka appears in the next five chapters, but his role is essentially limited to that set out in the Pali version. However, the Maharaat chapter (chapter 11 on the Great King), in which Jūjaka dies from overeating, is another northern favorite and is often performed by monks who also specialize in the Jūjaka chapter. *Tujok* monks find numerous opportunities to enlarge Jūjaka's role, elaborating on the huge variety of foods the king gives him, how very miserable he feels after overeating, the myriad inappropriate medicines a variety of bad doctors give him, how far his stomach explodes, how no one can decide where to bury him, how no monks can be found to conduct the funeral rites, and how incorrectly the funeral rites are finally performed.

EARTHY ELABORATIONS

Tujok monks apprenticed with other monks to learn their versions of the story and their chanting styles. Although the *tujok*'s additions to Jūjaka's journeys might have begun as oral wordplay, over time either the *tujok* himself or his apprentices included the new versions in written form. However, they did not simply adhere to a written text, but broke the monotony of formal recitation with more colloquial comedic ad libs. These provided opportunities for the monks to make certain moral lessons explicit. Many of the comedic asides were, by today's standards, quite bawdy. Thus *tujok* had no problems including anecdotes about how sagging breasts can be useful for keeping cigarettes dry, or discussing such natural body functions as urinating, defecating, and passing gas. Many of the asides highlighted problems of everyday life, problems arising between married couples, with aging parents, and with wayward children. Other asides irreverently dealt with monastic life, making jokes about how monks have to eat whatever they are given, have to teach even the most difficult children in the village (like Jūjaka as a young boy), or are harassed by mischievous temple novices.

Luang Poh Bunthong incorporated a wide variety of such comic anecdotes in his renditions of the Jūjaka chapter, particularly when he was invited to perform single chapters at funerals or other special occasions. When discussing the marriage of Maddī and Vessantara, Luang Poh Bunthong embarked on a lengthy digression about relations between husbands and wives. The basic points of this digression are summarized in the following brief excerpt:

Are we like *Phra* Wetsandon [Vessantara] and *Nang* Maddī? Do we love each other so much we are willing to eat dirt and sand (*kin din kin saaj*, an expression referring to enduring poverty and other hardships) together? . . . At first, people swear they are willing to eat dirt and sand until they die, but after a few years they are ready to have their spouses eat kindling and brooms (*kin lua kin daamyuu*; i.e., throwing things at each other in a fight). As the saying goes:

"*Yam mya hak nam som ben waan;*	When in love, sour is sweet;
yam bocheeibaan, nam waan ben som.	when miserable, sweet is sour."

Some sense of how risque these ad libs once were can be gained from his tape recorded in 1990. For the wedding of Jūjaka and Amittatāpanā, Luang Poh Bunthong sang several songs, including one that describes a fight between a village couple in fairly bawdy terms:

Laelaeliu baj sutchan saaj taa	*Laelaeliu*, one could see him coming,
Kin sulaa maa mao khao baan	entering his home drunk.
Loi loi. . . . [flute part].	[flute imitation]
Khropkhrua thyng man bo khang	He didn't care about his family.
Man tae moh man tae haaj	He broke pots and vessels.
Thaa mia man lon khao baj	When his wife arrived,
Man pia phom mia man waj nen	he grabbed her tightly by her hair.
Yang maa tukh ok	Why such pain in her breast?
Yang maa tukh caj	Why such pain in her heart?
Wan waaj niipnaen.	She was very upset.
Panyaa kan kaen	She couldn't think clearly.
Sia mia man yuam taem kam.	Then the wife grabbed a handful (i.e., testicles).
Phutthoo tho tham	In the name of the Buddha and the dhamma,
Naa man byyt yao yao.	his face became very pale and long.

The scene in which village women gang up on Amittatāpanā provided Luang Poh Bunthong with an opportunity for further lessons on how one should treat one's spouse. Remarking on the village men who upset their wives by praising Amittatāpanā's dutiful treatment of Jūjaka, Luang Poh Bunthong cautioned his audience in scatalogical terms:

You know the saying, "Holding shit is better than holding a fart" (*kam khii dii kwaa kam tot*)? You should praise your own wife, not someone else's. Shit you can smear on your face; you can't do anything with a fart. If you complain about your own wife and praise someone else's, they will be upset. If you just want to complain about something, that's one thing, but don't bring someone else's wife into the picture.

Encouraging his audience to mind their own business and not interfere in other people's affairs, Luang Poh Bunthong said, "We all have our work to do, and we should just focus on doing that well." He then continued:

Mii suan ia suan hia.	If you have gardens, work your gardens.
Mii naa ia naa hia	If you have paddy fields, work your paddy fields.
Mii mia . . . ko liang duu hia.	If you have a wife, . . . take care of her.
Mii luuk ko liang duu luuk.	If you have children, take care of them.

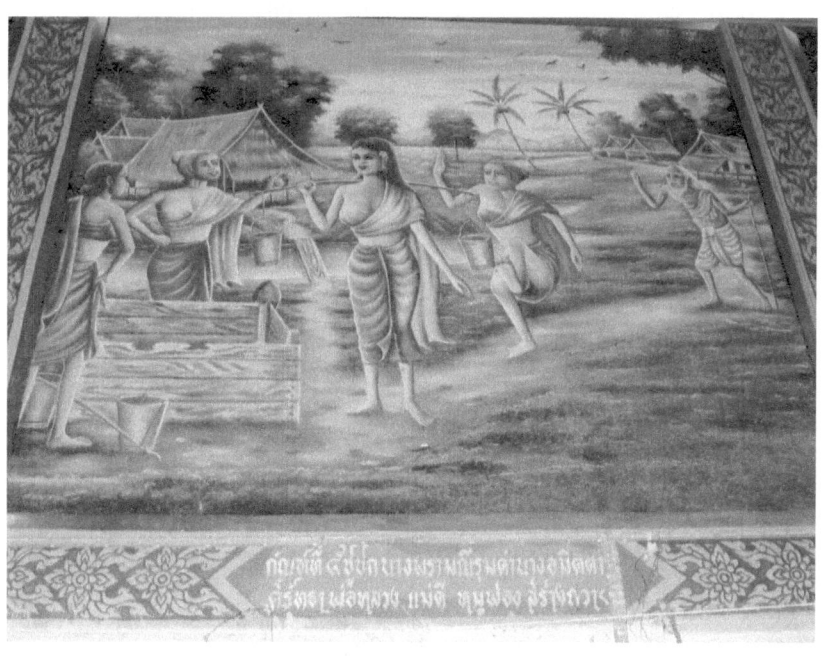

FIGURE 4.6 Temple painting of a crying Amittatåpanå surrounded by angry village women, Wat Huarin, Tambon Thungsatok, Amphur Sanpatong, Chiang Mai Province PHOTO BY AUTHOR

In this passage, Luang Poh Bunthong paused at a key moment, allowing his audience to fill in the anticipated word "vagina" (*hii*; *mii mia, ko ia hii hia* is implicit). However he never actually used the word, replacing it with a perfectably acceptable phrase, *liang duu hia*, which means "take care of her," generating even more laughter.

His treatment of life in the temple was no more reverent. He used the occasion of Jūjaka's invented childhood to create a scenario in which Jūjaka ordained as a novice. Of life in the temple, Luang Poh Bunthong sang in a mock-somber monastic chanting style:

Yuu kap tu kap phra	If you live with monks and novices,
Daj kin im kin taem	you can eat until you're full.
Kin gaeng ho kap khao yen	You can eat *gaeng ho*[26] with cold rice.
Bo chaj khaa uu en	I'm not bragging
Tot dang bang bang.	with loud farts, bang, bang.

He suggested that Jūjaka's parents sent him to the village abbot because they wanted him reformed. He went on to a long series of jokes describing life in village temples. Noting the common village phrase that parents use to scold their children, "Go to the temple if you just want to sit around and be comfortable like a monk (*sabaaj jang tu*)," Luang Poh Bunthong commented, to laughter:

> What is it about being a monk? We never get the good kids. The kids with high IQs and lots of knowledge, the parents keep to raise themselves, paying their school fees, etc. The bad ones get sent to the temple. You've all heard parents saying, "If you are this lazy, why don't you go to the temple?" It's like I'm supposed to be the head of a party of the lazy.

Luang Poh Bunthong then continued with a series about how monks tire of eating whatever vegetable is in season and complains about eating "hippie pork" (*muu hippii*), pork skin from which the pig hairs have not been fully cleaned. One of the funny stories he told was about a central Thai monk who was disliked by the village headman:

> There was once a central Thai monk. . . . The village headman decided he wanted to get rid of the monk. But he didn't want to be too obvious about it. What to do? He went around to all the villagers and told them, "This monk loves *phak kaat joh* [a kind of green plant boiled with tamarind seeds]. If everyone makes him *phak kaat joh*, he will stay with us a long time." So all

70 households made *phak kaat joh* to send to the temple, 70 platefuls, 35 for breakfast, 35 for lunch. The next day another 70, the day after another 70. He couldn't take it anymore. He had the novices protest and form a barrier in front of the temple. Each held a large stick.... Pretty soon a grandmother arrived, having specially made *phak kaat joh* to send to the temple. "Stop! [in English]. What dish have you prepared?" She got nervous. She had never before been accosted by novices holding clubs and had never before been asked what dish she had made. She put the *phak kaat joh* on the ground and waited, replying, "*Buu khiew hang dok* (flowering *phak kaat*)." The monk thought she must mean *kai khiew hang dok* [central Thai: chicken with white tail feathers]. So he thought, *Ah, this must be chicken*.... The grandmother delivered her dish and scurried off home. The monk was all excited; he could finally eat chicken. He opened the lid. In the name of the dhamma, in the name of the sangha, it was *phak kaat joh* again!

CONCLUSION

As Victor Turner has suggested, an anthropology of performance places text in context, "not in a static structuralist context but in the living context of dialectic between aesthetic dramatic processes and sociocultural processes in a given place and time."[27] Interpretive emphases of the *Vessantara Jātaka* have shifted over time and across regions in mainland Southeast Asia. When the northern written versions are compared with the Pali, one can see a significant expansion in the importance of the role of Jūjaka. Interpretations are continuing to change. If the nineteenth century, Jūjaka was primarily seen as evil and frightening in much of Thailand, today Jūjaka amulets are being produced to enhance Thai businesses, because Jūjaka was able to acquire everything he wanted. In northern Thailand, performances of the *Vessantara Jātaka* began to decline after World War II.[28] In part this decline paralleled the growing hesitation of *tujok* monks to engage in comedy. Several monks indicated their sense that their lay audiences increasingly felt that it was inappropriate for monks to engage in telling jokes. *Tujok* monks no longer wear costumes, although some bring elements of Jūjaka's costume and lay them next to their pulpit while they recite the chapter. Nevertheless, a few *tujok* remain, maintaining some sense of earlier performances.

Although individual *tujok* monks had considerable creative license, they shared an underlying comedic vision in their portrayal of Jūjaka. In the northern version, Jūjaka is not so much cruel and frightening as comic, a figure overcome by desire, without any normal social restraints

in effect. He is a study in paradoxes: a poor Brahmin who had amassed considerable wealth; an ugly old man who had gained a beautiful young wife; a terrified villager who tricked a royal guard; a beggar who was able to acquire royal children; a child abuser who lost his way in the forest but was gratefully feted at court. Like other tricksters who are "on the road," Jūjaka is amoral rather than immoral; his desires for money and a beautiful wife are human and understandable. The uncontrolled desires that culminate in his acquisition of royal children help provide all mankind with the possibility of salvation. As Radin explains:

> Trickster is at one and the same time creator and destroyer, giver and negator, he who dupes others and who is always duped himself. He wills nothing consciously. At all times he is constrained to behave as he does from impulses over which he has no control. He knows neither good nor evil yet he is responsible for both. He possesses no values, moral or social, is at the mercy of his passions and appetites, yet through his actions all values come into being.[29]

As its emphasis on Jūjaka suggests, the northern interpretation of the *Vessantara Jātaka* is a means to discuss the problems of everyday village life and provide a Buddhist paradigm for their solution. As one northern *tujok* explained to me, "Preaching the Jūjaka chapter is a technique of giving sermons using humor so that the listeners will find it enjoyable and pay attention to the story (*bot*), but the content is to teach about dhamma."[30] As a trickster bereft of normal social constraints, Jūjaka, meeting his demise by overeating teaches all of us—at a minimum—that moderation in all things is the best way to conduct our lives. Most of us are more likely to identify with Jūjaka's human desires than with Vessantara's superhuman denial of desire. Like most of his northern audience, Jūjaka is a poor villager trying to get ahead in life. The northern interpretation is a positive one of mutual recognition; Jūjaka represents understandable desires that exist in each of us, which wisdom must help us overcome.

Although proroyalist and promonastic readings are also valid, the northern emphasis on Jūjaka as trickster suggests the possibility of not only a nonroyalist interpretation but also an antiroyalist interpretation. Thai village folklore has a rich tradition of tricksters in which kings are not always heroic figures. Parallels can be seen between Jūjaka and the popular stories about tricksters such as Sri Thanonchai, a peasant who "employs guile, word play and wit to best everyone he encounters, including his own parents and his king."[31] In analyzing the factors

behind Sri Thanonchai's enduring popularity, Mechai Thongthep suggests that "common folk derived considerable vicarious pleasure from the ways the impudent hero irreverently challenged and bested officialdom, rich fools and foreigners with native intelligence, bluff and deception."[32] Royalist interpretations of the *Vessantara Jātaka* assume that villagers saw royal sponsorship of Vessantara recitations as a sign of a given king's incipient Vessantara-like nature. However, rather than simply confirming royal virtue, the *Vessantara Jātaka* can also invite a more complex discussion of ideal governance and whether the decisions of Vessantara, his parents, his courtiers, and his subjects were appropriate. In addition to serving as a proroyalist text, the *jātaka* may have functioned as a "weapon of the weak."[33] For village listeners who may have been hoping that their rulers would rein in their avarice and act more like Vessantara, the *jātaka* may have provided an implicit critique. Paying closer attention to regional variations in the performances of the *Vessantara Jātaka* provides insight into differences in textual emphases. Thus the northern comic figure of Jūjaka should encourage us to pursue new imaginative avenues in our scholarly journey into the long history of the *Vessantara Jātaka*.

NOTES

I would particularly like to express my appreciation to Luang Poh Bunthong Suwanno, whom I was fortunate enough to interview before his death in 2007. I would also like to thank Luang Poh Buntan (Phrakhruu Athong Visutikhul), Ajarn Manii Phayomyong (now also deceased), Naajdaap Thienchaj Buntanabutr, Poh Naan Saengmyang Ryangsin, Ajarn Prakong Nimmanhaeminda, Thanom and Khamphong Sutthana, Narong and Kongchan Mahakhom, Ot and Ning Mahakhom, Narintip Somjai Viriyabanditkul, Prakirati Satasut, Leedom Lefferts, Sandra Cate, Forrest McGill, Kesa Noda, Frank Reynolds, and Gertrud Bowie-Ulrich for their assistance with this essay.

1. Patrick Jory, "The Vessantara Jataka, Barami and the Bodhisatta-Kings: The Origin and Spread of a Premodern Thai Concept of Power," *Crossroads: An Interdisciplinary Journal of Southeast Asian Studies* 16, no. 2 (2002): 38. Jory suggests that because of their utility as "the principal conduit of a conception of authority and social hierarchy, Thai rulers would have actively promoted recitations of the Vessantara Jataka"; see Patrick Jory, "Thai and Western Buddhist Scholarship in the Age of Colonialism: King Chulalongkorn Redefines the Jatakas," *Journal of Asian Studies* 61, no. 3 (2002): 913.
2. Mikhail Bakhtin, *Rabelais and His World*, trans. H. Iswolsky (1965; reprint, Bloomington: Indiana University Press, 1984), 4.
3. G. E. Gerini, *A Retrospective View and Account of the Origin of the Thet Maha Ch'at Ceremony* (1892; reprint, Bangkok: Sathirakoses-Nagapradipa Foundation, 1976), 57.

4. Ernest Young, *The Kingdom of the Yellow Robe* (1898; reprint, Kuala Lumpur: Oxford University Press, 1982), 324. See also Jory, "Thai and Western Buddhist Scholarship."
5. Across the northern, northeastern, southern, and central regions, scholars have noted significant differences in the vernacular texts (e.g., Manii Phayohmyong, "Kaanwikhroh lae priapthiab *Mahachaat* chabab phaak klang, phak nya, phaak isaan lae phaak tai" [Analysis and comparison of central, northern, northeastern, and southern versions of the *Mahachaat*], thesis for Mahabandit degree, Srinakharinwirot University, 1976 [BE2519]).
6. Nidhi Eoseewong, "On the Phetchaburi Version of the *Mahachat*," in *Pen and Sail: Literature and History in Early Bangkok*, ed. Christopher John Baker and Benedict Anderson (Chiang Mai: Silkworm Books, 2005), 221–22; Sombat Chantornvong, "Religious Literature in Thai Political Perspective," in *Essays on Literature and Society in Southeast Asia*, ed. Tham Seong Chee (Singapore: Singapore University Press, 1981), 194.
7. Paul Radin, *The Trickster* (New York: Schocken, 1972), xxiv.
8. See Bonnie Pacala Brereton, *Thai Tellings of Phra Malai: Texts and Rituals Concerning a Popular Buddhist Saint* (Tempe: Arizona State University Press, 1995).
9. See Phayohmyong, "Kaanwikhroh lae priapthiab *Mahachaat* chabab phaak klang, phak nya, phaak isaan lae phaak tai"; Prakong Nimmanhaeminda, *Mahachaat Laanaa: Kaansyksaa naj thana thii ben waanakhadithongthin* [The Lanna Mahachaat: studied as local literature] (Bangkok: Munitii khrongkaandamraa sangkhomsaat lae manutsaat, 1983 [BE 2526]), 4; Sommai Premchit and Amphai Dore, *The Lan Na Twelve-Month Traditions* (Chiang Mai: So Sap Kan Pim, 1992), 77–85. In the central region, *Vessantara Jātaka* recitations could take place during Buddhist Lent over a period of several weeks. Central Thai novices often recited an individual chapter in a special ceremony sponsored by their parents and relatives. In northern and northeastern Thailand, recitations were unlikely to occur during Lent. Northeasterners could recall no occasions when an individual chapter would be performed. For further comparative details, see Katherine Bowie, "The Politics of Humor: The Vicissitudes of the Vessantara Jataka in Thailand" (unpublished ms.).
10. See H. Leedom Lefferts Jr., "The Bun Phra Wet Painted Scrolls of Northeastern Thailand in the Waters Art Museum," *Journal of the Walters Art Museum* 64/65 (2006/7): 99–118; Sandra Cate and H. Leedom Lefferts, "Becoming Active/Active Becoming: Prince Vessantara Scrolls and the Creation of a Moral Community," in *The Spirit of Things: Materiality and Religious Diversity in the Age of Religious Diversity in Southeast Asia*, ed. Julius Bautista, ed. (Ithaca: Cornell Southeast East Asia Program Publications Press, 2012); Leedom Lefferts and Sandra Cate, with Wajuppa Tossa, *Buddhist Storytelling in Thailand and Laos: The Vessantara Jataka Scroll at the Asian Civilisations Museum* (Singapore: Asian Civilisations Museum, 2012); Stanley J. Tambiah, *Buddhism and the Spirit-Cults in Northeast Thailand* (Cambridge: Cambridge University Press, 1970).
11. Mazes are also constructed in Burma (*wingoba*).
12. Matsi, Kuman, Maharaat, and Nakornkaan being the other particularly lucrative chapters.
13. Prakong, *Mahachaat Laanaa*, 44.
14. Henri Bergson, *Laughter: An Essay on the Meaning of the Comic*, trans. Cloudesley Brereton and Fred Rothwell (1911; reprint, Mineola, NY: Dover, 2005), 2–3.

15. Lewis Hyde, *Trickster Makes This World: Mischief, Myth, and Art* (New York: North Point Press, 1998), 6–7.
16. See Prakong, *Mahachaat Laanaa*.
17. Luang Poh Bunthong was the longtime abbot of Wat Sophanaaraam, Tambon Dohn Kaew, Amphur Mae Rim, in Chiang Mai Province. He died in 2007.
18. Tu Lung Thong (Luang Poh Bunthong Suwanno), *Thaet Mahachaat 13 Kan* (Wat Sophanaaraam, Tambon Dohn Kaew, Amphur Mae Rim, Chiang Mai: Distributed by Thipanet Enterprise, Chiang Mai, November 23, 1990 [2533]).
19. As Nidhi suggests, in nineteenth-century Thai versions the characters act less as puppets of the gods but "begin to be transformed into people who act according to their own personality and self-interest" (*Pen and Sail*, 221).
20. See Manii, *Kaanwikhroh lae priapthiab Mahachaat*; Prakong, *Mahachaat Laanaa*.
21. Wat Lampang Luang has one of the few surviving nineteenth-century northern Thai mural paintings of the *Vessantara Jātaka*; unlike temple paintings in other regions of Thailand, this mural shows Jūjaka's home with these four stilts.
22. Manii, *Kaanwikhroh lae priapthiab Mahachaat*, 225; Prakong, *Mahachaat Laanaa*, 60.
23. Prakong, *Mahachaat Laanaa*, 15–16; Manii, *Kaanwikhroh lae priapthiab Mahachaat*, 319–20.
24. Manii, *Kaanwikhroh lae priapthiab Mahachaat*, 231–32.
25. Poh Naan Saengmyang Ryangsin, age 82, interview, Kile Luang #4, T. Yuwa, A. Sanpatong, Chiang Mai Province, July 30, 2005.
26. A kind of village ragout.
27. Victor Turner, *The Anthropology of Performance* (New York: PAJ Publications, 1988), 28.
28. John P. Ferguson and Shalardchai Ramitanondh, "Monks and Hierarchy in Northern Thailand," *Journal of the Siam Society* 64, no. 1 (1976): 104–50; Brereton, *Thai Tellings of Phra Malai*.
29. Radin, *The Trickster*, xxiii.
30. Phrakhruu Athong Visutikhul (Tuchao Buntan), Rong chao khana and abbot, age 58, interview, Wat Nong Tong, A. Hang Dong, Chiang Mai Province, July 13, 2005.
31. Mechai Thongthep, ed., *Tales of Sri Thanonchai: Thailand's Artful Trickster* (Bangkok: NAGA Books, 1991), 9. Sri Thanonchai is also known as Sieng Miang.
32. Mechai, *Tales of Sri Thanonchai*, 9. Other examples are Maung Htin Aung, *Burmese Monk's Tales* (New York: Columbia University Press, 1966), and Chris Baker and Pasuk Phongpaichit, trans. and eds., *The Tale of Khun Chang Khun Phaen: Siam's Great Folk Epic of Love and War* (Chiang Mai: Silkworm Press, 2010).
33. James C. Scott, *Weapons of the Weak: Everyday Forms of Peasant Resistance* (New Haven: Yale University Press, 1985).

{ 5 }

NARRATION IN THE VESSANTARA PAINTED SCROLLS OF NORTHEAST THAILAND AND LAOS

Leedom Lefferts and Sandra Cate

PHA YAO *Phra Wet*, long painted cloth scrolls depicting key events in Prince Vessantara's life, add visual, textual, and material complexities to the social existence of this renowned *jātaka*. As visual narratives celebrating the merit of the prince, the scrolls tell the story. As objects processed and displayed in the annual Bun Phra Wet festivals of northeast Thailand and Laos, the scrolls enact the story. Utilizing storytelling strategies that differ from literary or oral narration, they rearrange relations between storyteller, story, and performance; and, in their materiality, they generate embodied effects beyond those of other modes of telling.

As art objects, the 18–40 meter-long *pha yao Phra Wet* live as contemporary descendants in the long lineage of visual Buddhist narratives,[1] from the monumental bas-reliefs of Sanchi, Bharhut, and Borobudur to the mural paintings found at Ajanta in India and in Sri Lanka, Thailand, Laos, Burma, and Cambodia. Today, these scrolls form one of Buddhism's largest corpora of visual presentations of the *Vessantara Jātaka*. As such, they continue a tradition of narrative scroll painting that originated in India millennia ago.[2] However, unlike in other oral storytelling events in South and Southeast Asia, performers do not narrate directly to *pha yao Phra Wet* scrolls, nor do they use them as visual references for an oral recitation. These scrolls do not serve solely iconic functions in the context of sacred spaces, as do other visualizations of *jātaka*-s.[3] Rather, they establish a distinctive, horizontal narrative space that shapes locally variant tellings of the Vessantara story, emphasizing the aspects most resonant

with local values and experiences.⁴ During the Bun Phra Wet festivals held throughout Theravāda Buddhist communities in northeast Thailand and Laos, participants process with the scrolls, asserting their own narrative agency to transform their time, spaces, and community into those of the prince.⁵ Performing collectively, the Thai-Lao retell the story with themselves as the actors, celebrating the promises of success of the prince and his subjects as their own, both in the present moment of the celebration and in the future.

THE THAI-LAO, THE LAO, AND THE BUN PHRA WET

Twenty million-plus Thai-Lao (ethnic Lao) inhabit northeast Thailand, known as Isan. They are cousins to some 4.5 million lowland Lao who live to the north and east of Isan, across the Mekong River in the Lao People's Democratic Republic. Both groups speak Lao and express a culture with a common origin in Tai socioeconomic forms associated with wet-rice agriculture and in Theravāda Buddhism.⁶ Over the past sixty years since the end of World War II, both Thai-Lao and Lao have been subjected to much economic and political pressure to become "modern" and "developed." This has been especially the case for the Thai-Lao of Isan, citizens without formal government recognition of the ethnic and cultural differences between them and the Central Thai (Siamese), who control the kingdom and its governmental and religious bureaucracies. Over time, many Thai-Lao and a number of Lao have migrated from their home villages into urban centers both in Thailand and abroad as contract laborers. This has shifted the balance of resources and consumption from a village-based, cooperative, wet-rice economy to one of remittances from family members employed elsewhere. While the economic structure may have changed, allegiance to village institutions remains strong, even among those who have moved away. The Bun Phra Wet, the festival for celebrating the life and merit of Prince Vessantara (Phra Wetsandon, short form: Phra Wet) and the occasion for the display of the *pha yao Phra Wet*, is one of the major religious festivals by which people who remain in villages attract relatives and village members who have left, to reinforce communal ties.⁷

Village or city *wat* (Theravāda Buddhist temples) and the monks, novices, and *mae chi* or nuns who reside there remain dependent largely on local residents for their material needs, through daily contributions of food and frequent donations of money and time. Secularizing and modernizing projects in the Thai northeast and in Laos increase pressures

for *wat* to sustain the merit exchanges that enable their activities and, indeed, survival. The story of Phra Wetsandon thus carries particular salience, and murals and lithographs depicting this *jātaka* have become increasingly popular. Permanently painted or hung in a temple's *sala* (Lao: *hau jaek*) (meeting hall), this imagery serves mimetic functions for the temple's social life, continually reinforcing the ethics and rewards of generous giving.[8] Unlike other regions of Thailand that emphasize the *Thet Mahachat*, the chanting of the Great Life (see Bowie, this volume), Thai-Lao *wat* celebrate the *bun* or merit of the prince through the Bun Phra Wet, enacting the festival through an abundance of merit-earning gifting opportunities.

The Bun Phra Wet is usually the largest festival in the annual ritual calendar; it is often termed the *Bun Pracham Pii*, the Annual Festival. Because of its importance for each of the more than 8,000 Isan Thai-Lao villages and perhaps 2,000 Lao villages, neighboring *wat* stagger the dates for their ceremonies. *Wat* usually hold the festival during the fourth lunar month (March and early April), but we have recorded instances of its occurrence from early January through late May and into June. As it is the *wat*'s best attended and, usually, most expensive festival, local monks and lay committees tend to schedule it at a mutually convenient time, to maximize donations and to increase the possibility of making merit at each location. They also hold Bun Phra Wet ceremonies as part of a larger celebration: to consecrate a Buddha statue,[9] to dedicate a major *wat* structure such as an *ubosot* (Lao: *sim*), ordination hall, or to ordain monks and novices. Some villages hold their Bun Phra Wet during Songkhran, the traditional Lao and Thai New Year in mid-April, when temples can anticipate larger crowds. A well-run, well-timed Bun Phra Wet attracts many attendees as well as turning good profits, its success reflecting on the village as a whole.

We have tracked the Bun Phra Wet and its scrolls across northeast Thailand, much of Laos, and into the Thai central plains, where Thai-Lao migrants have established communities with *wat* where Thai-Lao are the resident monks. Our ethnographic research includes visits to over 200 *wat*, documenting at least 100 scrolls that differ significantly from one another (many are quite similar). We have attended numerous Bun Phra Wet celebrations and elicited additional descriptions of what each *wat* "does" for the festival.[10] Generally speaking, all *wat* closely associated with a village, of both Mahanikai and Thammayut sects, hold a Bun Phra Wet, but forest temples, *wat pa*, generally do not, as they usually belong to

the stricter Thammayut order and do not have adjacent lay communities. Major urban *wat* hold Bun Phra Wet recitations, but may not process the long scroll.[11]

The drama of the festival occurs over several days. Our research underscores the scrolls' central role in this region, as informants consider them essential to the festival itself. Many we interviewed—monks and laity alike—claim that the Bun Phra Wet cannot be held without them; as these long painted scrolls are often beyond the means of small rural *wat*, one *wat* will lend its scroll to a neighboring *wat* so that it may also have a Bun Phra Wet. Further, of all the activities unfolding during the festival, the scroll procession—which performs the climactic scenes of the story—attracts the most participants from the village: young and old, women and men. In contrast, the recitation the next day attracts a much smaller audience, usually older and predominantly female. Those present during many recitations we have observed chat with their neighbors, prepare or

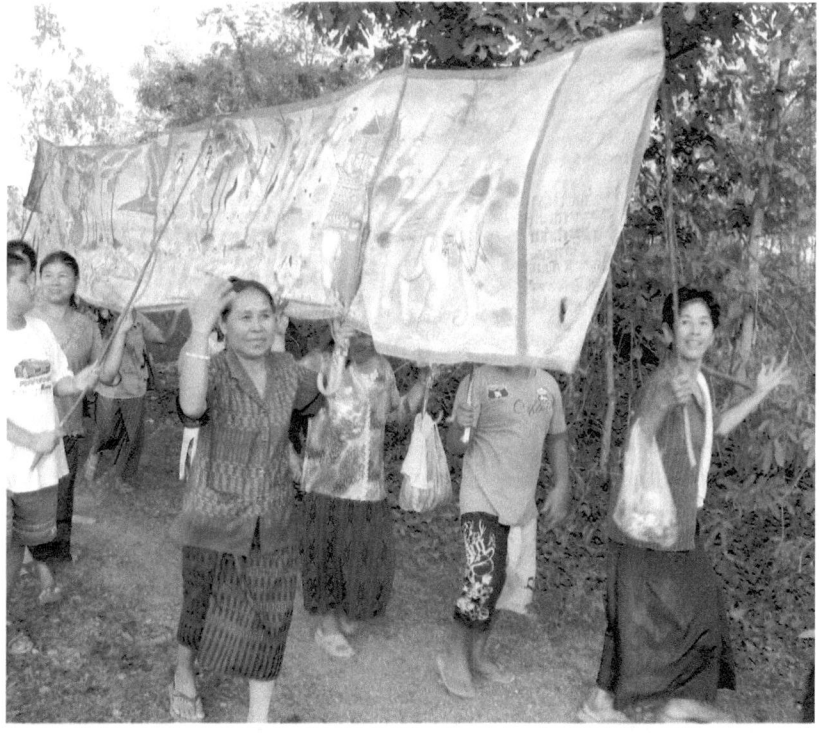

FIGURE 5.1 *Pha yao Phra Wet* in procession PHOTO BY AUTHORS

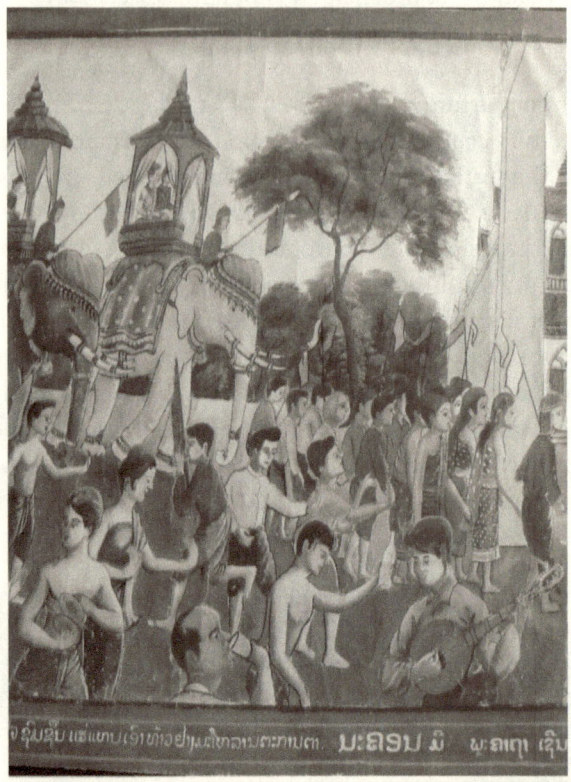

FIGURE 5.2 *Nakhon* procession on scroll PHOTO BY AUTHORS

organize offerings, come and go.¹² Loud musical accompaniment to the groups carrying *ton ngern,* money trees, often distracts from the monks' performance, rendering the recitations almost anticlimactic. Activities in the forest and the scroll procession itself move to the center of the Thai-Lao Bun Phra Wet.

Usually in mid-afternoon of the first day, members of a *wat* congregation and monks gather at the *pa,* a place designated as "forest."¹³ There a layman or monk recites an invitation to Phra Wetsandon and, sometimes, Matsi, his wife (often village residents may be designated to play these roles), to return to the kingdom from which they had been exiled, *choen Phra Wet khaw zu muang.* After the prince agrees to return, celebrants unroll the scroll and then, hanging it from long forked sticks or grasping its upper edge, they walk from the *pa* the few kilometers back to the *wat.* Sometimes rented live elephants (or papier-mâché versions carried

on pickup trucks) carry congregants dressed as King Sonchai and Queen Phutsadī (Phra Wetsandon's parents) and Phra Wetsandon and Matsī. A local Chuchok usually follows, dragging along the couple's two children with vine or rope leashes, thus suggesting they have not yet been ransomed.[14] At the end of the procession, villagers, many in various stages of inebriation, dance to the distinctive Thai-Lao melodies blasted out by a large truck mounted with electric generator, tape deck, and loudspeakers. As the procession winds through the fields and into the village, many join in, often eagerly taking hold of the scroll. Dogs and children on bicycles follow. Villagers set out mats along the pathways and water to drink or spray as relief from the heat. Their procession presents a striking confluence of Phra Wetsandon's triumphal return to his kingdom with his subjects, painted on the scroll they carry.

The procession ends at the village *wat*, decorated with flags, flowers, and other ornaments making it fit to receive a king. Those carrying the scroll circumambulate three times around the *sala*, the meeting hall that has been prepared as a *rajawat*, royal temple. They then enter and hang the scroll around the *sala*'s perimeter. As they enact physically what is depicted visually, the prince returns home.[15]

A NOTE ON READING: THE TEXTUAL, THE VISUAL, AND THE MATERIAL

Our research finds that *pha yao Phra Wet* tell the Vessantara story in a manner parallel to written or recited texts. Analyzing Thai and Lao monastic pedagogy, McDaniel characterizes texts as "individually fashioned lenses through which individual scholars read, translated, and commented on Pali texts in the vernacular . . . individually forged means by which scholars (in *wat*) taught."[16] Just as monastic scribes engaged with and altered manuscripts, scroll artists have painted unique and often quite local renderings of the story.

Rather than depicting only actions central to the narrative (as do most Phra Wetsandon temple murals), a number of scroll artists extend scenes and thus the story with details and perspective, for example, indicating the long path to be taken by Phra Wet, winding into the mountains. Some captions written on the scroll identify chapters; other captions explain and provide dialogue for the depicted actions and characters. Scenes of the story elaborated with great detail and captioning provide evidence that at least some artists intend their scrolls to be read by viewers, much as they might read a written text. However, our observations and discussions

with scroll artists and viewers suggest neither visuals nor written text are sufficient; neither stands alone as the complete story. The written and the visual reinforce and clarify each other, together constituting a full version of the *jātaka* for that time at that location.

The scroll's material qualities and use in the Bun Phra Wet procession, however, suggest a more complex relationship with the story as it is performed. Participants have told us they believe the scroll's cloth contains the spirit of the prince; thus hanging the scroll brings the prince into the recitation space.[17]

Scrolls remain rolled up until blessed in the forest by the monks of the *wat*; then they are unrolled and carried back in procession. Their extraordinary length and pliability not only enable but also require collective effort. The white cotton cloth of the scrolls relates to *sai sin*, the white cotton thread used in Buddhist ritual to encircle a merit-making, blessed group or to connect individual worshipers with sacred images of the Buddha and with monks. The thread conducts sacred powers of the images or the blessings of the monks.[18] This connection between scroll and *sai sin* was established clearly by one Vientiane Lao monk, who said the route along the Mekong River road was too busy for celebrants to carry the scroll, so instead they returned to the temple, connected to one another with a thick rope of white cotton thread. All those touching the scroll thus connect with the powers of the prince in the cloth (his merit made explicit in the painted story), and connect with one another to form a socio-karmic community, earning merit together.[19] While processed from the forest through the fields and into the village, the scroll thus encourages another type of visualization that merges the events painted on it—often with the "Nakhon," chapter 13's triumphal return to the procession's front—with the events enacted at the same time—subjects accompanying their king back to his, and their, kingdom.

This introduction to the *pha yao Phra Wet* illustrates the complexity of issues "behind" as well as painted into it, matching the complexity of the story itself. Much of the scholarly literature on the Bun Phra Wet has focused on the recitation of the *Vessantara Jātaka* by monks, considering the *pha yao Phra Wet* either peripherally or not at all.[20] Yet our research suggests that the visual and the material are as significant as the oral recitation in the performative life of the Prince Vessantara story in this region. Activities concerning the scroll and the other aspects of material culture in the festival contribute to the formation of the participants' religious subjectivities, as individuals and as a community making merit together, achievements contained within the narrative.

VISUALLY NARRATING THE
VESSANTARA JĀTAKA

As a visual portrayal of the *jātaka*, scrolls undertake two tasks. First, they depict crucial months of Phra Wet's life, the narrated events of the *jātaka*. Second, with introductory scenes or panels, they orient the members of this celebrating community to the story's relevance in their own lives. As a narrative event, then, these two tasks duplicate the oral and textual traditions, codified in the recitation. Once the scroll has returned to the *wat*, monks chant *Malai mun, Malai saen*, the story of Phra Malai, introducing audience-participants to a reason for the story and the possibility of a propitious future rebirth. The next morning they begin the recitation, chanting the "1,000 verses" of Phra Wet's life and the commentary that accompanies them. Structurally, the *jātaka* itself unites the events of narration, the story of the present, with the narrated events, the story of the past, and the identification of births of those actors in the story and those present at its telling—the story's consequences for the current Buddhist era in which we live.[21]

Introductory Panels

Most scrolls consist of more than the thirteen chapters of the *Vessantara Jātaka*. Many include a dedication panel that establishes the merit made through the scroll's donation, repeated every time the scroll is used. This dedication panel identifies the donor(s) who gave the scroll to the *wat*, the donor's wishes that the scroll be a remembrance of them or some other dedicatee, the amount spent on the scroll, and the date. This panel often includes the artist's name (sometimes with address or phone number) in case the viewer wishes to commission another scroll, or the name of the *wat* and its location in case the scroll is loaned out.

Apart from the dedication, Phra Wet scrolls almost always have panels depicting *Phra Malai mun, Phra Malai saen*,[22] and *Sangkhat* that proclaim the importance of the narrated events to the viewers, referencing the larger structure of the festival as well as the structure of the *jātaka* itself. In northeast Thailand and Laos, unlike in central Thailand, the Phra Malai story has become fully integral to written, visual, and oral Thai-Lao tellings of the *Vessantara Jātaka*.[23] The Phra Malai panels visualize actions preceding the *Vessantara Jātaka* and remind viewers to listen to the complete recitation of the story, an event that will take place the next day, so that they can be reborn in the time of Phra Ariya Maitreya, the Buddha to

FIGURE 5.3 Phra Malai visiting hell PHOTO BY AUTHORS

come. Sometimes preceding these two panels, an introductory segment depicts a young man presenting lotuses to Phra Malai, asking him to go to the other worlds and report back on what he sees.

The two Phra Malai chapters convey striking visual information: they encompass Phra Malai's descent to hell and his subsequent journey to heaven, where he meets Phra Ariya Maitreya, who enjoins him to take his statement back to the human world. Usually both scenes are painted as direct portraits of hell or heaven, with Phra Malai observing the events. The hell scenes provide copious room for the artist to display garish and gory punishments that are not present in written tellings. On some scrolls these scenes appear at the end, reinforcing the message that making merit is the purpose of life.

Sangkhat, a scene present on almost every scroll—and a requirement for a recitation of the *Vessantara Jātaka*[24]—serves as the story of the

present, locating the tale in the time of the current Buddha as he recounts his immediate past life. A monk initiates a recitation by noting that this story is told on today's date in this particular place and that it replicates the story the Buddha told about his past life so many years ago. The scroll's *Sangkhat* reproduces this event in usually one of two variations. One is a synoptic view of the Buddha achieving enlightenment, *Mahavijara*, through the assistance of Nang Thorani wringing water out of her hair to subdue the armies of Mara. This water flows from the merit Vessantara made during his previous reincarnations—including his penultimate human life as depicted in this story—when he poured water to seal his gifts as he made them in the course of that life.[25] The other variation replicates the Buddha reciting the initial version of the *Vessantara Jātaka* at Muang Kabinlaphat. He is seated on a lotuslike pedestal with monks and other disciples gathered below. He tells the story because a miraculous ruby-red "Bokkhoraphat" rain has begun to fall.[26] The Buddha remarks at the wonder of the assembled monks, saying that this rain had previously fallen when Phra Wetsandon had made great merit. The Buddha then continues to recount his previous life, the story of the past.

The *Sangkhat* enables the scroll and the recitation to achieve their combined power, as this scene conflates the past era of Prince Vessantara with the present Buddhist era and the telling of the story in the specific here and now of this *wat*. As every viewer of a scroll and listener to a recitation knows, when the Buddha completed his initial telling of the story, he stated that the people who were alive during his era and participated in his coming to enlightenment were the same people who participated in Vessantara's success, the connection. Current reciters—monks and novices, the descendants of the Buddha, sitting in an elaborately decorated *thammat*,[27] preaching chair—thus replicate the Buddha's own telling of his past life. *Sangkhat*, both on the scrolls and in performance, completes this identity.

With the Phra Malai scenes, scrolls offer contextual and ethical references to merit making as metacommentary to the story itself. The typical *jātaka* structure is here more complexly rendered: scroll *Sangkhat* scenes, of whichever type, function as the story of the present, and, with its scenes of the Vessantara story, the scroll tells the story of the past. The connection between those in the story and those living in the time of the current Buddha is implied in two ways. First the subjects accompanying the six royals back to the kingdom in the final scenes of the "Nakhon" are presented as contemporaries in dress, manner, and details (discussed below). Second, as the entire scroll is processed by the living community

returning the prince to his, and their, kingdom, the connection is established through this performance.

The Thirteen Chapters

Following the introductory scenes locating this visual telling in place, time, and significance, *pha yao Phra Wet* depict the *Vessantara Jātaka* in thirteen *kan*, chapters.[28] Variations in scroll presentation range from monoscenic narration, with one scene per chapter, to scrolls painted as continuous narratives, with landscape and/or architectural elements subtly marking the transition between sections. Since the 1990s each of the two villages in northeast Thailand producing the majority of scrolls has standardized its depiction, with defined borders between chapters. Community artisans tend to paint the story overall in a mode of continuous narration, with the storyline running either right to left or left to right; contemporary painters seem to prefer left to right. However, within specific sections, the storyline may move in other directions, often as synoptic narration, with multiple events contained within a single visual space.[29]

A border often encloses the narrative; older scrolls use variants on a vine, leaf, and flower pattern representing a lotus.[29] Some scrolls define borders using red or green paint. Dividers between chapters can consist of the same design as the borders or of simple bands of color, usually red.

Text appears on almost every scroll. At a minimum, this consists of a notation in or close to the bottom border noting the chapter number, its name, and the number of its *phra khatha*, verses or statements of the Buddha when he first recited this story. In total, these *phra khatha* number 1,000, the purported number of verses in the complete *Vessantara Jātaka*,[30] and a number ingrained in Thai-Lao conceptualizations of the story. For communicants, this *is* the number of verses spoken by the Buddha. Through citing this number, a scroll achieves congruence with the Buddha's authoritative oral recitation.[31]

Older scrolls tend to have more text than current ones. The Singapore Asian Civilisations Museum scroll, painted in BE 2502 (1959),[32] has approximately 195 captions, ranging from chapter headings to lengthy descriptions of actions, itemized deliverances of blessings, and dialogue. Some scrolls even annotate the flora and fauna that make up the magical Himalayan forest through which first the royal family, then Chuchok, make their way.

Several different scripts and languages appear on scrolls: Thai, Lao written in Thai script,[33] Thamma script (old Lao), Thai Noi, Khmer

(on Lao or Thai-Lao scrolls), and, in Laos, varieties of Lao. Often more than one script is present, possible evidence that more than one person wrote on a scroll. Captions are often added after a scroll's completion and donation to a *wat*; thus several hands can be involved in presenting what we see and read today.

Issues of Style

Visually, scrolls represent the skills, interests, and visual models available to local, usually self-taught artisans. Most often artists paint figures in an idealized rather than realistic manner, some with cartoonlike outlining in black that is filled in with color. These styles echo the flat narrative spaces and the multiperspectival and two-dimensional conventions of Thai and Lao mural painting.[34] Other artists add considerable decorative details to dress and shadings that indicate weight and materiality, or render perspectives of depth in both landscape and architectural scenes. Artists frequently paint animals realistically with great detail, placing them solidly in the *kamaloka*, the world of material form in the Buddhist cosmology.[35]

Scrolls differ radically in their degree of elaborative detail, either decorative or narrative; artists have told us this depends in part on their commission and the length of the scroll they are painting. Color palettes also vary widely. Some scrolls, painted with only a few subdued colors, have an overall unity that make other scrolls with a more expansive palette seem almost garish. The scrolls painted in Isan's two artisan villages since the turn of the twenty-first century are *si sawang*, painted in bright, fluorescent tones of blue, pink, green, and yellow, a color preference adopted by other regional painters as well. Some painters fill the scroll with painted landscape elements to contain the action; others retain lots of white space that frames rectangular scenes of action. The landscape can be expressively suggested with a few brushstrokes or painstakingly rendered in great detail. Few generalizations can cover the range of styles and manners of depicting humans, landscape, animals, and architecture on scrolls. That said, the royal figures of the story nearly always appear wearing the *chada*, Thai-Lao royal headdress. Villagers, such as those who torment Amittata in the Chuchok chapter or the king's subjects who march in the "Nakhon" procession back to the kingdom, are frequently painted in a looser, more naturalistic style than the idealized royals, marking distinctions of morality as well as social distance. Dress and the architectural settings of such scenes also connect the world of the Vessantara tale to that of the viewers.

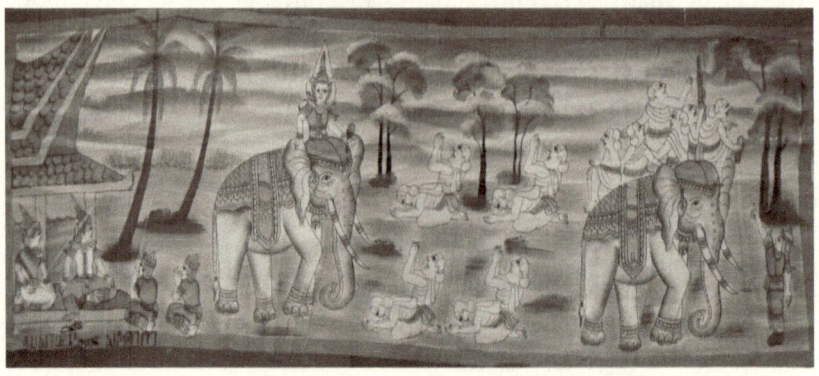

FIGURE 5.4 Phra Wet donates the elephant. PHOTO BY AUTHORS

Unity and Narrative Direction

That artists paint the story with different sequencing of its events complicates any simplistic notion of reading a scroll. The two villages that paint scrolls today provide separate panels for each chapter, which, with the inclusion of the Phra Malai panels and *Sangkhat*, means at least sixteen panels. If a panel has more than one action, they usually occur sequentially, left to right. This makes for a rather static, but easily followed presentation of iconic scenes from the story's chapters. An uninformed viewer might be able to work out the story, or at least its highlights, by following the scenes from left to right. Moreover, artists also change the sequencing from that of the written texts, suggesting other motives. Perhaps to underscore visually the underlying messages, artists place key scenes first in a panel's sequence of events, or repeat figures in the same action space.

For instance, the scrolls produced in Ban Kau, Mahasarakham Province, in the 1990s–2000s depict "Himaphan" (chapter 3, when Phra Wet gives the elephant to eight Brahmins) with three scenes:

a. far left, two royals sitting in a "palace," with two men lower down, bowing;
b. center: eight Brahmins (most likely the same stencil duplicated, with minor postural changes) bowing to Vessantara, who pours water from an ewer while sitting on an elephant; and
c. right, elephant carrying six Brahmins, walking out of frame to the right with commoner(s) in front, facing them, finger(s) pointing upward.

The elephant conveys narrative continuity and sequence, as it is repeated twice and walks toward the right, out of the panel to the next one. However, in narrative action, the two men bowing in front of the palace occurs *after* the elephant donation; it depicts the citizens complaining to Phra Wet's father, King Sonchai, that his son is giving away the kingdom's wealth. Placing this protest first in the left-to-right sequence emphasizes the citizens' action that initiates Phra Wet's exile to the Himalayan Mountains, instead of privileging the donation of the elephant, usually thought of as the crucial point of this chapter. It thus reinforces the chapter title, "Himaphan," focusing on the exile that is to come as the result of the donation.

A panel's sequencing of action is sometimes reversed, as for "Matsi" (chapter 9), with the scenes instead appearing right to left:

a. left, Phra Wet behind the fainted Matsi, pouring water over her from a ewer;
b. middle, Matsi walking in the pond, bent slightly down, searching for her children;
c. right, occupying more than a third of the frame, three growling animals holding Matsi at bay; and
d. right, above c), Matsi uses a pole to pick fruit from a tree, with two baskets resting beside her on ground.

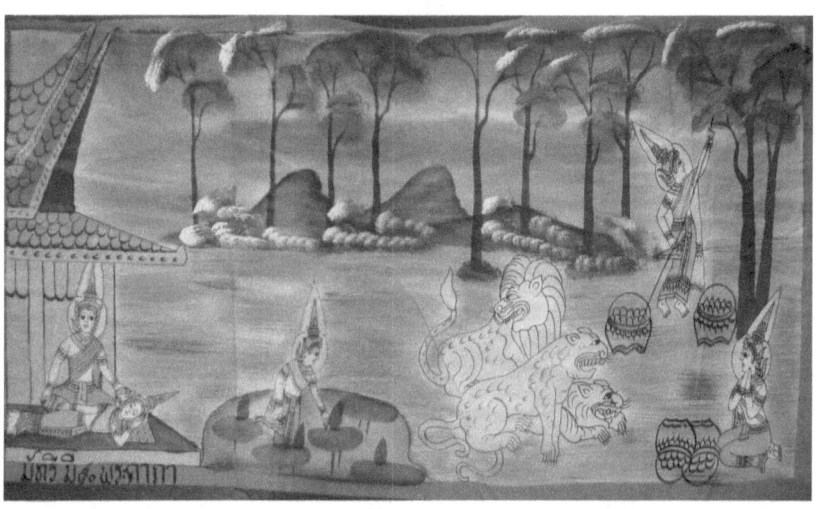

FIGURE 5.5 Matsi searches for her children. PHOTO BY AUTHORS

This right-to-left progression on the scroll reverses the order of the story's events as usually narrated. Matsi has gone into the forest to gather food for her family; she picks fruit (action d, to viewer's right) to signify this. To prevent Matsi from returning home and hindering Phra Wet's donation, three angels turn into animals that block her path (action c, center right). Once Matsi returns, she discovers the children missing and Phra Wet unresponsive to her appeals; she searches high and low for them in the mountains and in the hermitage pond (action b, center left). Finally, totally despondent, she returns to the hermitage and faints. There Phra Wet puts her head on his knee (the first tender action from him in the seven months they have been in exile) and pours water over her, reviving her and at the same time transferring to her some of the merit he gained by the gift of the children (action a, viewer's left). Since this arrangement holds in many other scrolls, even those not from this village, we think the reversal intentional. By placing the scene of Phra Wet comforting Matsi first, the artist maintains visual focus on the karmic nature of his gift, as well as depicting, even intensifying, this section's emotional core. This offers a counterpoint to the scenes that follow: Matsi's frantic and fraught search for her children.

A more dynamic example of this same scene is depicted in the scroll in the collection of the Asian Civilisations Museum, originally donated to Wat Ban Tha Pho Sri, Ubon Ratchathani Province, dated 1959 (Buddhist Era 2502).[36] Rather than using the red frames of many contemporary scrolls, the artist, Sopha Pangchat, demarcates scenic transitions with trees, lumps of rocks, and chapter titles along the bottom edge. He manages

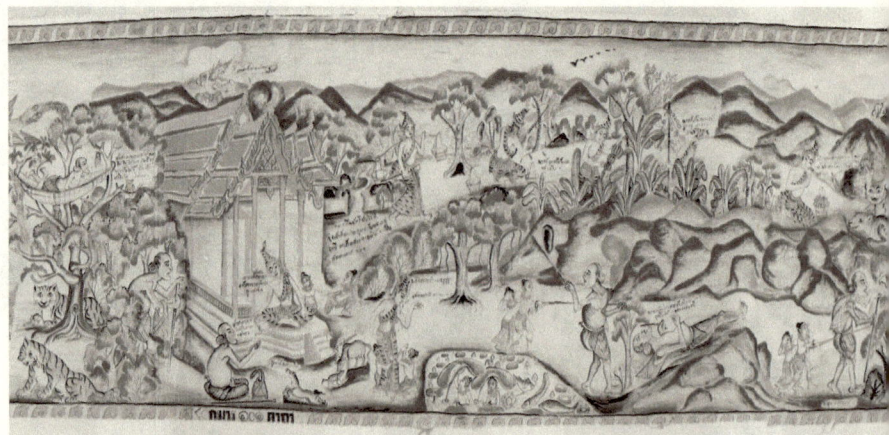

these transitions to establish dramatic continuity, rather than to paint a sequence of events matching written versions.

The artist ends Chuchok's journey to the hermitage in the evening, too late to ask Phra Wet for his children; thus, the artist concludes the "Mahaphon" chapter, the trek through the forest, with Chuchok going to sleep in a tree. The standard written narrative places this episode at the *beginning* of the next chapter, "Kuman," concerning the children.[37] Sopha depicts Chuchok lying in a hammock tied to a tree that is part of the forest he has just traversed. He is stretched out on his stomach with his legs raised in the air and crossed. Text near his head reads, "Oh, there is Phra Wet's hermitage. It's dark now, so I can't go in. Besides, Matsi is in; it won't work. I will just sleep in the tree. Early in the morning, I will go to ask [for the children]. That will work." By ending the section of the story at this point, the artist increases the dramatic tension of Chuchok's pending request to Phra Wet. In contrast, the written version uses this scene at the beginning of the succeeding chapter, "Kuman," to increase the impact of the gift of the children, the episode's focus.

Following Chuchok's words, the scroll depicts, more elaborately than any other scroll we have seen, Matsi's travails during and after her husband's giving away their children. Using two images of the hermitage to visually contain the action (and captions to identify and explain scenes), Chuchok's plea to Phra Wet at the hermitage opens the "Kuman" chapter; the second portrayal of the hermitage begins the "Matsi" chapter. The textual narration continues from Chuchok's earlier comments to state that Matsi "had a nightmare" and has "entrusted her two children to Phra Wet

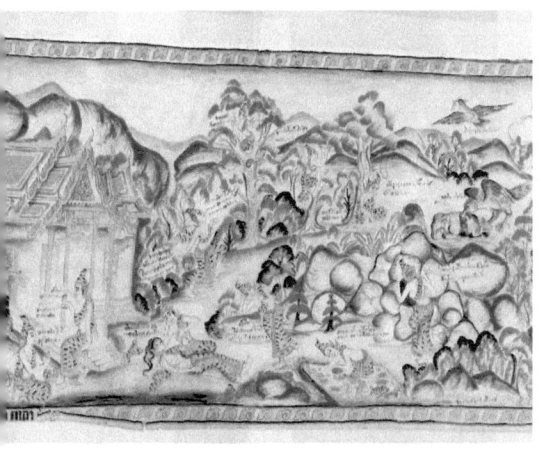

FIGURE 5.6 While Phra Wet donates the children to Chuchok, Matsi searches for food and for her children.

PHOTO COURTESY ASIAN CIVILISATIONS MUSEUM

before leaving to gather fruit for their meals." She says to the children, "Be good and be obedient children."

Sopha, the artist, splits the panel horizontally to depict Matsi's search for food on a long path that arcs above the simultaneous activities of Phra Wet, Chuchok, and the children below. Matsi moves into the forest carrying her two baskets on a shoulder pole, with a *siem*,[39] a digging tool, in her right hand. First she uses her *siem* to dig for roots. Then she moves farther along the path to harvest bananas. Finally she picks fruit from a tree. And, immediately above the location where Chuchok walks out of this scene, leading the two crying children with a vine tied around their wrists, Matsi kneels to honor the three magical animals who keep her from interfering with Phra Wet's Great Donation.

However, Matsi's travails do not end there. Beginning the next chapter, "Matsi," the artist portrays her continuing down the arced path, returning to Phra Wet, sitting alone on the porch of his hermitage. In text written on the scroll, he says to her sarcastically, "Good grief, you have come [home] so early." She says, "Come, my dear Kanha and Chali, come to welcome your mother. I am back. Where are you, my two babies?"

Phra Wet replies with yet another slight: "You were playing with the Thon, the musician. You chased away the lions so you could play with him. Now why are you quiet? (This must be true because you do not argue.)"[38] Matsi begs him to tell her where the two children are: "Where are my two royal babies hiding, Your Royal Highness? Pray tell." Phra Wet does not respond, and Matsi spends the remainder of the panel searching, literally, high and low for her children.

The artist paints Matsi again following an arcing path through the forest, but here the path circles around and she eventually returns to the hermitage. First (as the captions tell us), she climbs tall trees; second, she climbs low trees; third, she wants to climb rubber trees and other tall trees that are straight and have few leaves, but she cannot.[39] Fourth, she sits down in the path and cries. At this point, the artist paints an eagle bloodily extracting the rib from a baby elephant and soaring away; Matsi's agony is equivalent to this. Nonetheless, she continues, fifth, searching in cliffs, caves, and crevices, and, sixth, in the hermitage pond where, indeed, her children had hidden to avoid going with Chuchok. But of course, she doesn't find them. Having circled back to the hermitage and with nowhere else to look, she faints. The scene closes in the panel's left center (in front of the hermitage) with Phra Wet cradling her head on his lap and bathing her face in water, poured from the same ewer with which he poured water over Chuchok's hand, certifying his gift. The pouring of this water thus transfers to Matsi some of the merit he made when he donated the children.

The above comparison between the Ban Kau, Mahasarakham, and the Asian Civilisation Museum's Ubon scrolls demonstrates how scroll configuration—with and without defined borders—affects the impact of the visual narrative and illustrates different strategies in "telling" the story. Just as written manuscripts and translations differ, and certainly the oral recitations differ, so do scrolls. As visual depictions, they make their own statements with their own powers concerning the epic story of Prince Vessantara. The flexibility of scrolls to present visual narrative that would otherwise be lost through the fleeting spoken word becomes more clearly evident in the next section.

Visual Reversal in Chapter 13, "Nakhon"

Western viewers are, of course, accustomed to reading—and viewing sequences—from left to right. Written Pali, Thai, and Lao are read left to right. On most recently produced or contemporary scrolls from Ban Kau, Mahasarakham, painters sequence narrative action in the same direction, so that in the last, "Nakhon," scene, the procession walks rightward in the direction of the storyline and thus "off" the scroll.

Scrolls produced today in the other major scroll-producing village, Ban Samrong, Ubon, differ dramatically.[40] While the panels as a whole are sequenced left to right, the "Nakhon" procession usually turns back into the scroll's storyline, moving from right to left. The reason for this change in direction is unclear. We asked several people—*wat* abbots, chairs of

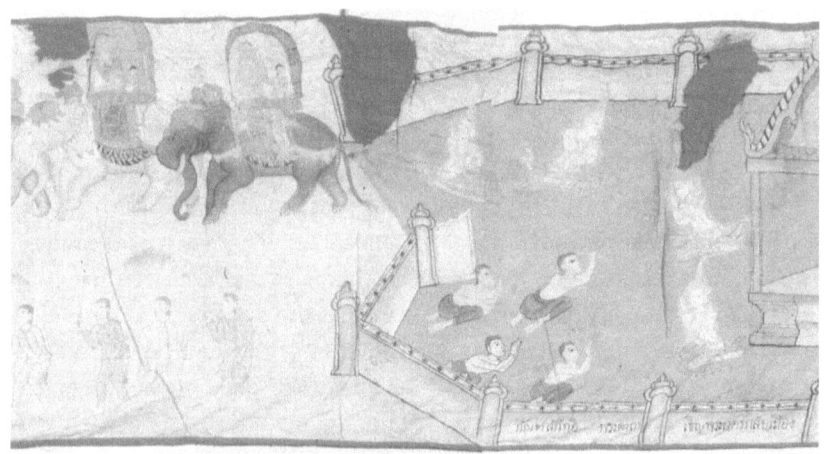

FIGURE 5.7 Phra Wet and Matsi are asked to return to their city.
PHOTO BY AUTHORS

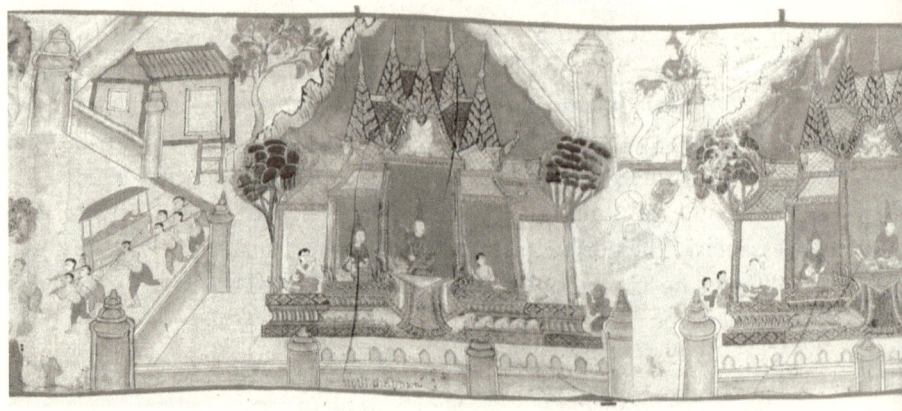

wat committees, people in processions, etc.—about this, explaining that in other scrolls the procession walked "out of" the scroll. Uniformly they said they didn't realize that scrolls from the two villages were painted differently.

Perhaps the oldest extant northeast Thai *pha yao Phra Wet*, donated an unknown number of decades ago to Wat Luang in Ubon Ratchathani city and now on display in the Ubon Ratchathani Branch of the Thai National Museum, provides a clue as to possible meanings of the procession turning back into the storyline.[41]

The storyline moves from left to right and concludes, at the scroll's right end, in a walled-off area from which a procession of elephants, soldiers, and dancers leads back to the left along the upper border. Within this walled area commoners bow to Phra Wet and Matsi while King Sonchai and Queen Phutsadī hold their two grandchildren. On the exterior wall of this area is written, in Thai, "*Kan Sakkati . . . Coen Phra Wet Klap Muang*," "Sakkati Chapter . . . Inviting Phra Wet to Return to the City," denoting that this is the next-to-last chapter. This placement requires the story to double back on itself to reach its formal conclusion. The "Nakhon" procession that leaves through the gate wends its way back across the upper portion of the scroll to reenter the city that is at the scroll's far left end, where chapter 2, "Himaphan," took place. As the procession reaches this city, the funeral procession carrying Chuchok's body for cremation exits through a gate to the lower left. Thus, in its visualization of time,[42] the Ubon Museum scroll portrays one of the main points of the written and oral versions of the Vessantara text: this *jātaka* relates events of this world and of success within it.

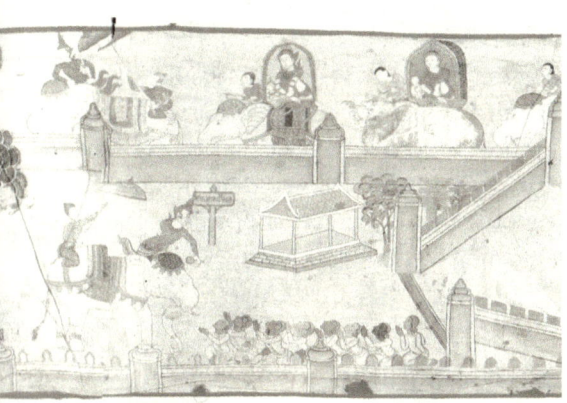

FIGURE 5.8 The procession returns to the city while Chuchok's corpse is sent for cremation.
PHOTO BY AUTHORS

It is unclear whether the format of the single panel in contemporary Ubon scrolls from Ban Samrong, in which the procession walks back into the storyline, is a direct successor to the earlier Ubon scroll. No artist acknowledged that they were aware that the direction of the final panel was anything but "normal"; none indicated that it had any special meaning; no one had viewed the old scroll in the Ubon Museum. However, these Ubon artists *are* aware of the mural in the *sim*, ordination hall, at Ubon city's Wat Thung Sri Muang, almost a duplicate of the scroll depiction, in which the "Nakhon" procession travels right to left.

The reversal of the procession that returns Phra Wet and his family to the city also appears in several Isan temple murals. The paintings on the exterior of the *sim* of Wat Ming Mang in Roi-et city, about 200 kilometers northwest of Ubon, show the procession curving back toward the palace where the story began, though here the procession ends above the entrance, acting as a guide for entering the space. The interior wall paintings at Wat Sanuan Wari, Khon Kaen Province, present chapters 12 and 13 in their lower register, ending with the procession's arrival in the city behind the head of the current Buddha statue.[43]

It would be inappropriate to claim that all these instances of the reversal motif derive from the same motivation or have the same meaning. For instance, those processions that end over the door of the ordination hall or behind the main Buddha statue of such a hall could be seen as directly connecting Prince Vessantara to the Buddha, one whose life preceded the other's. However, the procession's reversal does establish the role of visual narrative in highlighting an aspect of the *Vessantara Jātaka* relevant to the viewers: the story ends in the human world, as

Phra Wet and his family return united to his kingdom. This visual reversal on many Phra Wet scrolls parallels the *Vessantara Jātaka*, which reverses the ending of the life of the Buddha. Contrary to the Buddha's story, in which Siddhartha Gautama achieves the ideal of nirvana, the *Vessantara Jātaka* enshrines moral actions by which one becomes a meritorious person and yet remains in the human world. In this sense, the *Vessantara Jātaka* paints a more realistic picture for people engaged in the travails of daily life, encouraging their identification with and participation in the story.

Transforming Time and Place

The *pha yao Phra Wet* is an exceptional artifact. Both painted and manipulated, this long, flexible, portable cloth bridges past and present with future. In the Bun Phra Wet procession, the scroll brings one set of events

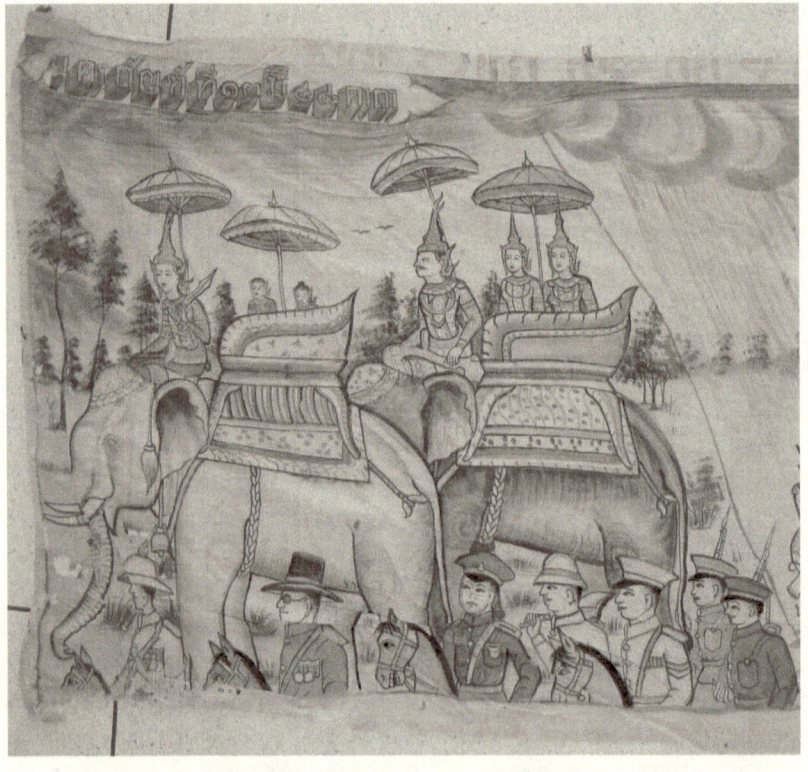

FIGURE 5.9 King Bhumiphol Adulyadet accompanying Phra Wet on his return. PHOTO BY AUTHORS

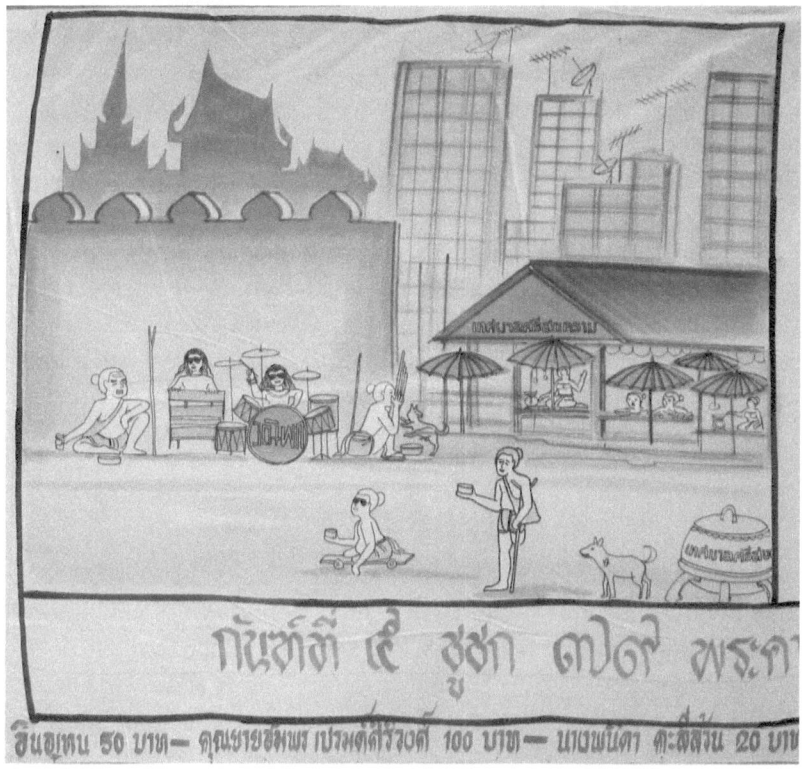

FIGURE 5.10 Poor in the city PHOTO BY AUTHORS

from the distant past—but of a time and for a people with motivations and desires very similar to ours—to life in our own time.

The *pha yao Phra Wet* achieves these temporal confluences in different ways—with localizing details, with particular emphases on journeys to and from the forest, and with the scroll's final installation in the temple. On the scroll (and in the Bun Phra Wet performances) Phra Wetsandon, his family, and the primary actors of that time are usually painted in garb that speaks of an older time. The royal family wears regalia appropriate to their social position: *chada* and jeweled neckpieces. The hermit wears the traditional tiger-skin robe and hat. Brahmins have bodies, faces, and loincloths that indicate their distinctiveness from normal people. However, other actors in this story, especially commoners, appear in dress either from an earlier but locally recognizable period or from the present time of those viewing the scrolls.[44]

As has become conventional in many contemporary Thai mural paintings, actual people of the current era are portrayed; on one scroll from the 1950s a likeness of King Bhumiphol Adulyadej appears near the head of the procession bringing Phra Wetsandon back to his kingdom.[45] More often, however, indications of present time are given through dress, material objects like pots and baskets, and scenery. Thus, bicycles, motorcycles, skyscrapers, rock bands, and handicapped people indicate that the time of Vessantara is our time, while Phra Wetsandon and his contingent remain clothed as actors of the past and of a superior moral and social status. Locating this story firmly in Thai-Lao culture, the Singapore Asian Civilisation Museum's scroll mentions and depicts a *basi sukhwan* ceremony that binds the spirit, performed for Phra Wet's children as they are reunited with their grandparents.

JOURNEYS AND ENDINGS

As in many Buddhist narratives, including the life of the Buddha, journeys organize narrative action as a central trope, with mountains and forest dominating the landscape. Although scroll landscapes do not match those of northeast Thailand or Laos today or at any time in the past, many include plantings of locally familiar trees, bringing these worlds together.

In the *Vessantara Jātaka*, the family's journey is the first of five into the Himalayas to Khao Wongkot, Crooked Mountain. Many scrolls do not dwell on the family's initial journey into exile in chapter 4, "Wannaphrawet." In Vessantara texts, and as captioned on scrolls, the second journey to Crooked Mountain, Chuchok's, consists of two chapters, 6 ("Chulaphon," The Sparse Forest), and 7 ("Mahaphon," The Great Forest). Chuchok's travel receives the most visual attention, not only because it is depicted in great detail with fantastic creatures but also because fun is made of Chuchok as he makes his bumbling, lying way to Phra Wet's hermitage.

The third journey is Chuchok and the children's return journey. The travelers—Chuchok tugging at the children to get them to come along—are usually depicted in only two scenes: Chuchok stumbles ("The old Brahmin slipped and fell on the cliff. Getting up, he saw the two royal children running away," as written on the Asian Civilisation Museum's scroll). They run back and hide in the pond outside Vessantara's hermitage. Chuchok returns to the hermitage and accuses Vessantara of reneging on his gift;

their father calls the children out of the water and enjoins them to go with Chuchok. "May you two be golden ships," he says in a caption.

Most scrolls show Chuchok and the children's journey recommencing. Representing this long trip and Chuchok's cruel, uncaring behavior, he sleeps in a tree, leaving the children below. They are comforted by two angels in the guise of their parents.

Giving additional narrative and visual focus on the forest, Matsi, for all the time the family has been in exile, has traversed the forest, not leaving it, seeking food for her family. This daily quest is poignantly depicted in the Asian Civilisations Museum scroll.

The final two traverses of this route to the mountains through the forest occur when, first, King Sonchai and his subjects come to ask Phra Wetsandon to return to the city and, second, the family, reunited with their subjects, finally return to the city. Bun Phra Wet participants celebrate this return as their own as they carry the scroll back from the forest to their own home.

Contrary to Cone and Gombrich's decision to sequester seven pages of forest description in an appendix, the scroll vividly re-creates the forest as a liminal place. This continuing interplay between people, forest, and mountain resonates with the ambivalent attitudes of Thai-Lao and Lao toward the wildness of nature, strange and unknown. Traditionally, village life has been lived close to the forest, and wresting productive rice paddy, orchard, and village and house land from the wild has been an arduous challenge. Forest and mountain are undomesticated worlds in which strange things happen and powerful, unknown forces are at work.[46] It is the contrast with these forces that makes the lives of successful forest monks so important; they have confronted these mysteries, alone.[49] Initially (in written versions), Prince Vessantara seems loathe to subject his family to this frightening place, even though his wife and children beg to go with him to the forest, out of love.

The Phra Wet scrolls depict the total environmental setting of the narrative, often using landscape elements—rocks and trees—to frame the spaces where events take place and to mark off one chapter from the next. On the scroll in the Singapore Asian Civilisations Museum, blue mountains establish the background, continuing in the distant horizon across the scroll from the first chapter almost uninterrupted through to the last. When the story is concerned with the initial events in the palace, the mountains appear at a great distance. As the action moves into these mountains, the artist brings them lower down into the foreground and

close to the scroll's border; as each of the five journeys takes place, he makes the mountains and forest more prominent.

Other scrolls use the same or similar atmospheric devices. On the plainest scrolls from Ban Kau, Mahasarakham, artists split the narrative space in half horizontally. The lower register—the earth rendered in yellow, but textured with orange brushstrokes—is where most of the narrative action takes place. Here and there, rocks or shrubs or stands of trees punctuate the landscape. On the horizon in key passages, blue lumps indicate mountains. The upper register, the sky (or heavens), contains roughly rendered clouds, accomplished with a few brushstrokes. Trees, buildings, and some of the action placed higher toward the middle serve to visually unite these two registers. That said, the landscape, i.e., "nature," is quickly brushed in; only the figures and their activities are given detail. As a setting, the one village scene depicting Amittata with the other wives (near typical Thai-Lao buildings) differs little from the following panel, where Chuchok travels through the forest, and the succeeding panel of the hermitage. The landscape in these scrolls has been deforested, much like Isan itself. Trees and animals—deer, rabbits, civet cats, peacocks, and the fanciful animals of the region's folklore—run riot through many other scrolls. The viewer can ponder their meanings; perhaps they simply project nearness to a nature that may or may not be benign.

But meaning also resides in the scrolls' movements. We have already described above how scrolls are central to the procession that brings Phra Wetsandon and Matsi from the forest through the fields and village into the center of the celebration. Those carrying the scroll hang it in the meeting hall, *sala wat*, usually around the perimeter, facing in toward the congregation and the recitation that will take place there the next day. The end of the scroll that includes the procession is hung nearest the most important Buddha statue, toward the front. Effectively, having brought the prince and his family into the temple, the scroll thus delimits a sacred space. Those preparing the *sala wat* transform the central space into Phra Wetsandon's forest hermitage, named *parimonthon* or *rajawat*, bounded or royal space. They erect a fence of crossed bamboo slats, placing large banana stalks and sugarcane cuttings at its four corners. Near the border of this space, and sometimes from strings in rows above it, they hang wooden flowers, as well as strings dangling with glued-on rice grains, birds made of bamboo strips or cut-up soda cans, and other "strange" objects, including packets of food to eat during the long recitation. Two tubs of water are placed in the space: one replicates the pond in which Phra Wet's and Matsi's children hide themselves so they will not be given

away to Chuchok; this "pond" of the forest contains lotus stems and leaves, fish, a turtle, crabs, and some mud. Over the other tub of water, lay members create lustral water, *nam mon*, by burning candles during the course of the recitation. The *thammat*, preaching chair, garlanded with branches, leaves, and flowers, dominates this space. From the *thammat*, monks take turns chanting or reading the *jātaka*. If a number of monks participate together in a combined sung/chanted performance (*thet lae*), three or more chairs are placed in the space so that they will be able to see one another and interact.

All together, then, the scroll with its images of trees, flowers, mountains, and the story of Phra Wetsandon and his family provides the backdrop, visual references, and spiritual presence that transform the *sala wat* into Vessantara's hermitage, its surrounding forest brimming with strange flora and fauna and bounteous plenty. With the *thammat* so prominent, the sacred space also recalls the "perfumed" pavilion from which the future Buddha emerged to recite the story of his karma's immediately previous birth.[47]

Victor Mair, in his comprehensive survey of painted recitation scrolls and shadow plays throughout Asia, points to the importance of trees and mountains in defining the action space for these dramas, observing that the "movements (of mountains and trees) envelop the audience in the flow of sacred time." A pillar, tree, vine, or mountain (usually Mount Meru of Indian mythology) stands center stage, to create a point of "ontological transition," following Paul Wheatley.[48]

The Singapore scroll displays one artist's adroit use of trees and mountains to move the narrative and the viewer's eye from scene to scene, action to action. Additionally, all Bun Phra Wet scrolls visually present this family's arena of success, the forest. The scroll narrates this success and also, through its material properties—length and flexibility—encloses and creates a particular transformative environment for the success of the Bun Phra Wet participants. The scroll, the banana trees and sugarcane cuttings, the muddy tub of water with fish, turtle, and lotus leaves and stems, the strange flowers made of wood and rice evoke also the strangeness of the Himalayan forest of Phra Wet's exile. To shift Wheatley's expression, the scroll encloses a space of "ontological transition" where the past of the prince and of festival activities recalling that past, the present moment in this space, and the future merge. Having already reenacted key events by inviting and then accompanying Phra Wet and the reunited family on their return to the kingdom, the participants sit now within this space to listen to the monks recite the story. And in so doing, they

project themselves simultaneously into the future of the prince—the time of this Buddha—and to their own envisioned future rebirth in the era of Maitreya, as a karmic community.

Thai-Lao and Lao Theravāda Buddhists have devised their long narrative scrolls as modern iterations of an ancient Buddhist art form, the bas-relief narrative scenes found in India and Indonesia, and painted murals from India, Sri Lanka, and mainland Southeast Asia. These scrolls emerge in an oral narrative culture. Monk storytellers know the story they are to recite to audiences intimately familiar with it, who expect improvisatory elaboration and localization connecting the past of Phra Wet with their own present and future. *Pha yao Phra Wet* offer visual evidence of this elaboration; they engage reciters and audience in a transformative interaction by which they can see themselves moving from the past world through the community of the present to the future. Indeed, in processing the scroll and performing key characters and scenes of the story, the lay villagers, along with monks and artists, have themselves become the storytellers of Phra Wet's life and fortunes.

Pha yao Phra Wet vary tremendously in composition and artistry, ranging from relatively static arrangements of chapter scenes to fluid narrative movement across a long horizontal space. Crucial events draw increased attention through storyline and background/foreground reversals. These visual strategies, amplified in processing the scroll and then installing it in the *sala wat*, underscore a major theme of the story: that the successful hero and his family remain in the human world. Additionally, the artistry on the scroll and in its use establish an environment in which participants aspire to better lives; it encloses, defines, and presents an arena of trauma and loss, as well as of the perseverance and dedication of the family, which results in their success. *Pha yao Phra Wet* independently parallel the written manuscripts through which scholars have tended to approach this story. The scrolls also offer the opportunity to consider other dimensions of richness and meaning by which Thai-Lao and Lao Buddhists make Phra Wetsandon's story their own.

NOTES

1. Alfred Gell, *Art and Agency: An Anthropological Theory* (Oxford: Clarendon Press, 1998) proposes the idiom of kinship to organize relationships between art objects, pointing to the inevitable entanglement of objects with social relationships.
2. Victor H. Mair, *Painting and Performance: Chinese Picture Recitation and Its Indian Genesis* (Honolulu: University of Hawai'i Press, 1988).
3. Robert L. Brown, "Narrative as Icon: The Jataka Stories in Ancient Indian and Southeast Asian Architecture," in *Sacred Biography in the Buddhist Traditions of South and Southeast Asia*, ed. J. Schober (Honolulu: University of Hawaii Press, 1997), 64–109; Peter Skilling, "*Paṭa* (*Phra Bot*): Buddhist Cloth Painting of Thailand," in *Buddhist Legacies in Mainland Southeast Asia: Mentalities, Interpretations, and Practices*, ed. F. Lagirarde and Paritta Chalermpow Koanantakool (École Française d'Extrême-Orient Études thématiques 19, Princess Maha Chakri Sirindhorn Anthropology Centre Publication 61, 2006), 223–75.
4. Following Collins, this volume, we use "telling" instead of "version" to avoid implying the existence of an original or ur-text.
5. Leedom Lefferts, "The *Bun Phra Wet* Painted Scrolls of Northeastern Thailand in the Walters Art Museum," *The Journal of the Walters Art Museum* 64/65 (2006/07): 99–118; Sandra Cate and Leedom Lefferts, "Becoming Active/Active Becoming: Prince Vessantara Scrolls and the Creation of a Moral Community," in *The Spirit of Things: Materiality in the Age of Religious Diversity in Southeast Asia*, ed. Julius Bautista (Ithaca: Cornell Southeast East Asia Program Publications Press, 2012), 165–81; Leedom Lefferts and Sandra Cate, *Buddhist Storytelling in Thailand and Laos: The Vessantara Jataka Scroll at the Asian Civilisations Museum* (Singapore: Asian Civilisations Museum, 2012); Sandra Cate, "Narratives, Scrolls and the Status of the Object in Thai-Lao Celebrations of Bun Phrawet," paper delivered at the International Association of Buddhist Studies, Jinshan, Taiwan, July 2011.
6. The Thai-Lao of northeast Thailand have been politically severed from their close relatives for over a century by the establishment of the Mekong River as an international border. The contrasting political, economic, and educational systems of the nations of Thailand and Laos have exacerbated a cultural division between these peoples. Our research indicates that the issues in this paper transcend these divisions. To ensure that they are treated as a unit, we refer to Thai-Lao and Lao jointly. See Richard O'Connor, "Who Are the Tai? A Discourse of Place, Activity, and Person," in *Dynamics of Ethnic Cultures Across National Boundaries in Southwestern China and Mainland Southeast Asia*, ed. Hayashi Yukio and Yang Guangyang (Chiang Mai, Thailand: Ming Muang Printing House, 2000), 35–50.
7. As an ethnography of the festival, this essay uses the local names for the story's characters.
8. Ferguson and Johannsen make this argument about the popularity of Vessantara mural themes for northern Thailand. See John P. Ferguson and Christina B. Johannsen, "Modern Buddhist Murals in Northern Thailand: A Study of Religious Symbols and Meaning," *American Ethnologist* 3, no. 4 (1976): 645–69.
9. Donald K. Swearer, *Becoming the Buddha: The Ritual of Image Consecration in Thailand* (Princeton: Princeton University Press, 2004).
10. The authors thank the many monks, novices, laymen, and laywomen who have helped us in our research, and especially our associate and driver, Thanwa Vongnongwa. The James H. W. Thompson Foundation of Bangkok, Thailand, generously

funded our crucial initial investigations. The Asian Civilisations Museum, Singapore, has provided funding for completing this chapter.

11. When temples in urban areas build *sala* with enclosed walls and can afford murals, the permanent Vessantara paintings may substitute for the more ephemeral scroll and celebrants no longer process. According to one monk, urban temples are more often seen as centers for education and funerals; thus they do not hold the Bun Phra Wet at all. However, we have found many *wat* with such murals that still do.

12. For contrasting accounts of Vessantara recitations, see Patrice Ladwig, "Narrative Ethics: The Excess of Giving and Moral Ambiguity in the Lao Vessantara-Jataka," in *The Anthropology of Moralities*, ed. M. Heintz and J. Rasanayagam (New York: Berghahn/EASA, 2009), 136–55.

13. This is a much abbreviated version of the total festival. See Lefferts and Cate, *Buddhist Storytelling in Thailand and Laos*, for a more comprehensive summary.

14. Including Chuchok and the children in the procession conflates scenes from two chapters in the narrative: Kan 8, "Kuman," with Kan 13, "Nakhon."

15. Ongoing since 2007, our research documents a number of Bun Phra Wet festivals, never identical and with minor variations in the sequences, activities, and artifacts recounted here.

16. Justin T. McDaniel, *Gathering Leaves and Lifting Words: Histories of Buddhist Monastic Education in Laos and Thailand* (Seattle: University of Washington Press, 2008).

17. In this way, as the scroll manifests the presence of the prince, it parallels the iconic function of *jātaka* carvings and paintings discussed by Brown, "Narrative as Icon." But, as we contend, iconicity does not account completely for its place in the festival.

18. Swearer, *Becoming the Buddha*, 42.

19. Cate and Lefferts, "Becoming Active/Active Becoming," and Jonathan S. Walters, "Communal Karma and Karmic Community in Theravada Buddhist History," in *Constituting Communities: Theravada Buddhism and the Religious Culture of South and Southeast Asia*, ed. J. C. Holt, J. N. Kinnard, and J. S. Walters (Albany: SUNY Press, 2003), 9–39.

20. Scholars who have mentioned or described the Bun Phra Wet in Thailand and Laos include Bonnie Pacala Brereton, *Thai Tellings of Phra Malai: Texts and Rituals Concerning a Popular Buddhist Saint* (Tempe: Program for Southeast Asian Studies, Arizona State University, 1995); Margaret Cone and Richard F. Gombrich, *The Perfect Generosity of Prince Vessantara: A Buddhist Epic* (London: Pali Text Society, 2011); Georges Condominas, *Le Bouddhisme au Village Lao: Notes ethnographiques sur les pratiques religieuses dans la societe rurale lao (plane de Vientiane)* (Vientiane: Editions des Cahiers de France, 1998); Bernard Formoso, "Le Bun Pha We:t des Lao du Nord-est de la Thaïlande," *BEFEO* 79, no. 2 (1992): 233–60; William J. Klausner, "Ceremonies and Festivals in a Northeastern Thai Village," in *Reflections on Thai Culture* (1966; reprint, Bangkok: The Siam Society, 1993), 37–52; William Klausner, *Reflections: One Year in an Isaan Village Circa 1955* (Bangkok: Siam Reflections Publications Co., 2000); Ladwig, "Narrative Ethics"; Stephen Sparkes, *Spirits and Souls: Gender and Cosmology in an Isan Village in Northeast Thailand* (Bangkok: White Lotus, 2005); Suriya Smutkupt, Pattana Kitiasa, Kanokpon Diburi, Sathapon Undaeng, and Pricha Srichai, *Kan Muang Watthanatham nai Bun Phawet Roi-et* [Cultural politics and the secularization of the Bun Phawes in Roi-et market town], Research Publication, Thai Studies Room, Research Studies Branch, Office of Social Technology Studies, Suranarii Technology University, Nakhon Ratchasima

Province, BE 2543 (2000); Stanley J. Tambiah, *Buddhism and the Spirit Cults in North-east Thailand* (Cambridge: Cambridge University Press, 1970).
21. Collins, this volume; Naomi Appleton, *Jataka Stories in Theravada Buddhism: Narrating the Bodhisatta Path* (Surrey, England and Burlington, VT: Ashgate, 2010), 6–7.
22. *Mun* refers to the number 10,000; *saen* to 100,000, symbolic valuations of the import of these texts.
23. Sets of Vessantara manuscripts offered for sale by the S. Dhammapakdii Co. Ltd., Bangkok, indicate that those in *phasa Isan* (the language spoken in northeast Thailand) contain five *kan* more than the manuscripts in *phasa klang* (Central Thai), which have the standard thirteen chapters.
24. Khamhaeng Visuddhangkoon, personal communication, March 2011.
25. Most scrolls depict these scenes with Phra Wet pouring water from an ewer or *kendi* on the hands of the person to whom he is making a donation.
26. Khmer renditions of the *Vessantara Jātaka*, which usually occur around the end of the rains retreat, in October–November, are called the Sermon of the Lotus-Leaf Rain.
27. John Strong, "*Gandhakuti*: The Perfumed Chamber of the Buddha," *History of Religions* 16, no. 4 (1977): 390–406.
28. We have found two scrolls that had both the *Vessantara Jātaka* and the history of the Buddha on them. We have also found only two other scrolls of the Buddha's life alone. While Central Thai mural paintings of the *Vessantara Jātaka* have been standardized at thirteen individual panels, Khmer panels usually number fourteen or fifteen.
29. For a typology of visual narratives, monoscenic, synoptic, and continuous, see Vidja Dehejia, "On Modes of Visual Narration in Early Buddhist Art," *The Art Bulletin* 72, no. 3 (1990): 374–92.
29. Scroll borders recall the "undulating stem of the lotus that meanders its way along the coping at Bharhut," though at Bharhut the stem of the lotus weaves its way through the story. See Dehejia, "On Modes of Visual Narration," 379. On Thai-Lao and Lao scrolls, the "undulating stem" is confined to the border.
30. Richard Gombrich, "The Vessantara Jātaka, the Rāmāyaṇa and the Dasaratha Jātaka," *Journal of the American Oriental Society* 105, no. 3 (1985): 427, states that "it has less than 800." Claudio Cicuzza and Peter Skilling, "The Number of Stanzas in the *Vessantara Jātaka*: Preliminary Observations," ed. G. Orofino and S. Vita, *Buddhist Asia 2: Papers from the Second Conference of Buddhist Studies* held in Naples, June 2004, (Kyoto: Italian School of East Asian Studies, 2010), 35–45, state that the number is somewhere around 786.
31. The number 1,000 deserves commemoration it its own right; it is memorialized in the manufacture and required presence of the multitude of material items essential to the correct and complete presentation of this festival. See Cate and Lefferts, "Becoming Active/Active Becoming."
32. Accessions number 1997–02933; we express our thanks to the Asian Civilisations Museum for letting us use the example of this scroll.
33. Thai government policy does not permit Thai-Lao to use Lao script for their language.
34. Jean Boisselier, *Thai Painting* (New York: Kodansha, 1976); Brereton and Samroay, *Buddhist Murals of Northeast Thailand*; Sandra Cate, *Making Merit, Making Art: A Thai Temple in Wimbledon* (Honolulu: University of Hawai'i Press, 2003); Pairote

35. Samosorn, *Chitrakaam Faa Phanang Iisaan (E-sarn Mural Paintings)* (Khon Kaen, Thailand: E-Sarn Cultural Center, Khon Kaen University, BE 2532 [1989]).
35. Frank E. and Mani B. Reynolds, *Three Worlds*.
36. Many thanks to Wajuppa Tossa for translating and contextualizing this scroll's many captions.
37. Cone and Gombrich, *Perfect Generosity*, 47.
39. The appearance of this tool, basically a pole to which a short, sharp, shoehorned iron attachment is fixed, is significant here; it is the usual tool for women to use when going out to dig up root crops. Prof. Ang Choulean (personal communication) hypothesizes that this tool is a crucial symbol of traditional Southeast Asian practical culture.
38. Phya Thon refers to mythical creatures, half human and half deity, who are skilled in music. Phra Wet is accusing Matsi of committing adultery with these creatures (Wajuppa, personal communication, 2011).
39. The captioning mentions "The tall *yang* and *yong* trees," retaining the alliteration of a Lao/Isan written or chanted version of the story as well as referencing local tree species (Wajuppa, personal communication, 2011).
40. Our thanks to Suriya Choksawad of Ubon University for his assistance with the Ban Samrong material.
41. We have been given dates as long ago as 150 years for this scroll, when Wat Luang was founded, but this seems improbable. This scroll was first exhibited and partly illustrated in Mattiebelle Gittinger and Leedom Lefferts, *Textiles and the Tai Experience in Southeast Asia* (Washington, DC: The Textile Museum, 1992): 126–29. It has since been republished, in its total length (but in smaller format), in Chaarunii Inchoetchaai, *Phrabot (Temple Cloth Paintings)* (Bangkok: Fine Arts Department, Royal Thai Government, BE 2545 [2002]).
42. The use of this phrase is a conscious play on and expansion of Collins's use of "the textualization of time" (*Nirvana*, 254–81).
43. For the latter, see Brereton and Samroay, *Buddhist Murals of Northeast Thailand*, figures 7 and 8.
44. Southeast Asian murals, paintings, and scrolls often depict narrative actors of the human (not royal or deified) world as from another historical era—many twentieth-century mural scenes recall classic-era murals of the late eighteenth or nineteenth centuries—as well as from the historical time of their painting.
45. This issue is discussed in Cate, *Making Merit, Making Art*.
46. Andrew Turton, "Introduction to Civility and Savagery," *Civility and Savagery: Social Identity in Tai States*, ed. Andrew Turton, (Richmond, Surrey, UK: Curzon, 2000), 3–31; Bernard Formoso, "From the Human Body to the Humanized Space: The System of Reference and Representation of Space in Two Villages of Northeast Thailand," *Journal of the Siam Society* 78, no. 1 (1990): 67–83.
49. Kamala Tiyavanich, *The Buddha in the Jungle* (Chiang Mai: Silkworm Books, 2003).
47. Strong, "*Gandhakuti.*"
48. Paul Wheatley, *Pivot of the Four Quarters: A Preliminary Enquiry Into the Origins and Character of the Ancient Chinese City* (Edinburgh: Edinburgh University Press, 1971), 417, cited in Mair, *Painting and Performance*, 65.

{ 6 }

A MAN FOR ALL SEASONS

THREE *VESSANTARA*S IN PREMODERN MYANMAR

Lilian Handlin

THIS ESSAY examines three tellings of the *Vessantara Jātaka* that survive from Myanmar's premodern history. Two versions date to Pagan, a powerful kingdom that flourished between the tenth and thirteenth centuries in the country's central dry zone, the third to the early years of the Konbaung dynasty at the end of the eighteenth century. From the former period, two extended visual *Vessantara*s survive, one with inscriptions in Mon, the other in Burmese. The Mon and the Burmese were two ethnic groups that shaped Pagan's history, each with their own written and spoken languages and somewhat different definitions of the Buddha's teachings that were grounded largely in similar sources. The Mon *Vessantara*, covering 134 plaques, survives on top of a revered structure called by tradition the Ananda, dating to about 1100, the reign of Pagan's third attested monarch, King Kyanzittha. The Burmese-inscribed Lokahteikpan, pronounced *Lawka-they-pan*, from about 1120, when Alaungsithu was king, tells the Vessantara story in murals. The Mon plaques were stupas' traditional décor, and their inscribed and narrative content was limited, whereas the Lokahteikpan amplified and added to the story. Neither could have been read easily by anyone who saw it in 1100 and later, which suggests to scholars that their presence was important for each structure's interior: not for what the content actually communicated, but for its iconicity, the reverence its presence evoked.[1] But iconicity and extended narratives mask meanings that enable us to recover how early Pagan related the story to the social world around it, what it was meant to achieve, and who decided that. All translations, visual and textual, are

interpretative interventions that reconstitute the original and inscribe on it the presuppositions of the context in which it is set. These two early *Vessantara* visualizations compensate for the absence of more textual historical evidence regarding how the story lived on the cusp of the twelfth century in Pagan.

The following pages will compare these two early visual *Vessantara*s with Myanmar's first complete prose translation of the story, which appeared in 1773, to show how changed historical circumstances altered the way the story was received and interpreted. This long trajectory illustrates how revered materials that remain essentially the same acquire different resonance when brought alive in shifting environments. The Mon and Burmese *Vessantara*s began their Myanmar career in the domain of ritual, by being incorporated in the décor of a ceremonial capital's most revered structures. By the end of the eighteenth century the recapitulation of the story moved it to more user-friendly domains, more accessible to the population at large; by this time, not only the story's very existence but also its content mattered.[2]

This juxtaposition of early visualized *Vessantara*s with a complete written retelling might seem like equating apples and oranges, but especially in the past two decades a new academic discipline has materialized, investigating writing in pictures and how images, "saturated in textuality," are subchapters in the sociocultural history of knowledge formation.[3] Visual and verbal transmission technologies are not as distinct as it seems. The visualized *Vessantara*s resembled modern comic strips but also shared written materials' narratological assumptions. A text by definition need not be solely in words, since images were articulate equivalents of written words. Pagan's strips had significant inscriptional content to augment their inherent textuality, narrowing the gap between images and written counterparts. They retold the same set of events and were constrained by the way their likely similar source, the Pali version of the *Vessantara Jātaka*, wanted the story told. The story's format, largely the same throughout the centuries, was one inbuilt interpretative key to tame the content and its multiplicity of meanings. And as it was the Word of the Buddha, disregarding its guidance entirely was not an option. Furthermore, both forms of retelling, the visual and the literary, contended with analogous difficulties in reception, such as visibility, access, and illiteracy, since images were as rare in the premodern world as was reading literacy.

The story's prestige also remained intact over the centuries because in spite of great historical changes, the Myanmar perception of the human condition remained the same. Those living in the Pagan and

early Konbaung periods agreed that the human condition made people refugees. They would have recognized each other's *Vessantara*s and their roles, grounded in humanity's need for crutches. The human predicament necessitating support (the dhamma's original meaning) remained constant, as did assumptions about the law of karma and human responsibility, articulated in the *Vessantara Jātaka*'s metaphor of the narrow path that each being traversed alone. The two settings differed in how such crutches were made user friendly. In Pagan, they were activated by royal and elite generosity that sponsored ritual settings on everyone's behalf, whereas evidence from the later period indicates a more knowledge-oriented engagement with the dhamma and greater dogmatic specificity clothing an intrusion by the authorities on lay and monastic lives.

AN EARLY MON *VESSANTARA*

Sometime around 1100 C.E. Pagan's King Kyanzittha endowed an elaborate temple topped by a *sikkhara*, a towerlike structure situated above the temple's core. The tower was decorated with more than 1,000 terra-cotta plaques illustrating all the Buddha Gotama's previous 547 lives as redacted in the Pali *jātaka*s. Of these, 537 stories were illustrated monoscenically, one plaque capturing each life story's spirit, in contrast to the last 10 stories, which were retold in detail.

Of these 10, the story of Wessantar, as the Mon called him, was the longest: more than 134 discrete frames, suggesting its unique status and great prestige. That status reflected the story's place in the immensely long path traversed by the being who became the Buddha Gotama and his fulfillment of the requirements for buddhahood. That being's life as King Wessantar was his last earthly existence prior to his penultimate rebirth in Tusita heaven, from which he would descend to be reborn as Prince Siddhartha. The Ananda's Mon designers underscored these linkages by the very way the temple's uppermost structure was decorated.

Each Wessantar frame was also inscribed with a very short Mon sentence. The inscriptions were summaries, not translations from the Pali source, suggesting that the story may well have circulated orally in the Mon vernacular, but also that no one thought it necessary to have the Pali version as a whole told in the language people actually used. What was done with the story outside the domain of cultic and ritual settings in Pagan is unknown. Only two references survive to Pisamantra, read as Vessantara by Myanmar scholars, indicating that the Pali narrative was heard in oral recitations but most likely the story as a whole, in everyday languages, was not.[4]

How did the Ananda's Mon-inscribed plaques tell the story? And can we recover from the depictions themselves what the story meant to convey, by teasing out what the plaque designers thought they were doing when interpreting their source for visualization? What did it mean to have the story on top of the Ananda, in a rather inaccessible location, where few would have engaged with it?

The location and how it was interpreted suggest that in Pagan the story of the Mon Wessantar was of lesser importance than the performative meanings of the context in which the story was situated, a context that interpreted how *Vessantara* functioned in terms of atypical social concerns, such as elite endowments testifying to the donors' status, fit only for a buddha. The story was interpreted in light of royal tasks and elite practices performed in relation to a conception of an orderly society, with technologies employed to assuage life's travails on their subjects' behalf. The retelling took account of how the human condition was conceived and what was necessary to alleviate its hardships.

Wessantar thus existed in a dual realm: this telling's project was informed by the social structure to which it referred, a focal point of rituals and worship to be reverenced. But at the same time, the way the story was visualized provides a glimpse of what its architects, most likely King Kyanzittha's most respected monks, thought the story meant. They interpreted the Buddha's teaching on behalf of their society, a creative act, since determining how such teachings could be taken to resonate around 1100 indicates an intention to contend with their earthly significance, a historically conditioned move.

The Ananda's plaques narrated the story by limiting the number of protagonists and situating them in stock settings, dividing their adventures into discrete segments as links in a chain showing what happened. The segments appeared in rows and moved the narrative forward through repetitive visual elements to comprehend how the story evolved. Vernacular sentences provided bare-boned clarification, in the form of concise Mon comments on plaques that addressed each frame's limited content. A story told in plaque images rarely referenced the protagonists' emotions and interior lives, since the plaques could only allude (but not refer directly) to dialogues, interior monologues, and the omniscient narrator's framing that gave the story its depth.

The most striking feature of the Ananda retelling was a precision facilitated by the extremely long series of plaques that enabled their designers to incorporate numerous seemingly small details, as if cleaving closely to what the Buddha said mattered greatly. In the Pali, greedy Brahmins

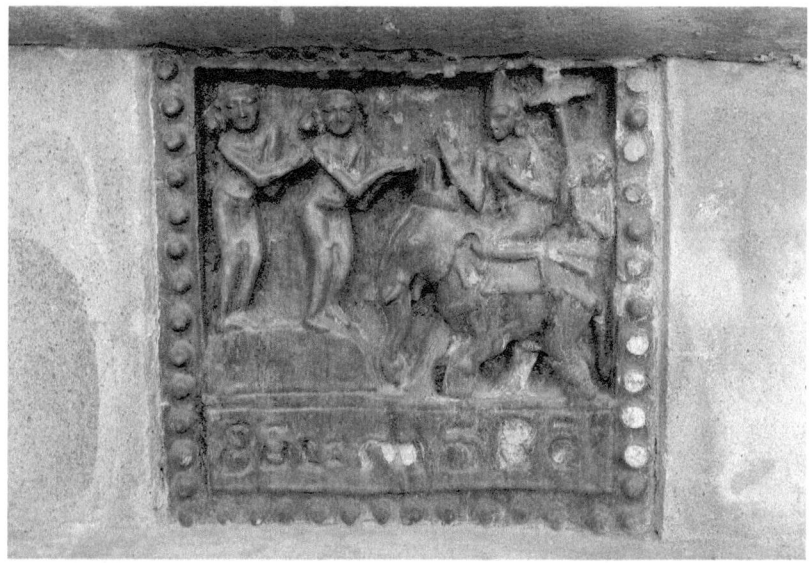

FIGURE 6.1 Brahmins ask for the elephant (275). PHOTO BY AUTHOR

anticipating Vessantara's coming in the elephant donation episode were situated on a promontory, which is what the image showed. The miracle of the deer bearing the family's carriage included the carriage pole suspended in mid-air, as in the Pali. When in the Cetan episode, the Pali had Maddī ministering to Vessantara's sore and dusty feet, the plaque showed her doing so. In the plaques presenting Maddī's ordeal, the children's toys and animals also echoed their textual source.

Precision also extended to occasional efforts to recall the protagonists' emotions, extremely difficult to do. When Kaṇhājinā (in the Mon) looked back at her father prior to departure, Wessantar's response was shown in a gesture of empathy, alluding to his compassion for the children's plight. The tearful Wessantar (348, "Wessantar weeps,") faced a tree, representing the jungle the children were about to enter but also his future awakening, since buddhas always attain enlightenment under their own trees.

On the next plaque, the inscription says, "gives *dāna*" (a gift), which recalls the verb employed for enabling access to the Three Refuges via the precepts, which in the Mon vernacular was something given; this linkage indicates an interpretative move. Lamentations notwithstanding, Kaṇhājinā needed to be disposed of, so that everyone could ultimately bask in the Buddha's compassion.[5]

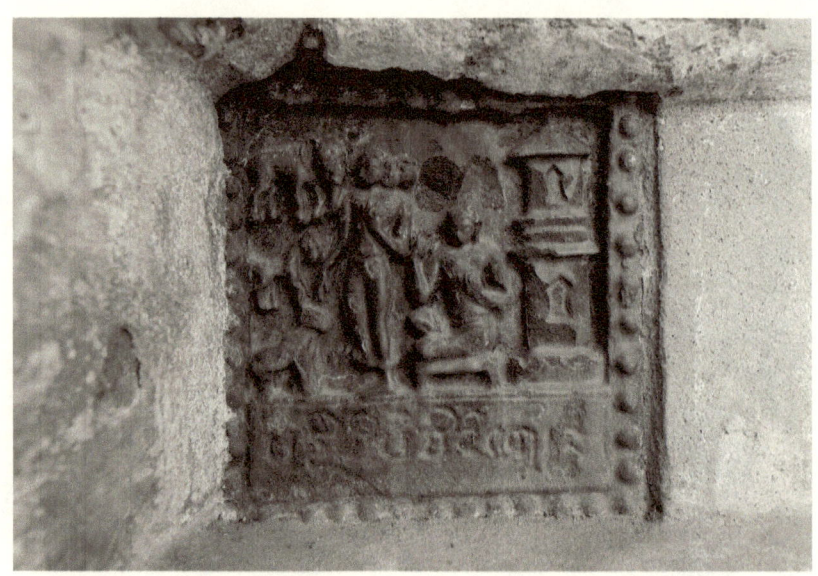

FIGURE 6.2 Maddi notices toys (355). PHOTO BY AUTHOR

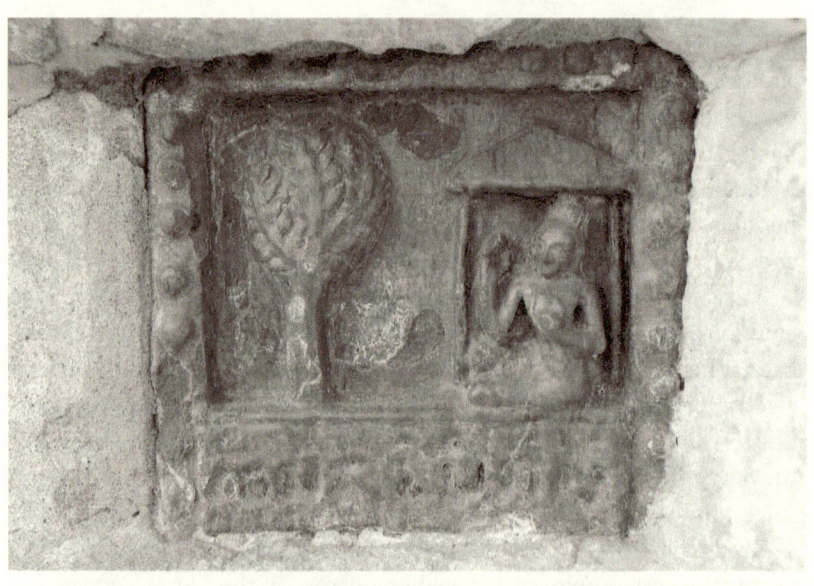

FIGURE 6.3 Wessantar weeps (348). PHOTO BY AUTHOR.

The plaques transmitted a late eleventh-century Mon retelling of the story by means of such inscribed depictions. An interpretative juxtaposition of mundane events and their supramundane significance resolved the grand meaning of the dramatic story and its multiple ambiguities. As the images told the narrative, the Mon reading was about transformations and transitions, lives' journeys, resolve, self-reliance, the need for guidance and support, and how deeds changed their doers. Generosity, usually taken to be the story's main concern, was, in the Mon retelling, just the icing on the cake, since the story was about much more. Wessantar's transformations, first from husband and king (stressed in instances calling him *raja*, king, rather than plain Wessantar) to ascetic, and then to king yet again, were the story's axis. Such shifts were in play throughout the Mon telling, punctuated by deeds whose significance merited bystanders' recognition, and thereby that of outside viewers, as indicated by repeated gestures of reverence directed toward deeds or their doer, almost always Wessantar, or else by Wessantar himself. One example occurs in the birth episode, when Wessantar's folded hands express gratitude to his mother, absent from the Pali version.[6]

Given how Pagan conceived the relationship between devotees and what the Buddha said, engagement with the story's full content was by itself unnecessary. The interaction between the dhamma's transmitter and his acolytes had less to do with knowledge, doctrine, and dogmatics than with feelings and sensibilities encouraged by popular reliance on royal interpretations of that dhamma. Royal glosses on what the Buddha taught articulated the kingdom's hegemonic ideology, explaining why the world turned as it did, creating an ideational apparatus in which Wessantar played a supportive role. His story thereby was interpreted, at least in the public domain, in light of its relationship to the broader context, in the Buddha Gotama's overall biography encapsulated by the path to buddhahood. The realm was conceived as a *sāsana*, a dominion enveloped by the dhamma and protected by the Buddha, whose terrestrial representatives, the kings, sheltered their subjects under the Buddha's care. Wessantar was part of the ideational construct justifying the Buddha's veracity, and, by extension, royal authority that relied on what the Buddha said. To instantiate that status and provide appropriate settings for interaction with the Buddha, King Kyanzittha sponsored the Ananda's construction and memorialized the story of Wessantar within it.

Royal subjects' interaction with the Buddha and what he taught were grounded in what the Mon called trust, an eleventh-century equivalent of what we would call belief—belief in the veracity of royal claims to be the

Buddha's earthly representatives. This trust (Pali *saddhā*), often translated as "faith," but more correctly as "confidence," imbued ritual practitioners' deeds with an aura activating refuge by delight in its availability.[7] The Ananda was one venue to facilitate such beneficial interactions between devotees of the Buddha and the object of their veneration. The interaction resembled Maddī's experience in one Ananda Wessantar image (362),[8] her posture recalling how devotees approached the Buddha: on their knees. In so doing, devotees expressed their dependence upon the Buddha's aid, since taking refuge generated a sense of stability, like feeling the earth underneath one's feet.

In the Mon Wessantar retelling, Maddī's ordeal generates her receptivity to benefit from what her husband says and does, much as it was anticipated that devotees would be receptive to messages from royalty and, by extension, the Buddha. Maddī's acquiescence in her husband's deeds transforms her very being, since humans were so constituted as to harbor innate, though dormant, capacities to take advantage of what the ever-compassionate Buddha made available to alleviate their lot. The story's import, and thus the work it was expected to do, thereby took account of the human condition, as Wessantar's Mon interpreters framed it and creatively interpreted the story in light of what they thought its presence there facilitated. The Ananda enabled the performance of

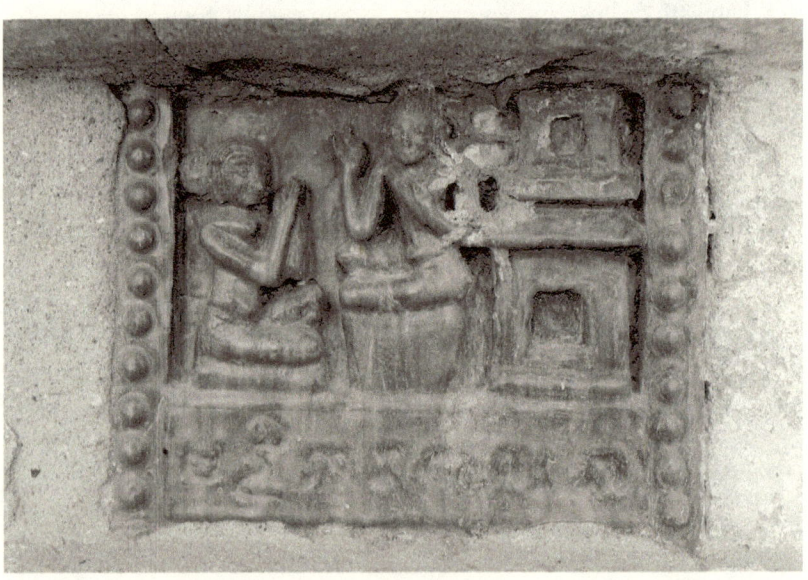

FIGURE 6.4 Maddi rejoices (362). PHOTO BY AUTHOR

pujaw—ritualized reverence—suggesting that for the Mon the story was not something people needed to *know* so much as to *venerate*, because its presence in the human world attested to the veracity of what the Buddha taught, and to the reliability of royal instructions.

Mon terms for reverence also harbored connotations of remembrance and recollection, suggesting that pious activities were meant to be informed by such mental practices, to make them efficacious. Forms of worship and attendance at recitations activated transformative mechanisms by their very exposure to what was heard, even if not understood. Such practices were necessary for lives that at least notionally were lived in a dark world, shadowed by insecurities that contemporaries articulated in Pali terms referencing 25 perils, 32 bad fates, and 99 diseases.[9] Pious practices accumulated insurance against past and future unknowns, outcomes of deeds people had no way of predicting but for which they were held accountable. Since opacity of self-knowledge was the norm, and one's sense of agency was constrained, authoritative instructions encouraged subjects to rely on the royal paternal concern that made Wessantar part of the people's haven, one of the sheltering umbrella's many spokes.[10] That the future Buddha's previous lives, including that as Wessantar, really happened was knowledge that needed to be recalled when in the Buddha's presence.

The décor's occasional inaccessibility, and thus the story's invisibility, has sometimes puzzled modern scholars, since the story was unreadable without prior knowledge and often in remote locations. Earlier investigators nonetheless assumed that displays were instructional, so that "illiterate villagers could be . . . urged to enter on the road to Buddhahood."[11] This was highly unlikely because of the complexity of these displays, but even more so because the very idea would have been astonishing, given how humans were conceived during these centuries. Didacticism also places a modern gloss on "teaching" as guided interaction between recipients and specific knowledge. But the Ananda, with its Wessantar décor, was not a twelfth-century classroom, it was a site for *pujaw* whose informational components always occurred in the hallowed settings' outer precincts, where in special pavilions people sat at a monk's feet and listened. Worshipers were thus physically remote from the Wessantar depictions when the story's significance was explicated. By contrast, they were in Wessantar's vicinity when reverencing the Buddha, an activity that was one of the means employed by this society to domesticate the supramundane and harness its potentialities for terrestrial purposes.

The Wessantar visual narrative indicates a bifurcated sensibility, suggesting that although its presence mattered greatly, one did not really need

to know much about it. The story's otherness (its relationship to the Buddha, a transcendent being straddling the mundane and supramundane realms) was attenuated by its very presence in the human world that the plaques instantiated. One could get the good of it really without knowing what it contained, all the more so since Ananda's Wessantar remained in an ideational realm in which human quibbles were irrelevant. If lies, cruelty, and selfishness were the price of omniscience, so be it.

That was the case because the Ananda's significance derived from the function of the stupa as a stand-in for the Buddha. It was the site for pious activities, its décor meant to recall why the Buddha mattered, why his supramundane persona and accomplishments answered humanity's most profound needs. One Ananda Wessantar plaque encapsulated this visually, showing the Wessantar family seated under the banyan tree, making humanity as a whole beneficiaries of what Wessantar's quest ultimately accomplished.

Both the story's presence and its meaning in the Ananda context were thus symbolic. Evidence appears in numerous plaques, one clear instance being the frame inscribed "subdues anger" (344). That plaque incorporated the Flower of the Dharma, in the Mon spelling of the term, unreferenced in the now extant Pali sources utilized by the Mon designers for their visual retelling.[12] The flower was prominently displayed above a seated Wessantar, next to his hermitage, resembling the sun in the sky. The Mon verb denoting mastery and taming, used for other crucial instantiations of the Buddha's Word in the human world, meant to say that Wessantar regained equanimity by harnessing the dhamma, as devotees did by reverencing the Ananda stupa and the story with it.[13] Wessantar's unmediated grasp of the dhamma differed profoundly from common folk's access to the real. But they had the good of it too, by virtue of his, and subsequently the Buddha's accomplishment.

What this was meant to convey can be teased out of the multiple uses made of identical visualizations, first for the alms halls and later for the hermitages sheltering the family in the wilderness, the juxtaposition of which, in the Mon reading, lay at the core of the story. This was why familiarity with the story's availability for devotees mattered. The striking visual elements were markers suggesting broader meanings, beyond what was happening in each frame, as in the case of Maddi's search for the children, where her ordeal was justified by transcendent considerations that hermitages-resembling-alms halls evoked. The alms hall–hermitage duality symbolized the ambiguities of generosity in the Mon retelling. The young Wessantar marked for future greatness in an elaborate pavilion topped

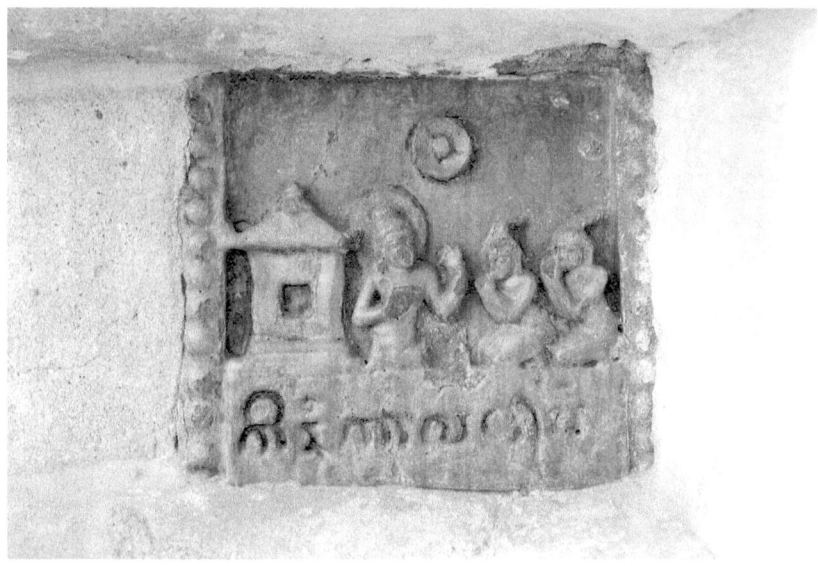

FIGURE 6.5 Subdues anger (344) PHOTO BY AUTHOR

by an umbrella, and said to be considering the meanings of generosity, was followed by a frame saying that he was looking at the alms halls. This was thereafter the standard image for human habitats, villages and cities, summed up in the alms halls that resembled the hermitages the family inhabited in the wilderness.

Alms halls thereby became symbols that linked the story's two settings, the human and the jungle worlds, pivotal concepts of the relationship between lives in an orderly society and asceticism in the wilderness, their transformative potential and mutual interdependence. The hermitages appear in numerous later episodes, most strikingly in the plaques narrating Wessantar's resumption of kingship, when Maddī and Wessantar reverence their former abodes. The plaque was inscribed with the Mon term for adoration, the sensation evoked when in the presence of the Buddha, one's parents or a stupa. The Ananda as a whole, and Wessantar with it, meant to evoke such adoration, for the good that did for its performers.

In the Mon Wessantar story's most profound rite of passage, when Maddī and the children witness Wessantar emerging from the hermitage for the first time, no longer *raja*, the plaque (328) showed *three* hermitages, and a standing Wessantar facing the kneeling family.[14] The renunciation of royal power and thus earthly authority was the essential prelude

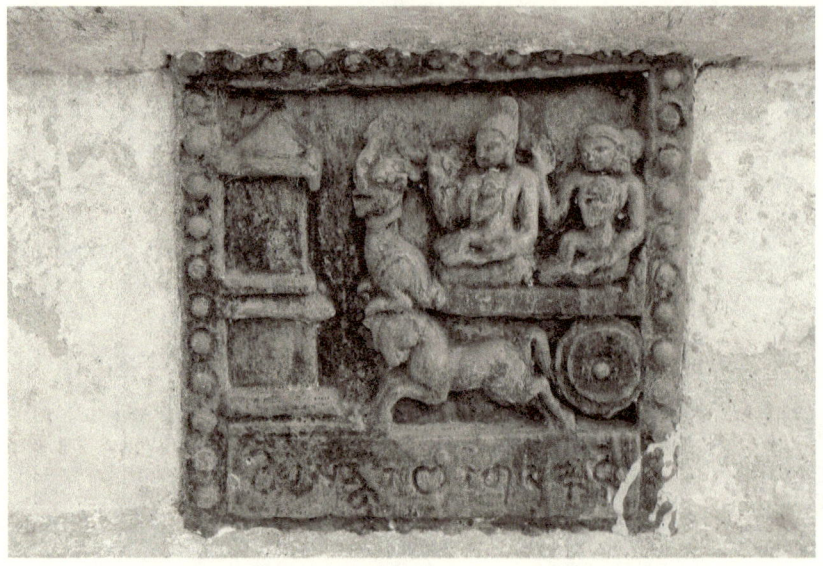

FIGURE 6.6 Looks back (at Jetuttara) (297) PHOTO BY AUTHOR

to the subsequent severing of familial bonds between father and children, and husband and wife. Wessantar had come to inhabit a realm in which such ties were irrelevant. To call attention to Wessantar's transformation, image makers inserted an additional hermitage into the plaque (327), on top of the standard two that represented the couple's celibacy. Wessantar's new persona did not make what needed to be done thereupon any easier. But this outward divestiture of royal robes was a necessary visual indication of the subsequently vastly more difficult transformations of Wessantar's self, an introduction to grasping the import of the more mundane dramatics that followed, the giving away of the children and Maddī.

The image merited attention because it enhanced Wessantar's achievement: the Mon interpretation emphasized the story as a prelude to the life of the future Buddha, whose interpretation of reality Pagan monarchs claimed to follow, as did, by extension, their subjects. The story thereby substantiated the veracity of the hegemonic ideology disseminated by royal propaganda. King Kyanzittha, the donor of the Ananda, sponsored several grand inscriptions throughout his domain, reminders of his subjects' great good fortune to live in a realm governed by a recipient of the omniscient Buddha's prophecy foretelling the glories of his reign. Kyanzittha's ceremonial title said it all: great in majesty, king of the dhamma,

shining like the sun of the three worlds. Given the Buddha's unerring veracity, Pagan's lucky denizens were thereby reassured that the peril of their lives was how things needed to be, but that help was at hand. The Mon Wessantar, with his symbolic significance, was a component of that helpfulness. He thus remained, for Mon devotees, a distant being whose societal import inhered not in their knowing his travails and their resolutions, but in feeling how earthly authorities justified the ways their society was constituted and governed. Its Wessantar reflected this reality, but the story was also a teaching, doing what profoundly meaningful ideational materials always do for their settings—engendering a reality. The Mon Wessantar on the Ananda, for all its decorative and inspirational tasks, was not an object of seeing, but of function.

THE BURMESE *VESSANTARA* OF THE LOKAHTEIKPAN

The Lokahteikpan, built about a decade after the grand Ananda, was a small *gandhakuṭī*, "perfumed hut," the Pali term for a dwelling whose occupant was the Buddha present in the form of a statue. All hollow endowments in Pagan's ceremonial center were structures so conceived. Their extremely varied décor suggests the absence of a standardized conceptualization of what his story was, indicating the fluidity of Pagan's privileged Buddhist path. Hollow endowments, where that path was made present in the public domain, usually imaged in their decors the story of the Buddha Gotama's complex antecedents. The *Vessantara* was one of these antecedents, and in the program selected by the Lokahteikpan's designers the most important one. This is evident by its detailed narrative, prominent location, and way of relating to other elements included in the Lokahteikpan's imagery.

The *Vessantara*'s interaction with other décor components in the Lokahteikpan suggests a different understanding of the story, and with it, a somewhat different formulation of what the story was meant to do. The Lokahteikpan's *Vessantara* was within eye view and was reached on the temple's east wall after circumambulators passed other images illustrating crucial chapters in the Buddha's overall biography. These chapters included the occasion on which the future Buddha Gotama, in his life as Sumedha, encountered the then reigning Buddha Dīpankara, to receive the crucial prediction of his own future buddhahood. In the Lokahteikpan as in all other hollow endowments, the Vessantara story's proximity to these and other chapters concerning the Buddha's overall

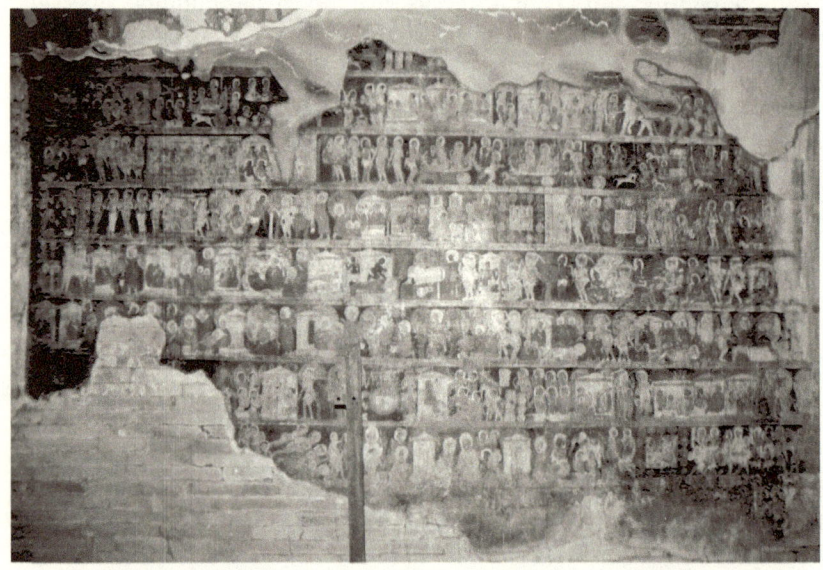

FIGURE 6.7 The Vessantara story in the Lokahteikpan. PHOTO BY AUTHOR

transfigurations, deeds, accomplishments, and victories encouraged a somewhat different reading from that of the Ananda, where the story of Wessantar culminated the 547 series of his previous lives only.

The Lokahteikpan's décor was also largely Burmese-inscribed. Unlike the Mon descriptions, which succinctly *summarized* plaque content, in the Lokahteikpan sentences accompanying mural images were longer and thus more informative. Probably because the Lokahteikpan Vessantara story was highly accessible, its designers tried to engage viewer-worshipers who, having performed the necessary rituals in front of the temple's statue, were also told what they were looking at.

Such differences between the Ananda's and the Lokahteikpan's handling of the Vessantara story suggest that the Lokahteikpan's designers had a different interpretation of the tasks of the Buddha's teachings in the human world. They also reinterpreted the *Vessantara*, whose protagonist in the Burmese inscriptions was called throughout *hpaya laung*, the future Buddha, unlike the Mon interpretation, where he was either Wessantar or *raja*, king. The Myanmar inscribers' vernacular vocabulary also used other words for which the Mon terms differed, the most significant being *taya* for dhamma (or *Dharma* in Mon) and *ahlu* for *dāna*, gifting (the Mon *dan*). The Myanmar assimilation of the Buddha's Word was moving

in different directions from the Mon at this stage, of which a differently contoured Buddha Gotama story was another indicator. Both vernaculars evolved strategies to draw attention to what the Buddha taught, but the Burmese variant employed local terms and underscored such teachings' more relational aspects by frequently recalling who was being taught.

As will be shown below, this also applied to how the Lokahteikpan's designers imaged the *Vessantara*'s events, suggesting that the Myanmar understanding of the story and what it could do differed from its Mon counterpart. The Burmese-inscribed *Vessantara* was more of a story than a symbol, the narrative of his travails more flowing and interlinked, as if its designers cared about viewers' assimilation of its content. Such concerns suggest ideational differences, also evident in the terms the two vernaculars employed to denote revered teachings' transmission. The Burmese recourse to the verb "to preach" took account of interactions between what the Buddha taught and its recipients. This paralleled a Mon equivalent that harbored a more authoritarian, top down, instructional connotation. The Burmese-inscribed Vessantara story was thus retold in a more continuous, flowing narrative that reflected the inscribers' effort to draw viewers into its content, to engage with what was being seen or heard.

To make the narrative more coherent, but also perhaps because its sources differed, the Burmese-inscribed *Vessantara* in the Lokahteikpan was much longer and omitted many fewer episodes than the Mon version. This is already evident in the Lokahteikpan's opening segment, which instead of the Ananda's succinct birth episode featured Phusatī's antecedents; the sandalwood gift; Buddha Vipassin's blessing the king's daughter's aspirations; her life as Sakka's consort and ten wishes—clarifying, as it were, Vessantara's DNA. Unlike the Ananda also, Lokahteikpan had Sakka invite the future Vessantara to be reborn on earth and while recalling his name's origin, endowed him with a skill, learning writing—useful given that he needed to read the inscription left by Sakka's architect on the hermitage wall. Negotiations regarding Vessantara's immediate future were inscribed to say, "Causing [Sanjaya] to banish *hpaya laung*," thereby lessening the king's complicity in Vessantara's fate, blaming his banishment on popular anger. Sakka's responsibility for constructing the hermitages, Jūjaka's early years, the acquisition of Amittatāpanā, and other episodes made this retelling more complexly different from its Ananda counterpart. The fuller narrative suggests an engagement with a text's interiority, as for example in an image paralleling one in the Ananda that has Phusatī overhearing Vessantara's conversation with Maddī by standing outside their door: but here she was seated on the ground, overcome with

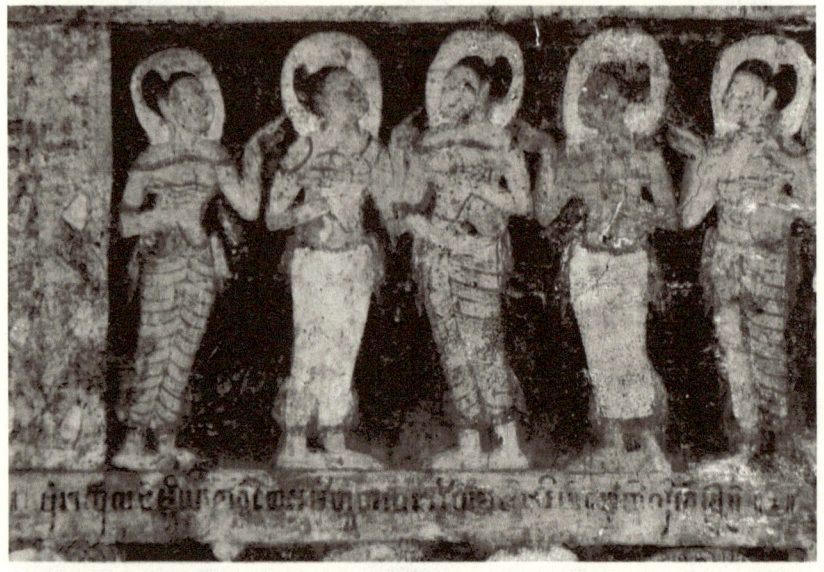

FIGURE 6.8 Amittatapana taunted by other women near the well.
PHOTO BY AUTHOR

grief. Both endowments failed to reference Vessantara's striking refrain to his parents, "I am doing good deeds while you sink in the mud," but Lokahteikpan's *hpaya laung* reverenced his mother prior to departure, not shown in the Ananda in this episode.[15]

The "looking back" incident showed the carriage facing Jetuttara, but omitted how Jetuttara looked, drawing attention to the glance as an expression of Vessantara's unsurmounted longing for his birthplace. Where the Ananda needed only two frames for the family's daily routine, the Lokahteikpan's more elaborate retelling showed Maddī in her ascetic outfit, basket in hand, off to the forest, leaving the children with their father. Ananda's Jūjaka's encounter with the Cetan had its Lokahteikpan counterpart, but the latter's naiveté was captured in saying "Continuing to believe Jūjaka's words, [he] points the way," reflecting narrators' engagement with their protagonists' inner being, making the story's characters not stick figures in a morality play but gullible mortals.[16]

Maddī's dream, omitted in the Ananda, was precisely imaged and inscribed, attesting to the episode's importance, showing her stretched out on the bed, the horrific figure hovering above her body, then departing, followed by an image of the sleeping children, a juxtaposition that clarifies

FIGURE 6.9 Maddī's dream PHOTO BY AUTHOR

in viewers' minds their interconnectedness. Modern interpretations often regard the apparition as a Vessantara double, but the twelfth-century image visualized a mysterious being instead. In the dream's aftermath, Maddī could be seen kneeling at Vessantara's feet, followed by five segments covering their conversations, the children's presence an allusion to her concerns, ending with a frame inscribed, "Having instructed her children, leaving them in their father's care, Maddī enters the forest." All this was omitted in the Ananda but important for how telling the Burmese story, partly about a househusband, was told.[17]

The remainder of the tier featured Jūjaka's arrival, the moment's tension captured by showing him gazing, much like in the Ananda, at the seated Vessantara and children. The giving-as-addiction metaphor was absent from the inscription, eliding his donations' profound ambiguities and costs. A close narrative of the children's futile escape attempts, as in the Ananda, was followed by Maddī's return. Neither structure mentioned the ensuing earthquake nor alluded to Vessantara's declaration that omniscience was more precious than his son. The Lokahteikpan also differed from the Ananda in omitting reference to how Vessantara regained his self-control and wept. Maddī's journey through the forest encountering

FIGURE 6.10 Maddi encounters three gods disguised as animals.
PHOTO BY AUTHOR

the three gods-as-animals showed her on her knees, reverencing them as her kin, with the symbolic basket, a stand-in for her care and resourcefulness, on the ground—a different interpretation from the Ananda's more prosaic take.

A sentence saying, "Stays with a sunken head," evoked Vessantara's initial response to her inquiry, showing Maddī kneeling at his feet. The next inscription had her back in the forest, birds in the tree and toys on the ground, in line with the Pali text. Her return ("the wife Maddī raises her palms and swoons") was shown in slow motion: she first stood, her hands reverencing her husband, then fainted, which is followed by an image of her head on Vessantara's lap, his hand barely touching her body.[18]

The tier moved back to the children's and Jūjaka's journey, including another image of Jūjaka sleeping on the treetop, the children tied to the tree below; Sañjaya's dream (damaged but attested from the inscription), and a further inscription cleaving closely to the Pali saying that the king recognized his grandchildren from afar and ordered them brought into his presence. The ensuing frames recalled numerous dialogues, including between Jāli and his grandfather, the courtiers' criticism of Vessantara's deeds, Jūjaka's reward and death ("eats excessively"), messengers

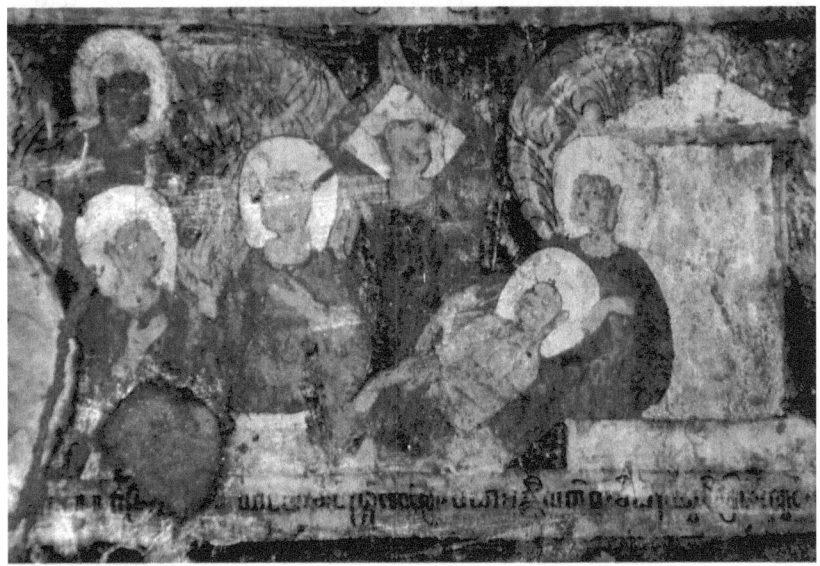

FIGURE 6.11 Maddī swoons. PHOTO BY AUTHOR

beating the drum in quest of potential heirs, and a fire, alluding to Jūjaka's cremation.[19]

The Lokahteikpan had two additional tiers, now badly damaged, covering the remaining episodes, including Maddī and Vessantara on a hill observing the entourage's approach, like in the Ananda; the elephant's reappearance; various royal conversations; and the children's reunion with their parents. One particularly striking image, unique in the extant Pagan record, showed the whole entourage prone: a reference to their being overcome by emotions, paralleling the Pali "the whole hermitage was like a grove of sal trees devastated by a storm at the end of an era" (CG 81), somewhat differently visualized in the Mon retelling. The remainder closed with a happy ending: the couple's transformation from ascetics to king and queen, their consecration, their return to Jetuttara, and Vessantara's additional good deeds.

This juxtaposition of two visualizations shows how the Ananda's selective and frequently symbolically interpreted Wessantar differs significantly from the Lokahteikpan's effort to clarify the narrative's continuities and actions, to trace protagonists' deeds, their emotional costs, and their outcome. The Lokahteikpan's retelling fleshed out personalities and

predicaments by employing images and vocabulary to draw spectators into the story's world, as if close engagements with the tale as told mattered. The Lokahteikpan visualization not only was technically different (murals as opposed to terra-cotta plaques) but also expressed a distinct translation, transmission, and reasoning mode when its designers' communicative endeavors harnessed graphic means to create greater transparency and accessibility, and thus assimilation.

Instead of Ananda's iconicity and symbolic significance, Lokahteikpan's *Vessantara* is permeated with evocations of the world that the story's protagonists inhabited, and their travails, as if to suggest that the story's meanings could be found in its content, more than in its overall significance. The absence, with one exception, of the "hermitages" element in the Lokahteikpan imagery is particularly noteworthy, given its centrality in the Mon interpretation. Even in the wilderness, protagonists resided in pavilions resembling the settled realm. Perhaps for the Lokahteikpan interpreters of the *Vessantara*, the stark Mon juxtaposition between life in the settled world and in the wilderness mattered less and was not regarded as the interpretative key to unlock the story's significance, attenuating the problematics of what generosity in the absence of material goods represented.

The ambiguities of generosity in the Lokahteikpan were only one aspect of the story's content, evidenced in the attention paid by the murals' designers to so much else in the narrative that the Mon reading ignored. The very attempt to tell the story fully indicates a profoundly different take on what the Buddha taught meant in the world of his Myanmar devotees. The future Buddha's travails were beginning to acquire a resonance that merited attention beyond the crucial fact of their occurrence. Wessantar the symbol had become a being with a past, as was true of other protagonists in the story. The two vernacular interpretations, however, were similar in that neither presented him as a role model, since both underscored that his deeds were inimitable. The approved response from Mon and Myanmar followers of the Buddha's teachings in Pagan was gratitude for Vessantara's sacrifices, not imitation of them.

U OBATHA'S WETHANDAYA

In the post-Pagan era, perceptions of humans as refugees in in the world did not change much. A poet in 1523 elaborated: "Birth after birth, over and again, with dirt and besmirching, oppression and evil, fading and withering, longing and craving, crying and growling, clutching and

clinging, panting and gasping, sobbing and weeping, toiling and weariness, all pervading, round and round like a spinning reel."[20] Vessantara was on hand for support, but in Obatha's reflections, at the end of the eighteenth century, which helped foster reformulations of devotees' interaction with the Buddha's teachings, the result was a different Vessantara, now called Wethandaya. A monk who could tell his readers, "*You now know*," thereby presupposed that familiarity with the story mattered over and above acknowledging its existence, especially since this "You now know" was said by Obatha's Buddha.[21] The readers became bystanders, since the translator engineered a proximity that earlier centuries' ritualistic exposure had obviated, by exposing his generation to a Burmese-speaking Buddha. If they thereupon asked themselves, *Now that we know, what good does it do us?* Obatha showed how deeds changed people and why that mattered. In so doing, he participated in the hugely complex process of refiguring their sense of self. Obatha's Buddha helped those who fulfilled their duties and obligations as defined by relationships in which they were enmeshed. The story thereby became about transformative interactions, not Vessantara's but their own.

This Obatha did, by his own admission, in response to a request by the pious Maung Htauk, son of one of Obatha's lay supporters, who asked

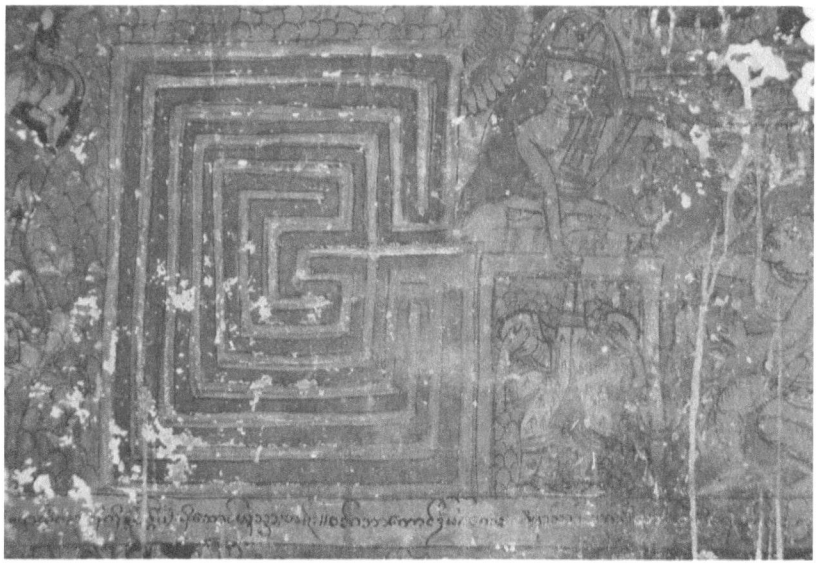

FIGURE 6.12 Wingaba Hill, site of the family's wilderness refuge, imaged as a labyrinth in an eighteenth-century Burmese temple. PHOTO BY AUTHOR

for a *Vessantara* in what was called language of the country, that is, in Burmese.[22] Obatha agreed to produce one, and the result was a breakthrough, enabled by several centuries of Burmese attempts at recasting the Buddha's Word into the people's spoken tongue. His predecessors' achievements enabled Obatha to share the Buddha's task in explicating the meanings of the teachings, generating a sense of empowerment and pride in accomplishment, which justified a freer use of Obatha's Pali source and numerous additions and elaborations.[23] As a translator who inserted words into the Buddha's mouth, Obatha thereby assumed that had Gotama delivered the Wethandaya in Burmese, he would have done so just like U Obatha.

His translation-interpretation was done against the background of ideational battles regarding how the Buddha's teachings needed to live in the Myanmar world, as learned monks labored to purify what was on hand from what they called "the thorn of corruption."[24] For the first time, doing things by the book, or the palm leaf, given the setting, became more than a slogan eliciting mostly lip service. Obatha's story of the present (that is, the occasion in the Buddha's life on which he told Wethandaya's story) added that the Buddha's deeds on that occasion were meant "to confound certain heretics and controvert their doctrines," making Wethandaya an ally in ideational confrontations.[25]

Under Obatha's immensely skillful ministrations, the story became a masterpiece suffused with literary and poetic pyrotechnics, since he rarely passed an opportunity to insert three or four modifiers where one would have sufficed. An example of literary techniques was the occasional effort to sustain tension by delaying what followed, as when Obatha stretched out numerous conversations, improving on how the Buddha told the story.[26] Literary flourishes abound, such as the following, to explicate Vessantara's resolve: "Then, with the hand of wisdom, he fastened to the post of watchfulness by means of the rope of exertion the wild elephant anxiety" when nothing less than Wethandaya's resolve and intention were at stake.[27] Other ministrations reflected Obatha's eroticism, indicating sensuous delight in femininity, also imitating poetic predecessors, all monks. Fascination with the beauties of the natural world was another instance where Obatha let himself go, enabled by the legitimacy of amplifying the Buddha's metaphors, something none of his Pagan predecessors would have dared to do.

Obatha reinterpreted characters' personae, including Maddī's, who become more forceful and assertive, and was also said to be perfecting her own accomplishments on the road to a rebirth as Prince Siddhartha's

wife. Since Obatha was also a poet, Wethandaya's advice to Maddī was often in verse, an indication that Obatha wanted his readers to memorize more easily why confidence in the Buddha's teachings on behalf of the good merited assimilation, and why Maddī was an appropriate role model for women unlikely to be married to a future buddha.

The highly literate Obatha, who knew his sources and the story's life in his oral universe, textualized what was available to create an object of knowledge, reflecting a contemporary sense that lives shadowed by ignorance needed an antidote in the form of internalized guidance. Such guidance was necessary because ignorance smothered inborn human qualities conducive to living well.[28] The eighteenth-century variant of the human predicament was imaged (literally) in the form of a maze, to represent Vankagiriya, the Burmanized Wingaba Hill, site of the family's jungle exile. The image was a metaphor for the human condition, and Wethandaya's path's intricacies were thereupon reconstructed on pagoda platforms.[29] Wethandaya's seat in his abode was a metaphor for the future Buddha's throne, from which the Great Being would dispense to humanity the antidote for what ailed it.

In order to make his readers or auditors knowledgeable enough to take guidance on how to walk their own narrow paths, Obatha explicated complex concepts like causality, hindrances, impurities, or rebirth, to illustrate loaded terms like truth in light of the Buddha's teachings.[30] Other elaborated fillers were morals, as in distinguishing people en route to hell for their greed, selfishness, and inattention to duties contrasted with meritorious actions of those destined to be gods. These and other moves were meant to attenuate the Pali's stress on "what is hard to do," because Obatha thought other means to elicit appropriate behavior preferable.[31] He thereby inscribed a path to knowledge in tune with his times, providing the know-how to contend with karmic injunctions, because Wethandaya and Obatha's readers, walking labyrinthine paths, required assistance to contend with accountability.[32]

Such glosses on accountability also created new forms of agency, as responsibility defined by obligations became personalized. Fulfilling one's duties accumulated merit, but also activated the benefits of taking refuge, an all-encompassing shadow providing shelter. The Wethandaya protagonists' choices, when informed by knowledge of the difference between good and evil, generated the serenity and acquiescence that were the appropriate response to life's curves. A stellar cast lamenting and celebrating in Burmese came to inhabit a Burmanized world, teeming with Myanmar terms and names, for humans, plants, gods, spirits, birds, and locales.

Obatha's main innovation was to inscribe a more humanized Wethandaya while sustaining his extraordinary persona, attested by wonders and miracles. Supramundane intercessions attenuated his responsibility, diminishing Wethandaya's blame for the sufferings his quest inflicted, as well as for slippages. No Pagan image ever showed Wessantar or *hpaya laung* wielding weapons, but several in Obatha's time did. In the elephant donation episode, Obatha remarked that the Brahmins' departure occurred "under the gods' watchful care so that *hpaya laung*'s merit should not be lessened nor his good deed become of no effect."[33] Wethandaya was also absolved of wrong intentions, as in the Great Donation episode where alcohol was on hand. This was meant not to encourage drunkenness, Obatha added, but to meet people's desires, illustrating Wethandaya's consideration of everyone's wishes and effort to meet them. The problem of this violation of precepts, in short, was theirs, not Wethandaya's.

The humanity of Wethandaya, central to how the Pali conceived the story's core conflicts, was considerably fleshed out. Obatha insertions, for example, elaborated on seeming backsliding, as when touching Maddī's body, Obatha commented that, knowing the softness of women's hearts, Wethandaya was afraid to break Maddī's by blurting out the truth. The Pali Vessantara was sometimes at his most human when under great stress, and Obatha exploited such possibilities: when describing his response to the approaching army, the Pali has the couple "climb the mountain," but in Obatha, the two "fled." Obatha further amplified his hero's tearful anxiety and self-pity, in which Maddī somewhat shares since, the translator added, "Afraid of being put to death, they wept."[34]

A future buddha's burdens were made more intelligible not by elaborating on omniscience but by explicating self-mastery to subdue negative propensities. This was the primary engine of experience Obatha's retelling meant to activate, because the road to buddhahood was for future buddhas alone, but self-control was good for everyone. Obatha's rewritings thereby clarified how generosity, defined as good deeds of all kinds, and more importantly appropriate behavior in relationships, were cause of and support for their performers' transformation, making keeping precepts efficacious. Only now, late in Myanmar history, did the story thereby become a prompt for ethical actions that knowing its content informed.

Obatha's retelling thus sustained a Vessantara on an inimitable path, but by elaborating Wethandaya's human predicament, showed how obstacles and challenges altered the story's protagonists mostly for the better. He thereby suggested that though Wethandaya's challenges were unique,

regular mortals, when tested by more mundane travails, profited likewise in surmounting them. The benefits of trial by fire are especially clear in how Obatha handled the drama surrounding Jūjaka's maltreatment of the children and their father's murderous rage. Obatha thereupon elaborated on the (in the Pali) technology Vessantara employs to steel his resolve, a practice that Obatha's auditors knew, since their Buddha recollections parallel Wethandaya's by channeling his predecessors, who performed the five good deeds with minds unstained by passion. Wethandaya was fortunate to be able to draw on earlier buddhas' resolution of similar difficulties. Thanks to his success, humans were also granted means to bolster their own fortitude.[35]

Obatha's takeaway message, in verse, showed how personal responsibility depended on interactions with others, clarified in the conclusion appended at the end of his adaptation, which paired the story's characters with individuals alive during the Buddha Gotama's time. Wethandaya's relationship with his father instantiated compassion, while King Theinzee (the Burmanized equivalent of the Pali Sañjaya) forgiving Jūjaka's transgressions was an example of *mettā*, commonly translated as "loving-kindness." Children's gratitude to parents was exemplified in what Obatha repeated was their ultimately voluntary departure with Jūjaka, while Maddī was the paragon of true womanhood because of her devotion. Relationships were about meeting other people's needs and thereby transforming the self, making the siblings' interactions an example of how brothers and sisters should cohabit in this world and the story a means for kings to learn what monarchs needed to do. In such a realm, authorities spared their subjects poverty, as big brothers (Obatha's term) would, because governance was paternalism, not a badge of lost innocence. Even Jūjaka's descent to hell was useful now, since squandering good fortune by overindulgence reflected his stupidity, ignorance, greed, and cruelty. All of this indicates how far the story had moved away, in the Myanmar world, from issues of Vessantara's gifting.[36]

In Obatha's world, where laypeople's pieties mattered more than in the past, Vessantara ceased to serve only a remote hegemonic ideology, thus allowing the story to become explicitly about how to live in the world. Its retelling reflected more intrusive interventions in people's lives that required new forms of self-awareness. A king's prohibition in 1679 of selling children to settle parental debts was one example. Vessantara's repayment of his karmic debts was presumably not what the king had in mind. But such interventions to alter common practices also paralleled broader popular inclusion in what were once elite activities, signifying closer

engagement with the Buddha's teachings and Vessantara. Endowments in Obatha's era often had individual images illustrating and inscribing morals unambiguously: penalties for abortion, thievery, cockfighting, and other transgressions. Royal orders targeting customary practices were, given the historical record, innovations, as were differences in how the transcendent was harnessed for mundane purposes, all indicating how far Obatha's world had moved since Pagan times, and Vessantara with it.

Obatha sometimes called the elephant Pissaya (*paccaya*, the Pali "cause"), elaborating the animal's significance when Wethandaya tells the Brahmins, "I give you this elephant that no one on this earth is worthy to ride upon but myself, and of which I am owner only by reason of my merit (*phun*) and which is mine." By Obatha's time the Pali *paccaya* was a loan word in Burmese. In the Pali, Vessantara was the cause of the elephant and not the other way around, but Obatha here followed a reading derived from another revered commentarial source where the Pali *paccaya* also names the elephant. Obatha interpreted the animal to be the cause of Vessantara's deed, the "good support" that Wethandaya owns, repeated when he explains to the Cetans Pissaya's significance.[37] Wethandaya, for Obatha's contemporaries, was such a support because the story showed how life needed to be lived in a new world whose sense

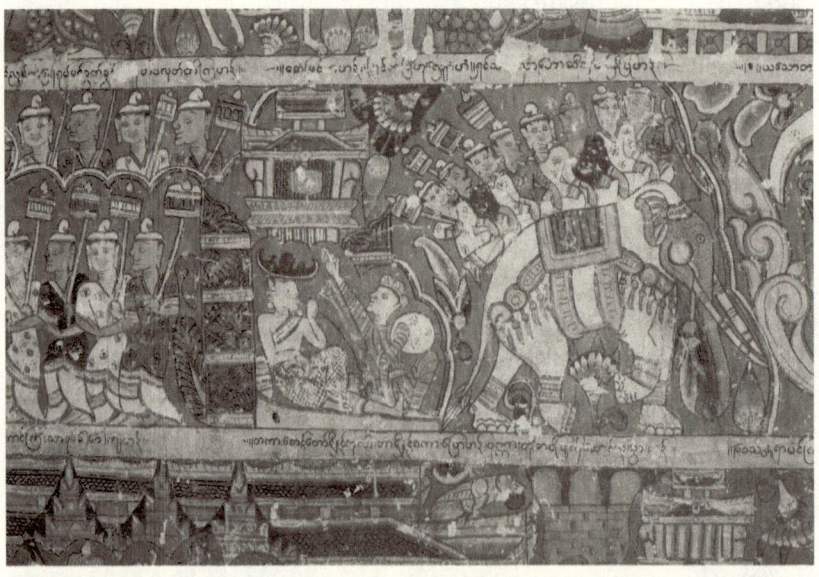

FIGURE 6.13 Donation of the white elephant, imaged in an eighteenth-century Burmese temple. PHOTO BY AUTHOR

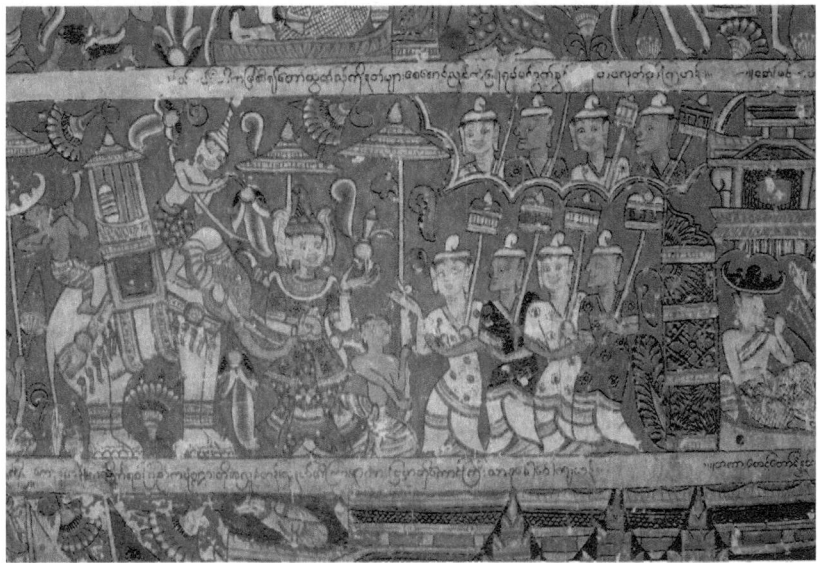

FIGURE 6.14 Brahmins departing on an elephant, imaged in an eighteenth-century Burmese temple. PHOTO BY AUTHOR

of instrumentalism had shifted. The donation of the elephant thereby became for Myanmar the story's emblematic image, since by implication Wethandaya became for everyone what the elephant had been for him, if only they proved themselves worthy.

Obatha thereupon showed the attainability of worthiness, by greatly broadening the meanings of generosity. Laypeople's generosity, he knew, could not possibly compare with Wethandaya's, necessitating reformulation. The sense of Wethandaya's inimitability haunted Obatha sufficiently to give the story a different slant. As counseling of patience on behalf of glorious afterlives, Pagan's slogan, no longer sufficed; innovative socialization practices demanded a new Vessantara, and Obatha obliged. His Wethandaya thereby ceased to be what this volume's editor has called "a signifying device in a morality play" concerned with ethically insoluble conflicts.[38]

This was good to know, since in Obatha's time Niban (nirvana) was deemed attainable in this lifetime rather than only at the future Buddha Metteyya's coming, which meant that more was expected from devotees than delighting in other people's good deeds. Obatha's and other contemporary monks' rearticulations of the Path in the late eighteenth century

swept the *Vessantara* along currents bearing the entire corpus of the Buddha's teachings in directions no one in Pagan could have foreseen. His stated intention to make the good people of his time "understand and remember" Wethandaya indicates suspicion that their ancestors didn't get it right, but also optimism regarding possible change.[39] Obatha's retelling provided a mirror for his times by showing, as he understood it, the meanings of lives lived well, which his version of the Vessantara story made present.

This chapter takes the *Vessantara Jātaka* beyond issues of iconicity and generosity, to show how two different visualizations and one elaborate retelling—when contextualized historically—can illuminate the story's transmutations over the centuries, above and beyond its textual content. Relating two Pagan interpretations to a later Myanmar version engages three discrete retellings to tease out how a core text lived as an evolving paradigm, sustaining its great prestige and resonance while being constantly reinterpreted.

King Hsin Pyu Shin, patron of Obatha's teachers, the reigning monarch in his lifetime, donated an umbrella for a revered Pagan stupa, the Shwezigon, initially completed by one of his predecessors, king Kyanzittha, donor of the Ananda. Hsin Pyu Shin also rededicated the lands to the monastic establishment given by his other putative ancestor, King Alaungsithu, during whose reign the Lokahteikpan was built.[40] Hsin Pyu Shin's link to Pagan's dynasty was an enabling fiction that indicates how necessities of historical memory mythologize the past, *inter alia* reconstituting the Buddha's teachings, making them an endless work in progress. Traces of such Myanmar reconceptualizations are evident in terms used to label the privileged Buddhist path in the course of a millennium. Obatha was alive when for the first time the term *Theravāda* appears in the public domain. The donor of a 1761 endowment whose Vessantara narrative features a labyrinthine Wingaba Hill inscribed another image with the hitherto not encountered title *Theravāda Zaq (Jātaka)*, the image relating a previous Buddha life, of unknown origin. The eighteenth-century contours of what constituted the Buddha's teachings, and above all their social tasks, differed from identifiable Pagan counterparts, generating new associations in whose light Vessantara lived and was meaningful. As Dickens would have said, it has been ever thus.

NOTES

I thank the anonymous reviewer for an illuminating critique of an earlier version of this chapter, as well as Professors Steven Collins, Anne Monius, Charles Hallisey, and Michael Aung Thwin for their instructive comments.

1. Robert L. Brown, "Narrative as Icon: The Jataka Stories in Ancient Indian and Southeast Asian Architecture," in *Sacred Biography in the Buddhist Traditions of South and Southeast Asia*, ed. Juliane Schober (Delhi: Motilal Banarsidass, 2002), 64–109.
2. The most influential Burmese retelling of the story is U Obatha's, written in 1773. Minbu U Obatha, *Wethandaya Zat Daw Gyee* (Rangoon: Hanthaway, 1951). The Obatha quotations in this chapter, unless otherwise noted, are my own. Two English translations are L. Allan Goss, *The Story of Wethandaya, a Buddhist Legend* (Rangoon: American Baptist Mission Press, 1886), and O. White, *A Literal Translation of The Textbook Committee's Revised Edition of Wethandaya, the prescribed text for the sixth, seventh and eighth standard and entrance examinations* (Rangoon: American Baptist Mission Press, 1906).
3. Sabine Gross, "Writing in Images," *Monatshefte* 102 (Fall 2010): 278–79. Earlier adumbrations of the approach can be found in Paul Mus, *Barabudur: Sketch of a History of Buddhism Based on Archaeological Criticism of the Texts*, trans. Alexander Macdonald (New Delhi: Sterling, 1998); Dieter Schlingloff, *Studies in the Ajanta Paintings: Identifications and Interpretations* (Delhi: Ajanta, 1988); and Vidya Dehejia, *Discourse in Early Buddhist Art: Visual Narratives of India* (New Delhi: Munshiram Manoharlal, 1997).
4. Than Tun, "History of Buddhism in Burma," *Journal of the Burma Research Society* 61 (December 1978): 85–86.
5. Henry L. Shorto, *Dictionary of the Mon Inscriptions from the Sixth to the Sixteenth Centuries* (London: Oxford University Press, 1971), 42; Charles Duroiselle, ed., "The Talaing Plaques on the Ananda," *Epigraphia Birmanica*, II (1921) (hereafter *EB*), Part 1, 129; C. O. Blagden, ed. and trans., "Mon Inscriptions, Nos. IX–XI," *EB* III (1923), Part 1, 38. Almost all Ananda plaques and their inscriptions were published. They appear in Charles Duroiselle, ed., "The Talaing Plaques on the Ananda: Text," *EB* II (1921), Part 1; and in Charles Duroiselle, ed., "The Talaing Plaques on the Ananda Plates," *EB* II (1921), Part 2.
6. (1921).
7. Claudio Cicuzza, ed. and trans., *A Mirror Reflecting the Entire World: The Pali Buddhapadamangala* (Bangkok: Fragile Palm Leaves Foundation, 2011), 161.
8. (1921).
9. Tin Lwin, "A Study of Pali-Burmese Nissaya With Special Reference to the *Mahaparinibbana sutta*" (M.A. thesis, University of London, 1961), 93.
10. C. O. Blagden, ed. and trans., "A Third Inscription Found at the Shwesandaw Pagoda, Prome," *EB* I (1920), Part 2, 166–67.
11. Ba Shin et al., "Pagan Wetkyin Kubyaugyi, an Early Burmese Temple with Ink Glosses," *Artibus Asiae* 33 (1971): 172.
12. *EB* II, Part 1, 128; for the flower metaphor, see C. O. Blagden, ed., and trans., "The Great Inscription of the Shwezigon Pagoda," *EB* I, Part II, 123.
13. Gordon H. Luce, "Pali and Old Mon Ink Glosses in Pagan Temples," *Journal of the Burma Research Society* 58 (December 1975): 157, 240–41; Shorto, *Dictionary of the Mon Inscriptions*, 37.

14. *EB* II, Part 1, 139.
15. Bohmu Ba Shin, *The Lokahteikpan* (Rangoon, 1962), 107:138, 108:139, 109:140. Margaret Cone and Richard F. Gombrich, *The Perfect Generosity of Prince Vessantara, A Buddhist Epic* (Oxford: Clarendon Press, 1977) (hereafter CG), 27.
16. Ba Shin, *The Lokahteikpan*, 110:141.
17. Ibid.
18. *EB* II, Part 1, 128, 129, 133; Ba Shin, *The Lokahteikpan*, 111:142, 110:142, 110:141; CG 62.
19. Ba Shin, *The Lokahteikpan*, 111:146.
20. John Okell, "'Translation' and 'Embellishment' in an Early Burmese Jātaka Poem," *Journal of the Royal Asiatic Society* 99 (April 1967): 135.
21. Goss, *The Story of Wethandaya*, 79; Obatha, *Wethandaya Zat Daw Gyee*, 266.
22. Obatha, *Wethandaya Zat Daw Gyee*, 273 ff. For his biography see Aung Maung, *Vessantara Questions and Answers* (in Burmese) (Rangoon: Gandhama Press, 1954).
23. For examples see Obatha, *Wethandaya Zat Daw Gyee*, 101, 214.
24. D. Christian Lammerts, lecture, April 15, 2013, Harvard University; Patrick Pranke, "Thathana Than Shin, the Legend of Anawratha," unpublished conference paper, 14.
25. Obatha, *Wethandaya Zat Daw Gyee*, 18; Goss, *The Story of Wethandaya*, 3.
26. Compare CG 17 with Obatha, *Wethandaya Zat Daw Gyee*, 56, for example, in the case of the conversation between the king's messenger and Wethandaya.
27. Obatha, *Wethandaya Zat Daw Gyee*, 168; for the significance of Wethandaya's resolve and intention, see Steven Collins, *Nirvana and Other Buddhist Felicities: Utopias of the Pali Imaginaire* (New York: Cambridge University Press, 1998), 510.
28. Obatha, *Wethandaya Zat Daw Gyee*, 276.
29. Goss, *The Story of Wethandaya*, 32. See also Gabaude, this volume.
30. Obatha, *Wethandaya Zat Daw Gyee*, 107, 210.
31. Compare CG 77; Goss, *The Story of Wethandaya*, 62: White, *A Literal Translation of The Textbook Committee's Revised Edition of Wethandaya*, 102.
32. Obatha, *Wethandaya Zat Daw Gyee*, 118, 144, 160, 189.
33. Compare CG 14 with Obatha, *Wethandaya Zat Daw Gyee*, 49.
34. Obatha, *Wethandaya Zat Daw Gyee*, 243–44, by contrast with CG 87.
35. Obatha, *Wethandaya Zat Daw Gyee*, 180, 181, 184; Goss, *The Story of Wethandaya*, 51; White, *A Literal Translation of The Textbook Committee's Revised Edition of Wethandaya*, 83–84; CG 63.
36. Obatha, *Wethandaya Zat Daw Gyee*, 274ff.
37. Obatha, *Wethandaya Zat Daw Gyee*, 37, 107, 241–42; Tin Lwin, "A Study of Pali-Burmese Nissaya With Special Reference to the *Mahaparinibbana sutta*," 165; CG xxxiv–xxxv, 12.
38. Steven Collins, "What Is Literature in Pali?" in *Literary Cultures in History*, ed. Sheldon Pollock (Berkeley: University of California Press, 2003), 660.
39. Obatha, *Wethandaya Zat Daw Gyee*, 10–11, 208.
40. *Inscriptions of Pagan, Pinya and Ava* (Rangoon: Government Printing, 1899), 19–21.

7

VESSANTARA OPTS OUT

NEWAR VERSIONS OF THE TALE OF THE GENEROUS PRINCE

Christoph Emmrich

THE TALE of the generous prince in the versions written, painted, read, told, heard, and viewed among the Newars of the Kathmandu Valley is a complicated one, marked by both unique narrative developments and an unexpected convergence between story and ritual. The Newar language version is striking, as much as it ends with Vessantara persisting in blissful renunciation, dramatically emulated by his father, and kingship casually passed on to the grandson. This is a plotline that may help complicate models that conceive of Newar Buddhism, and Buddhism beyond Nepal, as centered on a certain idea of the domestic and help us look at their reverse side: what kind of literary *domus* are we talking about in which the husband protagonist remains ascetic? How, for his public, does the ascetic resist home, and through that allow for imagining life beyond the family? What does that mean for the family, particularly the wife, and how does she make sense of the story both affectively and ritually? And how did such an ending come to be told in the first place? What is its historical and thematic location in the larger network of variants of the story? This study tries to answer these questions through a closer reading of the 1980 documentation by Siegfried Lienhard of one manuscript's text and illuminations and a comparison of that manuscript with further Newar and Sanskrit variants. It will explore how this story and its oral and visual commentarial field may have been transformed by the purposes and circumstances of its ritualized telling.

MANUSCRIPTS AND PERFORMANCES

The traditional Newar Vessantara, called Viśvantara and often spelled Bisvaṃtara, inhabits, as his variant name indicates, a proximate yet rather distinct literary universe set apart from that of his Pali, Sri Lankan, and Southeast Asian relatives.[1] The development of a written vernacular literature in Newar[2] in the Kathmandu Valley in the early centuries of the second millennium C.E. happened from within and in conscious emulation of the North Indian traditions of Sanskrit literature. The emerging Newar Buddhist literati of that period would have been conversant less with Pali than with Sanskrit texts, and with the whole range of Sanskrit genres and canons popular in North India at the time. That would have included the epics, the *purāṇa*-s, *kāvya* literature in its multiple forms, and household ritual prescriptive texts, to name just a few relevant to our text. Particularly crucial for the story's composition would have been the *avadāna* and *jātaka* collections in Sanskrit, such as the *Divyāvadāna* and the works of authors such as Ārya Śūra and Kṣemendra. But so would ritual literature, particularly, as we shall see, that connected to the interface of devotional narrative and prescriptions for the performance of vows. Hence, when we talk about a Nepalese or a Newar version, it is with the knowledge that the Newars themselves were aware of a wide range of variants of the story that they would have considered "theirs." They would have been conversant with, copying, and preserving Ārya Śūra's *Jātakamālā*, Kṣemendra's *Avadānakalpalatā*, or Somadeva's *Kathāsaritsāgara*, all three of which contain versions of the story and of which a great number of manuscripts are extant in Kathmandu Valley archives. They would also have known, at some point in time, versions that, at least in their Sanskrit form, were not as successfully transmitted. And this is what the Newar version seems to reveal.

When we talk about a Newar version, we refer more restrictively to a multiplicity of variants composed and transmitted in Newar, sometimes accompanied by visual representations in a similarly distinct Newar idiom. Most available dated manuscripts record prose versions. We know only of one dramatic rendering,[3] and there seems to have been a tradition of song cycles, of which Lienhard published two pieces.[4] Though the oldest known manuscript hails from 1749/50 and Lienhard's painted scroll from 1837, most dated manuscripts fall in the period between the 1860s and the 1920s, a time frame in which sponsors' and priests' interest in the story seems to have intensified. One connected development could have been

the increased production of literature for the performance of a particular ritual. In fact, the majority of dated manuscripts of a genre of ritual texts composed in Sanskrit and in Newar called the *aṣṭamīvratamāhātmya*, usually containing one or more *avadāna*s, fall in the same period. These works are compilations used and referred to in the performance of the Eighth-Day Vow (*aṣṭamīvrata*[5]), a ritual that involves the narration of birth stories.[6]

The performance of the Eighth-Day Vow[7] is a one-day affair to be carried out on the eighth day (*aṣṭamī*) of the bright lunar fortnight (*śuklapakṣa*).[8] It is undertaken to generally increase one's merit and only sometimes to work toward the fulfillment of specific personal wishes, usually takes place in the temple courtyard, and centers around a main event requiring a fire sacrifice, beginning in the morning and ending in the afternoon. The participants, most of whom are women, are guided by a chief priest (*mūlācārya*), who is likely to follow a manual called the Aṣṭamīvratavidhāna,[9] and by the instructor (*upādhyāya*) in charge of eventually telling the story, among other things. The group of worshipers, usually presided over by at least one leading couple from the sponsoring family, make subsequent offerings to the Buddha, the dharma, the sangha, and the bodhisattva Amoghapāśa-Lokeśvara, a form of Avalokiteśvara. All four are represented by particular mandalas painted on the ground or depicted on artifacts brought along or distributed. The women and men are said to observe the Eight Precepts: no killing, no stealing, no improper sexual behavior, no lying, no intoxication, no eating after noon, no participation in entertaining events, and no sleeping on big and high beds. In practice this also involves bathing in the morning, the men in some cases shaving their heads; not wearing either jewelry or makeup; fasting, i.e., eating only rice pudding, sweets, and fruits, and breaking the fast only once in the afternoon after the main event; and spending the following night on a mat on the floor without coming into physical contact with members of the opposite sex—all of which observances are to be kept until the morning after. Immediately after worshiping the mandala and before the breaking of the fast, the white votive thread (*vratasūtra*) attached to the main ritual pitcher (*kalaśa*), later to be cut into pieces and tied around the participants' neck, is run through the worshipers' clasped hands. The women and men, sitting on their right leg with the left leg raised, hold on to it as the *upādhyāya* reads out one of the stories associated with the event. One of those stories is the tale of the generous prince.[10]

PRODUCING VIŚVANTARA: STORY AND RITUAL

In what follows I would like to present a reading of a manuscript (and to a certain extent its images) made accessible through the marvelous documentation by Siegfried Lienhard.[11] The manuscript reproduced in his edition is called the *Bisvaṃtara rājāyāgu kathā* (*The Story of King Viśvantara*, henceforth quoted as BRK) and dates from 1837.[12] Though Lienhard deals with some of the issues raised here in his introduction and his notes, the intention of his work is descriptive, not interpretative.[13] From the samples Lienhard quotes in the main part of his book, which includes a color reproduction of the entire scroll and an iconographic description of the images,[14] one may get an idea of the contrast between the narrative as represented by the captions on the scroll and by a text with claims to a certain literary sophistication. The advantage of the scroll's captions is that they give the storyline with a clarity that is hard to beat by versions found in other manuscripts. As important as what we may define as plot are the elements that frame and open or close the narrative.

The scroll text starts with an obeisance to Vajrasattva, the buddha central to Newar Vajrayāna, whose worship formula is the standard opening of most Newar ritual literature, and proceeds with verses directed at the bodhisattva Lokanātha Avalokiteśvara, described much more elaborately (BRK 2). The text then switches to the framing narrative (BRK 3) recording an event in which the Buddha Śākyasiṃha told the following story of Prince Viśvantara to the gods, a gathering of *bhikṣus*, and Upoṣadha Devaputra near the city of Kapilavastu. The obeisance paid to Lokanātha immediately preceding the frame is repeated at the end of the story, immediately after the closing reference to Buddha Śākyasiṃha (BRK 82), when Lokanātha is addressed again by his other two names common among the Newars, Karuṇeśvara and Lokeśvara of Bugama (i.e., Buṃgamatī, BRK 83), the local *devatā/bodhisattva/nāthyogi* also known as the Red Matsyendranāth, protagonist of one of the largest processions in the valley. It becomes clear that the real frame of this text is not, as is mostly the case, the telling of this story by Buddha Śākyamuni set in the present (the Pali *paccuppannavatthu*) or the concluding connection (*samodhāna*) made between the Buddha and his former birth, but rather the worship of Lokanātha Avalokiteśvara. This larger frame places the text within the liturgical context of the Eighth-Day Vow (*aṣṭamīvrata*) dedicated to the bodhisattva, during which the story is read as part of his veneration. This is the first indication that in the Newar context this particular text, but more generally this particular story, is explicitly and

inextricably connected to the conditions of its telling and the effects of its articulation.

Indeed, as if the text's narrated events themselves were to call for and poetically create the conditions for the celebration of the Eighth-Day Vow, causing beneficial powers to radiate forth, the story begins with King Sibi, the Sanskritic Śivi, ruler of the city called Bidarbhā (*Bidarbhā dhāyāgu nagarasa*), more commonly known as Vidarbhā, consulting with his queen and his ministers about the lack of a male heir. Then all of them, assisted by the *vajrācārya* in his position as *rājaguru*, or chief royal priest, as well as all the courtiers resort to nothing less than the Eighth-Day Vow to ask for male offspring (BRK 5). The corresponding image on the scroll (BRK plate II, scene 5) depicts them in front of a shrine containing an image of Lokanātha Avalokiteśvara with a mandala on the ground between them and the priest holding a manuscript as if to read out to them the story of Viśvantara. Sure enough, "thanks to the merit [accrued] through the performance of the Eighth-Day Vow dedicated to Avalokiteśvara" (BRK 6), Prince Viśvantara is born.

These first lines of the story do two things. Firstly and most importantly, they create a connection between what is happening inside and outside the text: it is *aṣṭamīvrata* time everywhere. Everyone is celebrating the same event and addressing the same deity. The text homologizes *what* is read with the conditions requiring *that* it is read and prefigure *how* it is to be read, aligning the purpose within the text with the purpose outside the text, the effects in the world of literary figures with the effects in the world of humans. This includes the *how*: the performance in the text serves as matrix, example, and model for the performance outside of it, which at the same time embraces, preserves, produces, and reproduces the text.[15] Inasmuch as the scroll and the story are artifact and performance, donated and staged, the safeguarding of the model itself depends on the artist and the priest reproducing it.[16] This means that there is a curious reciprocity in the mimetic relation between the performance inside and outside the text: the ritual performance that leads to the literary and artistic performance is a repetition, a reenactment of the literary artifice it has itself constructed. Simply put, the performers of the Eighth-Day Vow recognize what they are doing in the text as if witnessing or remembering and identifying with a parallel event: they are King Sibi and his queen, connected by the same object of worship, Lokanātha, here and there. But at the same time they understand that they are performing something that was performed by protagonists of Buddhist sacred history long ago, repeating that earlier act. This reveals that the current performance is less

a process of mirroring than one of transformation, of being and becoming similar or the same.[17] The fixed point at the center of these mimetic movements is the deity and the text from which the ritual power enabling these transformations emerges, and in whom the protagonists meet and merge while beginning to imagine who they might be.[18]

The second thing these first lines do is point at the effect and the efficacy of the vow. Here the mimetic power is harnessed into promising that the vow holds a particular power attractive to all performers: the power to produce a male child. It has worked once with the most miraculous results, suggesting that it will work in the same way for devotees who expect it to achieve much less. And yet the text as story does not state that, but instead reproduces the situation of the couple wishing for a child in which worshipers set out to perform the Eighth-Day Vow. The childless and child-desiring couple, however, is not just the ideal sponsor of the Eighth-Day Vow but also a popular paired protagonist, mostly in a supporting role, of innumerable stories transmitted in and beyond South Asia, and usually very helpful in getting a story started. One of the most prominent cases of temporary, yet eventually creative infertility is that of Daśaratha and his three wives at the beginning of the *Rāmāyaṇa*. There, after the royal horse sacrifice (*aśvamedha*) and an Atharvavedic son-producing sacrifice (*iṣṭiṁ* [. . .] *putrīyām*, *Rām*. 1.14.2a), the queens' consumption of the ritual rice pudding offered by a deity emerging from the fire brings about the birth of Rāma and his three half-brothers. The Pali version of the story of Vessantara has been compared with the *Rāmāyaṇa* by Bimal Churn Law[19] and Richard Gombrich. The latter points out the similarities between the passages in the *Ayodhyakāṇḍa* concerning the banishment shared by Vessantara and Rāma as well as Jūjaka's and King Sañjaya's journey to Vessantara and Bharata's to Rāma,[20] to which one should add the final glorious return of Vessantara and Rāma to inherit the kingdom and rule as model monarchs.[21] While the Pali version is interested in the intricate series of births and rebirths, particularly of Queen Phusatī, and Ārya Śūra and others start *in medias res* with a description of the king and his realm and directly introduce the hero as his son, only the Newar version begins with a problem, the ritual option prompting divine intervention and the birth of the hero, just as in the *Rāmāyaṇa*. The parallelism is carried further when in the Newar version, on the birth of his son, King Sibi makes lavish donations to *bhikṣu*s and Brahmins (BRK 7), recalling the very Viśvantara-like moment in the *Rāmāyaṇa* when Daśaratha, after the completion of the horse sacrifice, offers the entire earth to the officiating priests (*Rām*. 1.13.38). The priest refuses, reminding the king that he, the

king, is the protector of the earth, so that Daśaratha scales it down to millions of cows, a hundred million gold pieces, and four times that amount in silver (*Rām*. 1.13.39–41). Again the Newar version seems an attempt at harnessing the power of two worlds: the ritual world of the Eighth-Day Vow and the literary world of the *Rāmāyaṇa*. On the ritual side, and with the public of the vow in mind, the king's donations are what is expected from a proper patron of a Newar monastery's sangha and its priests, but as if to speak to the laywoman as much as to the layman, it adds that the queen in her parallel female world "engaged in various conversations about the dharma with her friends" (BRK 9). Again, as in the *Rāmāyaṇa* (1.17.11–12), the naming ceremony accompanied, as prescribed, by a fire sacrifice (BRK 10) concludes the first couple of paragraphs before the hero finally arrives at center stage. What we can anticipate at this point, with Viśvantara only emerging one eighth of the way into the Newar version, is that (comparable only to the Pali version with its interest first in former births and eventually in the vicissitudes of Jūjaka and different from the other "Northern" Sanskrit versions) this text dedicates more space to events in which the main protagonist is absent than any other version. That it could be read as much as the story of Viśvantara as that of his father or, most of all, of the Eighth-Day Vow would account for the fact that it feels as if it had sensitively but purposefully zoomed out and away from its larger-than-life protagonist.

The ritual role of men is another feature that makes this variant of Vessantara stand out and gives it its Kathmandu Valley signature: the high profile of ritual specialists performing their duties on their sponsors' offspring. Both Hindu and Buddhist priests[22] join the king in his vow, both *bhikṣu*s and Brahmins receive the king's gifts, and the chief priest and advisor (*purohita upādhyājuna*), represented as one person in BRK IV scene 10, is said to conduct Viśvantara's naming ceremony, including the fire sacrifice (*yajña homa*, BRK 10). The next sequence of captions, which deal with the prince's education by a *paṇḍita* of unspecified religious affiliation (BRK 11; BRK 12) and the choice and courting of a bride, culminate in the wedding of Viśvantara and Madrī (spelled thus in the Newar version) "at an auspicious time." The wedding is performed in conjunction with a fire sacrifice *comme il faut* (BRK 16) by the chief priest (*purohita*) and the advisors (*upādhyājupanisena*), depicted in BRK VI scene 16 as two individuals (assuming this particular identification of titles and images is valid), the former a *vajrācārya* engaged in the fire sacrifice, the latter a slightly less comely fellow with a rosary looking on. The scroll, therefore, depicts *vajrācārya*s in charge of all the major ritual events, thus turning

court ritual distinctly Vajrayānist, the king into a sponsor of the *śāsana*, and Viśvantara into the ideal Buddhist prince.

The description and depiction of the ritual specialists engaging in these events, however, should not be understood as individual vignettes but as parts of a larger process in which agents with clearly defined roles propel Viśvantara's development into a Newar adult layman. Reproduced here is the trajectory every upper-caste Newar citizen would be expected to follow on his way to full ritual maturity, which not only turns Viśvantara into a Newar Everyman but also makes the Newar hearer recognize himself or her husband or father or brother in the bodhisattva. While other versions seem to hurry along, paying little attention to what the prince did besides being generous, the Newar versions are as much concerned with painting a portrait of someone who is thoroughly part of the Kathmandu Valley society as with understanding the tale of the generous prince as one of progress. It is a progression of stages reached, left behind, and transcended, completions and perfections, *saṃskāra*s and *pāramitā*s, obtained and accumulated as much through the mundane Vedic household rituals as along the lofty path of the bodhisattva.

Keeping in mind the predominantly female audience of the narrative, at least in the context of the Eighth-Day Vow, Viśvantara's story may be as much about Newar males representing themselves as about inviting Newar women to recognize the story of their husbands. Indeed, in the votive performances I attended, the stories of marital distress and resolution, and particularly their interpretation by the *upādhyāya* in the form of admonishments directed at the listening women, were usually spontaneously commented upon by the women I sat next to. With quips like, "What does he know about marriage?" or "He should try to be married to my husband," the women critically or jokingly drew or occasionally questioned comparisons between the male protagonist of the story and their own husband. At the two *Bisvaṃtararājakathā* readings I attended,[23] I heard a woman half ironically, half self-commiseratingly remark that she felt she was living with Viśvantara all the time anyway, and another confess that Viśvantara going away reminded her of her husband spending a lot of time hanging around with friends or doing unproductive business. The latter is an expression of "the heartache and fears of the Newar wife," both as literary topos and as reality, as elaborated by Todd Lewis in his study of the *Siṃhalasārthabāhu Avadāna*.[24] We find this in narratives of Newar men spending much time on business travels, settling down in the Lhasa marketplace and making the long way back only periodically, sometimes founding and supporting parallel families at the other end of

the trade route.[25] The various comments are expressions of a perception common among Newar (and not just Newar) women that their men, whatever they may be up to, lead lives of their own. Viśvantara's life story thus seems to provoke an identification of the bodhisattva with the husband, to encourage the female listeners to picture themselves as Madrī and to put them into a position where they are forced to negotiate among the pressures of their own household duties, their own affective marital expectations, and the anxieties produced by the aspirations of their more or less bodhisattvalike husbands. It is insightful to read the storytelling *upādhyāya*'s intentions into the story as an appeal to reconcile these conflicts for the sake of safeguarding the happy and Buddhist Newar family and ultimately of harnessing the wife's energies for the joint progress of the couple in their spiritual practice and toward a better rebirth.[26] Yet it is equally important to listen to these "reader's reactions," as they give us reason to suspect that the telling of this story is as much an appeal to domestic piety as an occasion when domestic unhappiness, its relentless and seemingly unchangeable nature, finds a public place of articulation. We will see further on that the topos of irrevocable conjugal separation is not only a contingent oral, local, individual reaction but also something built into and intrinsic to the text itself.

EXIT VIŚVANTARA: THE OTHER ENDING

After textual and visual references to the prince enjoying the pleasures of marital love with his consort (BRK 17; BRK plate VI, scene 18); the birth of his children, Kṛṣṇājinī and Jālini; and intermittent acts of generosity, which merge the erotic fantasy of courtly life with the depiction of Viśvantara as a powerful Newar householder, the story unfolds in a straightforward way not unlike the other known versions of the tale. Viśvantara is maligned by the ministers (the only less-than-good persons of this version) and encouraged to request his father to dismiss him for a life of austerities (BRK 29–31), and his wife is committed to to joining him with the children in his venture (BRK 32–33).[27]

The drama unfolds in a way peculiar to the Newar versions, as Indra is "the one who bears the disguise" (*bhesadhāri*, BRK 55), not only once as in the other narratives, but twice. He plays the role of the first Brahmin who takes away the children (BRK 46–50) and instantly brings them back to their grandfather, being thereupon handsomely rewarded (BRK 55–57). Following a brief council of the gods, he also plays the role of the second Brahmin, who receives Madrī (BRK 59–67) and takes her too back to her

father-in-law, finally revealing himself to the king as Indra (BRK 70–71). Once Madrī is gone, Viśvantara "resumed keeping a vow of austerity for a long time and with one-pointed mind" (BRK 69), this time however with the marked difference, as the text states, of "having become someone possessing a body of dharma" (*dharmmasarīra juyāo*, BRK 69).[28]

What this transformation exactly means remains unspecified. However, as its implications may be critical to the Newar variant of the story's ending and the role it gives to the generous prince, it may be important to consider some possible interpretations. Obviously here the term *dharmaśarīra* is not used in the straightforward technical sense referring to a piece of written dharma inserted usually into *caitya*s and other artifacts as part of a rite of consecration.[29] Pointing out the shared semantic field of *kāya* and *śarīra* in conjunction with dharma, Paul Harrison[30] remarks that both terms refer, on the one hand, to an assembly, a collection, a physical encompassment and realization of the dharma in its constituent parts as in its totality, and as he stresses, multiplicity. On the other hand, they refer to the representational, substitutional, identificatory character of the dharma in its relation to the physical, corporeal, personal, charismatic, authoritative presence of the Buddha. The term *śarīra*, however, different from *kāya*, bears the additional denotation of bodily remains, i.e., it refers both to a body of a living being and to its remains, in their entirety or in parts, in the absence of the living whole.[31] This seems to refer clearly to bodily but even more so to textual relics, understood in the above way as collections of and identifications with the Buddha and the dharma.[32] If we take these observations together, we have the following range of readings regarding Viśvantara's fate. If we take *dharmakāya* and *dharmaśarīra* to overlap and read both as referring to bodies alive and present, then we can understand Viśvantara's body as having acquired the qualities of dharma. These include, in addition to that of the perfection (*pāramitā*) of generosity (*dāna*), more generally that of virtue (*śīla*), and in view of his meditative endeavors, possibly the complete set of dharmas as well as the dharma in its entirety, necessary to identify him with the Buddha. We have good reason to consider stopping short of reading *śarīra* primarily as bodily remains, as the text does not mention death or *parinirvāṇa*. By reading *dharmaśarīra* as denoting Viśvantara's bodily transfiguration into a buddhalike being, alive and strong, we would remain safely within the story. This reading would even narratively prefigure the Buddha's standardized words at the conclusion of this birth story, in which he identifies the narrative's protagonist as his own previous birth.

If, however, one were to take the connotation of *śarīra* as relic more seriously, that would involve understanding Viśvantara as virtually absent and as having turned into a relic. His absence could be explained by his having removed himself from the world both through his remote location and his constant and deep meditation. However, with the term *dharmaśarīra* used to refer to relics of the Buddha, we have here, as in our previous option, a clear attempt to stress the Buddha-like qualities, in this case both in life and after death, if not in *parinirvāṇa*. Hence, the use of this term may indicate not only a buddhafication of Viśvantara but also a hint at his fate in terms of a realization of nirvana even before death, turning Viśvantara into someone who reaches liberation in life, a *jīvanmukta*. That would imply that he reaches final liberation even before his final birth as Gautama Siddhārtha. While this may be surprising in a unified and consistent buddhology in which details within individual birth stories are expected to be consistent with and subordinated to the logic of the larger narrative tying together previous births and the hagiography of Buddha Śākyamuni, taken for itself and within the Newar Buddhist context this tale would still make sense. For a traditional Newar Buddhist storyteller, the ideal hero is the layman tending toward asceticism and the ideal ascetic is Buddha-like, which implies possessing the qualities of a *siddha*. The *siddha* in turn is he who, due to his secret knowledge and his practice of tantric ritual, has achieved liberation in his lifetime. With Viśvantara moving along that very same series of identifications, it may not be surprising to see him attributed with all the features of how the Newar householder may have imagined a mountain forest-dwelling *siddha*. In the order of things presented by this narrative, Viśvantara would have become a buddha before the Buddha, and, with even the soteriological accoutrements that come with Newar Buddhism spilling over into the penultimate birth of the Buddha as a human, a very Newar Buddha at that. This Viśvantara is elevated to buddha status irrespective of its compatibility with the larger picture of the bodhisattva heading toward his birth as Śākyamuni. This goes well with the fact that unlike the Pali version (where the prebirth narratives weave Vessantara's life into the cosmic workings of karma that extend beyond his birth), Viśvantara's life, despite the concluding *samodhāna* by the Buddha (and similar to the other "Northern" prose versions of Ārya Śūra, Kṣemendra, and Saṃghasena), appears particularly closed and singular.

And yet, while the term *dharmaśarīra* may point at Viśvantara's departure and be a hint at his elevation to buddhahood, it remains open why a

term should be used for the prince's final transmutation that so obviously refers to the continued presence of the Buddha in texts. There may be no way to account for this semantic aspect of the term, and it may not even have been intended in the understanding of this passage. However, if one were to take it seriously, the text Viśvantara may be said to become could be the one he embodies, represents, and is identified with, the one narrated by Buddha Śakyamuni to his disciples, the Buddha's word repeated during the Eighth-Day Vow and inscribed in this scroll, the *dharmakathā* of the generous prince. Could it be that Viśvantara vanishes as he becomes his own story, formulated in the Buddha's own words? Though caution demands that we merely entertain the thought of such a reading, it would resonate well with the self-reflexive workings of the reformulation of the story as a ritual text that includes its own telling as performance, and more generally with the practices revolving around texts as embodiments of buddhas and bodhisattvas.

With more than one eighth of the story left to tell, this is the last we hear of Viśvantara. That the protagonist does not return to become king is probably the most striking difference between the Newar version and others. And yet, the Newar version of the story is not the freak accident in literary history it may appear. In the Sanskrit Buddhist version authored by Saṃghasena, studied by Dieter Schlingloff[33] and in more detail by Hubert Durt,[34] the story wraps up very similarly, which, apart from the closeness to Ārya Śūra's version noted by Lienhard,[35] may be the strongest indication that the Newar versions are part of what Durt calls a "Northern tradition."[36] Durt characterizes Saṃghasena's version (T. III. 153, j. 2–3, 57–61), the third story of a collection entitled **Bodhisattvāvadāna (Pu-sa ben yuan jing* 菩薩本緣經 T. 153) and a less well-known version of several Chinese ones, as "radical" and "épure."[37] Here the author decides to do without descriptions of the prince's youth or of the scenery, be it the city, the palace, or the wilderness; omits place names; and, similarly to the Newar versions, mentions only the most prominent figures by name, with the hero being called either bodhisattva, prince, or both.[38] It has in common with Ārya Śūra's and the Newar versions that the children are not given back to the bodhisattva-prince but to his father and shares only with the Newar versions the episode where Indra impersonates a Brahmin twice: one who asks the bodhisattva for his spouse and the other, in this case, his eyes, neither of which given.[39] But it is with regard to the ending that the parallels are most striking: though the children are returned to the king by the payment of a ransom and the bodhisattva-prince seems to continue living with his wife—which again diverges from the Newar

tellings—here too there is no reconciliation between the king and his son[40] and no glorious return of the exiled couple to the kingdom.[41] Instead the bodhisattva-prince undergoes, as Durt calls it, "a minor apotheosis,"[42] with celestial voices proclaiming "that this man (the prince) has enlarged [. . .] the tree of the way to *bodhi*[, . . .] that in a not too distant future he will achieve *anuttara-samyak-saṃbodhi* [unsurpassable, proper, and complete enlightenment], that he is a *bodhisattva mahā-sattva* practicing the *dāna-pāramitā* [the perfection of generosity] whose action [. . .] will not be met with indifference."[43] That neither Saṃghasena's nor the Newars' predilection for a somewhat ragged ending represents some deviant narrative choice is shown by a look at the larger South Asian context.

Somadeva's monumental Sanskrit *Kathāsaritsāgara* too features the story of the generous prince (KSS 113.17–97).[44] In it he is called Tārāvaloka, son of the ruler of the Śivis Candrāvaloka, husband of Mādrī (spelled thus here) and father of Rāma and Lakṣmaṇa (not *the* Rāma-and-Lakṣmaṇa, but nevertheless). His story, from his early generosity right up to the role of Indra and the hero's return as king, is so similar to the pattern of the other Viśvantara tales that it would be inadequate not to call it a version. Where it differs from most versions is where it agrees with Saṃghasena's and the Newars'. After the ascetic Tārāvaloka has been consecrated as king by his father, he is promoted by the goddess Lakṣmī to the ruler of the *vidyādhara*s, mythical creatures endowed with magical powers and usually residing in remote Himalayan regions: "There having enjoyed overlordship and having absorbed the [magical and secret] knowledge [of the *vidyādhara*s] he at a certain point became detached and retired to an ascetic grove" (*tatropabhuktasāmrājyaś ciraṃ vidyābhir āśritaḥ / kālenotpannavairāgyas tapovanam aśiśriyat //* KSS 113.97). Just like Viśvantara, Tārāvaloka does not return to his father's kingdom, but different from Viśvantara, he keeps his wife and accepts kingship and, again, finally ends up renouncing for good.[45] Though Tārāvaloka's story may be slightly more convoluted than Viśvantara's, who only renounces once, both heroes, in addition to receiving heavenly praise, undergo a transformation: while Viśvantara has acquired a body that is the dharma, Tārāvaloka has "absorbed" (*āśritaḥ*) *vidyādhara* techiques, among which feature prominently those of alchemical orientation that, usually through the ingestion of metals, make the ascetic body refined, incorruptible, and everlasting.[46] But the final *saṃskāra* resulting in the newly perfected body through which Viśvantara, the *siddha*, exits the Newar narrative is more than just an echo of the alchemical processes associated with the *vidyādhara*s—it has to be understood as very much part of how the

Buddhist enlightenment process itself was understood. A prominent text like the *Bodhicaryāvatāra* calls the thought of enlightenment (*bodhicitta*) a *rasajāta*—a term for a particular alchemical agent—elaborating that "once it has taken hold of the impure image [i.e., the human body], it transmutes it into the priceless image of the jewel that is the Jina [i.e., Buddha]" (*aśucipratimām imām gṛhītvā jinaratnapratimām karoty anarghām*).[47]

One may suspect, and maybe not without reason, that the versions that end with the hero in the wilderness, alchemically-soteriologically transmuted, are less about him as a king than about him as an ascetic, or more precisely, less about the employment of the ascetic topos for the reformulation of kingship than about the employment of the topos of kingship for the reformulation of asceticism. In fact, the Theravādin's Vessantara, the Mūlasarvāstivādin's, Ārya Śūra's, and Kṣemendra's Viśvaṃtara, Vālmīki's Rāma, and the purāṇic Hariścandra have in common that their stories end well because they are ultimately bound for kingship, resolving and yet containing, as David Shulman and Steve Collins have pointed out,[48] the tragedies that have unfolded along the way. The Newar Viśvantara, Saṃghasena's bodhisattva-prince, and Somadeva's Tārāvaloka are all disinclined to rule, and the happy ending in their case consists in their final and irreversible renunciation. Though, at least in terms of the ending, the second type of narrative may be reminiscent of the hagiographies of Buddha Śākyamuni, it is consistently not about outright rejection of life in the palace or kingship: rather, all the above protagonists simply forgo it temporarily or for good because conditions are created that prevent them from succeeding their respective fathers. In all the cases, the decision in favor of asceticism is not one of dramatic renunciation but rather one in which, on the contrary, compliance with the society's demands and expectations leads the protagonists to further demonstrate their superhuman capacity to abstain. Conditions emerging during their penance—an invitation to return or the lack of such an offer, the proposition of an alternative kingship or simply the wish to pursue their ascetic activity—bring about one or the other conclusion.[49]

Whether the fact that the Newar version has this particular ending is somewhat causally connected to its place within the Eighth-Day Observance is doubtful. How much before the date of the earliest Newar manuscript known to us the first Newar version (i.e., 1749/50) was composed will remain difficult, if not impossible to say. To be sure and as we have seen, this ending is not a Newar invention but a feature of the story accepted and transmitted as part of the narrative parcel that arrived in the Kathmandu Valley. Hence the eventually husbandless family is not

something a local oral commentator may have sarcastically added, but built into a version of the story that may have found its domestication in many homes, possibly as a part of various and related ritual contexts, and may have traveled between many locales independently from being domesticated in the Kathmandu Valley. To write a history of its emergence and development in the literature of the Kathmandu Valley will require a more detailed look at the extant manuscripts,[50] possibly without much hope, in view of the manuscripts' late date, of firmly establishing its historical route of provenance.[51] But a protagonist who remains suspended in penance and acquires a superhuman body approximating him both to the lone forest monk, to the bodhisattva who is at the center of the event's worship, and to the *siddha*-like *vajrācārya* does fit both the ritual intention and the ascetic, devotional, and self-empowering stance taken by those who undergo the Eighth-Day Vow. In the Kathmandu Valley historically, the closest the Newar kingdoms' Malla monarchs would come to being Buddhist was the degree to which they supported Buddhist institutions. If one additionally considers that the extant versions of the story of Viśvantara and their increased production are from a period of a triumphant and firmly ensconced house of Gorkha supported by a rejuvenated Hindu ritual establishment, oriented at least as much toward perceived North Indian orthodoxies as toward local Newar power groups, a version that depicts Buddhist asceticism rather than Buddhist kingship as a model for Newar householders would make eminent sense to a Newar Buddhist public and ritual community. And yet, as most of the ritual and narrative has shown and as we shall see in the concluding sections of this chapter, such a historiographical justification is probably one of the lesser worries of those who participate in the telling of this story.

As least as striking as the Newar Viśvantara abandoning his prospects for kingship is that he thereby effectively abandons his own story. The narrative at this point seems to leave its protagonist behind and turn to others, thus expanding the boundaries of its events beyond the actual occurrence of its hero. It is less the hero's actual fate, which is shared with other versions, than the nonchalance with which the narrator continues to tell the story after some of us may expect it to be over already that makes the Newar narrative unique. After the repatriation of wife and children and Indra's epiphany, this text in a way returns (BRK 72) to its metanarrative, ritually self-conscious, and here most eminently self-reflexive stance by having Madrī and their children tell the king, the queen, and the minister nothing less than "the story of King Viśvantara" (*Bisvantara rājāyāgu kha*). Upon this King Sibi makes an announcement on this

matter to his subjects and, together with his reformed minister, instructs them to celebrate the Eighth-Day Vow of Lokanātha Avalokiteśvara (BRK 73–74). After having brought along an image of the bodhisattva, the king initiates a fire sacrifice performed by the *rājaguru* functioning as *purohita* and has the *uphādhyāya* give a sermon, all as part of a major celebration of the vow. In line with what was said above regarding the text-image discrepancy, the painted episode (BRK plate XXIII, scene 75) presents the viewer with a setup familiar even to modern-day witnesses of a Newar votive event, with the *vajrācārya* conducting the fire sacrifice and his ritual associate, the *upādhyāya*, to his left, handling a manuscript and preaching to a courtly crowd, and the figure of a white Avalokiteśvara, present also at the first Eighth-Day Vow (BRK plate II, scene 5). Repeating this first *aṣṭamīvrata* performance, in its wake the king copiously donates to *bhikṣu*s and Brahmins. King Sibi then proceeds to take the dramatic step, again reminiscent of the *Rāmāyaṇa* and the preoccupation with installing a crown prince (*yuvarāja*) to succeed weary Daśaratha, of first announcing and then having performed at an auspicious time the royal consecration (*rājyābhiṣeka*) of his grandson Jālini, henceforth bearing the title *kumārarāja* (BRK 76–78). Hubert Durt has pointed at the more substantial role Jālini plays in what he calls the "Northern tradition" of the tale.[52] In a variant mirroring of Viśvantara's departure King Sibi too, to the distress of the crown prince and his entire family, relinquishes his royal responsibilities, takes the ascetic's vow, leaves Bidarbhā, and "in an ascetic's grove practiced austerities for a long time" (BRK 80). The story ends with a paragraph stating that Bidarbhā was now jointly governed by Crown Prince Jālini, Queen Madrī, Princess Kṛṣṇājinī, and the minister and "ruled happily ever after" (BRK 81).[53] In this last part it is King Sibi who becomes the protagonist by mimicking his son in abandoning (or donating?) his kingdom and heading for the life of an ascetic, which then leaves Jālini as Prince Regent, a similar position to that of Vessantara or Viśvantara in other versions, but within a joint royal family cabinet. This continuation of the story without its main protagonist can be understood through a perceptive remark of Lienhard's. When referring to the concluding frame reminding us that it was the Buddha who told this story, Lienhard[54] points at the easily overlooked fact that here, syntactically, the reference of "the birth the Buddha took there" (*thao janma kāyāgu*) is not to King Viśvantara, but to "the story of King Viśvantara" (*Bisvaṃtara rājāyāgu kha*, BRK 82). In its ritual context, storytelling comes first, and the protagonist is only relevant as he is part of a story, only insofar as he *has* a story, and more than that: only insofar as he drives the story. The

story is the protagonist and the protagonist is his story. Would this not indicate that Viśvantara, who turns into a *dharmaśarīra*, does become indistinguishable from his own *dharmakathā*?

While the actions of King Sibi can still be read as his son's powerful example extending beyond the limits of his narrative everyday presence, the preoccupation with the handling of power in the kingdom after the departure of the first in line to the throne and the incumbent may be nothing more than a more comprehensive way of prefacing that "they" (actually "the others") "lived happily ever after." And yet it does try to achieve closure after a series of spectacular abdications and keeps a fine balance between the eccentric and shining example of the ascetic stars of the family and the conscientiousness of those who make sure that the kingdom prospers. The ritual worshipers concluding their vow would begin to recognize themselves and the state by which they are being ruled in the latter, who would ensure as part of their royal duty that the Eighth-Day Vow can be practiced again and again and the story of Viśvantara told and retold. Viewed this way, the panoramic version, so to speak, of the story of King Viśvantara does not zoom out from a hypothetical core plot, adding on frames and vistas to include more of the effects the central figures has on its world. Rather, it finds a place for that protagonist Viśvantara and places him within a variegated texture of commitments and agendas, of literary, ritual, visual, and doctrinal conventions and expectations specific (but not restricted) to the historical situation in and around the Kathmandu Valley around the middle of the nineteenth century, as well as within the liturgical setup of the Eighth-Day Vow. The story of that protagonist is refashioned to find a ritual place for that figure and to allow him to have a range of effects on the listeners and viewers and make them hold the tapestry together. In that sense, the hagiography of the generous prince is dis- and reassembled to build something that much more resembles the hagiography of the Newar family, imagined as royal, whose members go different, sometimes diverging (such as Viśvantara and his wife and children), sometimes converging (his wife and his children, and one could add the minister), sometimes parallel ways (Viśvantara and his father), in which a range of roles, goals, activities, and life stories are possible and the final frame or scale of the story keeps them all together and focused. It is again the same family that undergoes the shared activity of the Eighth-Day Vow and for whose happiness it is conducted. And it may not be a coincidence that the ending of the story of this ritual finds Viśvantara's wife as the most senior nonrenouncing family member, at the center of a family thoroughly renewed and reorganized by devotion, in whom the

mostly female participants of the vow may recognize themselves. Capturing the story of Viśvantara within a comprehensive ritual practice may be one means of domesticating the text the Newar way, but the performance of this domestication is left in great part to the woman and transfigured by a renunciation of her own that she is forced to live with.[55]

Viśvantara is no monk who becomes a householder, as some narratives of the vicissitudes of Newar Buddhism and the ritual performances of Newar Buddhist life-cycle rituals themselves may suggest. Following this Newar literary and visual narrative, the householder himself is imagined as homeless. Conversely, the story seems to be speaking primarily to women who are encouraged to imagine their husband going ascetic and to begin to understand the antifamily side of the various ideals he may be expected to follow. The woman may be asked to develop the ability to imagine herself following her husband into the wilderness he has chosen. There she becomes the very last gift he can offer and is divorced from her husband in the culmination of his merit-making and his ultimate and irrevocable un-becoming a householder. Hence, this is much more than just a variation on the theme of the homely wife versus the justifiably homeless husband. The Newar versions deal with the paradox that the ideal of the domestic, when applied to a conjugal partnership in which one role of the husband is to pursue the eccentric renunciatory trajectory, implies that the good wife, the *pativratā*, renounces her husband as he renounces her. The new domestic life of the family within the undomesticated wilderness of Mount Baṃka is only the first stage in a process that ultimately leads to the lonely de-domesticated man in his hut, as it is only thus that he will be able to acquire a body that is the dharma. This requires that the woman embrace a new kind of domesticity in which the husband is absent. In short, the constant thrust of the husband toward the ascetic is part of the challenges, limitations, and ultimately the transformation of domesticity. In the Newar versions there is no hope that all this will lead to his ultimately moving back into his father's palace with his queen. Rather, the wife will end up as a single mother ruling her house and with her son as king. To be clear, this scenario is primarily and exclusively imaginary: no ordinary Newar Buddhist wife has to fear being given away to a phantasmagorical Brahmin, and no Newar man finds himself under the pressure to work out a dharma body. And yet, marital suffering, whether of high or

low intensity, undergoes a literary, narrative, and religious transfiguration when it is represented as the de-domesticating tendency toward domestically outrageous behavior, in this case firmly embedded in its rationalization as asceticism in pursuit of the perfections of the bodhisattva. The Newar version of the tale of the generous prince offers us chances to think about the personal anxieties and the social expectations centering around the domestic, represented by marriage. It is a complex that mobilizes narrative and ritual themes that express forces that threaten to tear the domestic apart and scatter its protagonists into a prefigured and imaginative forest-monk wilderness full of demanding travelers, appreciative ṛṣi-s, and divine changelings. Yet the story strives to accommodate the wishes of a wife who is expected to enable, yet to never fully participate in her husband's outrageous fortune, who is advised to accept her husband's absence and her own enhanced domestic powers as if he were already living in a better place and not to return anytime soon. The story and the practices that call it to life promise to reconfigure the domestic under the conditions of its imagined breakdown.

NOTES

I would like to thank Steven Collins for giving me the opportunity to begin thinking about the material and eventually to write this piece, and both Steven Collins and Stephen Teiser for helping me "domesticate" it. My thanks go to Stephanie Jamison for her close and insightful reading, leading up to the publication of a longer version of this text as "How Bisvaṃtara Got His Dharma Body: Story, Ritual, and the Domestic in the Composition of a Newar Jātaka" in the *Journal of the American Oriental Society* 132, no. 4 (2012): 539–66. And I would like to thank Srilata Raman for her constant advice, crucial comments, and our shared ongoing conversation.

1. This has been changing as, from the middle of the twentieth century, an emerging Nepalese Theravada Buddhist community has brought with it an interest in literature in Pali (for the bigger picture see Sarah LeVine and D. N. Gellner, eds., *Rebuilding Buddhism: The Theravada Movement in Twentieth-Century Nepal* [Cambridge, MA: Harvard University Press, 2007]). Nevertheless, it is in the home of the old Newar Vessantara that the new one has begun to look for a place of his own, and this chapter deals with the new one's older and resilient landlord. Burmese monks and Burma-trained Newar female monastics have introduced the Burmese prince Wethandaya of the *Wethandaya Zatdaw* (*Vessantara Jātaka*). A narration I attended in 2005 at the meditation center Antarrāṣṭriya Bauddha Bhāvanā Kendra in Kathmandu seemed very close to the Burmese schoolbook version documented in O. White, *A Literal Translation of The Textbook Committee's Revised Edition of Wethandaya, the prescribed text for the sixth, seventh and eighth standard and entrance examinations* (Rangoon: American Baptist Mission Press, 1906). Compare L. A. Goss, *The Story of We-Than-Da-Ya. A Burmese Legend, Sketched from the Burmese Version of the Pali Text* (Rangoon: American Baptist Mission Press, 1886).

The Thai *wat* in another Kathmandu Valley town called Kirtipur is another place where an alternative Southeast Asian version would be likely to be told.

2. To designate the language spoken and written by the Newars, I use the term "Newar" (New.) instead of the older and previously more common "Newari" (viz. "Newārī"), the more indological "Nevārī," or the more indigenous "Nepāl Bhāṣā" or "Nevāḥ Bhāy." I hereby follow proposals by two recent monographs on Newar linguistics: Austin A. Hale and K. P. Shrestha, *Newār (Nepal Bhāsā)* (München: Lincom Europa, 2006), and C. Genetti, *A Grammar of Dolakha Newar* (Berlin; New York: Mouton de Gruyter, 2007).

3. The play *Viśvantaranāṭaka* (recorded in the Nepal-German Manuscript Preservation Project as E1445/20), preserved on an undated manuscript, represents, apart from the Tibetan version enacting the story of Dri med kun ldan, one of the few examples of its dramatization outside of Sri Lanka and Southeast Asia.

4. S. Lienhard, *Nevārīgītimañjarī: Religious and Secular Poetry of the Nevars of the Kathmandu Valley* (Stockholm: Almquist & Wiskell International, 1974), 197–98. There is also a verse composition in Sanskrit entitled *Vissantaragītā* (NGMPP X 1078/1) from a handbook recording the lyrics to be sung by members of the marginalized *gandharva* or *gāine* caste, from which occupational bards are traditionally recruited.

5. All technical terms in this chapter are, if not marked otherwise (such as New. for Newar), in Sanskrit.

6. Another related genre of which only manuscripts dated from the early twentieth century are found is that of texts called *Vratāvadānamāla*. Texts without extensive narrative parts are the *Uposadhavratavidhi*s, which prescribe the *uposadhavrata*, a ritual almost identical to the *aṣṭamīvrata*, only shorter, to be performed at home on any given day and for a very specific purpose, primarily by women who wish to conceive. For a brief sketch see John K. Locke, *Karunamaya: The Cult of Avalokitesvara-Matsyendranath in the Valley of Kathmandu* (Kathmandu: Sahayogi Prakashan for the Research Centre for Nepal and Asian Studies, Tribhuvan University, 1980), 203–204, as well as J. K. Locke, "The *Uposadha Vrata* of Amoghapāsha Lokeshvara," *L'Ethnographie* 83, no. 100–101 (1989): 109–38; for a look at its textual history see W. Tuladhar-Douglas, *Remaking Buddhism for Medieval Nepal: The Fifteenth-Century Reformation of Newar Buddhism* (London: Routledge, 2006), 163–99. This kind of votive literature is not restricted to Buddhist Newars: the "Story of the Vow of Svasthānī" (*Svasthānīvratakathā*), one of the oldest religious narratives preserved in Newar manuscripts (K. P. Malla, *Classical Newari Literature. A Sketch* [Kathmandu: Educational Enterprise, 1982], 51–56) and read out or narrated during the celebration of a local goddess is probably the most popular text of that kind in the Kathmandu Valley (L. Iltis, "The Swasthani Vrata: Newar Women and Ritual in Nepal" [Ph.D. diss., University of Michigan, 1985]). More recently, the history of the text has been more thoroughly investigated in Jessica Vantine Birkenholtz's dissertation, "The Svasthānī Vrata Kathā Tradition: Translating Self, Place, and Identity in Hindu Nepal" (University of Chicago, 2010).

7. The liturgical side of the vow in the variant performed at the Newar Buddhist monastery Janabāhāḥ has been most elaborately described by John Locke (*Karunamaya*, 188–202), its place in the larger texture of Newar ritual practice has been elaborated by David Gellner (*Monk, Householder, and Tantric Priest: Newar Buddhism and Its Hierarchy of Ritual* [Cambridge: Cambridge University Press, 1992],

221–25), and its location within the larger context of South Asian vows has been pointed out by Todd Lewis (*Popular Buddhist Texts from Nepal: Narratives and Rituals of Newar Buddhism* [Albany: State University of New York Press, 2000], 89–94), and Will Tuladhar-Douglas has looked at some of its textual and historical ramifications (*Rebuilding Buddhism*, 168–71 and 182–99).

8. The most prominent eighth day (*mukhaḥ aṣṭamī*) is the eighth day of the bright fortnight in the month of Kārttik, which falls in October–November (*Monk, Householder, and Tantric Priest*, 216). This is usually the day when an approximately two-year series of Eighth-Day Observances is begun, with one performance each at a total of twenty-five sacred places (Gellner, *Monk, Householder, and Tantric Priest*, 224), including twelve well-known bathing places prescribed in the *Svayambhū Purāṇa* (B. Kölver, "Stages in the Evolution of a World-Picture," *Numen* 32, no. 2 [1986], 147–51).

9. Tuladhar-Douglas tentatively dates this back to the seventeenth century (*Remaking Buddhism* 164).

10. The narration of this story is not restricted to the Eighth-Day Vow: apart from informal tellings within the family or as part of school curricula, a time for storytelling is the lent month of Gūṃla (approx. July–August), when various activities are scheduled in the monastery or in Buddhist Newar homes. The manuscript at the center of this chapter is an impressive painted scroll (New. *paubhahā*) with the story told in a comic-book fashion in a series of tableaux with captions below each scene. Particularly on the day dedicated to "the display of the monastery's deities" (New. *bahī dyāḥ bvayegu*), it is a widespread practice to unfurl and put up extensive scrolls of this kind in Newar Buddhist temple courtyards, to view them, read out choice passages, comment on them, and use them to narrate the whole or just salient parts of the story. For photographs of such a display and its viewing by visitors, see M. S. Slusser, *Nepal Mandala: A Cultural Study of the Kathmandu Valley*, Vol. 2: Plates (Princeton: Princeton University Press, 1982), plate 508, and Lewis, *Popular Buddhist Texts from Nepal*, 172, fig. 7.1.

11. S. Lienhard, *Die Legende vom Prinzen Viśvantara. Eine nepalesische Bilderrolle aus der Sammlung des Museums für Indische Kunst Berlin* (Berlin: Museum für Indische Kunst Berlin, 1980). For a French summary with a more art historical focus, see S. Lienhard, "La légende du prince Viśvantara dans la tradition népalaise," *Arts Asiatiques* XXXIV (1978): 537–52.

12. The abbreviation "BRK" is followed by the caption number in Lienhard's reckoning; the images are referred to by "BRK plate" followed by the plate number in Roman and the scene number in Arabic numbers. The edition includes the photographically reproduced illuminated manuscript (Lienhard, *Die Legende vom Prinzen Viśvantara*, 71–249), a transliteration (Lienhard, *Die Legende vom Prinzen Viśvantara*, 53–60) and a translation of the text (S. Lienhard, *Die Legende vom Prinzen Viśvantara*, 61–69) as well as an art-historical description of the images. In his book Lienhard refers to a second, 50-folio-long unpublished fragmentary manuscript in his possession entitled *Viśvantarakathā* (henceforth ViK).

13. In view of the objectives and the projected public of the present volume I have decided to base the following discussion primarily on published materials readily available for students and scholars at international academic institutions, so as to supply an analysis that can be easily checked against its sources in both transliteration and translation. A more detailed study of the Newar versions of the story of Prince Viśvantara on the basis of unpublished manuscripts is in preparation

(C. Emmrich, "The Tale of the Generous Prince in Newar Manuscripts," forthcoming). All translations, if not stated otherwise, are my own.

14. Lienhard, *Die Legende vom Prinzen Viśvantara*, 71–249.
15. All of the scroll's captions referring to the story begin with the word *thana*; Lienhard explains this as meaning "as shown on the above painting" (*wie auf dem obenstehenden Gemälde gezeigt*, Lienhard, *Die Legende des Prinzen Viśvantara*, 69 n. 20), to be translated as "then," "now," "further," etc. Apart from this indication that the Newar employed here is intended to be not literary but functional, there is a certain resemblance with ritual handbooks (*vidhis*, *paddhatis*) in which new prescriptions indicating the beginning of a subsequent rite are introduced with *thana*, making it the standard section marker in Newar ritual prescriptive language. This gives the scroll's captions the ring of a liturgical manual.
16. This may remind one of the elaborate praises of the effects of reading the *Aṣṭasāhasrikā-prajñāpāramitā-sūtra* expounded in extensive passages located within that very text, one of the Nine Jewels (*navaratna*), a group of texts with paracanonical status in Newar Buddhism that also stands at the center of a popular cult of the female bodhisattva worshiped in form of a book (D. N. Gellner, "'The Perfection of Wisdom'—a Text and Its Uses in Kwā Bahā, Lalitpur," in S. Lienhard, ed. *Change and Continuity. Studies in the Change of the Kathmandu Valley* [Torino: Edizioni dell'Orso, 1996], 223–40; C. Emmrich, "Emending Perfection. Prescript, Postscript and Practice in Newar Buddhist Manuscript Culture," in S. Berkwitz, J. Schober, and C. Brown, eds., *Buddhist Manuscript Cultures: Knowledge, Ritual and Art* [London: Routledge, 2008], 140–55). Less immediate but worth considering is a possible parallel with a connection between ritual and narrative from a different context: J.A.B. van Buitenen points at the *rājasūya* as the ritual background for the composition of the *Mahābhārata*'s *Sabhāparvan* (*The Mahābhārata*, Vol. 2, The Book of the Assembly Hall; vol. 3, The Book of the Forest [Chicago; London: University of Chicago Press, 1975], 3–6; "On the Structure of the Sabhāparvan of the Mahābhārata," in J. Ensink and P. Gaeffke, eds., *India Maior. Congratulatory Volume Presented to Jan Gonda* [Leiden: E. J. Brill, 1972], 68–84). Similarly, and building on Christopher Minkowski's analysis of the Vedic *sattra* ritual ("Janamejaya's Sattra and Ritual Structure," *Journal of the American Oriental Society* 109 [1989]: 401–20), Thomas Oberlies explains the insertion of the *Mahābhārata*'s *Tīrthayātrāparvan* and the story of King Śibi, a close Hindu and Buddhist literary relative of our generous prince (see R. Ohnuma, *Head, Eyes, Flesh, and Blood: Giving Away the Body in Indian Buddhist Literature* [New York, NY: Columbia University Press, 2007], 110–15), contained therein as the reformulation of a ritual procedure in the language of epic narrative: the wanderings of the Pāṇḍavas and the presentation of substories dealing with extreme generosity, such as that of Śibi cutting up his own body to save a pigeon, reenact the *Sarasvatī-sattra*, in which the performers remove themselves from the world of men by "scaling the sky," by drowning themselves ("König Śibi's Selbstopfer," *Bulletin d'Études Indiennes* 19 (2001): 241–50).
17. That worshipers become (usually the lay) protagonists of sacred narratives, not just as an act of identification with characters in a story but in a physical performance, is a widespread ritual practice among the Newars and throughout South Asia. To give three examples, Newar *vajrācārya*s take over the role of deities when anointing the boy who undergoes temporary ordination (*bare chuyegu*) with the water of the Five Oceans (D. N. Gellner, "Monastic Initiation in Newar Buddhism,"

in R. F. Gombrich, ed., *Indian Ritual and Its Exegesis* [Oxford: Oxford University Press, 1988], 42–112). Jain laypeople feature as Indra and Indrāṇī in the celebration of the Five Auspicious Moments (*pañcakalyāṇa*) of a Jina's sacred biography (Lawrence Babb, *Absent Lord: Ascetics and Kings in a Jain Ritual Culture* [Berkeley: University of California Press, 1988], 79–82) and devotees take on various roles in enacting the love play of Kṛṣṇa in Vaiṣṇava Sahajiyā ritual (G. A. Hayes, "The Neclace of Immortality: A Seventeenth-Century Vaiṣṇava Sahajiyā Text," in D. G. White, ed., *Tantra in Practice* [Delhi: Motilal Banarsidass, 2001], 312–33). The identification of the Buddhist tantric priest with the deity he summons is, of course, possibly the most common such identification in Newar Buddhism (Gellner, *Monk, Householder and Tantric Priest*, 287–92).

18. For a more detailed study of the mimetic in Newar liturgy and ritual performance, see C. Emmrich, *Writing Rites for Newar Girls: Marriage, Mimesis, and Memory in the Kathmandu Valley* (Leiden, Boston: E. J. Brill, forthcoming).

19. B. C. Law, *Aśvaghoṣa* (Calcutta: Royal Asiatic Society of Bengal Monograph Series, 1946), 47.

20. R. F. Gombrich, "The Vessantara Jātaka, the Rāmāyaṇa, and the Dasaratha Jātaka," *Journal of the American Oriental Society* 105, no. 3 (1985): 428–33.

21. A text closely related to the Viśvantara story and of immense popularity in Newar Buddhist literature is the *Maṇicūḍāvadāna*. There too the theme is the perfection of giving (*dānapāramitā*), and the very same animals and people (elephant, children, wife) are given away in the same sequence. The ending moves it into a clearly distinct plot type, as the hero eventually gives away body parts and finally his own life. For the edition of the Newar text *Maṇicūḍāvadānoddhṛta* see S. Lienhard, *Maṇicūḍāvadānoddhṛta. A Buddhist Re-Birth Story in the Nevārī Language* (Stockholm, Göteborg, Uppsala: Almqvist & Wiksell, 1963), and for a Newar song version see Lienhard, *Nevārīgītimañjarī*, 86–90 and 198–201. For a reproduction of a painted scroll featuring the story in text and image in the same way as discussed here regarding Viśvantara, see S. Lienhard, *Svayambhūpurāṇa. Mythe du Népal suivi du Maṇicūḍāvadāna, légende du prince Maṇicūḍa. Présentation, translittération, traduction et commentaires de la peinture népalaise de la Collection Hodgson au Musée des Arts Asiatiques-Guimet* (Suilly-la-Tour: Éditions Findakly, 2009). One should here also add the story of Hariścandra as known from the *Mārkaṇḍeya* and the *Devībhāgavata Purāṇa* and its innumerable vernacular versions, comparable in popularity to the Vessantara story. It is similar in that Hariścandra too is a person of seemingly excessive virtue (he cannot lie), who consequently loses his kingdom, goes through a period of austerities, and gives away his wife and children. The parallelism includes literary details such as how the Brahmin leads them away and big issues like the relationship among family, penance, and kingship (for a recent study see A. Sathaye, "Why Did Hariścandra Matter in Early Medieval India? Truth, Fact, and Folk Narrative in the Sanskrit Purāṇas," *The Journal of Hindu Studies* 2 [2009]: 145).

22. S. Lienhard, *Die Legende vom Prinzen Viśvantara*, 69 n. 25, distinguishes the Hindu court and family priest (New. *purohita upādhyāju*) from the Buddhist priest (New. *guru bajrācāryya*), which is generally accurate, yet the situation in the scroll may be more complicated than Lienhard's distinction would suggest, as it fails to explain why the *purohita upādhyāya* seems to be depicted as a *vajrācārya* wearing a ritual crown, and in a passage referring to the performance of the Eighth-Day Vow, a *guru-purohita* is mentioned in addition to an *upādhyāya* (BRK 75), with the former

depicted as a *vajrācārya* and the latter suggestively reading out from an *aṣṭamīvrata* manuscript during his sermon (BRK plate XXIII, scene 75). Lienhard himself points at some discrepancies between text and image (Lienhard, *Die Legende vom Prinzen Viśvantara*, 45 n. 69).

23. The occasions were *aṣṭamīvrata*s on December 17 and December 31, 2007, the first at Cukabāhāḥ and the second in a private home, both in Lalitpur. I recorded similar comments when attending a *vasundharāvrata*, also at Cukabāhāḥ, on February 13, 2006.
24. Lewis, *Popular Texts from Nepal*, 84–89.
25. T. T. Lewis, "Himalayan Frontier Trade: Newar Diaspora Merchants and Buddhism," in C. Ramble and M. Brauen, eds., *Proceedings of the International Seminar on the Anthropology of Tibet and the Himalaya, September 21–28, 1990, at the Ethnographic Museum of the University of Zürich* (Zürich: Ethnographic Museum of the University of Zürich, 1993), 165–78.
26. Lewis, *Popular Texts from Nepal*, 47–48.
27. It is striking that Viśvantara's title, which until this point in the text (except for in a caption mentioning blissful family life) had been "prince" (*rājakumāraṇa*), here switches to "king" (*rājāna*, BRK 32) and is retained for the rest of the text, including the colophon, as if the renunciation of his kingdom had actually earned him a title equal to that of his father.
28. In the *Viśvantarakātha*, the other, still unpublished ms. Lienhard refers to in his edition, this development is analogously but in other terms narrated as: "Then, after remaining alone, Prince Biśvaṃtara performed the concentration called 'the placeless'" (fol. 49v; Lienhard, *Die Legende vom Prinzen Viśvantara*, 18 n. 39).
29. J. S. Strong, *Relics of the Buddha* (Princeton: Princeton University Press, 2004), 9–10; Y. Bentor, "Tibetan Relic Classification," in P. Kvaerne, ed., *Tibetan Studies (Proceedings of the Sixth Seminar of the International Association for Tibetan Studies, Fagernes, 1992)* (Oslo: Institute for Comparative Research in Human Culture, 1994), 16).
30. Paul Harrison, "Is the Dharma-kāya the Real 'Phantom Body' of the Buddha?" *Journal of the International Association of Buddhist Studies* 15, no. 1 (1992): 44–94. In my translation of the text's *dharmaśarīra* as "body of dharma," I follow Harrison, who in proposing to translate *dharmakāya* as "body of dharma(s)" and refuting the rendering "Dharma-body" in turn follows Edgerton (49–50, 54, 81 n. 48).
31. Harrison, "Is the Dharma-kāya the Real 'Phantom Body' of the Buddha?" 79 n. 27. The *Karmavibhaṅgopadeśa* (S. Lévi, *Mahākarmavibhaṅga [La grande classification des acts] et Karmavibhaṅgopadeśa [Discussion sur le Mahākarmavibhaṅga]* [Paris: Librairie Ernest Leroux, 1932], 157 ff., 172 ff., quoted in Harrison, "Is the Dharma-kāya the Real 'Phantom Body' of the Buddha?" 54) states that the realization of the *dharmaśarīra* equals or even exceeds in valence the physical body of the Buddha: "The *dharma* taught by the Lord is the body of the Lord" (157: *ya eṣa dharmo Bhagavatā deśitaḥ etad Bhagavataḥ śarīram*) and "The *dharma* is the body of the Lord" (160: *dharma eva* [or *dharmaś ca*] *Bhagavataḥ śarīram*), together with the frequent use of the noun compound *dharma-śarīra* (at one point—157—described as *Bhagavataḥ śarīram pāramārthikam*). Bahuvrīhis also crop up in the expressions *dharma-śarīras tathāgata* (158) and *dharmakāyāḥ tathāgatāḥ* (158–59), which have the same meaning we saw above: "The *Tathāgata(s)* is/are *dharma-bodied*" (Harrison, "Is the Dharma-kāya the Real 'Phantom Body' of the Buddha?" 80 n. 35).

32. Another ambiguity important to Harrison is that of the word "dharma," which, in Harrison's view, both one and many, would refer to both the dharma taught by the Buddha and the dharma(s) realized by the Buddha as a person, as well as, more specifically, a list of particularly pure dharmas necessary to constitute a *dharmakāya* ("Is the Dharma Body the Real 'Phantom Body' of the Buddha?" 56).
33. D. Schlingloff, "Das Śaśa-Jātaka," *Wiener Zeitschrift für die Kunde Südasiens* XV (1971): 60 n. 1; D. Schlingloff, *Studies in the Ajanta Paintings* (Delhi: Ajanta Publications, 1987), 96 and 111 nn. 18, 19.
34. H. Durt, "The Offering of the Children of Prince Viśvantara/Sudāna in the Chinese Tradition," *Journal of the International College for Postgraduate Buddhist Studies* II (1999): 147–82; H. Durt, 'The Casting-off of Mādrī in the Northern Buddhist Literary Tradition," *Journal of the International College for Postgraduate Buddhist Studies* III (2000): 133–58.
35. Lienhard, *Die Legende vom Prinzen Viśvantara*, 16.
36. Durt, "The Offering of the Children of Prince Viśvantara/Sudāna in the Chinese Tradition," 177.
37. Durt, "The Offering of the Children of Prince Viśvantara/Sudāna in the Chinese Tradition," 150 and 154.
38. Durt, "The Offering of the Children of Prince Viśvantara/Sudāna in the Chinese Tradition," 158–59.
39. Durt, "The Offering of the Children of Prince Viśvantara/Sudāna in the Chinese Tradition," 153 and 164–65. As Durt points out, there are echoes of this in the *Bhaiṣajyavastu* 66.a18–19, where the first Brahmin is Indra and second has been spellbound by Indra (T. 1448, 68.a15–17).
40. Durt, "The Offering of the Children of Prince Viśvantara/Sudāna in the Chinese Tradition," 162.
41. Durt, "The Casting-off of Mādrī in the Northern Buddhist Literary Tradition," 156.
42. Durt, "The Offering of the Children of Prince Viśvantara/Sudāna in the Chinese Tradition," 165; compare Durt, "The Casting-off of Mādrī in the Northern Buddhist Literary Tradition," 156.
43. Durt, "The Offering of the Children of Prince Viśvantara/Sudāna in the Chinese Tradition," 165–66.
44. *Śrī Mahākaviśīsomadevabhaṭṭaviracitaḥ Kathāsaritsāgaraḥ*, ed. Paṇḍit Durgāprasād and Kāśīnāth Pāṇḍurang Parab (Bombay: The "Nirṇaya-Sāgara" Press, 1889) (hereafter KSS); for a translation see *The Katha Sarit Sagara; or Ocean of the Streams of Story*, trans. C. H. Tawney, 2 vols., 3rd ed. (Delhi: Motilal Banarsidass, 1992 [1924–28]) (hereafter, KSS transl. Tawney 1924–28), vol. 2, 498–503.
45. That the *Kathāsaritsāgara* ending too is not singular, but may represent yet another common variant, spilling across religious, regional, and linguistic boundaries, is proven by the fact that one Tibetan version of the story of Vessantara shares a structurally very similar ending: return to kingship, rejection of kingship, mountainous retreat, and miraculous transformation. The drama of Dri med kun ldan, attributed to the 16th Dalai Lama (H. I. Woolf and Jacques Bacot, *Three Tibetan Mysteries: Tchimekundan, Nansal, Djroazanmo As Performed in the Tibetan Monasteries. Translated from the French Version of Jacques Bacot* [London: Routledge, 1894], 11–115), has the protagonist made king by his father on his return to his home city. Just like Tārāvaloka, he soon hands over the kingdom to his two sons and, joined by his wife and a ministerial entourage, heads for the mountain Siṅ ga la, where after five years, the royal couple transmutes into lotus flowers and is carried

off by a great wind blowing from India (Woolf and Bacot, *Three Tibetan Mysteries*, 102–109).

46. David Gordon White refers to a ritual called *vedha* (piercing) mentioned in the *Kulārṇava Tantra*: "This is the eighteenth and final *saṃskāra*, known as *śarīra-yoga*, 'body work' or 'transubstantiation'. In this final operation, the alchemist will generally hold in his mouth a solid 'pill' (*guṭikā*) of mercury, which will gradually penetrate his body and so transmute it into an immortal golden, diamond or perfected body" (*The Alchemical Body: Siddha Traditions on Medieval India* [Chicago: University of Chicago Press, 1996] 314–15). For the connection of these processes with *vidyādhara*s and mountains, see White, *The Alchemical Body*, 323–34, including references to the *Kaulajñānanirṇaya* attributed to the *siddha* Matsyendranāth, the yogic celebrity who, as mentioned above, is identified with Lokanātha Avalokiteśvara, to whom the Eighth-Day Vow is dedicated.

47. P. Vaidya, ed., *Bodhicaryāvatāra of Śāntideva with the Commentary Pañjikā of Prajñākaramati* (Darbhanga: Mithila Institute, 1960), 1.10ab. Another prominent literary figure who attains transhuman qualities thanks to his abandonment of kingship and endorsement of the ascetic life and can thus be considered a relative of Tārāvaloka and the Newar Vessantara is the epic Bhīṣma. His "terrible vow," to which he owes his name, of rejecting his father's throne and taking a lifelong vow of chastity, secures him the boon of being able to determine his own time of death (MBh I.94.94, Poona edition; MBh I.94.75–76, Southern recension). Padmanabh Jaini ("Buddha's Prolongation of Life," *Bulletin of the School of Oriental and African Studies* 21, no. 3 [1958]: 546) has drawn attention to the parallelism between Bhīṣma's power of *icchā-maraṇa* (death at will) and the Buddha's act, featured in the various versions of the account of his last days, such as the *Divyāvadāna*, the *Mahāparinirvāṇasūtra*, and the *Mahāparinibbānasuttanta*, of being able to reject the force of prolonged life (*jīvitasaṃskāra*, or *–saṃkhāra*) while retaining that of life duration (*āyusaṃskāra*, or *–saṃkhāra*).

48. Steven Collins refers to David Shulman in his own reading of Vessantara in *Nirvāṇa and Other Buddhist Felicities: Utopias of the Pali Imaginaire* (Cambridge: Cambridge University Press, 1998), 499–502.

49. Though Śākyamuni as narrator is found in both the Pali and the Newar versions and the placement of this birth story closely to the bodhisattva's last birth may suggest a thematic connection between the two princes, Buddha Śākyamuni's narrative may be part of a third plot type of active rejection of kingship either as a prince or as a king, found as subplot in the above-mentioned stories, such as Tārāvaloka relinquishing his suzerainty over the *vidyādhara*s or Viśvantara's father renouncing his throne. This paradigm is central to the narratives of the *Yogavāsiṣṭha* (*Vasiṣṭha's Yoga*, trans. Swami Venkatesananda [Albany: State University of New York Press, 1993]) where the framing narrative is about Rāma, who grows weary of his impending kingship and considers forsaking it only to be convinced by the sage Vasiṣṭha, in an argument reminiscent of that of the *Bhāgavadgītā*, to hold back and hang on. One of the stories told to the prince by Vasiṣṭha is the story of King Śikhidhvaja, who actually gives up kingship and is joined by his wife, Cūḍālā (*Vasiṣṭha's Yoga* VI.1.77–109).

50. For a contribution to this see Emmrich, "The Tale of the Generous Prince in Newar Manuscripts."

51. While a look at non-Buddhist versions is useful to contextualize the Newar (and not only the Newar) text, Lienhard's assumption that the ending of the Newar versions is due to "Hindu tendencies and the strongly syncretistic spirit that presumably

dominated in the Kathmandu Valley since very early times" (*hinduistische Tendenzen und der stark synkretistische Geist, der im Kathmandu-Tal vermutlich schon sehr früh geherrscht hat,* Lienhard, *Die Legende vom Prinzen Viśvantara,* 18; compare 233 n. 48) does not explain why the Newar ending should be particularly "Hindu," erroneously presupposes the Pali version as a model *for* rather than having possibly only a historically earlier verse core *than* all other Buddhist versions, does not take into account Saṃghasena's version as a possible early Buddhist predecessor of the Newar one, and tacitly dismisses the fact that, as we have seen, "Hindu" and "Buddhist" versions may have either ending.

52. Durt, "The Offering of the Children of Prince Viśvantara/Sudāna in the Chinese Tradition," 177.
53. In the version recorded in Lienhard's unpublished *Viśvaṃtarakathā* (ViK 50r; Lienhard, *Die Legende vom Prinzen Viśvantara,* 216 n. 46), while the prince's family is also said to live happily ever after, the king acts less dramatically than in the scroll version, though the thrust of his following his son's example is maintained: he remains on the throne and instead, with his mind set only on his son, commits to making generous donations as if becoming a Viśvantara on the throne.
54. Lienhard, *Die Legende vom Prinzen Viśvantara,* 70 n. 47.
55. Interestingly, in Saṃghasena's version, i.e., the only other Buddhist one ending with the prince not returning, as Durt has pointed out, Mādrī is depicted as the strongest and most self-reliant princely wife ("The Casting-off of Mādrī in the Northern Buddhist Literary Tradition," 260–61). Another tale prominent in Newar Buddhist literature in which the prince does not return and the wife remains separated from her ascetic husband is that of Yaśodharā from the *Bhadrakalpāvadāna,* studied by Joel Tatelman ("The Trials of Yaśodharā: The Legend of the Buddha's Wife in the Bhadrakalpāvadāna," *Buddhist Literature* 1 (1999): 176–261; "The Trials of Yaśodharā: A Critical Edition, Annotated Translation and Study of *Bhadrakalpāvadāna II-V*" (Ph.D. diss., Oxford University, 1996). The bodhisattva's wife there moves along an ascetic trajectory of her own, without the prospect of a reunion with her husband, and her offspring are destined for renunciation themselves; it is a comparative yet very different take on the effects of the husband's religious aspirations on family.

INDEX

Abraham (Old Testament figure), 69
Aesop's Fables, 11
affection, 10, 14, 46, 82, 86, 87, 92
Ajanta, 122
Alaungsithu (king), 153, 180
Along Chao Sam Lao, 67
Alsdorf, Ludwig, 4, 5
Amittatāpanā (Jūjaka's wife), 13–14, 16, 27, 42, 92, 94–95, 102, 108–9, 111, 114, 133, 146
Amoghapāśa-Lokeśvara (form of Avalokiteśvara), 185
Ānanda (Burmese monument), 155–65, 166
antiroyalist interpretations, 102
arahant (arhat), 2–3, 8, 86
Arcadia, 15
Aristotle, 14, 65–66
Artaud, Antonin, 71–72
Ārya Sura, 7, 9, 184, 188, 193, 194, 195
asceticism, 83, 96, 163, 193, 196, 197, 201.
 See also Perfection of Asceticism
Aṣṭamīvratamahātmya, 185
Aṣṭamīvratavidhāna, 185
aśvamedha (horse sacrifice), 188
Atharvaveda, 188
ati, "very great" or "excessive," 7–11
attachment (detachment, nonattachment), 23, 49, 62, 82–83, 86, 90, 92, 93, 94, 96
"authoritative" vs. "oppositional" tellings, 6–7

Ayuthaya, 41, 42
Avadāna stories, 184, 185
Avalokiteśvara (White), 198
Avīci hell, 86

Ban Khau, Mahasarakham, 146
barami ("sacred charisma"), 109
Benveniste, Émile, 22
Bergson, Henri, 107
Bharata, 188
Bharhut, 112
bhikṣu-s (monks), 186, 188, 189
(King) Bhumipol Adulyadej, 144
Bisvaṃtara rājāyagu kathā (story of Vessantara in Nepal), 186–92, 197–98
Bodhicaryāvatāra, 196
bodhicitta (thought of enlightenment), 196
Borobudur, 122
Bountan Boundteun, 63
Bowie, Katherine, 24
Brahmin(s), 7, 13, 14, 17, 21, 25, 27, 28, 93, 141, 156–57, 176, 178, 188, 189, 191–92, 198, 200
Buddha (Siddhattha Gotama, Siddhārtha Gautama, also Śākyamuni) 2, 3, 8, 9 11, 12, 25, 38, 46, 70, 155, 157, 159, 162, 173, 177, 186 (= Śākyasiṃha), 193, 194, 198; as *bodhisatta* (*bodhisattva*, future Buddha), 3, 7, 161, 164, 87, 88, 166, 172, 174, 176, 194, 195

Buddhadasa Bhikkhu, 39, 48
Bun Phra Wet (festivals), 123
Burma (Myanmar), 7, 55, 90, 122, 153–80
Burmese versions, 22
Bussaba (character in Story), 85
Butsarana (Sinhalese), 22

Cambodia, 55, 122
campū (prose + verse style), 12
Cariyā-piṭaka, 9, 10, 20
Cate, Sandra, 24
Cetans, 27, 157, 168, 178; Accuta (sage), 22, 27, 111; Jetabutr (hunter, guard), 104, 106, 107, 111, 113
Chai'anan Samutwānit, 41–42
Chapphong (Kowit Anekachai), 48
chapters in this volume, 23–29
Chavannes, 21
Christianity, 1, 8
Chulalongkorn (king), 39,
Chulalongkorn (University), 44, 45
Ciñcamānavikā, 102
Collins, Steven, 196
comedy, 15, 100–119
commentary (*aṭṭhakathā*), 9
Cone, Margaret, 4, 12, 13, 15, 22
connection (*samodhāna*, ending of a *Jātaka* story), 11, 186
Covell, Stephen, 82
criticism of the Vessantara story, 9–11, 38–46, 63, 100
crying. *See* weeping
Cullapaduma Sutta, 84–85

Daśaratha, 188–89, 198
Das Gupta, 20
defense of Vessantara and his actions, 9–11, 45–50
Delouche, Gilles, 42
Derrida, Jacques, 55, 69, 70
Devadatta (monk at the time of Gotama), 102
dhamma (*dharma*), 55, 57, 58, 162
dhamma-dāna (gift of the *dhamma*), 57
Dhammapada commentary (*aṭṭhakathā*), 85–86
dharmakathā, 199
dharmakāya (body of dharma), 192
dharmaśarīra (body of dharma), 192–93, 198

Dickens, Charles, 180
Dinnā, 85
Dīpaṅkara Buddha, 3, 165
Divine Abidings (*brahma-vihāra*), 4–5
Divyavadāna, 184
Dramatis Personae, 26
dtoo tham (special script used in Laos), 58
Dunniviṭṭha (Foulstead), 13, 27
Durt, Hubert, 21, 194–95, 198

Eberhardt, Nancy, 18–19
Egge, James, 61
"Eighth Day Vow" (Nepal), 24, 185, 186–87, 188–89, 193, 196, 198, 199
elephant. *See* Paccaya
Emmrich, Christian, 12, 21, 24
emotion(s), 15, 24, 28, 53–73, 82, 91, 92, 94, 136, 156, 157, 171
epic, 12
ethics, 4, 14, 24, 53–55, 59–60
excess, 7–11, 16, 38, 53, 55, 60–73, 106, 170
exemplary vs. unique virtues, 7–8, 9–11

feminist critique, 43–45, 50, 59
Five Precepts, 14
forest, 1, 12, 14, 15–6, 17, 20, 21, 22, 24, 25, 27, 29, 37, 55, 62, 84, 86, 90, 91, 93, 102, 105, 107, 111, 118, 124, 126, 128, 132, 136, 137, 138, 141, 143, 144, 145, 146–47, 168, 169–70, 193, 197
forest monks, 144, 197, 201
Formoso, Bernard, 55

Gabaude, Louis, 23
Geertz, Clifford, 65
Gellner, Ernest, 7, 8
gender (inside and outside the text), 16–19, 111, 190, 199–200
generosity = giving, *passim*. *See* Perfection of Generosity
Gibson, Andrew, 66–67
Golden Age, 16
Gombrich, Richard, 4, 7, 12, 13, 15, 22, 61, 188
Gorkhas (Hindus in Nepal), 197
Greek tragedians, 1, 14, 65, 66
grief, 12, 63, 92, 93, 167–68

INDEX [213]

Handlin, Lilian, 24
Hallisey, Charles, 54, 72
Hansen, Anne, 54
Hariścandra, 196
Harrison, Paul, 192
Hegel (on tragedy), 66
Heim, Maria, 54, 63–64
Homer, 1
Horner, Isaline Blew, 20
Hsin Pyu Shin (king), 180
humor (the "Trickster"), 100–21
Hyde, Lewis, 107

ideology, 6, 7–9, 12, 15, 41, 42, 45, 51, 159, 164, 177
India, 19, 111, 122, 147
Indian Buddhism, 82
Indonesia, 147
Indra. *See* Sakka
Isan (northeast Thailand), 123
Islam, 1

Jaffe, Richard, 82
Jaini, Padmanabh S., 90
Jainism, 54
Jāli (Jālini, Vessantara's son), 6, 10, 21, 24, 28, 47, 49, 50, 62, 106, 138, 191, 198
Japanese Buddhism, 82
jātaka (as genre), 11–12, 59
Jetuttara (city of the Sivis), 28, 168, 171
Jory, Patrick, 100
Jūjaka (Chuchok), 7, 13–14, 24, 27, 37, 40, 49–50, 64, 66, 84, 92, 94–95, 100–19, 127, 133, 137, 140, 143–44, 145, 146, 167, 168, 169, 170–71, 177, 189; amulets, 95, 117; as comic character, 100–19

Kaliṅga, Kaliṅgans, 13, 25, 49, 119
Kaṇhājinā (Kṣṇājinī, Vessantara's daughter), 25, 28, 47, 49, 50, 62, 106, 138, 157, 191, 198
Karuṇeśvara, 186
Kassapa Buddha, 9
Kathāsaritsāgara, 20, 184, 195
Kathmandu Valley, 183, 184, 189, 190, 196–97, 199
Khin Thitsa, 43
Khoen, 87–88
Khoroche, Peter, 7, 20

Khuddaka-Nikāya, 11–12
khwan (spirit, soul): *ming khwan* (soul substance, fate), 57, 68; *su khwan* ("binding of the soul ritual"), 57, 142
Kierkegaard, 7–9, 69
kingship, 12, 20, 21, 24, 55, 60, 67, 68–69, 100, 163, 183, 195, 196, 197
Kisā Gotamī, 86
Konbaung (dynasty, period), 153, 155
Korea, 46
Kornvipa Boonsue, 43
Kṣemendra (*Avadāna-kalpalatā*), 20, 184, 193, 196
Kukkuṭamitta (character in story), 86
Kukrit Pramoj, 39–41, 44, 45–46
Kyanzittha (king), 153, 155, 156, 159, 164

Ladwig, Patrice, 34
Laidlaw, James, 54
Lambek, Michael, 72
Lao, Laos, 18, 53–73, 122, 123–48
Law, Bimal Churn, 188
Lefferts, Leedom, 18, 24
Lenz, Timothy, 20
Lewis, Todd, 190
Lhasa, 190
Lienhardt, Siegfried, 21, 183, 184, 185, 198
Life of the Buddha (Aśvaghoṣa's *Buddhacarita*), 23
Lokahteikpan (Lawka-they-pan), 153, 165–72
Lokanātha-Avalokiteśvara, 187, 198
Lokaneyya-pakaraṇam, 90
Lokeśvara Bugama (Buṃgamati), 186
Lovejoy, Arthur, and Franz Boas, 16
Luang Pho Bunthong, 108, 112, 113, 114–17
Luang Phrabang, 55, 57, 64

Maddī (Vessantara's wife) (Matsii, Madsi, Madrī), 5, 10, 13, 15, 16, 21, 25, 27, 28, 37, 40, 42, 50, 43, 44, 46, 84, 91–94, 104, 113, 114, 126, 127, 135–36, 137–38, 145, 146, 160, 162, 163, 169–70, 171, 174–75, 176, 177, 189, 191, 197, 198
mae chi (nuns), 123
Mahābhārata, 12
Mahābrahmā, 87
Mahāyāna, 3

INDEX

Mahā Chat Kham Luang, 6, 41–42
Mahānikai (monastic faction), 124
Mahasila Viravong, 58
Mair, Victor, 147
Māleyys (Phra Malai), 38, 104, 129–30, 131, 134
Malla (monarchs in Nepal), 197
Mara, 131
marriage, 81–99
Marx, Marxism, 8, 60, 68–69, 70
Matsyendranāth (Red), 186
Maung Htauk, 173
maze (as symbol and ritual structure), 37, 104–5, 175
McDaniel, Justin, 23–24
Mechai Thongthep, 119
Mekhong (river), 55, 57, 123
melodrama, 15
Menander. *See* Milinda
mettā, 16
Metteyya (Maitreya), 2, 38, 43, 51, 56, 129–30, 147, 179
Milinda, Questions of, 7–10, 38, 62
Mon, 153, 154, 155–65, 163–72
Mongkut (king), 39, 100–101
Mongolian, 22
Mount Meru, 146
Mūlasarvāstivāda, 196
Myanmar. *See* Burma

Nāgasena, 9–10, 38, 62
Nang (Mae) Thoranī (earth goddess), 131
narrative (narration), 1, 4, 5, 8, 11, 12, 15, 17, 22, 23, 45, 53–73, 81, 82, 83, 84–90, 91, 95, 96, 122–48, 154, 155, 159, 161, 165, 167, 169, 171, 172, 180, 183, 184, 186, 190,191, 192, 193, 195, 196, 197, 199, 200, 201
Nepal, 2, 19, 21, 81, 183–201
Newari version(s), 183–201
Nietzsche, Friedrich, 67–68
Novice Ordination as a Life-Cycle Ritual for the boys' mothers, 18–19
Nussbaum, Martha, 53, 63–64, 65–66

offensiveness, 7–11
Olivelle, J. Patrick, 23
omniscience, 2, 10, 11, 162, 169, 176

Orientalism, 4
Osier, Jean-Pierre, 20

Paccaya (Vessantara's elephant), 49, 50, 57, 67, 68, 134–35, 171, 178–79
Pacceka-buddha (*pratyekabuddha*), 2
pagan, 153–65, 180
Pali, 2, 9, 83, 184
Pali Canon, 2, 11–12
Panji/Inao (Java), 85
paññāsa-jātaka tradition(s), 87, 90
parent(s), parenthood, 16, 21, 28, 46, 59, 82, 87, 89, 91, 94, 102, 108–9, 110, 113, 116, 118, 119, 127, 142, 144, 163, 168, 171, 177
Paṭācārā (character in story), 86
Peltier, Anatole, 88
perfection, 9, 55, 64, 65, 71, 73
Perfection of Asceticism (*nekkhamma-pāramitā*), 89
Perfection of Generosity (*dāna-pāramitā*) 1, 3, 9, 20, 38, 47, 50, 55, 93, 192, 195
Perfections (Ten), 3, 9, 15, 20, 28, 48, 55, 66, 69, 70, 190, 201
performance(s), 4, 5, 6, 7, 54–57, 63, 90, 100–101, 104 (monks specializing in different characters), 117, 119, 122–48, 160, 184–85, 187, 190, 194, 198, 200
Pha Yao Phra Wet (painted scrolls) 122–48
Phosaenyanupap (Mongkut Kaendiao), 48–51
Phra Malai (*Māleyya-deva Sutta*), 3
Phusatī (Vessantara's mother), 13, 94, 139, 167, 188
Pin Muthukant, 45
Pisamantra, 155
Poppe, Nicholas, 22
Pūjāvaliya (Sinhalese), 22

Rabelais, 100
Radin, Paul, 101, 118
Ralston, William, 20
Rāma, 5, 92, 188, 196
Rama III (king), 47
Ramanujan, A. K., 5, 6
Rāmayaṇa, 5, 12, 20, 57, 188–89, 198
renunciation, 6, 9, 24, 55, 61, 62, 63, 64, 163, 183, 196, 200
Rhys Davids, Thomas William, 62

INDEX [215]

Ricoeur, Paul, 67, 72
ritual(s), 4, 6, 18, 19, 24, 38, 48–49, 50–51, 54, 55, 56–58, 59, 71, 72, 83, 104, 122–48, 154, 155, 156, 160–61, 173, 183, 184, 185–91, 193, 194, 197, 198, 199, 200, 201

Sakka (Śakra, Indra), King of the Gods, 21, 25, 27, 28, 85, 88, 89, 91, 167, 191, 194, 197
Sakyans, 25
Saṃghasena, 21, 193, 194, 195
Sammāsambuddha, 2
Samuddhaghosa Jātaka (love story), 90
Sanchi, 122
Saṅghabhedavastu, 20
Sangkhat (Story of the Present), 130–1, 134
Sañjaya (Sonchai, Vessantara's father), 10, 13, 16, 25, 28, 29. 46, 47, 49, 50, 94, 135, 8, 139, 139, 144, 167, 170, 177, 188
Sanskrit, 2, 20, 21, 184, 185
sāsana, 2, 159, 190
Sathien Bodhinantha, 45, 46–47
Sāvaka (Hearer), Sāvakayāna (Hearers' Vehicle), 3
Schlingloff, Dieter, 194
Schrift, Alan, 68
scrolls, 24, 56, 104, 122–48
Serres, Michael, 67
sexuality (humor, sexual jealousy, innuendo), 13, 14, 27, 85, 94–95, 102–3, 110
Shakespeare, 1
Shan, 18, 37, 87
Shaw, Sarah, 4
Shulman, David, 11–12, 196
Shwezigon (Shwedagon) pagoda, 180
Sibi (Śivi, king), 61, 72, 187, 197, 198, 199
siddha, 193, 195, 197
Siṃhalasārthabāhu Avadāna, 190
sineha (affection), 82–83
Sinhala versions, 22
Sītā, 5, 17, 92
Sivis, 13, 22, 42, 49
Social Theater, 18
Sogdian, 22
Sombat Chantornvong, 41
Songkhran (New Year), 124
Sopha Pangchat, 136–37
Soreyya (character in story), 86

South Asia, 3, 6, 195,
Southeast Asia, 2, 3, 5, 6 19, 24, 55, 59, 82, 87, 94, 95, 147, 184
Spiro, Melford, 55, 61
Sridaoruang (*Matsii*), 23
Sri Lanka, 2, 7, 72, 122, 147, 184
Sri Thanonchai, 118–19
Story of Gotama Buddha (*Jātaka-nidāna*), 23
Story of the Past, 11
Story of the Present, 11, 174, 186
Strong, John, 20, 23
Sudhanukumāra Jātaka, 90
Sujavaṇṇa Wua Luang, 88–90
Sukkā (nun in story), 82
Sukhotai, 41
Sumedha (future Buddha Gotama), 3, 165
Suwanna Satha-Anand, 44, 45

Tambiah, Stanley, 55
Tārāvaloka (in *Kathāsaritsāgara*), 20, 195
teaching (*sāsana*), 2
tellings (= versions), 3–7, 19–23
Terral, G., 90
Thai-Lao, 123–48
Thai television, 59
Thai versions of the *Vessantara Jātaka*, 22, 94–95
Thailand, 24, 43, 47, 55, 56, 81, 82, 85, 90, 100–101, 122
thammat (preaching chair), 131, 147
Thammayut (monastic faction), 39, 100–101, 124
Theravāda, 2, 18, 69, 123, 180
Three Worlds (*Trai Phum*), 42, 84
Tibet, 3, 20–21, 81
ton ngern (money trees), 126
tragedy, 1, 12–15, 17, 65
Trailokanat (king), 42
translations of *Vessantara Jātaka*(s) in English and French, 19–23
tujok (Chuchok, Jūjaka) monks, 102, 104, 105–7, 108, 109, 113, 117, 118
Turner, Victor, 117

ubosot (*uposathāgāra*), 124
U Botha, 172–80
Ummādanti, 88–89
United States, 111

upādhyāya (instructor, storyteller), 185
Upagupta, 38, 55
Uposadha Devaputra, 186
ur-text (idea of), 5–7
utopianism, 16–17

vajrācārya (= *rājaguru*, chief royal priest), 187
Vajrayāna, 186
Vaṅkatapabbata Mountain (Shan: Mangkapa, Thai Wongkot, Burmese Wingaba, etc.), 37, 104, 111, 143, 175, 180, 199
Vidarbhā (Bidarbhā), 187
Vientiane, 56, 59, 63, 68
Vietnam, 46, 68, 111

Vissakamma, 27
Vrajasattva (deity), 186

Wat Longkaram, 83
Wat Ming Mang (Roi-et City), 140
Wat Sanuan Wari, 141
Wat Suthat, 85
weeping (at the Vessantara story), 64–65, 101
Wheatley, Paul, 147
Williams, Bernard, 71
"world religions," "religious," 1–2
written text(s), 113, 127–28, 132–33, 138, 148, 154, 167, 174, 175, 184, 187, 192

Yasodharā (Siddhattha Gotama's wife), 87, 90

GPSR Authorized Representative: Easy Access System Europe, Mustamäe tee
50, 10621 Tallinn, Estonia, gpsr.requests@easproject.com